The Menil Collection

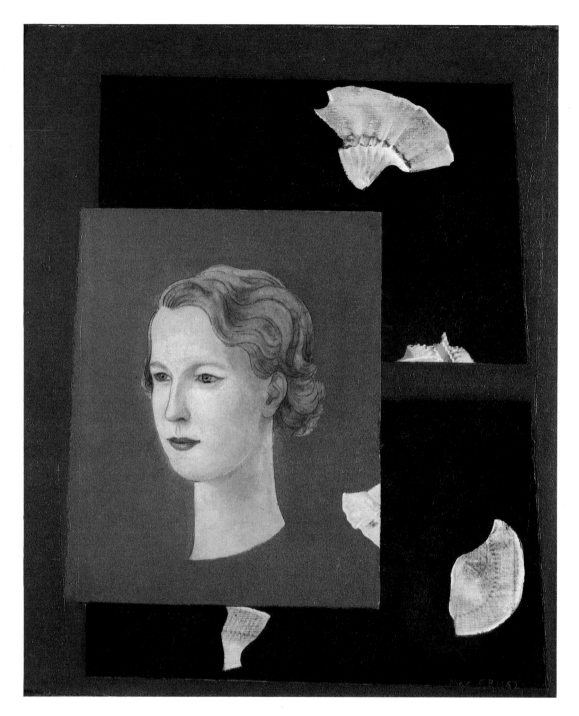

MAX ERNST
Portrait of Dominique, 1934
Oil on canvas
26 × 21½ in.

The Menil Collection

A Selection
From the Paleolithic to the Modern Era

Harry N. Abrams, Inc., Publishers, New York

This publication has been conceived and produced on the occasion of the inauguration of The Menil Collection, a museum established by The Menil Foundation and other benefactors in Houston, Texas. The Menil Collection museum opened to the public on June 7, 1987.

Front cover: René Magritte
 La clef de verre, 1959
 Oil on canvas
 51⅛ × 63¾ in.

Back cover: Takis
 Espace intérieur, 1957
 Bronze
 5 in., diameter

Editorial Coordination: Nora Beeson, Margaret B. Rennolds
Design Coordination: Darilyn Lowe
For The Menil Collection: Susan Davidson, John Kaiser, Neil Printz, Paul Winkler

Library of Congress Cataloging-in-Publication Data

The Menil Collection.

 Includes index.
 1. Art—Texas—Houston. 2. Menil Collection
(Houston, Tex.)
N576.N68M46 1987 708.164'1411 86-32045
ISBN 0-8109-1440-9
ISBN 0-8109-2330-0 (pbk.)

Published in 1987 by Harry N. Abrams, Incorporated, New York
No part of the contents of this book may be reproduced without the written permission of the publisher

Times Mirror Books

Printed and bound in Japan

TABLE OF CONTENTS

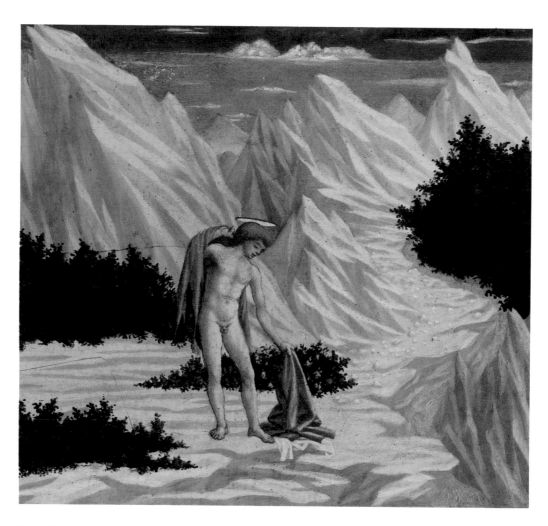

Domenico Veneziano
St. John in the Desert, ca. 1445
National Gallery of Art, Washington,
D.C., Samuel H. Kress Collection

Foreword
Dominique de Menil

This is a beautiful book of images. Images of art works, old and contemporary, and of precious objects retrieved from the devastating wreck of time. Some have been addressed by scholars who are bringing a wealth of information. What else might I say?

I hesitate to write. Events, people, situations, and works of art most of all are always beyond what may be said of them. Language restricts, limits, impoverishes. Elémire Zolla, an Italian scholar of immense erudition, speaks of the poverty of language ("l'insuffisance de la parole"), and Roland Barthes wrote, "la parole est fasciste"; "imperialistic," would say Edmund Carpenter. Indeed, language has an inherent impotence as well as a disposition toward aggressivity. Perhaps only silence and love do justice to a great work of art.

And yet words can be illuminating. They may put you in a frame of mind that the invisible becomes visible. The same Roland Barthes helped me to love Cy Twombly's work; Leo Steinberg led me to see Jasper Johns' more fully; and my daughter Christophe revealed many a painting to me with just a few remarks. To say nothing of the Henri Focillons, the Charles Sterlings, the Erwin Panofskys.... Far from me to exclude verbal communication. Poets as well as scholars must participate in the permanent celebration that should surround art. Books, catalogues, lectures, informal talks, panel discussions, all have their privileged and welcomed place. But discourse must not take the place of art itself.

However well parenthood is planned, children are what *they* are, not what parents decide. Like children, treasures of a collection are what *they* are. Complex sets of circumstances brought these treasures into the family: a chance encounter, a visit to an artist or dealer, a glance at an auction catalogue, a successful bidding, and, of course, a favorable moment for spending. This somehow unsystematic approach was our way of collecting. Nothing was excluded from consideration, yet deep inclinations existed. Constraints too: price and availability. I would love to see in the Collection a predella that once belonged to Bernard Berenson, *St. John the Baptist in the Desert* by Domenico Veneziano, now in the Kress Collection of the National Gallery of Art in Washington, D.C. A lonely adolescent is disrobing in the solitude of mountains; a grey landscape with brownish green bushes and a flash of dark ruby-red—his cloak. I am so fond of this strange and miraculous little painting that I experience it as totally mine when I stand in front of it. And I think that in years ahead there will be those, unknown to me, who will take and "possess" works that I have acquired.

As the idea of a museum slowly took shape, I dreamed of preserving some of the intimacy I had enjoyed with the works of art. I came up with a concept to which the architect Renzo Piano responded brilliantly: we would rotate the works of art. We would show only portions of the Collection at a time, but displayed in generous and attractive space. What would not be shown would be "compressed," yet remain visible in storage for scholars, students, and art lovers. The public would never know museum fatigue and would have the rare joy of sitting in front of a painting and contemplating it. Some great works would be shown alone, like the *Burial of the*

Count of Orgaz in the small Toledo Chapel. Works would appear, disappear, and reappear like actors on a stage. Each time they would be seen with a fresh eye. Habit blunts vision. People who live in Chartres take the cathedral for granted.

"A museum should be a place where we lose our head," said Marie-Alain Couturier, the Dominican father who initiated a renaissance in sacred art in France in the 1940s and 50s. Alas, we rarely lose our head in a museum. Great museums are overloaded with masterpieces, each fighting for attention, and we are bombarded with information that distracts from contemplation and remains foreign to the magic of a great painting. The truth is also that we are not prepared to lose our head. We have been trained not to, trained by emphasis on analysis, on virtuosity, on "accomplishments." Except for music, the natural longing for enchantment is discouraged in our culture. And what is art if it does not enchant? Art is incantation. Like Jacob's ladder, it leads to higher realities, to timelessness, to paradise. It is the fusion of the tangible and the intangible; the old hierogamy myth—the marriage of heaven and earth.

The Collection was put together as much by John de Menil as by myself. He loved painting. He had a discerning eye and a high sense of quality; his impulses proved right. The Collection owes him many of its treasures. He actually started it during a business trip to New York, when he brought back in his briefcase a watercolor by Cézanne that he had bought with Father Couturier on a tour of galleries. In 1959, when reasonably we should have stopped buying, he decided we could not let pass the admirable Léger *Still Life* of 1926 (No. 144). His last acquisition was a large painting by Jasper Johns, *Voice.*

John de Menil enjoyed the company of artists and he loved to entertain them. He was devoted to Max Ernst and always willing to treat him like the prince Max was. When Alexander Calder came down to Houston in 1951 to install a show at the Contemporary Arts Museum, he struck up a friendship with him. Later, he gave to the Museum of Fine Arts in Houston an intoxicating white Calder mobile. And, of course, Jean Tinguely was a favorite of his. In a grand gesture, very much in his style, he bought and gave to the Museum of Fine Arts the entire exhibition of Tinguely's machines that James Johnson Sweeney had assembled there in 1965.

John de Menil would have liked to commission monumental works of art for Houston and to involve others in the enterprise. To his failure in eliciting civic cooperation we owe the presence of Barnett Newman's *Broken Obelisk* in front of the Rothko Chapel, which otherwise would have been in front of the City Hall. John de Menil was convinced that it was the greatest sculpture of our time, and he had the joy to decide its placement with the artist. It went exactly where Barney thought it should go. A house happened to be at this location. It was bought and pulled down without a moment's hesitation.

Through struggles and failures, John de Menil and his dogged determination to strive for the highest values prepared the way we are following today. The aesthetic and moral principles he fought for are embodied in the museum and the Rothko Chapel, two buildings where the highest aspirations of humankind can be expressed.

INTRODUCTION

Walter Hopps

The book at hand represents indeed a selection: no more than five percent of the paintings, sculpture, drawings, and objects in The Menil Collection. Guided by Dominique de Menil, we have chosen works for this book that include major examples but also those from less obvious realms. Taken together, the intent is to show something of the spirit and range within the Collection as a whole.

The authors contributing essays to this book have been drawn not only from The Menil Collection staff but from a network of scholars and colleagues whom Dominique and John de Menil came to know as their Collection developed. Each essay addresses a work or body of works reflecting the author's special knowledge. It was a conscious decision to include a limited number of texts focusing on specific works considered in depth. The diversity of disciplines and approaches among the essays reflects the varied perspectives of the Collection itself. Like the selection of works of art, the selection of texts has been made to illuminate special parts rather than attempting to explain the generality of the whole.

Four primary areas may be identified within The Menil Collection: antiquities, Byzantine art, the arts of tribal cultures, and twentieth-century art. The art of ancient cultures from the Paleolithic to the pre-Christian eras includes selective concentrations of material, mostly from Europe and Asia Minor. The Mediterranean tradition, for example, while not completely excluding Greco-Roman art of the Classical period, emphasizes pre- and post-Classical cultures from Bronze Age Asia Minor, the Cycladic Islands, Archaic Greece, and Hellenistic and Roman art from Asia Minor and Egypt. In this book, Mayan art has been viewed as an ancient culture from the New World. The collection of Byzantine artifacts and icon paintings from the Mediterranean world, Asia Minor, and Russia has emerged as another significant area of activity during the last ten years. Companion to the Byzantine is a small collection of medieval art.

The de Menils' interest in modern art was the one awakened first. Soon after, they began to look at, and seriously acquire, the arts of the tribal cultures of Oceania, the Northwest Coast, and especially Africa. Informed by Cubism and Surrealism, they delighted in the formal invention and stylization in tribal art, while the mystery of these objects' meanings and uses engaged them intellectually.

The collection of twentieth-century art was assembled from the vantage point of the School of Paris modernism. From the first half of the century, Cubism and neo-plastic abstraction predominate, while Expressionism has been virtually excluded. Surrealist art, particularly the work of Max Ernst and René Magritte, forms a renowned part of the Collection. Developments in American art from mid-century forward became a major focus of work collected within the last twenty-five years.

Among the special facets of the Collection is a group of European paintings and artifacts from the sixteenth through the eighteenth century. It is less significant in numbers than in the importance of many of the works themselves. Above all, their presence here often resonates with a Surrealist-inspired affinity for the fantastic and the allegorical. The art collected from the Colonial period in the New World, on the other hand, constitutes a far more modest realm. It reflects a sensibi-

lity in which aesthetic delight may be discovered in an object of any pedigree and nourished by a passionate humanism and engagement with the spiritual and the transcendental as they illuminate Christian and non-Christian art.

Among the approximately 10,000 works in The Menil Collection, approximately one half are comprised of prints, photographs, and rare books. Prints from the sixteenth through the nineteenth century have been collected mainly according to categories of subject matter, e.g., the grotesque, gardens, and so forth. Drawings, before the late nineteenth century, as well as prints and photographs, were felt to be beyond the scope of the present volume.

In a major research project of the Menil Foundation, images and iconography of blacks in Western art are studied. Beyond archival documentation and scholarly publication, this ongoing project has stimulated a collection of important objects and paintings depicting blacks from antiquity to the present. Another endeavor of Dominique and John de Menil, the commissioning of the Rothko Chapel and the acquisition of Barnett Newman's *Broken Obelisk*, has been viewed here as a companion to the great works of modern art in the Collection.

Dominique and John de Menil began collecting with no specific grounding or preconceptions as to what kind of art to pursue. Chance encounters and serendipitous circumstances often played an essential role in the course of their activities. Such were the circumstances guiding their first acquisition. In Paris in 1934, a friend suggested that they help a talented young artist by buying something of his work. When the de Menils visited Max Ernst for the first time, they were rather puzzled by what they saw; John de Menil suggested that the artist paint a portrait of his wife. Ernst agreed, the portrait was painted and brought to a frame shop by Ernst's companion, Marie Berthe Aurenche, who apparently left neither the name nor address of its owners. After a year the framer, in despair, exhibited the painting in his shop window. A neighborhood priest identified the sitter as Dominique de Menil, and the portrait was claimed. During the German occupation of Paris, the painting was left wrapped in a cupboard and forgotten. When Dominique de Menil discovered it after the war, her "eyes had been opened." Thus Max Ernst, whose art was to occupy a central position in their Collection, was introduced to the de Menils.

Dominique and John de Menil began acquiring art actively after their arrival in America in 1941. Conditions in Europe had led to the relocation of the headquarters of the family business, Schlumberger, Ltd., to the Americas. From the beginning of the de Menils' life in the New World, their activities thrust them into markedly different physical and cultural environments: Caracas, Houston, and New York City.

Austerity in America during the war years was of a very different order than that experienced in a Europe devastated by territorial occupation and warfare. In many ways art and life in the United States continued uninterrupted, and even flourished, during World War II. Artists, intellectuals, and dealers exiled from Europe vitally infused American culture of the period. A generation of emerging American artists enjoyed a proximity to a European vanguard that they might otherwise never have directly known.

In New York, the de Menils renewed their friendship with Father Marie-Alain Couturier, a French Dominican circumstantially exiled by the Occupation. Father Couturier (1897–1954) was a key figure among the few Catholics advocating a new religious art. Writing and co-editing the French Catholic journal *l'Art Sacré* before and after the war, Couturier argued that the Church should commission religious

art from among the finest, most venturesome artists of its time. He initiated and participated in the great mid-century commissions of modern art by the Catholic Church, with artists such as Léger and Rouault for the churches at Assy and Audincourt; Matisse's decorative program for the Chapel of the Rosary, Vence; and Le Corbusier's Notre-Dame-du-Haut, Ronchamp.

Father Couturier's essays and the photographs he selected for *l'Art Sacré* embraced not only modern art but the cultures of remote times and places. A painter himself, he saw in visual form the embodiment of the human spirit and the impulse of the sacred. Father Couturier's ideas and convictions were catalytic for the de Menils. In an anthology of his writings from *l'Art Sacré*, published in 1983, Dominique de Menil wrote: "The fervor of his words, carried by the gravity of his discourse, passes beyond the ephemeral and touches us like the mark of an absolute." With conviction and purpose, Father Couturier led them to New York galleries, such as those of Valentine Dudensing, Kurt Valentine, and Pierre Matisse, where they saw and acquired their first works by such artists as Cézanne, Braque, Léger, Miró, and Matisse.

It was Alexandre Iolas, a Greek born in Egypt, who introduced the de Menils to Surrealism. From a position at the post-war Hugo Gallery in New York, where he first met the de Menils, Iolas became the impresario of his own galleries in New York and Europe. He inherited the legacy of Julien Levy, whose gallery had introduced Surrealism to an American audience during the thirties and forties. For Iolas, art embodied the magical and enigmatic, which led him to champion with exceptional flair the work of the Surrealists and a variety of emerging contemporaries. Iolas acted upon his intuitions without hesitation and possessed a strength of purpose that could convert others. As Dominique de Menil observed: "He was so convincing; he was himself so convinced of the importance of what he was showing. I remember my skepticism in front of our de Chirico, *Hector and Andromache*. I was not taken in; I bought it on his word, on faith."

The third remarkable person who played a decisive role in forming the character of the de Menils' growing involvement with art was Dr. Jermayne MacAgy (1914–64). One of the first American women to receive a Ph.D. in art history, MacAgy served variously as both museum curator and director of the California Palace of the Legion of Honor, San Francisco, during the forties and early fifties, where she came to know artists such as Clyfford Still and Mark Rothko. At that time, San Francisco was a center of Abstract Expressionism second only to New York. MacAgy evinced enthusiasm for work as disparate as the vigorous abstraction of Still's paintings and the delicate intimacy of Joseph Cornell's box constructions. In 1955 Jermayne MacAgy came to Houston as the first professional director of its Contemporary Arts Museum, subsequently teaching and directing the art department established by the de Menils at the University of St. Thomas from 1959 until her untimely death in 1964.

An embodiment of contradictions, Jermayne MacAgy was a scholar who loved playfulness, combining inspired chance with the scholastic ideals of discipline and study. Like Iolas, she had an innate sense of visual theater and with resourceful alchemy mounted exhibitions of exceptional appeal and invention. MacAgy pioneered thematic exhibitions, mingling periods, cultures, and genres. Her brilliant installations combined enchantment and erudition, drawing from the de Menils' diverse collections. Dominique de Menil recently remarked: "Gradually my eyes were opened by Father Couturier, by Iolas and by Jermayne MacAgy. But I have become more difficult to please; objects have to have something very special. It was very late before we would admit we were collectors."

After MacAgy's death, Dominique de Menil assumed her role organizing exhibitions at the University of St. Thomas until 1969, when the de Menils founded the Institute for the Arts at Rice University. The Institute for the Arts encompassed academic programs in art history, a media center where photography, film, and video were taught, and an exhibition hall, at the Rice Museum, active through 1986. Dominique de Menil's style and approach to programming were guided by MacAgy's inspiration. As Harris Rosenstein, Editorial Counsel of The Menil Collection has remarked: "Museums tend to be either haughty or didactic. Mrs. de Menil lets the artist tell you."

The commissioning and building of the Rothko Chapel and the acquisition of Barnett Newman's sculpture *Broken Obelisk* can be seen today as the germinal act in establishing the future site of The Menil Collection. When Jermayne MacAgy died in 1964, Dominique de Menil stated: "When the floor collapses, it's time to make an act of faith." That year the de Menils commissioned Mark Rothko to make a series of mural-sized paintings for a chapel to be designed by Philip Johnson. Johnson had previously designed the de Menils' house in Houston (1949) and the master plan they commissioned for the University of St. Thomas. Originally the Chapel was to have been part of the St. Thomas campus; however, John de Menil made the decision in 1969 to build it independently and to have an adjoining park.

In 1969 the de Menils had offered Newman's sculpture as a partial gift to the city of Houston and had asked that it be dedicated to Dr. Martin Luther King, Jr. When the city refused the dedication, the de Menils purchased the work themselves. They sited it with Newman across from the Chapel. Dominique de Menil has noted:

> *It is really remarkable that the Rothko Chapel and the Newman sculpture go so well together that today we are unable to think of one without the other. When you come out of the chapel, you do not want to face houses or be lost in nature. Barnett Newman's sculpture is the answer. It was not planned, not planned at all—it just happened.*

When the Chapel was dedicated in February 1971, both Newman and Rothko had died. This artistic and spiritual landmark represents the fruition of ideas first implanted by Father Couturier.

By the early seventies, the de Menils were considering a permanent museum for their collection. The architect Louis Kahn was engaged in 1972, but his plans for a storage museum with exhibition facilities were abandoned after John de Menil's death in 1973 and Kahn's in 1974. Dominique de Menil did not relinquish the idea for the museum. Reassured by the interest and support of a group of friends, she engaged Renzo Piano in 1980 to design it on land adjacent to the Rothko Chapel and its park.

Renzo Piano's building to house the Collection and its exhibitions responded to Dominique de Menil's request that it seem large on the inside but small on the outside; it stands in harmony with its neighborhood of park, Chapel, and small houses preserved by the Menil Foundation for both domestic and professional use. A second essential element of the museum's program was to achieve a new order of controlled and "alive" natural light for the interior. With engineers Tom Barker and Peter Rice, Piano conceived of a unique ferro-concrete and steel roof ceiling to serve as a "platform of light." An additional aspect of the museum's architectural program has given special priority to the professional facilities of the building, as well as to storerooms that function as compact study galleries.

According to a flexible scenography of presentation, works from the permanent collection will be seen in changing configurations in a manner appropriate to a collection where the unexpected encounter, the unusual juxtaposition, and the solitary communion of an individual viewer and artwork are allowed. In its rational approach to structure and engineering, and in its visual simplicity, Piano's building consciously embodies traditions of mid-century modernism in architecture. It may be said to reflect the affinities of the Collection and the formative sensibilities of its patrons.

A collection may be characterized as much by what it consciously chooses not to collect as by the cumulative scope of what it does choose. The essential particularity of The Menil Collection, the patterns of what it has been and what it is presently, were arrived at within the first twenty-five years of its existence. Bertrand Davezac, medievalist and curator at The Menil Collection, has attempted to invoke it as the uniquely factured artifact that many great private collections are. Elsewhere, he has described the Collection as a set of archipelagoes or islands, in contradistinction to the continental expanse which characterizes the encyclopedic museum. The Menil Collection surveys vast areas of the globe and time, from pre-history to the present. It encompasses the reach of the largest art museums but maintains no imperative for inclusiveness.

Davezac has observed parallels between the views held by the de Menils and those expressed by André Malraux, the French intellectual and cultural statesman, in his writings about art from the late forties and early fifties. Davezac has noted:

> ...Beyond formal reductivism...there is the dimension of what Malraux calls "sacred," a type of universalist and transcendental ecumenism....The Menil Collection is indeed an imagined museum, not an homage to Malraux...but a type of parallel concretization. Even more interestingly, it [the Menil Collection] is the American embodiment of Malraux's mythic "museum without walls," an idea which expresses most eloquently what can be called the transmurality of this collection.

Public understanding of bodies of art is largely informed by the most collective and distanced of social artifacts, e.g., the textbook or the continental expanse of the museum, as opposed to the more narrowly focused, idiosyncratic vision of the private patron. Generally, it has been the case that private collections are absorbed into larger collective endeavors. It is the intent of The Menil Collection, even as it becomes a public institution, to preserve and proceed from the characteristics that have been unique to it in its formation.

The particular eclecticism of The Menil Collection gives rise to a number of distinct insights into the ways in which art has functioned or has had meaning for the de Menils. On one level, they have collected art according to their intellectual inclinations. They have lived with works of art as one would with books in a personal library, as reference objects conveying particular historical knowledge or ethnological information. But none of the aforementioned would ever disallow the role of art as both a stimulus of aesthetic delight and wonderment, or as a carrier of spiritual value. Beyond the public functions of The Menil Collection, Dominique and John de Menil always believed in the meaning and power of the work of art to generate for the viewer an individual communion, a dialogue in silence.

ART OF ANCIENT CULTURES

Retracing the history of man fascinates me, as though some clue to our existence could thus be found. A few acquisitions illustrate the long road of cultural evolution. The earliest in the Collection are Paleolithic bones engraved with deer (No. 1) and horses. However crude the life of these early men was, they had achieved artistic sophistication. Man had been in existence for hundreds of thousands of years. A million, a million and a half?...Whatever. We know now that the dawn of humanity was interminable.

The first fully-modeled human representations are of women with overdeveloped breasts and buttocks, women as birthgivers (Nos. 2 and 4). For millennia so-called "fertility idols" were placed in graves. As time went by, the figures became abstract. Sometimes just the outline of bulging hips and shoulders was indicated (Nos. 10–20). Enough to suggest womanhood. Enough to affirm life in front of death. Enough to evoke and invoke the source of all life.

Survival was the great concern. Food and procreation. These primal needs, so often defeated, called for help, for prayer, for magic. The recourse to the invisible is a mark of the religious, a search for spirituality. Spirituality seems to have been expressed by abnormally large eyes. On a small Neolithic head (No. 3), almond-shaped eyes are incised from the nose to the ears. A statue from Mesopotamia (No. 25) has large inlaid eyes that give it a mysterious gaze.

In antiquity, Europe and Asia were covered with forests and steppes. Except for the famous fertile valleys, only a relatively small part of the land was cultivated. Hunting was a major activity. Animals, real and fantastic, played an important role. They were sources of mystical powers as well as sources of food. Gifts to men, but also gifts men had to make to the gods. As sacrificial offerings they were men's surrogates and as such eminently noble. The Menil Collection owns many pieces illustrating the intrinsic dignity of animals (Nos. 34–39, 52).

There are also animal representations originating from the Eurasian steppes, where for centuries nomadic cultures flourished. They built no monuments, but left small bronze objects (Nos. 44–47) decorated with felines, antelopes, wild boars, etc. Often the animals were represented in ferocious combats evoking the combats of men. Human figures were almost absent from the iconography of these nomadic people. Their cultures were marginal compared to the great urban centers around the Mediterranean. In these urban centers, representations of man were preponderant. If occasionally they became informal in the late Hellenistic and Roman world, they were solemn enterprises during high Classical periods. Man was attempting the formidable task of reaching higher than himself. Using himself to express visually the inexpressible, two paths were followed: one concentrating on the eyes, intensifying the gaze (Nos. 25, 54, 55, 56); the other achieving an idealized perfection of form (No. 26). The sensitive modeling of a youthful body, taut and tender, could express serenity and timelessness. Alternating and combining both the mystical and sensual paths, Egypt, Greece, and Byzantium produced miraculous works of art.

Dominique de Menil

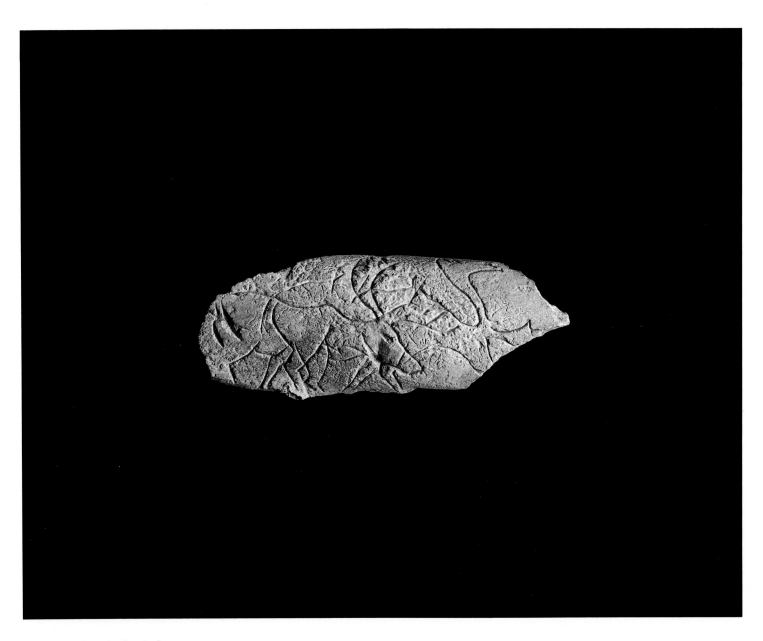

1. *Bone with Incised Reindeer*
Southwestern France
Paleolithic, Magdalenian Period
15,000–10,000 B.C.
Bone fragment
1½ × 4¼ × ¾ in.

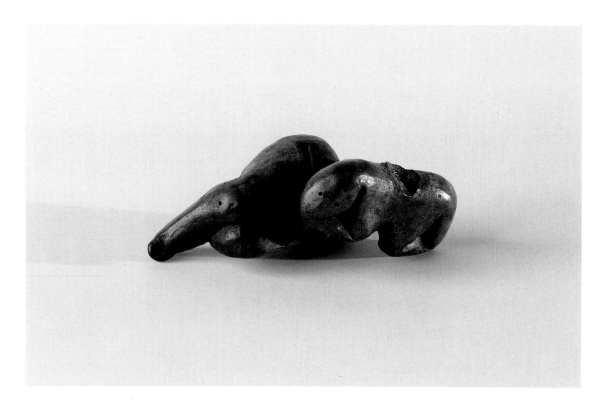

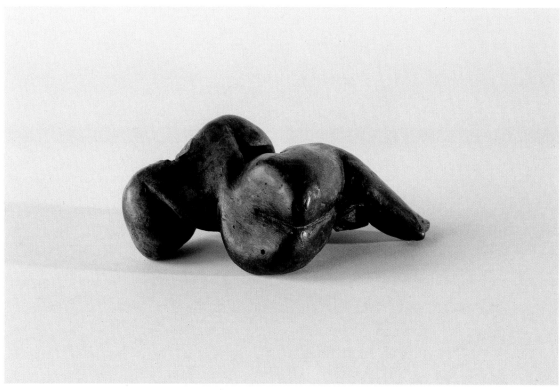

2. *Female Idol* (front and rear view)
Turkey, southwest Anatolia
Neolithic, Hacilar VI type
ca. 5600 B.C.
Polished terra cotta
1¹¹⁄₁₆ × 3¼ × 1³⁄₁₆ in.

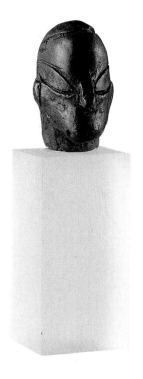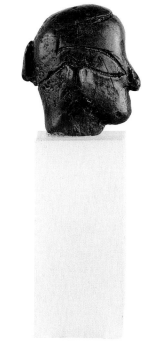

3. *Head of an Idol* (front
and profile view)
Turkey, southwest Anatolia
Neolithic, Hacilar VI type
ca. 5600 B.C.
Polished terra cotta
$13/16 \times 9/16 \times 13/16$ in.

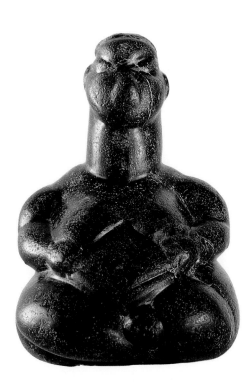

4. *Female Idol*
Turkey, southwest Anatolia
Neolithic, Çatal Hüyük VI type
6000–5800 B.C.
Stone
$1 11/16 \times 1 3/16 \times 1 1/16$ in.

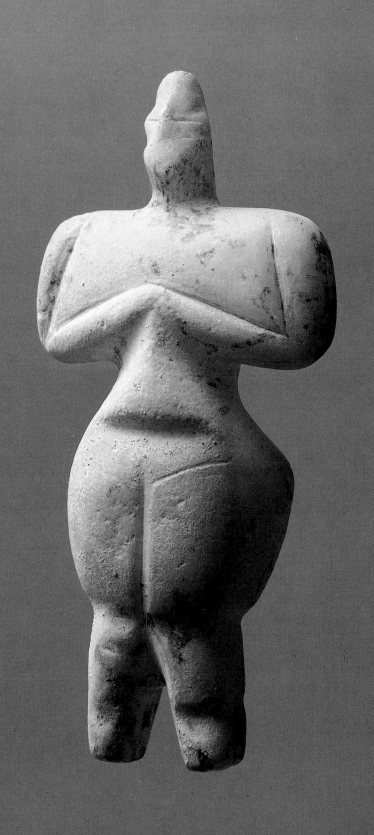

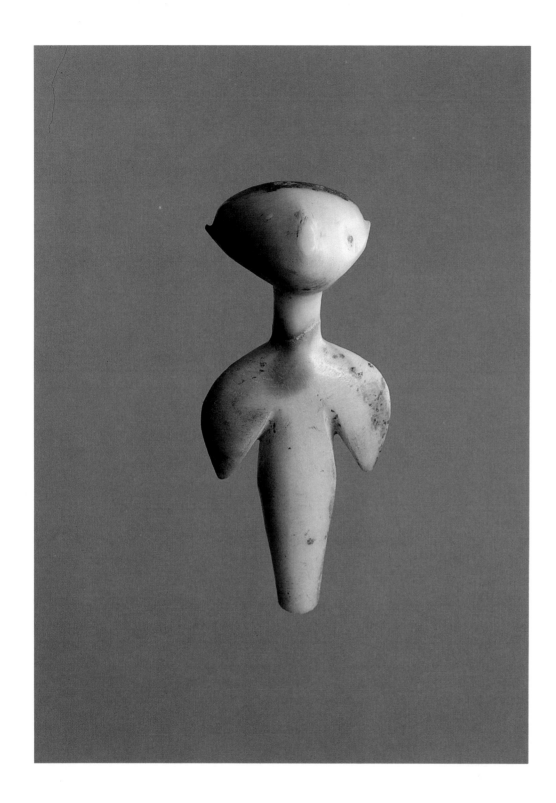

6. *Female Idol*
Turkey, southwest Anatolia
Late Chalcolithic, Kilia type
ca. 3200 B.C.
Marble
4¼ × 1⅞ × 1¹¹⁄₁₆ in.

Opposite:
5. *Female Idol*
Greece, Thessaly
Late Neolithic, 4000–3000 B.C.
Marble
6½ × 3⅞ × 1⅝ in.

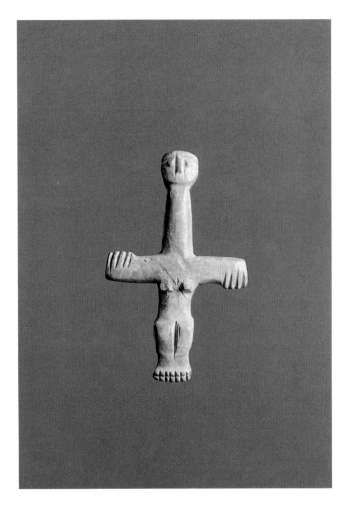

7. *Cruciform Female Idol*
Cyprus
Chalcolithic I, 3000–2500 B.C.
Steatite
2⁹⁄₁₆ × 1⅝ × 3⅛ in.

8. *Cruciform Idol*
Cyprus
Chalcolithic, I, 3000–2500 B.C.
Steatite
3¼ × 1⅝ × ⁷⁄₁₆ in.

Opposite:
9. *Female Idol*
Cyprus
Early Bronze Age III–Late I
2100–1900 B.C.
Red polished and incised terra cotta
with white filling
9¾ × 4³⁄₁₆ × ⅞ in.

10. *Abstract-Schematic Idol*
Turkey, Anatolia
Early Bronze Age I–II, Beceysultan
type, ca. 2700 B.C.
Marble
3¾ × 2⅛ × ⅜ in.

11. *Abstract-Schematic Idol*
Turkey, Anatolia
Early Bronze Age I–II, Beceysultan
type, ca. 2700 B.C.
Marble
5³⁄₁₆ × 5¼ × 2⅜ in.

12. *Abstract-Schematic Idol*
Turkey, southwest Anatolia
Early Bronze Age II, Kusura type
variant, 2700–2400 B.C.
Marble
4¼ × 2¹³⁄₁₆ × 2 in.

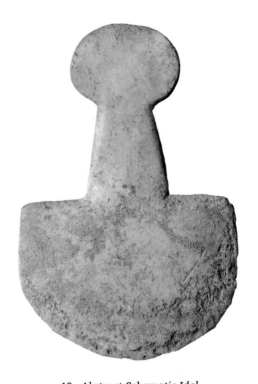

13. *Abstract-Schematic Idol*
Turkey, southwest Anatolia
Early Bronze Age II, Kusura type
2700–2400 B.C.
Marble
5 × 3⅜ × ⅜ in.

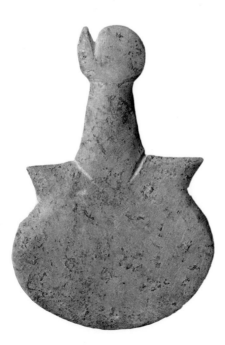

14. *Abstract-Schematic Idol*
Turkey, southwest Anatolia
Early Bronze Age II, Beceysultan type
variant, 2700–2400 B.C.
Marble
4³⁄₁₆ × 2⅞ × ⁵⁄₁₆ in.

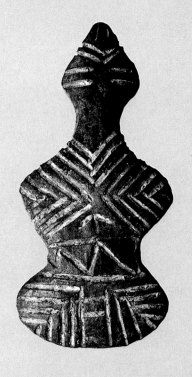
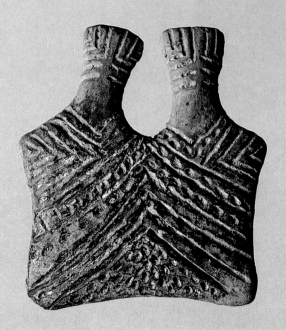
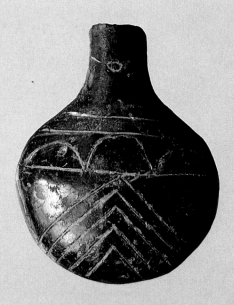

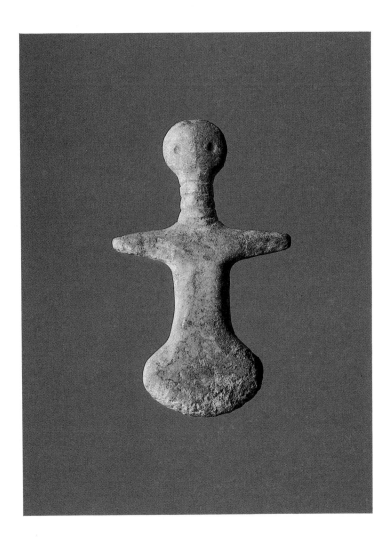

18. *Idol*
Turkey, Anatolia
Early Bronze Age II–III
2400–2300 B.C.
Marble
3¼ × 1¹⁵/₁₆ × ⅜ in.

19. *Female Idol*
Turkey, southeast Anatolia
Early Bronze Age, 2700–2100 B.C.
Polished and incised terra cotta
2¾ × 1⁷/₁₆ × ⁷/₁₆ in.

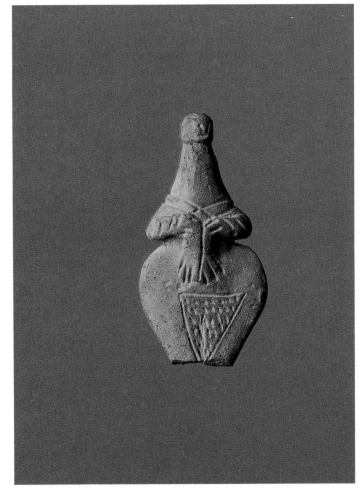

Opposite:
15. *Abstract-Schematic Idol*
Turkey, Anatolia
Early Bronze Age II, Çaykenar type
2700–2400 B.C.
Polished and incised terra cotta with
white filling
2⁷/₈ × 1⅜ × ⅜ in.

16. *Abstract-Schematic Double Idol*
Turkey, Anatolia
Early Bronze Age II, Çaykenar type
2700–2400 B.C.
Polished and incised terra cotta with
white filling
2½ × 2¼ × ½ in.

17. *Abstract-Schematic Idol*
Turkey, Anatolia
Early Bronze Age II, Çaykenar type
2700–2400 B.C.
Polished and incised terra cotta
2¼ × 1⁷/₈ × ⅝ in.

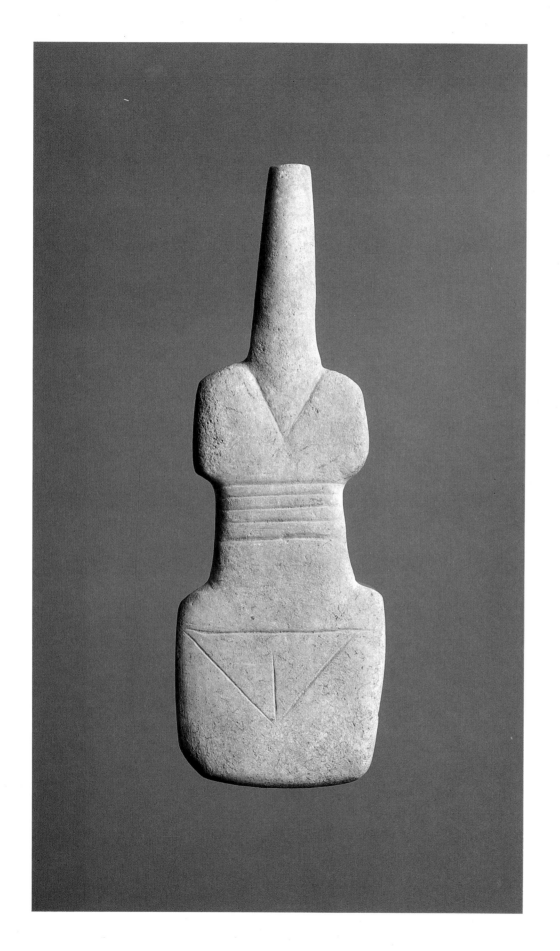

20. *Violin Idol*
Greece, Cycladic Islands, Naxos (?)
Early Cycladic I, 3200–2700 B.C.
Marble
$8\frac{9}{16} \times 3 \times \frac{7}{8}$ in.

Opposite:
21. *Collared Jar Kandilli*
Greece, Cycladic Islands, Paros
Early Cycladic I, 3200–2700 B.C.
Marble
13×13 in., diameter

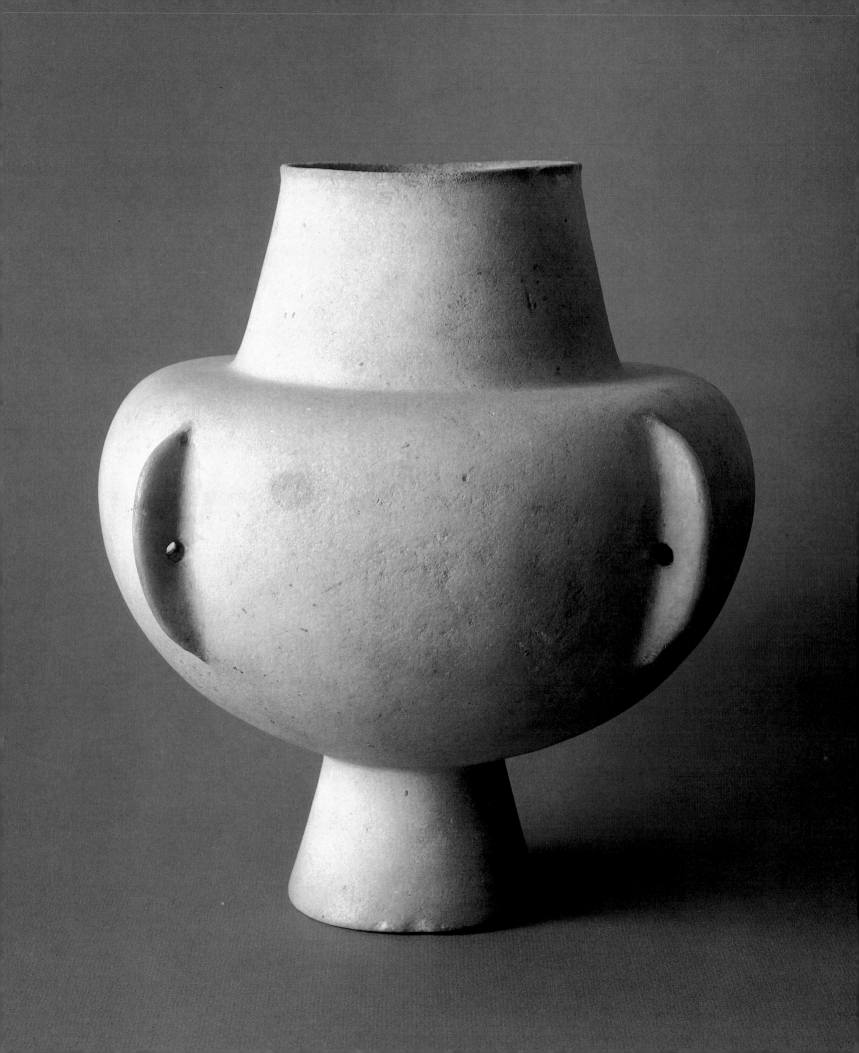

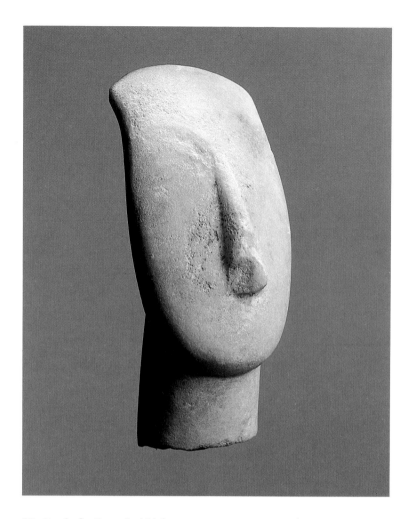

Opposite:
24. *Canonical Female Idol*
Greece, Cycladic Islands, Naxos (?)
Early Cycladic II, Dokathismata type
2700–2400 B.C.
Marble
14½ × 4⁷⁄₁₆ × 1¼ in.

22. *Head of a Canonical Idol*
Greece, Cycladic Islands
Early Cycladic II, Spedos type
2700–2400 B.C.
Marble
5⁵⁄₁₆ × 2⁵⁄₈ × 2½ in.

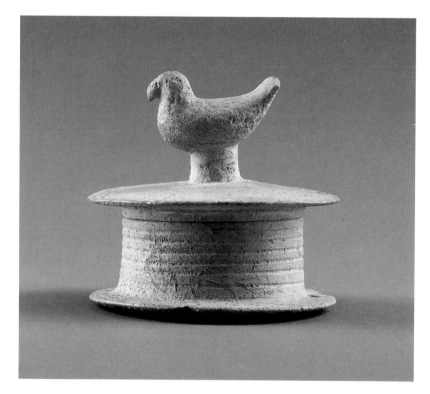

23. *Pyxis with Dove*
Greece, Cycladic Islands
Early Cycladic II, 2700–2400 B.C.
Marble
3³⁄₁₆ × 3⁷⁄₁₆ in., diameter

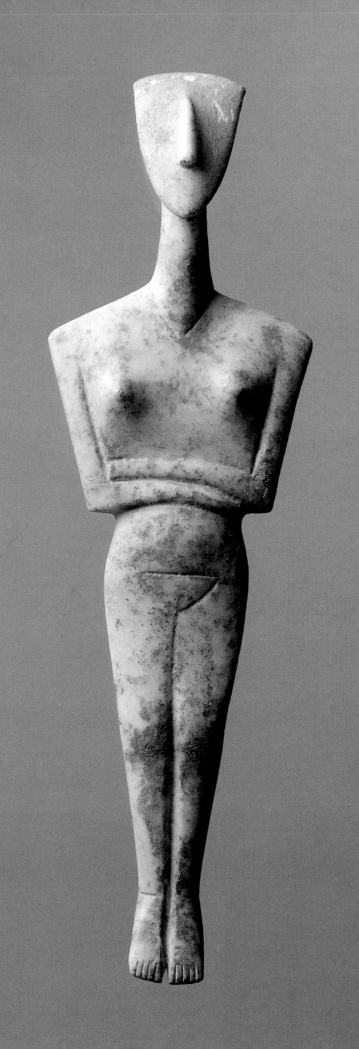

A Statue of Eannatum, Prince of Lagash

Pierre Amiet

Sumer's proto-historical civilization, located in present-day southern Iraq, experienced decisive growth during the second half of the fourth millennium B.C. This took place particularly in the city of Uruk (biblical Erek), cradle of the oldest form of writing which was to become cuneiform. During this period both temples and private residences shared similar architectural concepts. Furthermore, their dimensions and ornamentation were akin to those of palaces, and thus these residences could have been intended as housing for the king-priests known to us through the iconography of their images in art. We also know that these priestly kings were called upon to act as gods, in turn contributing decisively to the conception of gods in human form. These buildings were only sparsely furnished with a few statues—the art of statuary developing later, during the course of the third millennium in connection, it seems, with a new religious context. Dynasties, first legendary then actual, evolved progressively from this time on; their histories were recorded by Sumerian historiography only much later.

Following an era of transition there emerged a period definable as ancient (or Early Dynastic II), which saw the emergence of an archaizing art represented by numerous statues and statuettes. Devoted worshipers designated these statues as their proxies in the newly refashioned temples, thus indicating their presence in an everlasting state of worship. They frequently had themselves represented with a surprising lack of realism. In general, these works are characterized by excessive, even strange, stylization of the face, as well as an angularized, or geometricized, anatomy, which in representations of men is partially concealed by a half-length skirt. Only rarely are the identities of these individuals specified by inscriptions—men and women alike were represented as equals.

Somewhat later, between 2600 and 2340 B.C., during the "recent" third period of the Early Dynastic era, statuary, insofar as it is expressive of a human ideal, came to reflect a cheerful realism. At this time costumes were entirely covered with strange, stiff little "tongues." These correspond to woolen tufts of fur from animal skins. Scholars gave to this fabric the Greek name of *kaunakès*. During this period one also frequently finds the names of individuals portrayed inscribed on the right shoulder and on the upper part of the statue's back.

The numerous contemporary texts written on clay tablets—mostly of an economic or administrative nature—in general do not allow us to reconstruct a precise history. Only in the state of Lagash, southeast of Sumer, can a complete lineage be found. This is known to us from the discoveries made at Telloh (the site of ancient Girsu) from 1877 on by Ernest de Sarzec and his successors, as well as from those made more recently by Donald Hansen at El Hiba—the site of the ancient city of Lagash after which the state itself is named.

Around 2500 B.C. Ur Nanshe founded his dynasty at Lagash and took the royal title of *lugal*. He chose to have only his peaceful acts, such as the erection of temples, commemorated in inscriptions. Akurgal, his son, having apparently suffered setbacks, had to make due with the title of *ensi*, which was presumably a low-ranking princelike position. Around 2450 B.C. the state of affairs changed. Eanna-

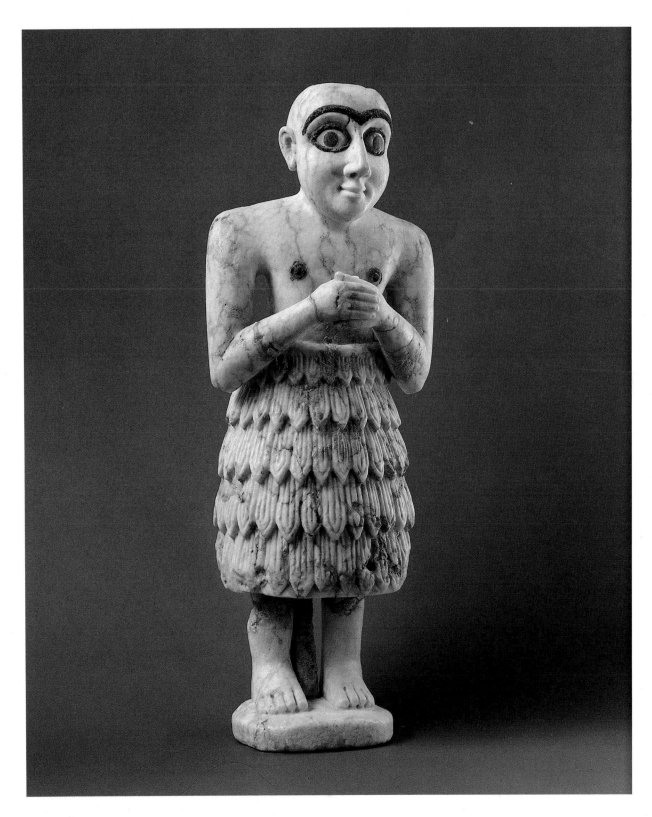

25. *Statue of Eannatum*
Southern Iraq
Sumerian, 2600–2450 B.C.
Alabaster with lapis lazuli and
mother-of-pearl
12 × 4½ × 4 in.

tum, Akurgal's oldest son, initiated a policy of conquest and commemorated his victories in words and images on his *Stele of the Vultures*. This oldest *page d'histoire* to come down to us is a key monument in literary as well as in actual history. Eannatum had both his name and title inscribed on the back of the small statue in The Menil Collection: "é-an-na-tum enśi lagaš^ki dumu a-kur-gal" (Eannatum, [the] prince of Lagash, son of Akurgal).

This inscription (Fig. 1) is drafted in a beautiful archaic Sumerian script in which, though it is already cuneiform, the pictographic origins of certain signs can still be recognized. The prince's name inscribed in the upper right can be deciphered as follows: the first sign, *é*, symbolic of the temple, has the shape of a large squared rectangle; the next sign, *an*, symbolic of heaven, is followed by *tum*, representing a foot. This name signifies "Worthy of E-anna," that is to say of the temple of the great planetary goddess Inanna, the Venus of the Romans, who was honored in Uruk. However, contrary to custom (there are exceptions), the inscription does not end with a dedication to a divinity.

Although the statue seems thus to be securely dated, its stylistic analysis presents some interesting problems. It is made of hydrated calcium (or alabaster), a material easily soluble in water and commonly used in Mesopotamia during the Early Dynastic period. As a result certain details have faded, especially in the inscription, and some breaks have occurred. The figure stands in a strictly frontal position on a slightly convex, irregular disk-shaped base. The bare legs in a rigid stance are carved in the round from below the knee to the feet. The sculptor deliberately gave them a certain massiveness, increasing their sense of solidity; consequently the ankles are not defined and the calves are barely outlined. The feet are fairly well proportioned though the toes are a bit long. Despite their apparent solidity, however, the legs were broken in the course of time. Their repair was effected with strong bronze pins, inserted vertically, each as thick as a big nail and tapering from head to tip. Such pins, to which a colored stone could have been attached on the head, are well represented in tomb furnishings of the period. A rod measuring 13 to 8 mm. in diameter passes through the base for about 1.4 cm. alongside the right leg and under the skirt. The copper and tin alloy of which the rod is made, though documented for Sumer during this period, is rare. In any case, the freestanding legs beneath the relatively short skirt appear more characteristic of statuary from the preceding period, as can be seen in examples from the series of statuettes discovered in a pit at the foot of an altar in the Temple of the God Abu at Eshnunna (modern Tell Asmar situated east of Baghdad). This evidence suggests that this statue could date from a period preceding the dynasty of Lagash. However, though the skirt is only half-length it is entirely covered by the tonguelike pattern of the *kaunakès*, which makes it exceptional for its time. As is often the case, an appendage hangs at the side toward the back. André Parrot has convincingly identified it as the tail of an animal of which the skin was used for clothing. Usually the appendage hangs on the left, while here it appears at the right.

The nude bust is highly stylized. Each of its sides is nearly flat, forming sections encompassable in a rectangle with rounded corners. This is another stylistic detail characteristic of the older Early Dynastic period. The front of the bust is barely rounded with no indication of the pectorals. The nipples, however, are marked by small protruding inlaid studs of lapis lazuli. This is not unusual: statues, notably from Mari, bear cavities designed to hold such inlays, most of which have disappeared. At the back, the spine is not indicated under the inscription, which is well centered rather than being shifted to the right. The very angular fold-

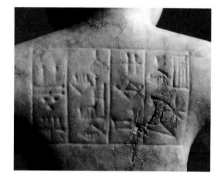

Fig. 1 Inscription, back of statue

ed arms are clearly and freely positioned, and the joined hands are thrust forward slightly rather than resting on the bust. The right hand extends horizontally and there is no indication of the finger joints, which is customary for this period. The right hand is folded over the left, which in turn folds upon itself and is thus only visible from the bottom while the two thumbs are crossed. This is a traditional posture for worshipers, especially those at Tell Asmar, who could hold a goblet in joined hands. This gesture was an indication of their participation in a liturgical banquet held in the divinity's presence, which, however, was never represented in the numerous illustrations of this ceremony.

The neck, short as always, is scarcely exposed at the front under the double chin. The bald head, slightly tipped forward, is almost as massive as the chest without arms, following a long-lived convention that can be seen in statues from Gudea dating from the end of the third millennium. The head is globular when seen from the back, and the occipital bulge is clearly indicated. It is chipped at the top. The ears are unequal, the right one being larger and showing a double external fold. The face is oval, and the brows and eyes have been hollowed out to receive colored inlays, as is frequently the case. These have since disappeared and have been carefully restored. Thus the eyes, with pupils of lapis lazuli inserted into corneas made of mother-of-pearl, are mounted in a black paste setting, which replaces the ones made of bitumen or schist used by the ancients. The big straight nose has large nostrils turning up slightly at an oblique angle. The small mouth, protruding slightly from between two dimples, attempts to smile. Again, these characteristics follow a convention more frequently observed in statues dating from the old phase of the Early Dynastic period. Finally, a small chin protrudes over a fold of flesh, serving to emphasize it; the fold of flesh curves alongside the lower edge of the cheeks set under slightly prominent cheekbones.

To sum up, this particularly pleasing work offers some stylistic traits preventing its dating to a period as "recent" as Eannatum's. Yet this is not surprising. In fact, this statuette can be compared to another work with similar—though less rich—archaizing stylization, which was taken over by Eshpum, prince of Susa, during the time of Manishtusu, third king of Agade, ca. 2250 B.C. Thus we can conclude that the inscription of Eannatum was incised on an older work, following a custom that Mesopotamian princes adhered to from the dawn of Sumerian history to its more recent periods. If Eannatum could take over this ancient statue, which clearly did not look like him, it is because his period did not attach importance to the fleeting features of a personal portrait. Instead, the interest was focused on a more general, ideal human type and corresponded to a tremendous desire to perpetuate one's presence before the gods. The statue, of modest dimensions, inscribed with the name of Eannatum, is representative of an archaizing art that is marked by a spirit we would call popular in spite of its refinements. People from different social levels could commission effigies following similar norms, which would not deviate significantly from those of their princes. The latter, conversely, could see themselves as well in the human ideal reflected by these statues.

BIBLIOGRAPHY

André Parrot, *Tello, vingt campagnes de fouilles,* Paris, 1948.

E. Sollberger and J. R. Kupper, *Inscriptions Royales Sumériennes et Akkadiennes,* Paris, 1971, pp. 47–62.

Agnès Spycket, *La Statuaire du Proche-Orient Ancien,* Leiden, 1981.

Eva Strommenger, *Zeitschrift für Assyriologie,* 1959, pp. 30–36, and Pierre Amiet, *Elam,* Auvers-sur-Oise, 1966, fig. 135.

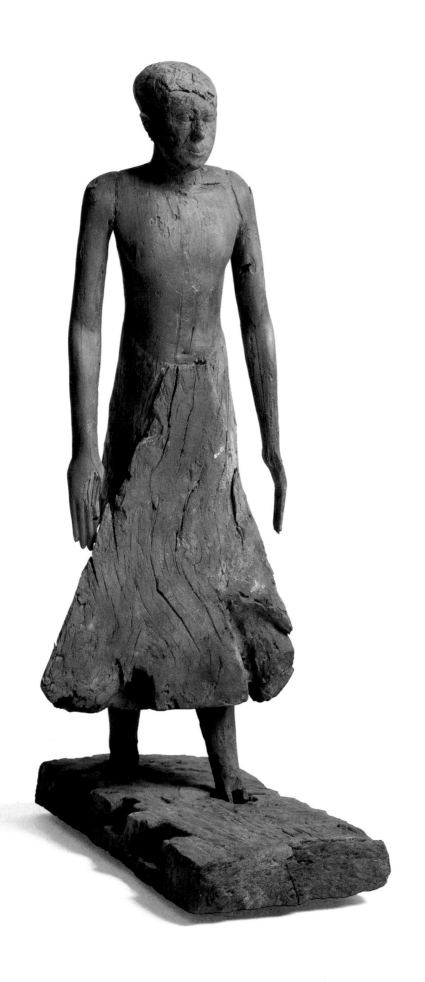

26. *Male Figure*
Egypt
Old Kingdom, VI Dynasty
2300–2200 B.C.
Wood with traces of pigment
35½ × 12½ × 19 in.

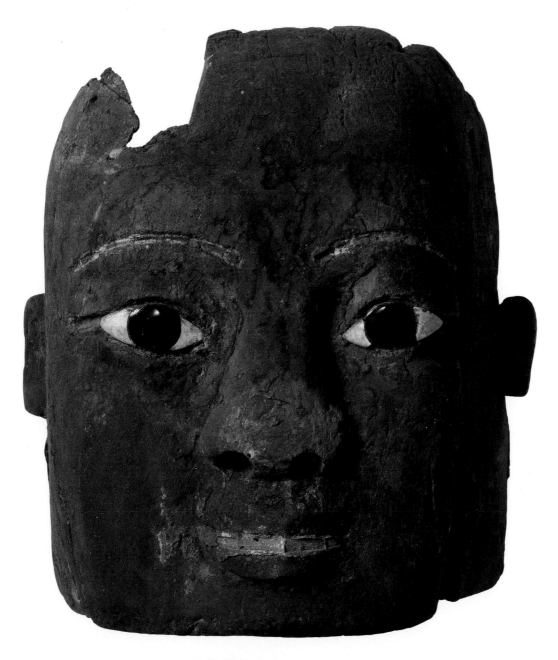

27. *Funerary Mask*
Egypt, Nubia (?)
Middle Kingdom, XI–XII Dynasty
ca. 1700 B.C.
Wood with glass inlay
16¾ × 16 × 9¼ in.

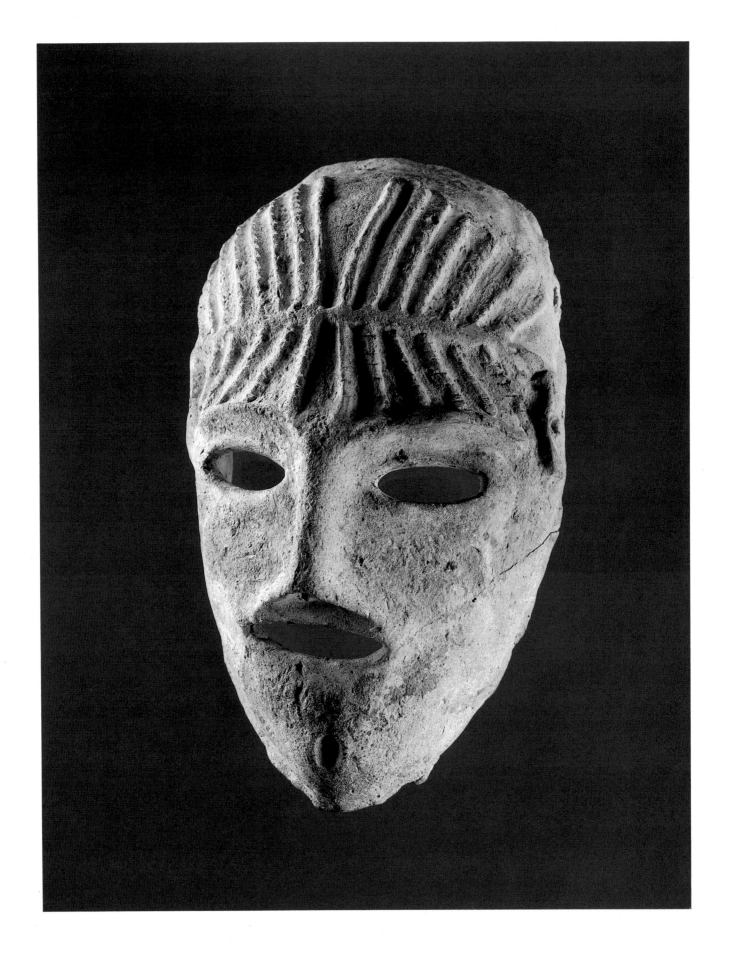

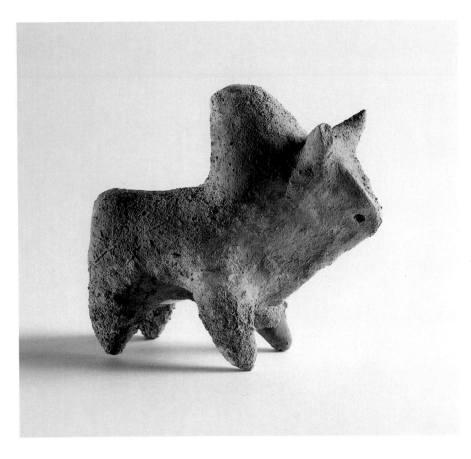

29. *Zebu*
Northwest Iran, Marlik
ca. 2000 B.C.
Terra cotta
4¼ × 2⅜ × 5⁵⁄₁₆ in.

30. *Funerary Vessel*
Northwest Iran, Azerbaijan,
site near Hasanlu
ca. 1000 B.C.
Terra cotta
7⁷⁄₁₆ × 3⅞ × 8½ in.

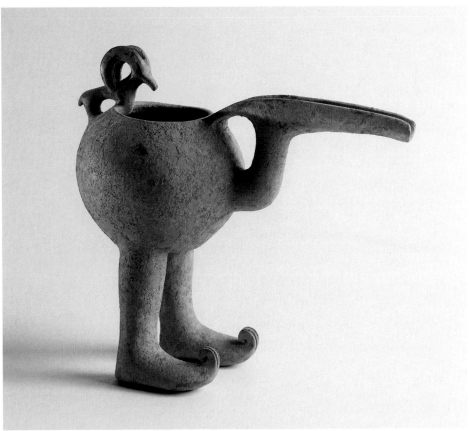

Opposite:
28. *Mask*
Syria-Palestine (?)
ca. 1200 B.C.
Terra cotta with white slip
11¹⁄₁₆ × 6¹¹⁄₁₆ × 4¼ in.

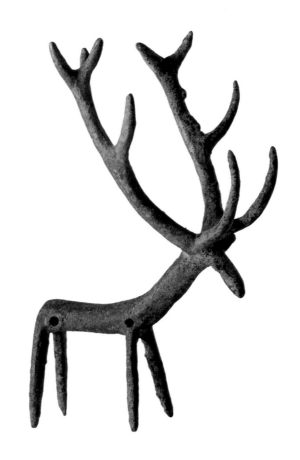

31. *Stag*
Northwest Iran, Marlik
9th–8th century B.C.
Bronze
4½ × 3½ × 2⁷⁄₁₆ in.

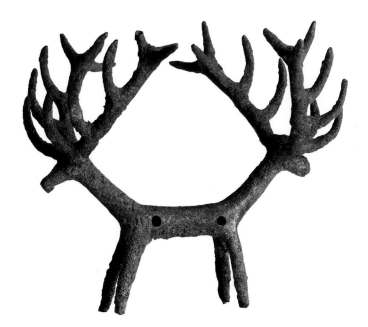

32. *Bicephalic Stag*
Northwest Iran, Marlik
9th–8th century B.C.
Bronze
3⅜ × 4 × 3 in.

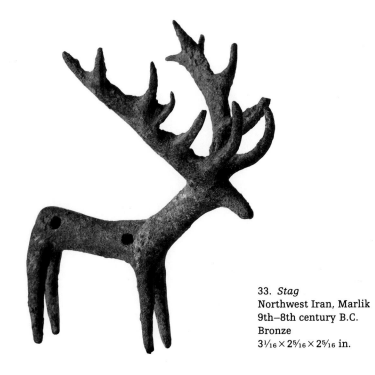

33. *Stag*
Northwest Iran, Marlik
9th–8th century B.C.
Bronze
3 1/16 × 2 5/16 × 2 5/16 in.

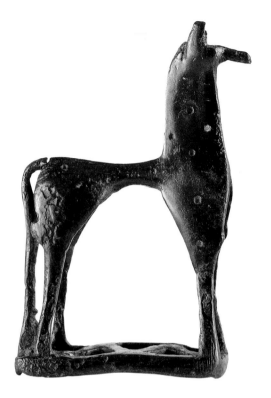

34. *Horse*
Greece, Thessaly
Geometric style, 750–700 B.C.
Bronze
2⁷/₈ × 2 × ⁵/₈ in.

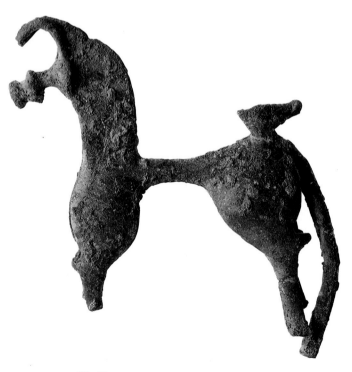

35. *Horse*
Greece, Thessaly
Geometric style, 750–700 B.C.
Bronze
3⁵/₁₆ × 3¹/₈ × ⁵/₈ in.

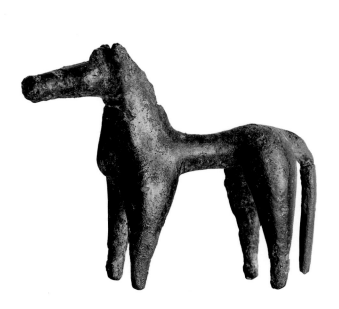

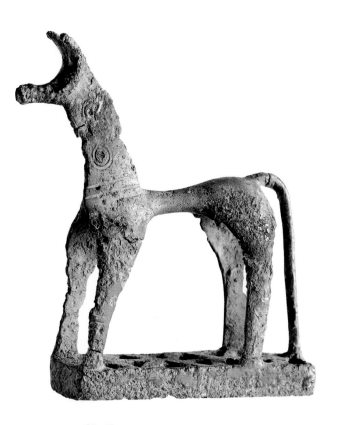

36. *Horse*
Greece, Peloponnesus
Geometric style, 800–750 B.C.
Bronze
$2 \times 2\frac{1}{2} \times \frac{5}{8}$ in.

37. *Horse*
Greece, Thessaly
Geometric style, 750–700 B.C.
Bronze
$2\frac{3}{4} \times 2\frac{3}{4} \times \frac{9}{16}$ in.

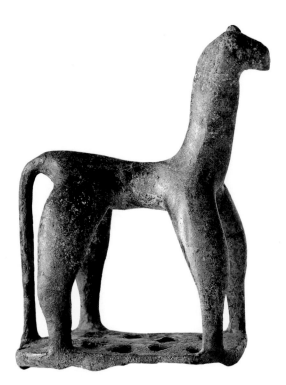

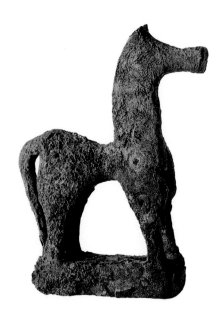

38. *Horse*
Greece, Thessaly
Geometric style, 750–700 B.C.
Bronze
$2\frac{11}{16} \times 2\frac{1}{4} \times \frac{7}{8}$ in.

39. *Horse*
Greece, Thessaly
Geometric style, 750–700 B.C.
Bronze
$2 \times 1\frac{1}{2} \times \frac{1}{2}$ in.

41

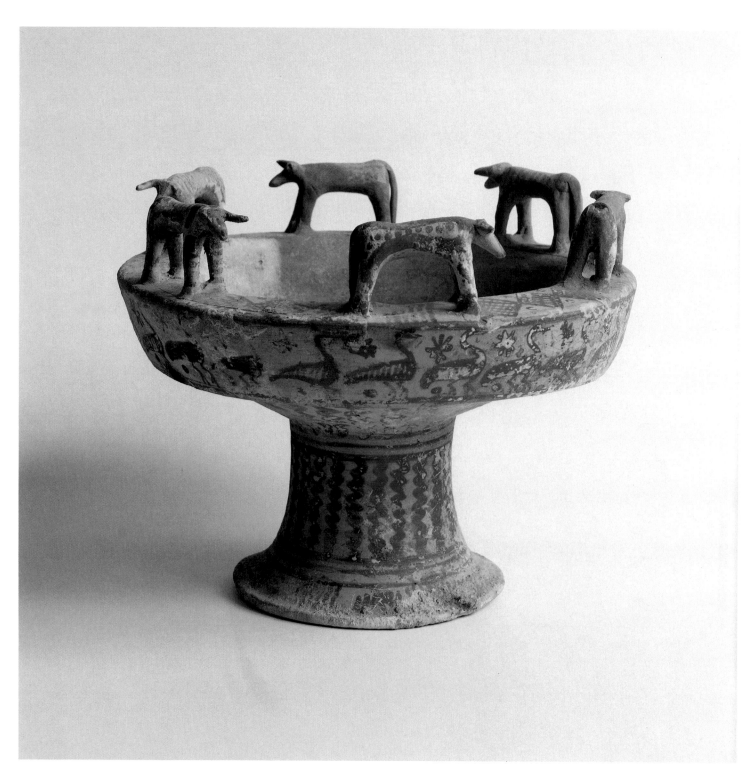

40. *Libation Bowl*
Italy, Etruria, Vulci
7th century B.C.
Terra cotta with red and black slip
7⅞ × 10 in., diameter

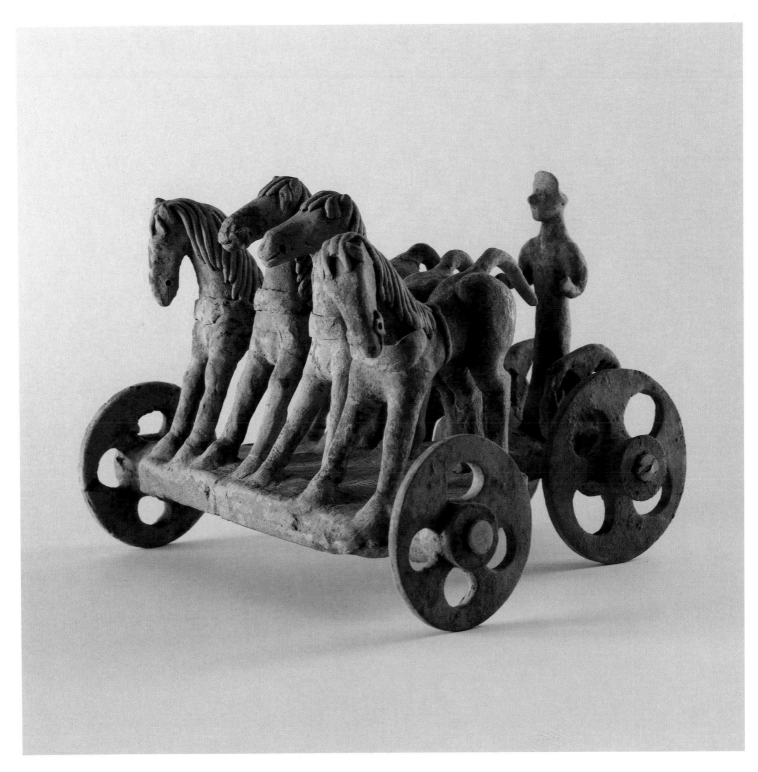

41. *Chariot Group*
Greece, Boeotia
600–550 B.C.
Terra cotta with red slip
7³⁄₈ × 10¹⁄₂ × 9¹⁄₂ in.

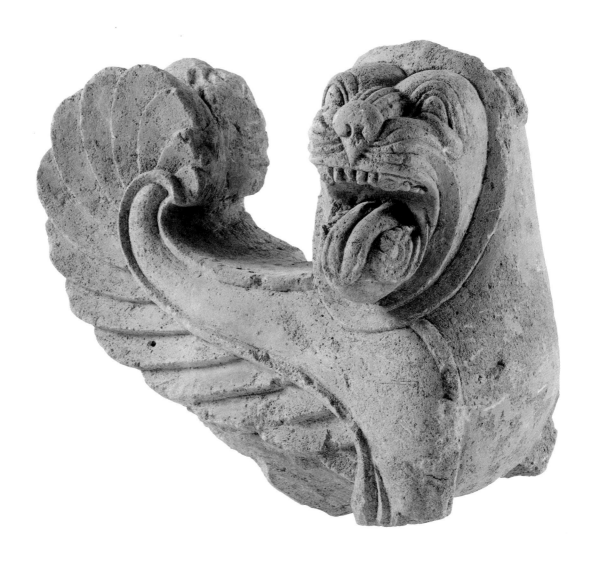

42. *Winged Lion*
Italy, Etruria, Vulci
Mid-6th century B.C.
Volcanic stone
28 × 34¼ × 17 in.

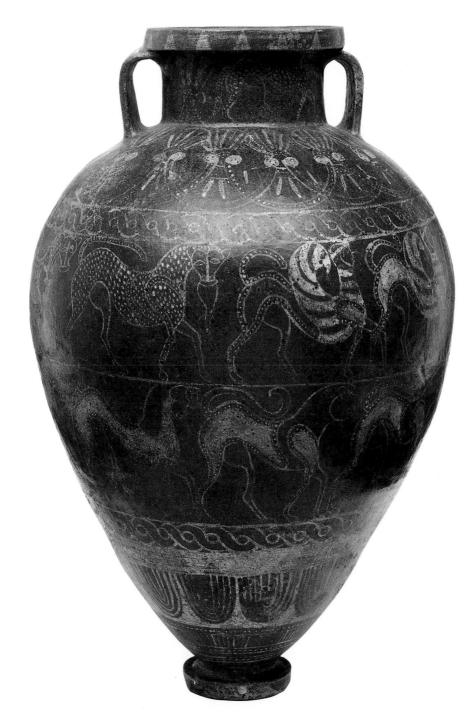

43. *Amphora*
Italy, Etruria
6th century B.C.
Terra cotta with red slip
26 × 17 in., diameter

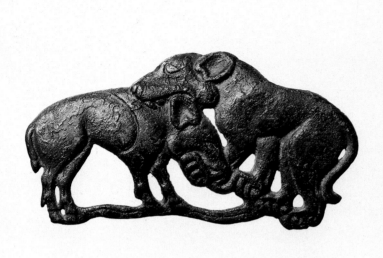

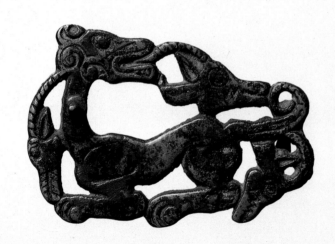

44. *Plaque—Wolf and Wild Boar*
Soviet Union, southern Siberia,
Yenisei River valley
Tagar II period, 5th–4th century B.C.
Bronze
2⅛ × 3⅞ × 9⁄16 in.

45. *Belt Hook—Feline and Antelope*
China, Inner Mongolia
3rd–2nd century B.C.
Bronze
2¼ × 3⅜ × ⅜ in.

46

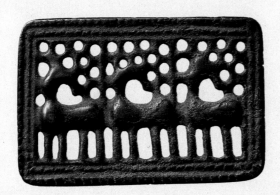

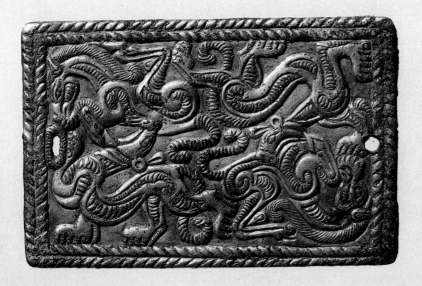

46. *Plaque—Deer*
China, Inner Mongolia, Ordos region
1st century B.C.
Bronze
$2^{15}/_{16} \times 2^{7}/_{8} \times \frac{3}{4}$ in.

47. *Plaque—Tiger and Wild Horses*
China, Inner Mongolia
4th–3rd century B.C.
Gilded bronze
$2^{7}/_{8} \times 4^{7}/_{16} \times \frac{5}{16}$ in.

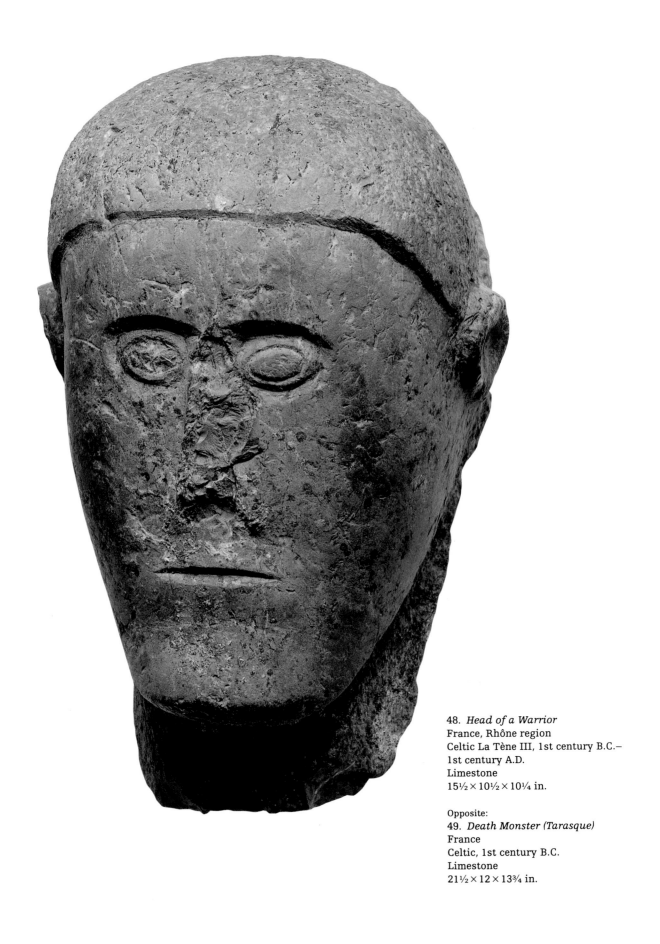

48. *Head of a Warrior*
France, Rhône region
Celtic La Tène III, 1st century B.C.–
1st century A.D.
Limestone
15½ × 10½ × 10¼ in.

Opposite:
49. *Death Monster (Tarasque)*
France
Celtic, 1st century B.C.
Limestone
21½ × 12 × 13¾ in.

48

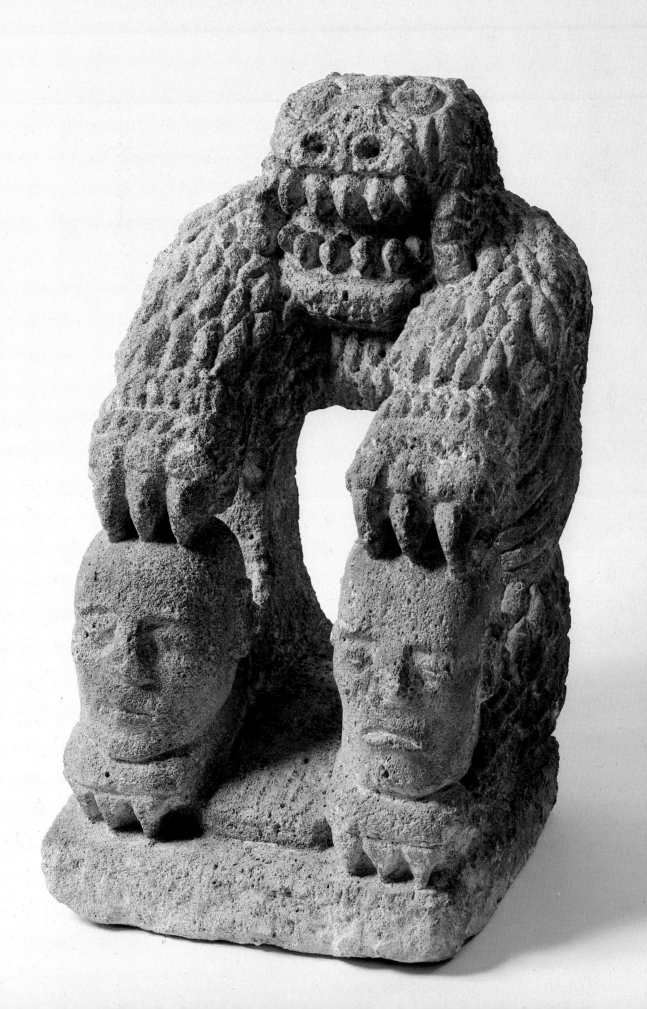

A Celtic Head from Roscrea

Anne Ross

In the spring of 1969 the Roscrea Head was left with me at my house in Southampton, England, for detailed study. When my friend and colleague, the late Professor T. G. E. Powell, saw the head he was quite amazed and referred to it thereafter as "The Wondrous Head." This was no random assessment of the unique nature of this rare Celtic artifact but a scholarly reference to the sacred severed head of the euhemerised deity of the early Britons, Bran, "raven,"[1] whose cult legend is contained in the medieval Welsh literary compilation known as the *Mabinogion*. The tale of Bran is one of the four oldest stories in the group known as the *Pedeir Keinc,* "The Four Branches," and the humanised god, who appears as king of the Island of Britain, is known as Bendigeidfran, "Bran the Blessed." The legend furnishes us with the most succinct account of the veneration of the human head in the rich literary and folklore repertoire of the insular Celtic world.

The storyteller here attributes to one single godhead all the multifarious powers with which the Celts believed the severed human head to be imbued—powers of continuing life and movement; powers of apotropaism, of averting evil from those under its protective aegis; powers of fertility; powers of hospitality, of entertainment, of speech and song and storytelling. The severed head was believed both to host the Celtic Otherworld Feast, that divine entertainment which was to be the reward of warworn heroes after their earthly striving, and to bring forgetfulness by means of its engrossing tales and mellow music so that years melted away and mortal time ceased to be. All these coveted qualities were possessed in full measure by the magic head of Bendigeidfran. Of Bran's comrades, who bore his severed head with them to the enduring feast, the storyteller relates: "Nor was it more troublesome having the head with them then, than when Bendigeidfran was alive. And because of those fourscore years it was called *The Assembly of the Wondrous Head*."[2] Thus, it was with this superb Welsh story in mind that Professor Powell so saluted the Roscrea Head.

KNOWN HISTORY

In the mid-nineteenth century a member of the Birch family of Birch Grove, Roscrea, was digging in the family burial plot on what had been an island in a former lake, where there had been a Celtic monastery founded in the seventh century by St. Cronan (Cainneach). During the digging operation, a wooden head was brought to light. After release from long submersion in the bog, cracks developed in the wood, but they were not serious enough to destroy the head. How long the Birch Grove estate had been in the possession of the Birch family is not quite clear; in all probability they had held it at least since the beginning of the seventeenth century, when the abbey that had succeeded the monastery, having been dissolved in 1586, was finally terminated in 1607. In 1955 the contents of the Birch Grove House, including the head, were sold at auction in Dublin.

The head was presented for analysis to the Jodrell Wood Laboratory at Kew, London, where the wood was found to be bog oak from the British Isles, using the scientific term British which includes Ireland as well as what is now Britain. Subse-

Opposite:
50. *Head of a God*
Ireland, County of Tipperary, Roscrea
Celtic La Tène IV, 4th–5th century A.D.
Oak with traces of pigment
15 × 7¾ × 7½ in.

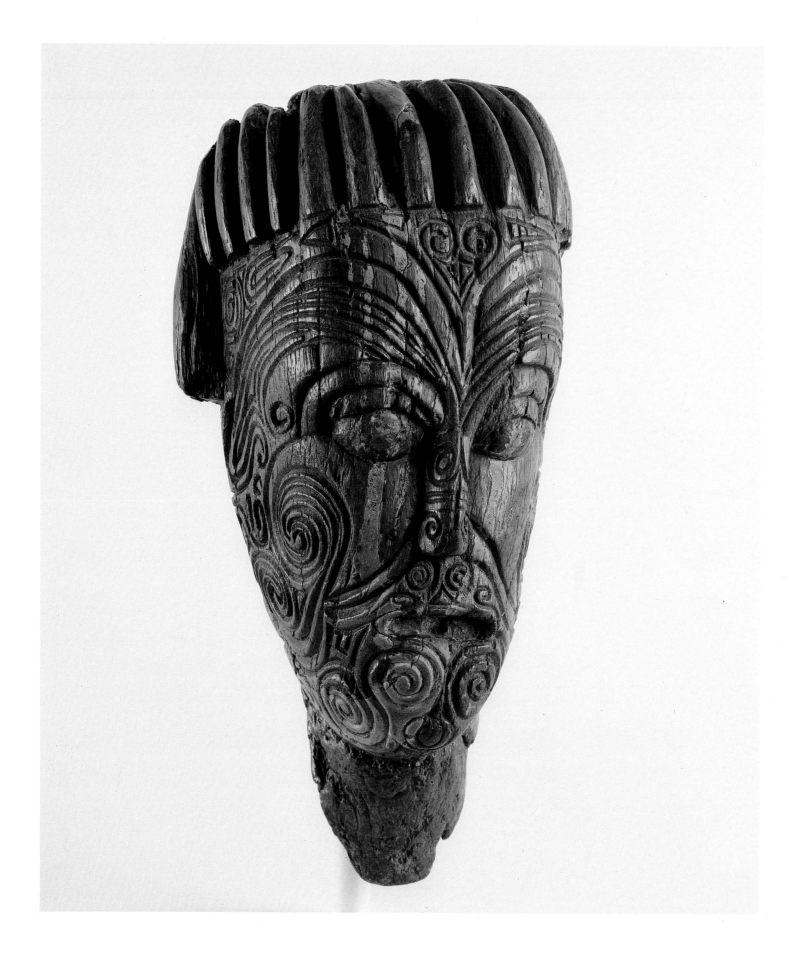

quent tests were carried out in the laboratories of the British Museum, London, in which it was determined that the carved ornamentation of the wood was contemporary with it. Carbon-14 tests carried out in Washington, D.C. established that the dating of the wood is within the fourth and fifth centuries A.D.—the period immediately prior to the formal acceptance of Christianity by the Irish people. These scientific conclusions serve to substantiate those of the artistic evidence that the Roscrea Head is native to Ireland. Traces of red and white pigment, and of gold and silver, give an indication of its original magnificence. Of La Tène style in inspiration, the Roscrea Head provides yet another example of the late flowering and continuity of early Celtic art in the immediately pre- and post-Christian eras and constitutes one of Ireland's treasures, fit to rank alongside the finest of them.

ORNAMENTATION

The head itself, fashioned from "British" oak, reveals in its form and features its essentially Celtic cult origin. The austere, and indeed awesome, visage comprises an elongated face surmounted by the deeply ridged hairstyle that was characteristic to Celtic and Romano-Celtic sculptures throughout Europe. It was a style that was to persist in Irish anthropomorphic art within the Christian milieu. The lentoid eyes, the eyeballs full and without pupils, unless marked by a now-vanished pigment, represent another feature common to representations both human and animal in La Tène art, with their compelling regard. The lines rising harmoniously from the nobly sweeping eyebrows deliberately concentrate the essential importance of the eyes themselves. As in many Celtic representations of the human head, there are no ears. The narrow, elegant nose and the calm serenity of the stiff-lipped mouth complete a repertoire of features common to the finest early Celtic cult heads, which here result in an artistic drama that led Professor Powell so instinctively to designate this work of art "The Wondrous Head."

Consideration of the decorative motifs with which the head is adorned leads me to offer the following comments on the major elements. The heart-shaped motif at the center of the forehead appears to be some kind of badge or emblem, a "blaze" like the "trefoil" on the brow of a stone head from Heidelberg or a comparable feature on another from St. Goar.[3] The motif above the browridges is an inverted version of a pattern occurring on the Battersea Shield and on the Witham Shield.[4] The eyebrows are created by a void, pointed where the ridges converge close to the nose and widening at the outer end to curl into a spiral with expanded terminal. This feature occurs, for example, on the Witham Shield, in the terminal roundels immediately within the circle where the spine joins.

As Professor Powell pointed out to me when examining the head, the most exciting motif of all is the curvilinear, trumpet-shaped void formed by the carved lines linking the bottom of the eye and the side of the nose to the cheek-spiral, which is best seen from the front half-right view. It is a noble, confident pattern, executed with superlative skill by the Celtic craftsman, a skill worthy of the finest illuminated manuscripts which were, in their turn, to derive so much of their inspiration from their La Tène predecessors. This void may be compared, for example, with that on the Weston Spoon and with patterns on bronzework from Llyn Cerrig Bach, in Anglesey, the great Druidic center of Britain.[5] The pelta motif, which comprises essentially two opposed spirals joined by their outer extremities, is another widely spread Celtic art motif. In Ireland it occurs, for example, on the Athlone Plaque (sixth century), where three pelta motifs occur on the breast of the Savior, and also, fourfold, on the pinhead of a penannular brooch from County Cavan,[6] which may be of the same date or slightly later.

Exuberant spirals used in harmonious profusion form one of the most characteristic and prolific of all Celtic art motifs from the Neolithic onward. In simple spirals, the line winds into the center and out again; in more complex examples, two or more lines originate at the center, to wind out alongside each other. The mystical, magical origins of this motif in Celtic, as in other, contexts cannot be called in question. Another feature to be found in the adornment of the Roscrea Head is the use of what we may call space-fillers. When arranging curvilinear patterns on a rounded surface, the artist may avoid leaving unsightly gaps by the use of appropriate lesser motifs, such as the small three-sided patterns which are inserted freely where called for, while less simple curvilinear devices are employed in the larger gaps. Each facet of the decorative carving on the Roscrea Head is to be found elsewhere in the repertoire of Celtic La Tène art.

TATOOING AND SKIN-PAINTING IN ANCIENT EUROPE

Tatooing and the painting of living human skin are well attested in the ancient Western world. Several Classical commentators refer to the practices, among them Julius Caesar, Ovid, Solinus, Martial, Herodian, Claudian, Jordanes, and Isidore, covering between them the period between the first century B.C. and the seventh century A.D. The later writers refer specifically to tatooing—puncturing the skin, not painting it. And they make special reference to the inhabitants of northern Britain in this connection, peoples among whom were the marauders, or colonists, from Ireland, engaged in securing a foothold in the neighboring territory which was eventually to become their kingdom—Scotland—in the fifth century.

Some of the best surviving evidence for facial tatooing can be found among the coins of the Celtic world, such as a silver coin of the second century B.C. found in Hungary.[7] Traces of pigmentation found on many early Celtic cult heads may be slight but they do, nevertheless, provide evidence that the colorist augmented the work of the sculptor, painting on hair and eyeballs and decorative patterns. The La Tène artist's passion for leaving no part of the material undecorated is most excellently demonstrated by the Roscrea Head.

A further testimony to another version of the practice of adorning venerated heads comes from a comment by Livy who, describing the Celtic custom of head worship, mentions that the Boii customarily used the gold-mounted skulls of prized enemies as libation cups in their temples (XXIII, 24).[8]

EVIDENCE FOR THE USE OF WOOD FOR CELTIC CULT FIGURES

Despite the high degree of perishability of wood, which is best preserved in a damp, oxygen-free context, statues and cult heads made of this substance abound from Celtic Europe. Classical references to such artifacts are supported by archeological finds, with oak the predominating material. The oak (*darach* in Irish) was the most revered of all the sacred Celtic trees. Great collections of carved wooden cult objects have been found throughout Europe at Celtic aquatic cult sites—springs, pools, sources of rivers, and bogs. Often, when carved wooden figures or heads have been found in Ireland by peat diggers or drainers, they have been cast back into the bog holes by the finders, for superstitious reasons; this recalls the observations by the Classics that Celts would not steal dedicated treasure offered to deities and lying open on the ground. Had the Roscrea Head been excavated under such circumstances it might well have been returned to its resting place unrecorded.

Like other oaken artifacts of the period, the Roscrea Head exhibits the characteristic economy of line and treatment so often dictated by the proportions of the branch or beam on which the work was executed. Whether the head originally

served as a complete cult object, or was part of a figure or of a structural feature, cannot now be determined. In the earliest Irish tradition the background for the heroic tales is usually the feasting hall of some mighty warlord. The roof of the massy wooden structure was supported by carved and decorated pillars. We know from the story of Bran that the head dominated the feast; and the presence of the Roscrea Head, fixed or as now, would have been apposite in such a context.

CULTURAL AND GEOGRAPHIC CONTEXTS

By the time Christianity was gaining firm ground throughout the Roman Empire, Druidism persisted in modified form in spite of Roman persecution. Native gods required native priests, and the Romans were not opposed to the continuing worship by the Celts of their established deities, until the advance of "official" Christianity rendered this undesirable. Schools of Druidism flourished, as the earliest Irish tradition makes clear. Celtic disciplines of law, philosophy, genealogy, history, and archaic mythology were taught by oral methods—the Druid chanted the lesson and the acolytes chanted it back until it was firmly committed to memory. Christianity itself is essentially logical, and to the Celts, accustomed as they were to codifying and classifying their ancient lore and learning, Christianity was not only comprehensible but readily acceptable. The sacrificing Druid priest could eagerly turn his austere devotions toward the altar of Christ, and could eat, with intense sincerity, the symbolic flesh and drink without question the bitter blood of the One Sacrifice.

The lack of any Christian martyrdom recorded in Ireland points strongly toward the easy conflation of the old with the new faith; this is demonstrated by the fact that Christian monks, Irishmen themselves, preserved for all time, in writing, the ancient pagan oral traditions of their people. The godhead and the severed head both symbolised the power of faith; and in Ireland, unconquered and but slightly affected by the Roman Empire, the melding of the old and the new beliefs must have presented no serious problems.

Roscrea is in the northeast of County Tipperary, close to the point where the boundaries of Tipperary, Offaly, and Laoighis meet, and deep in the heartland of south-central Ireland, where Christianity grew and flourished from early times and paganism long lingered. One of the more important towns of early Ireland, Roscrea is situated on one of the five ancient routes[9] radiating from Tara, the sanctuary of pagan Ireland. Among these were the northwest road, Slige Asal; the midwest road, Slige Mór; and Slige Dála, the road from Tara through Roscrea to the eastern shore of Lough Derg. Roscrea was at the hub of crossroads on Slige Dála, always an important position in ancient superstitions. It is of further interest that, in this area of ancient sanctity, an impressive earless limestone head was unearthed at Killavilla, County Offaly, the estate which adjoins Birch Grove on the northeast.[10] Its strangely formed crown suggests a hood or helmet, while its severe, almost savage, countenance proclaims its pagan connotations. Early relics from Roscrea almost certainly include the eighth-century "pocket" Gospel Book, known as the Book of Dimma;[11] part of the shaft of a late eighth-century cross and a beautiful penannular brooch;[12] and the remains of the twelfth-century Romanesque church of St. Cronan.[13]

Roscrea was itself a seventh-century establishment, founded by Cronan or Cainneach, bishop of Aghaboe, Ossory. St. Cronan's altar was set up on what was then an island sanctuary—the place where the head was dug up twelve centuries later. The pagan Celts worshiped islands, believing them to be the dwelling places of their powerful deities, paradises of the Otherworld. There is little doubt that

Roscrea Isle was a pagan sanctuary before the coming of Christianity. The Roscrea Head may have hung or stood in some pagan wooden shrine there; and it may well have been "sained" (purified) and used again in Christian ritual, as so often happened in Ireland. It may eventually have been deliberately concealed in the ground. We cannot know the full answer to what was its actual background and function, but we can at least examine the possibilities.

The most universally eminent and accomplished of all the pagan Celtic gods was Lugos, venerated in Ireland as Lugh and in Britain as Lleu. In Ireland he was known as Lugh Lámh-fhada, "Lugh of the Long Arm," and as Ildánach, "The All-skilled One." In short, Lugh was possessed of every power, every quality, every skill desired of man. His name means "brilliant, light," and he came to save his people from destruction. In his honor a great annual feast was established, held on August first, called Lughnasa in Ireland and known in later times in England as Lammas, the First-Fruit Feast. The festival is still observed in Ireland, albeit in etiolated form and under a number of different names. The pagan god, in later Irish legend, became the friend of mankind, the good god who fought for the success of the harvest against his grim antagonist Crom Dubh, "The Black Crooked One," god of blight and despair. One fascinating legend, recounted by Máire MacNeill in her brilliant study of the Lughnasa festival, testifies not only to Roscrea's religious associations in Christian times but also points to its age-long association with the good god of the harvest, Lugh. The traditional tale occurs in a medieval Irish legend, "The Salvation of Crom Dubh." Crom Dubh is the Antichrist, and in many parts of Ireland the Lughnasa feast was known from medieval times onward as Dómhnach Chruim Duibh, "Crom Dubh's Sunday." This version of the legend is from the Book of Fermoy and is entitled *This is the Reason why Crom Dubh Sunday was so called*:

> *One day that Saint Cainneach (Cronan) was in the island of Roscrea he saw a great legion of demons flying over him in the air. One of them came down to the island, and Cainneach asked him where the devils were going. He replied that a good friend of theirs, named Crom Dubh, had died that day, and they were going to take possession of his soul. "Go," said the saint, "but I charge you to return to me here on your way back and tell me how you have fared." The demon after some time returned, but limping on one leg, and groaning with pain. "Speak," said the saint, "what has happened to you?" "My lord," said the demon, "we seized upon Crom Dubh, certain that our claim to him was good; but suddenly Saint Patrick, with a great host of saints and angels, appeared, who assailed us with fiery darts, one of which struck me in the leg, and has left me lame forever. It seems that Crom Dubh's charities and good works were more than a balance for his sins. So the saint took possession of his soul, and put us to flight."[14]*

Immediately to the northeast of Roscrea is the group of hills named Sliabh Bladhma or Sliabh Smóil, both signifying Hill of Fire and now anglicised to Slieve Bloom, "a centre of ancient worship and the home of a presiding deity."[15] Its Lughnasa associations are well attested and extremely archaic. In the shadowy woods on the Slieve's slopes Fionn MacCumhaill (Finn MacCool), leader of the war-band known as the Fian, was reared in secret, according to ancient tradition. Lugh's cult legend and the earliest Fionn tales are closely similar, and it has been suggested that Fionn, "White," may have been but another name for the great and brilliant god Lugh.

The lake at Roscrea dried up in the late eighteenth century, leaving only the islet, now set in bogland, known as "The Island of the Living," which the people

believed to be sacrosanct, a place untouched by death. Giraldus Cambrensis knew of this holy place and referred to it in his writings (1188) as "Insula Viventum," the Island of the Living, Inis na mBéo; and it featured as one of the four chief pilgrimages of Erin in a Life of Saint Kevin.[16]

Roscrea Island, then, no doubt an important Lughnasa site, may have had the Wondrous Head as a guardian, just as the head of Bran the Blessed, buried in London, was reputed to protect Britain. However, to claim that the Roscrea Head necessarily portrays the god Lugh himself would be to carry the argument beyond the limits of the evidence at present available.

SUMMARY AND CONCLUSION

The Roscrea Head, the most lavishly carved and decorated head yet known from the Celtic art repertoire, was unearthed on an island on which pagan legend and Christian belief had flourished. In the wider region round about, the old worship of the great god Lugh is still vestigially commemorated in folk gatherings and in legends in which Christian saints and pagan deities enact their age-old parts. The Roscrea Island of the Living (Inis na mBéo), focus of widespread belief in the deathless Otherworld of the pagan Celts, was also the seat of early Christian teachings. In the Lughnasa legends the feared and revered gods and goddesses of the pagan past become baptized into the Faith by the good churchmen, and their archaic cult legends are thereby preserved, under many Christian guises, for the enjoyment of all posterity. The harmonious fusion in Ireland of Druidic divinity with compelling Christianity resulted in the magnificent imagery and design that was to become the glory of Irish ecclesiastical art. Nowhere is this to be witnessed more poignantly and dramatically than in the carving of the Wondrous Head of Roscrea.

NOTES

1. Ross, A., *Pagan Celtic Britain*. London, 1967, pp. 61–126.

2. Jones G. and Jones T., *The Mabinogion*. London, 1949, p. 39.

3. Ross, *op. cit.*, p. 63.

4. Fox, C., *Pattern and Purpose*. Cardiff, 1958, pls. 14–17.

5. *Ibid.*, fig. 82, nos. 21, 24.

6. Henry, F., *Irish Art*. London, 1965, pls. 44, 46.

7. Kruta, V. and Szabó, M., *Les Celtes*, Fribourg, 1978, no. 88.

8. Ross, *op. cit.*, p. 64.

9. O'Grady, S. H., *Silva Gadelica I–XXXI*, London, 1892, p. 118.

10. Ross, *op. cit.*, p. 88.

11. Henry, *op. cit.*, pp. 161, 201.

12. *Ibid.*, p. 143, pl. 45.

13. de Paor, M. and L., *Early Christian Ireland*. London, 1958, p. 180.

14. MacNeill, M., *The Festival of Lughnasa*, Oxford, 1962, pp. 598 ff.

15. *Ibid.*, p. 221.

16. *Ibid.*, p. 75.

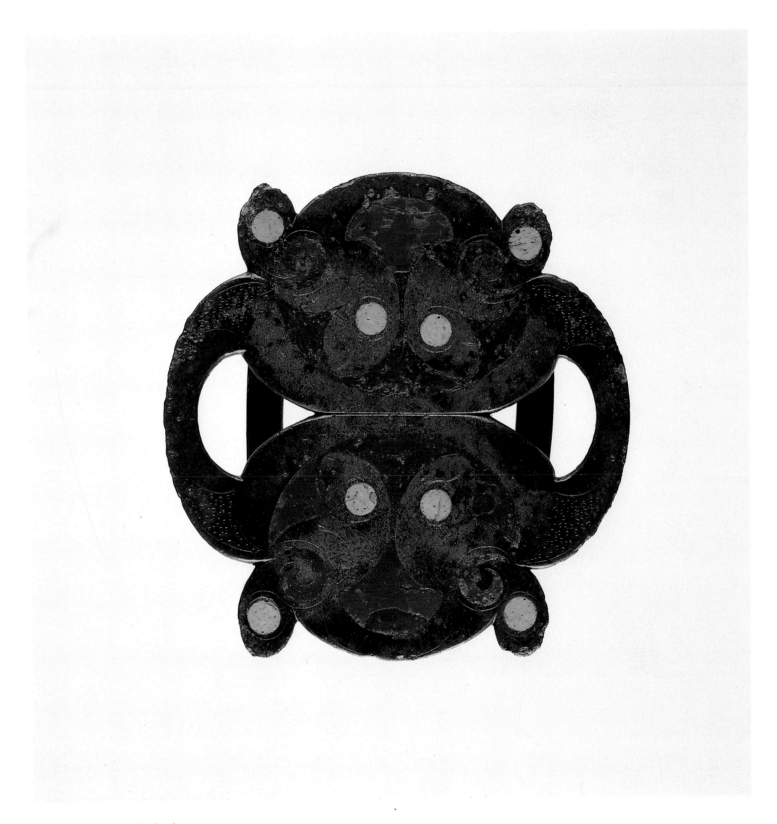

51. *Harness Mount (Phalera)*
England, South Buckinghamshire,
near Hambledon
Celtic, Iron Age II–C, 1st century A.D.
Bronze with champlevé enamel
3½ × 3⁷⁄₁₆ × ½ in.

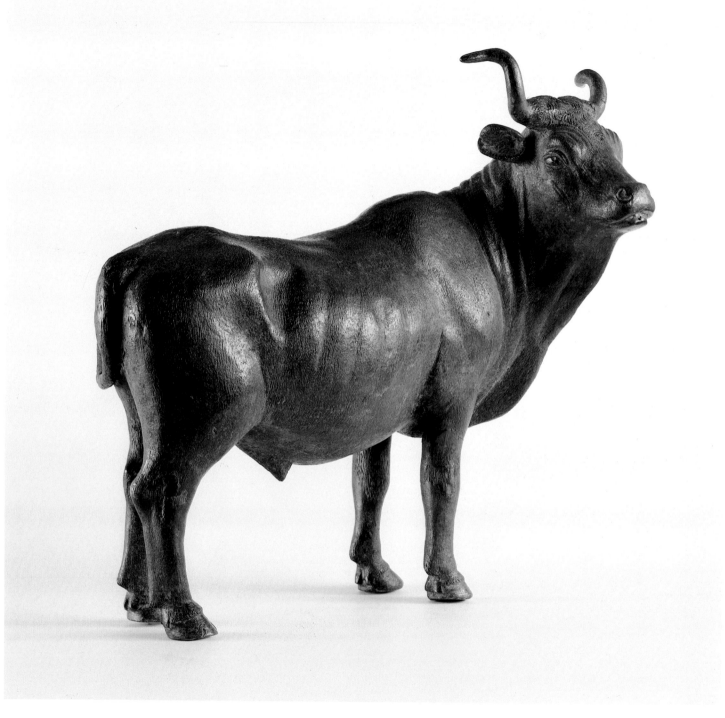

52. *Bull*
Asia Minor (?)
Graeco-Roman, 1st century B.C.–
1st century A.D.
Bronze
15¼ × 14⅜ × 7 in.

Opposite:
53. *Vase*
Asia Minor (?)
Roman, 2nd–3rd century A.D.
Terra cotta with lead glaze
11½ × 6¼ × 7¾ in.

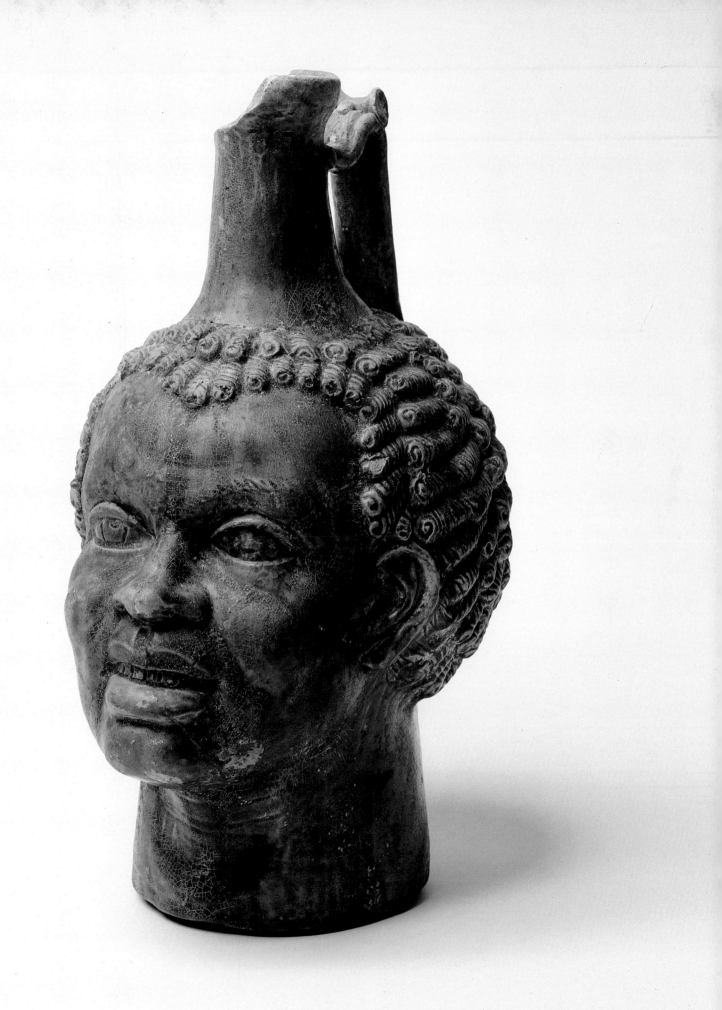

Two Egyptian Funerary Portraits from the Fayum

Bertrand Davezac

"Fayum portraits" constitute a well-defined—indeed unique—type which in modern times, however, has been transformed into a genre. They are painted in encaustic on wood, or on fabric when they are part of a funerary shroud. Their style is essentially nonpharaonic and characteristically East Roman during the time of their production from the first to the fourth century A.D. The portraits represent young, middle-aged, and even old men and women; children as well as couples. Only the head and shoulders are shown, placed against a neutral, often undifferentiated, background. Whether depicted full-face or posed at a slight angle, as is the *Portrait of a Man* in The Menil Collection, the sitters in these portraits are characterized by their fixed and absorbing glance which seems to project straight out of the picture, passing beyond the transfixed beholder and reaching to the ultimate boundaries of perceivable time.

The term "Fayum portrait" is, in fact, both a modern invention and a misnomer. It is a derivation from the original name of a geographical place, which mutated into the common name for the Roman-Egyptian portrait familiar to the art-educated public.

"Fayyūm" (al Fayyūm, a Coptic word meaning "The Land of the Lake," Paiumā meaning "water"[1]) actually designates the artificial Lake Qārūn, located near the city of Medinet-al-Fayyūm. This lake, one of the most extraordinary feats of water engineering and land reclaim of all times, was created by the kings of the Twelfth Dynasty (1991–1778 B.C.) in the Middle Kingdom. This project changed a desert area approximately 100 kilometers southwest of Cairo into what is still Egypt's most fertile land.

The formation of the designation "Fayum portrait" is bound up with the practice of separating the funerary images from their mummies, a practice common to nineteenth-century gravediggers, dealers, and collectors who, in so doing, systematized what seventeenth-century antiquarians had initiated. Due to the *sui generis* character of their particular style, these portraits were considered worthless at the time and simply discarded.

The radical re-evaluation of the Egyptian funerary portrait, which took place in the last two decades of the nineteenth century, eventually led to their vindication. As a result, their status changed from that of discard to collectible. Whereas mummies maintained the archeological interest they had always aroused, funerary portraits did not necessarily attract the same public or collectors. Their re-evaluation constitutes a turning point when the Roman-Egyptian funerary portrait became a specific entity, both archeological and aesthetic, quite distinct from the mummy with which it was originally intended to be inseparable. Thus the ancient beliefs governing the integration of the living features of the deceased, rendered in a painted image, with its real body arrested in a state of perpetual physical stability were utterly disregarded. The word "Fayum" came to denote this kind of portraiture and by identifying it as belonging to an autonomous type also implied its desacralization. This process resulted in a secular and essentially formalistic redefinition of this ancient portraiture.

The new appreciation demanded that these portraits be rooted out of their feeding ground and promoted to the status of *objet d'art*, not unlike the tribal artifacts from black Africa and Oceania, in order to win admittance into the Cubist and Surrealist collections earlier in this century. However, the term "Fayum," as already mentioned, is in this context a misnomer, and the genre it designates fallacious. It is a misnomer because many portraits were discovered as far north of the Fayum as Memphis and Sakkara near Cairo,[2] and as far south as Antinopolis, Achmim, and Thebes.[3] It is fallacious as a genre because a genre is the result of a tacit, but nonetheless real, entente between the artist and his contemporaries, whereas the funerary portrait regarded in isolation is a modern invention. In rare instances the large format of such portraits indicates that not all were intended as mummy portraits; a few functioned instead as individual funerary portraits.[4]

The extraordinary evocation of earthly life conveyed by the *Portrait of a Man* in The Menil Collection (No. 54) stands in sharp contrast to the timeless frozen expression generally found on mummy faces of the pharaonic period. The expressiveness of both the *Portrait of a Man* and the *Portrait of a Young Woman* (No. 55) reflects an entirely new influx from the Mediterranean world. The Hellenistic and the Roman are the two strands which, from approximately the first century A.D. under the Ptolemies, gradually infiltrated indigenous Egyptian art. This combined influence contrived to break its prodigiously stable momentum—sustained over three millennia—eventually bringing it to a halt. Oriental influences from the hinterland, east of the Mediterranean as far as Persia, also played a role. Therefore, Egyptian art during this period took a new direction and joined the broader concert of Mediterranean art before the Islamic conquest in the seventh century A.D. Roman-Egyptian mummy portraits are a foremost manifestation of this stylistic mutation, which, in turn, reflects a comparable disintegration in the interrelated concepts of divine kingship, state, and religion, although Roman emperors may on occasions still be represented in the traditional pharaonic style.

The two Roman-Egyptian mummy portraits discussed here (Nos. 54, 55) exemplify the first phase of this momentous art historical transformation. Both portraits reveal a new awareness of reality in the Egyptian art of portraiture. The features of the deceased, in contrast to funerary masks of earlier periods, are no longer generalized into an expression of eternity as fixed and immutable as a stellar configuration. No longer transcendent, eternity has become terrestrial, grounded in the existential "now." The man's face appears to register the passing of time. The sense of the hereafter radiating from it is not sterile but reverberates with all the vibrancy of life. While earlier masks depict what may be termed the life of expectancy (i.e., the reunification of the body with the soul in the hereafter, the stars, the underworld, or in a conflation of both), these two mummy portraits are virtual remembrances of things past. The eternity they evoke is incarnated. Lived reality and even personality, as the young man's portrait seems to suggest, are altogether summarized and immortalized in their painted image.

The *Portrait of a Man* was first published by Herbert Hoffmann.[5] It is painted on a very thin 3-millimeter-thick panel of fig wood; a crack runs vertically down the middle. The beveling at the top as well as along the lower horizontal edge of bare wood indicates both the format and size of the aperture disclosing the mummy's face over which it was inserted as the deceased's portrait plate. Like nearly all funerary portraits of this time, it is painted with a mixture of pigment and wax (encaustic), here applied in thin impasto.[6] The young man, dressed in a white toga folded over his left shoulder, stares straight ahead and is posed at a slight angle.

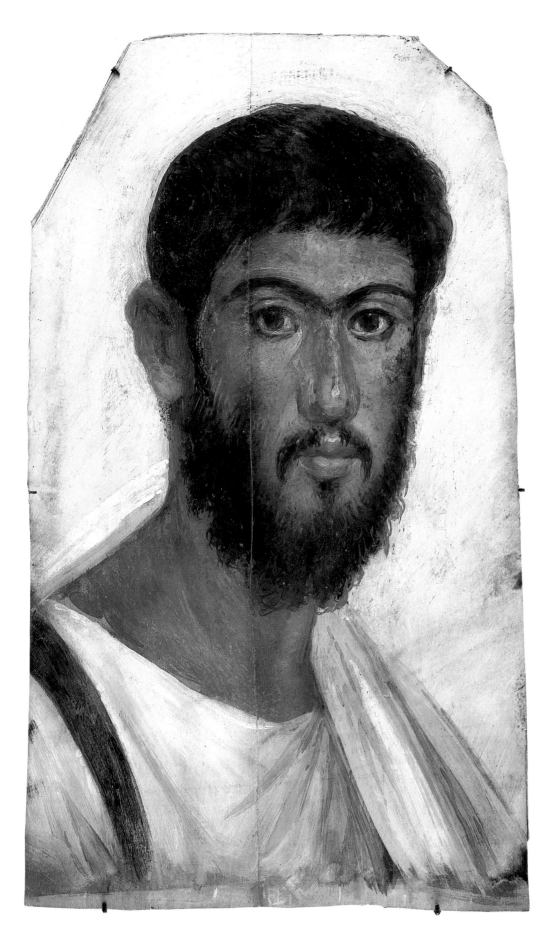

54. *Mummy Portrait of a Man*
Egypt, Fayum region
Roman, ca. A.D. 150–200
Encaustic on wood
17¾ × 10⅝ in.

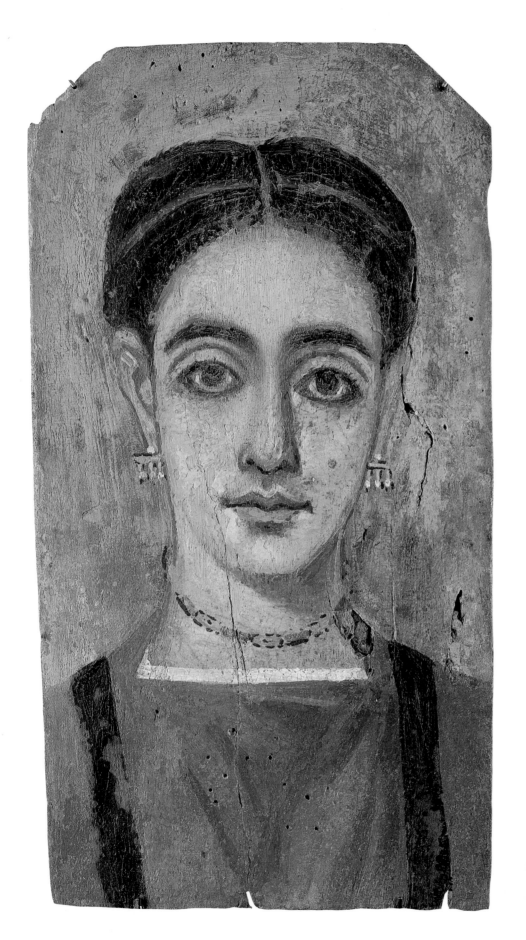

55. *Mummy Portrait of a Young Woman*
Egypt, Fayum region, Er Rubayat
Roman, ca. A.D. 150–200
Encaustic on wood
15¾ × 8⅞ in.

Also characteristic for this type of portraiture is the continuous line of the eyebrows over the bridge of the nose as well as the black color of both hair and beard. The hairstyle itself, as correctly observed by Hoffmann, bespeaks of art of the Antonine period at the time of Marcus Aurelius in the second half of the second century A.D. The complexion, subtly rendered with highlights and shadows, testifies to late antique sophistication in handling nuances in portraiture. The toga's white color is in harmony with the pale green tonality of the heightened background applied in brisk brushstrokes. The *Portrait of a Young Woman* displays a similar coordination of color between her purple tunic and the pinkish white background. The brownish purple band (*clavus*) over the man's left shoulder is indicative of social status. The corresponding band, concealed by the fold of the toga on the other shoulder, is a feature not uncommon in mummy portraits.[7]

It may seem surprising that a prominent person was not identified by means of an inscription.[8] However, name inscriptions on mummy portraits are the exception rather than the rule before the fourth century A.D. During the last century of their production, a period in which half of the approximately seven hundred known portraits were produced before their prohibition by Theodosius in A.D. 392, artists had frequent recourse to name inscriptions because by that time portraits, done in a coarse style, had become totally depersonalized. Such portraits are referred to by the unfelicitous designation of "nominal portraits."[9] Tags bearing identifying inscriptions and traditionally placed across the chest, over the coffin, were frequently discarded by early gravediggers. Attempts to identify names with famous people of antiquity have generally been dismissed as fantastic.[10]

It is tempting to make a correlation between the social prominence of the deceased and the discriminating choice of the painting's support: a small-grained, satin-smooth, and cardboard-thin panel of wood of undetermined family (lime or sycamore).[11] The extraordinary freshness of color, and here credit is due once again to Egypt's climate, is not as exceptional as it is remarkable. Other than some insignificant flaking, the state of preservation is excellent. The lively expression of the young man is unusual in funerary portraiture, even at this early date; that alone, aside from its great artistic merit, singles this portrait out as one of the best of its kind. Its lifelikeness is also an ingredient of a type of realism specific to Roman portraiture (as distinct from the rendering of the face indigenous to Egyptian art), and the portrait itself *qua* type has rightly been associated with the medallion portrait (*imago clipeata*) of Roman sarcophagi. Such a connection with Roman funerary art excludes the possibility that the unstable pose and the impulsive brushwork of the toga and the background be connected to the epicurean, the mundane, the ephemeral, and the fleeting moment. Instead, the adumbration of death confers upon it a spiritual quietude.

The likeness of the young woman marks the transformation of life before death into life after death. It illustrates the belief, transmitted to Rome via oriental religions, that only life exists.[12] Death is neither the cessation of life nor its negation; it is a milestone denoting the passage from the stage of life to its perpetuation in another world. Death in this sense can be seen as the threshold through which the body passes to be reanimated and reunited with its soul for eternity. Unlike the *Portrait of a Man*, the *Portrait of a Young Woman* has suffered numerous losses of paint and has been restored. It is painted on a much thicker support, a 15-millimeter-thick, coarse-grained panel of what seems to be, in the absence of structural analysis, fir wood. The frontality, static composition, thick impasto, and broad stare closely focused to the center of the young woman's face stand in contrast to

the spatially conceived composition, fluid brushwork, and more naturalistic eyes of the male portrait. Nevertheless, consistencies of style underlying these differences become apparent upon closer inspection. The treatment given to each of the young woman's ears suggests that the frontality of the portrait is, in fact, an adaptation from a painted model posed at an angle similar to that of the male portrait. However, the artist neglected to modify the rendering of details inappropriate to a frontal view, such as the exaggeration of one ear and the attenuation of the other. The fleshy, curvy lips in both portraits are similar, as is the treatment of the nose and the drawing of the deeply recessed eyes and thick eyelids. The recent removal of an earlier restoration has uncovered the upper part of the young woman's ear, on our left, which now corresponds more closely to the ear in the man's portrait.[13] Her wavy hairstyle, parted in the middle and pulled back—entirely exposing her ears— is here again characteristic of the Antonine period. It is the hairstyle of the Empress Faustina, wife of Marcus Aurelius, and was current between ca. A.D. 160 and 180.[14] The last third of the second century A.D. thus seems indicated for this portrait.

A comparison of the painting (No. 55) with a funerary portrait of a woman in Dijon (Fig. 1), painted on wood, brings its style into relationship with a group of works from Antinopolis, founded in A.D. 130 by Hadrian and named after his lover. This site was extensively excavated early in this century.[15] However, an origin at Antinopolis must be ruled out because our portrait bears the seal on its back of the prestigious Graf Collection. This collection of portraits, the largest ever assembled, eventually numbering over two hundred pieces (whole or in fragment), is extremely well documented. It was formed from portraits excavated at Er Rubayat on the eastern side of the Fayum during the summer, or at the latest the fall, of 1887 and was acquired by the Viennese collector Theodor Graf. Graf's collection was shown in Berlin and Paris in 1889, at which time it was catalogued; it was photographed in Vienna around 1930.[16] Thereafter the collection was eventually dispersed through a series of sales. The presence of the Graf seal on The Menil Collection painting therefore rules out an origin at Antinopolis. I propose instead Er Rubayat as the site for its exhumation sometime between August and October of 1887.

Roman-Egyptian mummy portraiture stands at the triple confluence of Egyptian, Roman, and Eastern Mediterranean art. Yet anyone familiar with Egyptian civilization cannot be deceived by the Roman disguise imparted to the funerary portrait. The spiritual, religious force of Egyptian funerary art stands behind it.

The lifelikeness of funerary portraiture marks a radically new chapter in Egyptian painting, in contrast to Egyptian sculpture which had a long tradition of realism. At first sight, a Fayum portrait appears to be a true likeness of the deceased, painted during his lifetime and not necessarily updated at the time of death, serving as a substitute by means of the representation of the particular features of the deceased; in other words, it is a lifelike memento. But closer analysis of physiognomic elements such as the ears, the eyes, the nose, the lips, and to a not insignificant extent the neck, reveals that a good deal of generalization, if not idealization, has entered the process of portrait-making. Specific features are brought to bear on the basic ethnic types. Conversely, these generalized features do not violate the specific character of the portrayed individual.

The influence of oriental art of the Eastern Empire is detectable in the schematization of the area around the eye. The continuous line of the young man's eyebrows, and the almond-shaped eyes of the young woman, are characteristic features of Syrian art from Dura-Europos and Palmyra of about the same period.

Finally, these portraits raise the question of the spirituality latent in both

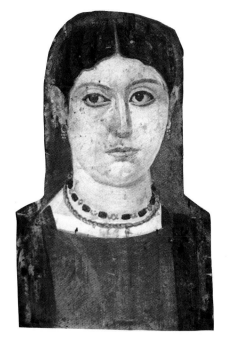

Fig. 1 *Mummy Portrait of a Young Woman*
Musée des Beaux-Arts, Dijon

pagan and Early Christian art. Although nearly all mummy portraits are pagan, it is difficult to resist seeing a parallel with Early Christian art of the following centuries, and very specifically, Christian monumental painting of Egypt of the fifth and sixth centuries. Frontality often signifies absolute concepts including authority, dogma, eternity, temporality, intemporality, presence, absence, and eternal bliss. The glaring eye of the after-death no longer looks out but lets itself be looked into the recurrent "inner eye" of late antique philosophy.

NOTES

1. J. de Rougé, *Géographie ancienne de la Basse Egypte*, Paris, 1891.

2. Paris, Louvre, Inv. P 200.

3. Berlin, Staatliche Museen, Aegyptische Abteilung, 17900. K. Parlasca, *Mumienportraets und verwandte Denkmaeler*, Wiesbaden, 1966, pls. 2, 29; New York, Metropolitan Museum, Inv. 09.187.7 and Louvre, Inv. P 211.

4. Parlasca, *op. cit.*, p. 66.

5. H. Hoffmann, *Ten Centuries that Shaped the West*, Houston, 1971, p. 488 and plate p. 489.

6. Some portraits were executed in tempera. However, they constitute a rare exception. See F. W. M. Petrie, *Hawazu, Biahmu and Arsinoe*, London, 1889, p. 18.

7. Parlasca, *op. cit.*, pl. 30, 1. It can be found, for example, along with a similar shift to the side of the neck of the collar opening, in a portrait in the Art Museum in Dijon (Inv. GA 1, 2).

8. One mummy of the first century A.D. in the British Museum bears such an inscription. It reads: ARTEMI PH EY YXI = "Farewell, Artemidoros." E. A. W. Budge, *The Mummy: Chapters on Funeral Egyptian Archaeology*, London, 1884, reprint, 1964, plate opposite p. 186.

9. "Namungsportraet," E. Buschor, *Das Portraet*, Munich, 1960, p. 69; and K. Parlasca, *Ritratti tardoantichi e copti in Egitto, XXVIII, Corso di cultura sull'arte ravennate e bizantina*, Ravenna, 1981, p. 23.

10. Parlasca, *op. cit.*, pp. 76–84.

11. In addition to limewood and sycamore, fir wood, i.e. the reference material for pinewood, a timber imported from Syria, was also used. See A. Lucas, *Ancient Material and Industries*, London, 1962, new enlarged edition, pp. 329–36,

429–56. For more recent technical studies of wood, binding media, and pigments, see also B. Ramer, "The Technology, Examination, and Conservation of the Fayum Portraits in the Petrie Museum," *Studies in Conservation*, 24 (1979), pp. 1–13, esp. pp. 1–6; M. Martin and S. N. Reisman, "The Surface and Structural Treatment of a Fayum Portrait," in N. S. Brommelle, A. Moncrieff, and P. Smith, *Conservation of Wood in Painting and the Decorative Arts*, London, 1978, pp. 191–98; S. P. Sack and N. Stolow, "A Micro-Climate for a Fayum Painting," *Studies in Conservation*, 23 (1978), pp. 47–56.

12. F. Cumont, *Les religions orientales dans le paganisme romain*, 1906, 1909, 1928; Engl. ed., *Oriental Religions in Roman Paganism*, New York, 1956.

13. The recent restoration on this panel by Andrea di Bagno was done at The Menil Collection.

14. E. Coche de la Ferté, *Les portraits romano-égyptiens du Louvre*, Paris, 1952, p. 15.

15. A. Gayet, "Les portraits d'Antinoé," *Gazette des Beaux-Arts*, 50/1, 1908, pp. 121–34.

16. Parlasca, *op. cit.*, pp. 23–32, and complete analytical bibliography, pp. 217–19, nos. 16–33.

BIBLIOGRAPHY

Klaus Parlasca, *Mumienportraets und verwandte Denkmaeler*, Wiesbaden, 1966.

———, *Repertorio d'arte dell'Egitto greco-romano, Serie B.*

———, *Ritratti di mummie*, vol. 1, Palermo, 1960; vol. 2, Rome, 1977; vol. 3, Rome, 1980.

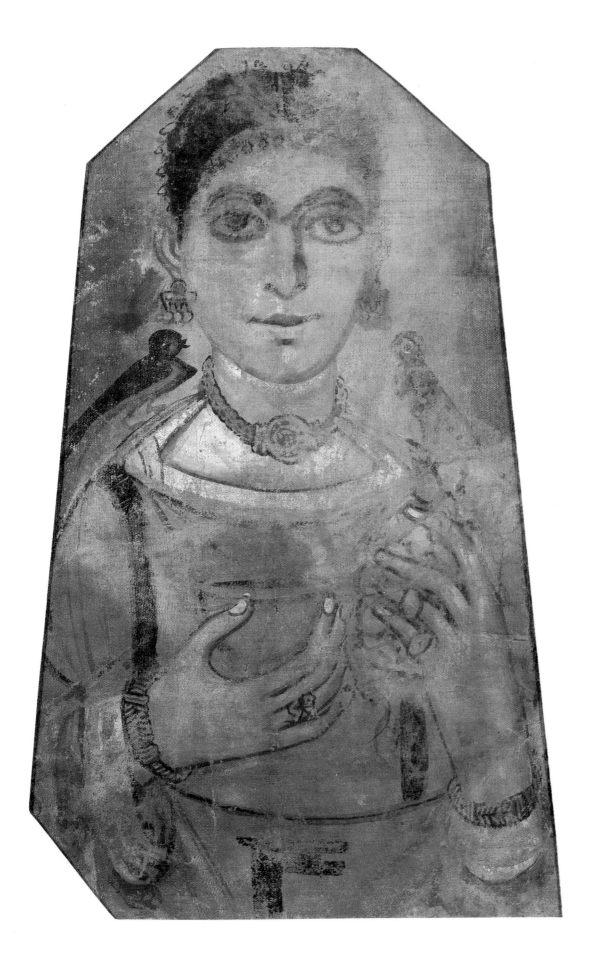

56. *Mummy Portrait of a Young Woman*
Egypt, Sheikh Abâdeh, near Antinoöpolis
Roman, ca. A.D 250–300.
Painted cloth
22¼ × 15 in.

57. *Personification of the River God Nile*
Egypt
Coptic, 5th century A.D.
Dyed wool and linen
24¾ × 13¼ in.

58. *Pomegranate Tree*
Egypt
Coptic, 4th–5th century A.D.
Dyed wool and linen
42⅛ × 22 in.

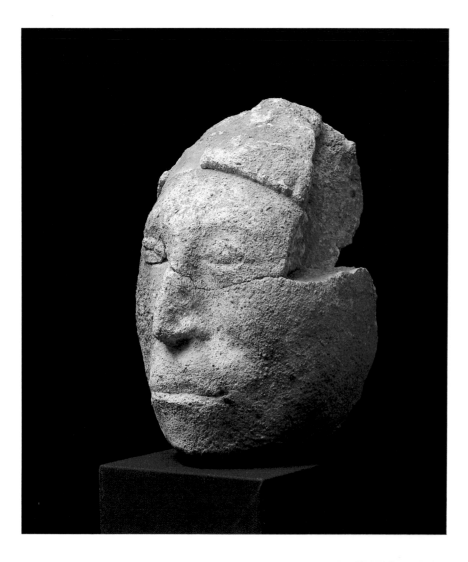

59. *Head of a Man*
Mexico, Tabasco-Chiapas region
Late Classic Maya, 600–900
Stucco
8⅛ × 6 × 6⅝ in.

60. *Bowl with Incised Serpents*
Mexico, Tabasco
Late Classic Maya, 600–900
Terra cotta
4¾ × 6 in., diameter

61. *Carved Lintel with Hieroglyphics*
Mexico, Chiapas, Bonampak
Early Classic Maya, 498
Limestone
28 × 30¾ × 1⅛ in.

MEDIEVAL AND BYZANTINE ART

The six works in this section—a thirteenth-century German miniature, a gold Byzantine reliquary, a French Gothic head, two Russian icons, and a post-Byzantine icon from Crete—are separated by various historical and territorial distances, their linkages more philosophical than topical. Two of these works, Nos. 63 and 65, are addressed in individual essays; here I would like briefly to consider the others.

The *Tree of Consanguinity* (No. 62), a frontispiece illustrating canonic and common law, is more familiar to the medievalist than to the general public. These manuscripts lack the visibility of church art, and fewer have survived than miniature paintings of religious subjects. Here, blood relationships are visualized in a treelike tabulation, because, as a fourteenth-century scholar once observed, "the tree tells about degrees of consanguinity better than words would."

Originating in the fast-developing artistic milieu of the French Gothic, the *Head of a Bearded Man* (No. 64) may be contrasted with the conservative German miniature. The globular eyes, partially concealed by exquisitely outlined eyelids, the bone structure, the emaciated, sorrowful, yet serene expression, the unbelabored hairstyle, and the short, simple beard, all point to an Ile-de-France workshop between 1170 and 1180. Retrieved from the site of a Gothic church during a nineteenth-century restoration, this head exemplifies an autonomous moment of expression in Gothic sculpture.

The Resurrection icon (No. 67) dramatizes the coexistence of both Orthodox and Westernized aesthetic and doctrinal traditions during a period of crisis in Russian icon painting in the seventeenth century. A new sense of tactility and a new tonality of muted warm colors are symptomatic of the break from Orthodox tradition. Likewise, the composition is no longer arranged in rigid tiers. The icon reveals its Orthodox program in a vivid pictorial transposition of the Byzantine Easter liturgy in which the destruction of the Gates of Hell is correlated to the opening of the Gates of Paradise to the Good Thief and the Elects.

The confirmation of the Byzantine style on Crete was not tempered by a native style as in Russia, but manifested itself as an unmitigated reaffirmation of the late Byzantine traditions of the Palaeologue dynasty (1261–1453). St. Onuphrius (No. 66), an early Christian hermit who became the mythical "Wild Man" in the Latin West, is represented here with a hermetically long beard and clad in a unique loin garment of leaves. The ascetic spirituality and austerity of mood, which parallels the hesychastic visionary intensity of certain frescoes from Mount Athos, reaches a climactic pathos in this icon. El Greco, another native of Crete, shares a common culture with the Emmanuel Lambardos who painted this icon of St. Onuphrius a generation after El Greco's death. While El Greco dematerializes matter, Lambardos crystallizes it stereometrically as a symbolic concretion of Orthodox Byzantine style.

Bertrand Davezac

62. *Tree of Consanguinity*
Germany
First quarter 13th century
Tempera on vellum
13¼ × 8⅛ in.

73

A Gold Byzantine Reliquary

Bertrand Davezac

The gold casket in The Menil Collection belongs to a small, though well-known, category of objects originating in the early centuries of the Christian era.[1] These objects are generally made of stone (marble in the Eastern Mediterranean and limestone in the West); however, other examples exist made of wood (only rarely), silver (*capsellae argenteae*), lead, and gold. Only a few works in gold have come down to us, the survivors of what must have been a larger number now lost to thieves and looters.

All three media, stone, silver (or lead), and gold, share a physical interdependence, for caskets of different materials have been found one inside the other. The stone casket is occasionally perforated several times on the lid to allow for the pouring of liquid and on the base for collection; this facilitated libation, a common funerary practice in antiquity. The stone casket, in turn, often contains one or more smaller boxes of lead or silver, only rarely of gold.[2] Unlike the antique pyxis, yet similar to the sarcophaguslike Etruscan urn, the form of these caskets is essentially derivative. To put it in Neoplatonic terms current throughout late antiquity, it is the emanation of an archetype: the late antique sarcophagus.

The Menil gold casket is an exceptional specimen among an already rarified group of *capsellae aureae*. In contrast to all other known examples, it is devoid of decoration. No ornamental patterns, symbols, or figuration detract from the geometric quality or purity of its sparse architecture. Three features, however, point to its function as an Early Christian funerary object: its size, medium, and form.

Its small dimensions and precious medium suggest that the Menil casket was the innermost of one or two other casket reliquaries. Archeological evidence supports this hypothesis. Four small gold caskets have been found inside one or two small pyxes or small sarcophagi made either of silver or marble.[3]

These four caskets were deposited in silver *scrinia*, or boxes, which in turn were shaped either as pyxis (as the one in Vienna) or miniature sarcophagi. These were then placed in a small stone sarcophagus, sometimes with other reliquaries as well. Unlike the Menil casket, they all bear some kind of decoration, such as cloisonné patterns, cabochons and crosses, and so on. They are also flat-lidded in contrast to the Menil casket, which consists of a rectangular trough fitted with a lid in the shape of a gabled roof resting on vertical walls. The lid does not slide on and off but is secured by a pair of gold hinges on the back and a riveted latch on the front in distinction to the above-mentioned gold cases and other gabled ones. The hinges, judging from both style and workmanship, appear authentic. However, the small latch on the front as well as the rivets betray recent origins. A 4-millimeter-wide gold strip soldered inside and around the rim of the bottom half of the box ensures a tight fit for the lid. Thus both size and medium define the status of the Menil gold casket as the innermost receptacle of a multiple casket reliquary, while its very shape proclaims its funerary character.

Although the Menil casket is reputed to have been found at Stobi (Yugoslavia) near Gradesko, this place of origin cannot be securely confirmed, nor, indeed, can most archeological objects on the market. The ancient city of Stobi (destroyed by an

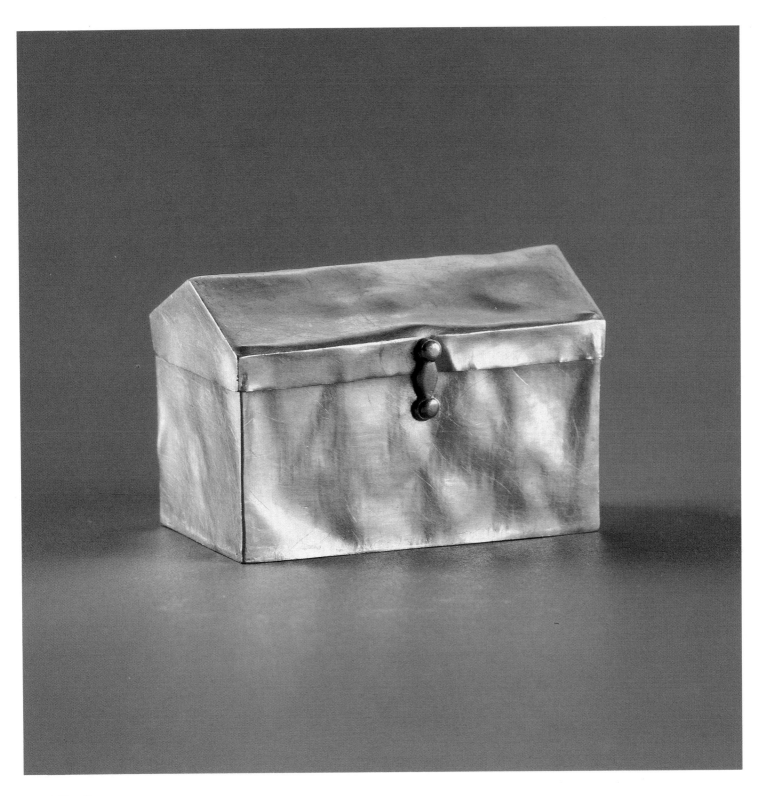

63. *Gold Reliquary*
Yugoslavia, Stobi (?)
Early Byzantine, 6th century
Gold
1¾ × 2¹¹⁄₁₆ × 1½ in.

earthquake in A.D. 518) has yielded extensive remains from Greek and Roman antiquity to the Early Christian period.[4] The Menil casket could have been discovered under an altar in one of the basilicas, such as the episcopal basilica (end of the fifth century), a funerary basilica, or one with a baptistery nearby. Such a place of origin is attractive since it gives a secure date, 518, as the *ante quem* for the Menil casket; but this remains regrettably undemonstrable.

While the form and lack of ornament are uncharacteristic of the few known examples of contemporary reliquaries, they are typical of the sarcophagus-shaped caskets that contained such small *scrinia*.[5] Some examples are: a stone reliquary from Vigo d'Anonia (Italian Tyrol, early fifth century, now in the Trent Museo Nazionale) and another from the Val di Non region in the Trentino (again in the Italian Tyrol, also fifth century, Trent Museo Nazionale).[6] Along with the Menil casket, these reliquaries belong to a well-known type of sarcophagus commonly found in the Near East and Asia Minor from late antiquity. Unlike the stone casket from Vigo d'Anonia, the Menil *capsella* has a flat bottom and no corner supports (Fig. 1), and, unlike the reliquary from the Val di Non, it has no *acroteria* (Fig. 2).

An interesting though subtle comparison can be made between the Menil gold casket and the seemingly unrelated *Leningrad Silver Casket*[7] (Fig. 3). The embossed decoration of this splendid object (A.D. 550–565) has been convincingly compared with art from Constantinople at the time of Justinian I. Similarities in type and workmanship can be found between the two caskets despite certain obvious differences, such as in aesthetic contrasts and in design (the Leningrad casket having massive *acroteria*). Both works display the distinctive high-gabled lid and, more significantly, both appear to be made from a single metal foil which has been shaped around a hard-core column, one sheet for the lid and another for the bottom. This technique was not *de rigueur*. To cite one example: in the early fifth century a flat-lidded, round-cornered Innsbruck silver casket from San Zeno (Italian Tyrol, Tirolerlandesmuseum, Ferdinand Deum) was assembled from several sheets of silver soldered together.[8] The lid and bottom of the Leningrad and Houston caskets, in contrast, are not assembled.

Microscopic examination of the Menil *capsella* reveals no traces of soldering other than that fitting the same strip of gold around the opening of the bottom, already mentioned above. Furthermore, imperceptible hammer marks are visible under the microscope.[9] The sharpness of edge, keen to both eye and touch, yet immaterial, confers upon the Menil gold *scrinium* a geometry of line and plane that is only attributable to a major workshop.

Most of the remaining casket-reliquaries from the Early Christian, pre-medieval, pre-Iconoclastic period were found under or near Christian altars, predominantly in the Near East and in Asia Minor, also in the West and in North Africa.[10] A great number of sources, both narrative and epigraphic (inscriptions), as well as an extensive body of archeological evidence bear this out. These reliquaries are the tangible manifestation of a new phenomenon in the cult of martyrs that evolved during the following centuries. Christian martyrs, as we know, are those saints who, sometimes in life, and always through their violent death, bore witness to their beliefs. The veneration that they received was also extended to sacred sites, both biblical and evangelical, chiefly but not exclusively in Palestine, for bearing witness to a biblical figure, to a biblical event, to a divine manifestation (Membre, where Abraham had entertained the Three Angels [Old Testament Trinity] on Mount Sinai), or to Christ, his relatives, and companions. Relics are the material vestige of a human encounter with the divine. Such an encounter may be of a historical nature

Fig. 1 Stone Reliquary
Vigo d'Anonia, Italy

Fig. 2 Stone Reliquary
Val di Non, Italy

Fig. 3 Leningrad Silver Casket
Hermitage, Leningrad

(witnesses of Christ's life such as the apostles or Mary), or may be mystical (Christ appearing in a vision to a saint before his martyrdom [theophany]).[11]

From the second through the fourth century, the cult of martyrs consisted of pouring libations and of prayers. These rituals were eventually consolidated into the office of the mass delivered on the anniversary of the martyr's death at the burial site. The office was performed either over the sarcophagus (*arcosolium*) or above it in a funerary chapel or church (*memoria, martyrium*).

When, during the subsequent centuries, relics came to be disseminated across the Christian world, they were enshrined in single, double, or triple caskets and deposited inside or under church altars. Thus, the altar took on the function of the original *martyrium* through a double process of reduction and identification because, as Gregory of Nazianz explains it, "These few drops of blood and these minute evidences of torment are as efficacious as the body in its integrity."[12]

The funerary character of the reliquary-sarcophagus is undeniable, its shape reproducing that of the saint's original tomb. A mystical link exists between reliquary and tomb, confirmed by their identity of form. This correspondence is similar to that which exists between an icon and its prototype according to the theology of the image.

The dissemination of relics was in part made possible by the evolution of a religious sensibility condoning this practice which had been abhorred by Greco-Roman civilization, when it had been considered tantamount to desecration. Only by the end of the fourth century could the new phenomenon—the transfer of relics (*translatio*)—take place with a solemnity previously reserved only for the triumphal entry of a victorious general (*triumphum*). This practice did not receive universal approval. Even two centuries later it was strongly opposed in Rome as well as in Constantinople in an effort to preserve the respect for and integrity of the Holy Sepulchers in Rome and particularly in the Holy Land. Despite these injunctions, large Eastern cities such as Antioch, Ephesus, and even Constantinople, actively negotiated possession of large numbers of relics, including some very prestigious items. These in turn were traded, parcelled out, and eventually scattered throughout the more remote reaches of Christendom. Church officials and pilgrims were among the principal agents of this massive trade. The dedication of the church in Brescia to the "Assembly of Saints" (*Consilium Sanctorum*) stands as proof of this trade.

The Menil gold casket is exceptional; it differs from all others, except possibly the fifth-century silver reliquary from Tassulo,[13] in that it is not iconic. Unlike these, it bears no reference to the divine through sign (chrism, cross), image (the medallions of the Leningrad casket), or story ("The Raising of Lazarus," Brivio casket, Louvre). Instead, the Menil gold casket reveals its meaning through its shape which, as has been said before, is funerary in character. Its function, however, can only be surmised. As part of a double or triple casket it probably served as the innermost receptacle of an important relic. The fine workmanship points to Constantinople as its place of origin, sometime in the fifth or sixth century, at least prior to 518, the year of the earthquake at Stobi, where the casket is believed to have been found.

Beyond its shape, its medium also suggests meaning and can be investigated in the light of Early Christian and Byzantine aesthetics. The significance of the gold background in mosaics, wall paintings, miniatures, and icons has been frequently mentioned and variously interpreted. The "goldness" of a sacred object, on the other hand, can be understood differently. To Denis the Areopagite, gold was incor-

ruptible—an unadumbrated, inexhaustible, and splendid source of light. Furthermore, gold was believed to be the uppermost and subtlest layer of matter, as it were, and, as such, the reflection of divine light.

What is the significance of this rare and austere object? Like many, if not most, pieces in The Menil Collection, it was not acquired solely for the enjoyment of the innocent eye but primarily for the delectation of the inner eye. It can be appreciated by a sensibility attuned to invisible meanings, to the concepts and beliefs inherent in the religious, aesthetic, and stylistic elements embodied by the object as well as to that particular layer of civilization that it brings to light. Furthermore, because of its rarity this tiny object stands as a singular archeological relic from a distant and seminal phase of Christian civilization.

NOTES

1. H. Buschhausen, *Spätrömische Metallscrinia und frühchristliche Reliquiare*, Wiener Byzantinische Studien IX, Vienna, 1971.

2. F. Mayence, *Antioche. (Classe IV, 1954, 4ème campagne de fouilles à Apamée)*; H. Delehaye, "Saints et reliquaires d'Apamée," *Analecta Bollandiana*, LIII, 1935, especially pp. 235 ff; J. Lassus, *Sanctuaires chrétiens de Syrie*, Paris, 1947, p. 197.

3. These gold boxes are: the minuscule gold casket from Pola (Pula), Yugoslavia (ancient Pietas Julia), found under the altar of the cathedral in 1860, Constantinople, 6th century (Vienna Kunsthistorisches Museum, Antikensammlung, VII 763). H. Buschhausen, in K. Weitzmann, *Age of Spirituality, Late Antique and Early Christian Art, Third to Seventh Century*, New York and Princeton, 1977, No. 568, pp. 630–31. The gold casket from the Adriatic island of Grado, found under the altar of the cathedral in 1871 with relics inside, Constantinople. *Ibid.*, p. 630, and Buschhausen, *Metallscrinia*, no. B18. The gold casket from Cim near Mostar (Albania), found in a 6th-century altar of the basilica in 1968, Constantinople, 6th century. Weitzmann, *op. cit.*, pp. 630–31. The gold casket from Zanavartepi near Varna (Bulgaria), found in a church, Constantinople, end of 4th century– beginning of 5th century (Varna, Nardani Musej, III 768). *Ibid*, No. 569, p. 631.

4. E. Kitzinger, "A Survey of the Early Christian Town of Stobi," *Dumbarton Oaks Papers*, No. 3, pp. 81–162. R. Kalarik, "Provincial Improvisations in the Arts of Stobi," Ninth Annual Byzantine Studies Conference, November 4–6, 1983, Duke University, Durham, North Carolina.

5. These containers were variously called *scrinium*, *capsella*, *arcula* in Latin, σάρναχα, θηχη in Greek.

6. Omitted from Buschhausen's 1971 survey. R. Noll, "Ein Reliquiar aus Sanzeno im Nonsberg und das frühe Christentum im Trentino," *Öster-*

reichische Akad. der Wissenschaften, Vienna, 1973, p. 332 and pl. V, 1–2.

7. See *supra*, n. 3.

8. Noll, *op. cit.*, pp. 323–24, 336, and pl. II, 1.

9. I wish to thank Carol Mancusi-Ungaro, conservator of The Menil Collection, and Dr. John Harris, Chairman of the Department of Radiology, University of Texas Medical School, for their examination of the casket.

10. For the Near East and Asia Minor, see F. Mayence, *op. cit.*, H. Delehaye, *op. cit.*, J. Lassus, *op. cit.*, *supra*, n. 2. For the West, see R. Noll, *op. cit.*, p. 330; *ibid.*, n. 45. The Louvre silver *capsella*, found in Castello di Brivio (5th century), is an Italian work (E. Coche de la Ferté, *L'antiquité chrétienne au Musée du Louvre*, Paris, 1985, p. 105, with bibl.; K. Weitzmann, *op. cit.*, ill. pp. 632–33, ill. no. 571. The famous cubic electrum casket of St. Nazario in Milan (San Nazario), G. Traversi, *Architettura paeocristian Milanese*, Milan, 1964, colorplate V; F. de Mely, *Le coffret de Saint-Nazaire de Milan …Monuments de Piot*, 1900, VII, pp. 65–78. On North Africa, most recently, Yvette Duval, "Les saints vénérées dans l'Eglise d'Afrique," *XXX Corso di cultura sull'arte ravennate e bizantina, seminaro justiniano*, Ravenna, pp. 115–47, esp. pp. 118–19, with earlier bibl. See also O. M. Dalton, *Byzantine Art and Archeology*, pp. 563–64, on the silver reliquary from Henchir Zirara (Algeria) offered to Pope Leo XIII (with bibl.).

11. A. Grabar, *Martyrium*, Paris, 1946; London, 1972, pp. 28–29 and pp. 37–44.

12. Against Julian, Migne, *Patrol. graeca, XXXV*, 589, quoted by H. Leclerq in F. Cabrol and J. Leclerq, *Dict. d'archéologie chrétienne et de liturgie*, XIV, 1948, col. 2307.

13. Museo Dioceziano tridentino, inv. 584, 5th century. R. Noll, *op. cit.*, p. 231 and pl. IV, 1–2, not included in Buschhausen.

64. *Head of a Bearded Man*
France, Ile-de-France
ca. 1170–1180
Limestone with traces of later gilding
9¾ × 5¾ × 5⅞ in.

The Legend of Saint George and the Miracle of the Dragon

Bertrand Davezac

Born in Cappadocia, soldier by occupation, Christian by vocation, Saint George, by persisting in his Faith, earned the unique fate of suffering three deaths, each one consecutive to the most inconceivable torments ordered by Emperor Datianus of Persia, according to one legend, or by Diocletian in A.D. 303, according to a later one. Each death was rewarded by a score of conversions, according to the Acts of the saint's martyrdom, which Pope Gelasius was prompt to dismiss in 494. Saint George's relics were transferred to Lydda (Palestine), where Emperor Constantine erected a commemorative chapel (*martyrium*) over his tomb. Among the saint's many wondrous actions—forty of which are depicted on icons—the Miracle of the Dragon, of a later origin, is the one that has promoted the saint into a legendary figure and enhanced his stature as a hero reminiscent of Perseus delivering Andromeda from the dragon. The city of Lasia was plagued by a dragon, which demanded human flesh every day. Princess Elisaba had been designated as the monster's next victim when Saint George, a military tribune passing through town, delivered the princess by slaying the dragon before the city wall and then converting the entire population. There are several variants to the legend; the one in which Elisaba parades, holding the monster by a leash, is depicted here, while the saint is transfixing it under the eyes of the princess' parents and their retinue.

Popularized in the West largely through the Crusades—he eventually became the patron saint of England—George is of paramount importance in the Eastern Church, from Egypt to Russia, and is honored in Byzantium with the title of *Megalo-martyr*. Six churches were placed under his protection in Constantinople.[1] His veneration in Russia was particularly strong in Novgorod, the foremost center for religion and art in Old Rus from the eleventh through the fifteenth century.

This icon of *St. George and the Dragon* is attributed to the School of Novgorod on stylistic grounds and dated to a period when, as a thriving city, it sustained a number of calamities that eventually led to its irreversible decadence. This period lasted approximately one hundred years, between the capture of Novgorod the Great (Novgorod Velikii) in 1471 by Ivan III (the Great), revolts in 1503, and the plundering and massacre of 1570, engineered and supervised by Ivan IV (the Terrible), Russia's first tsar. Along with political and economic power, Novgorod also lost much of her artistic prestige as many of her iconographers, or icon painters, were called to the capital, Moscow, by Macarius, Novgorod's former bishop whom the tsar had appointed metropolitan of Moscow in 1542. They joined a task force of artists from Pskov and other places to decorate the walls of palaces and above all to replace the innumerable icons that had been lost in the catastrophic fire of June 21, 1547, which destroyed the cathedral, several churches, monasteries, and palaces. Artists were placed under the vigilant guidance of the archpriest Silvester, himself from Novgorod. Their work closely followed new rules established by recent councils, specifically the celebrated Council of the Hundred Chapters, known as Stoglav, dominated by Macarius, who was undoubtedly the leading intellectual and spiritual figure of the time under the supervision of Ivan IV.[2]

Along with Saints Menas and Demetrius, the two Theodores, Tyron and Stra-

Opposite:
65. *Saint George and the Dragon*
Soviet Union, Novgorod School
Early 16th century
Tempera and gold leaf on wood
37 × 27⁹⁄₁₆ in.

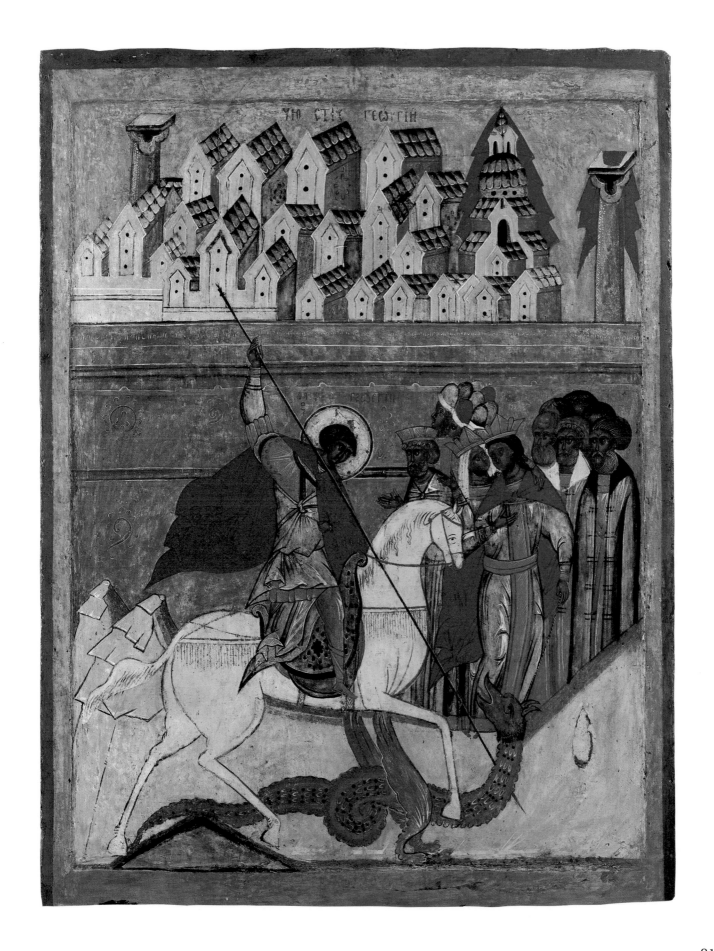

tilatis, Sergius and Bacchus, Procopius, and Russia's two national saints, Boris and Gleb, Saint George is a warrior saint.[3] Unlike ecclesiastical saints, the warrior saints insured the survival of a classical type throughout the Byzantine and post-Byzantine period by christianizing the Roman soldier, whether he be on foot, seated, or mounted. However, the mounted soldier has lent himself to the formulation of one of the most brilliant, dynamically harmonious, and expressive motifs in Christian art; no school has interpreted it with greater elegance than Novgorod from the fourteenth to the middle of the sixteenth century. Rider and horse may be facing either left or right. The knight may be attacking the dragon frontally or vertically, or else, by swinging his shoulders sideways, in beautiful contrapposto. Visualized in sequence, six icons from Novgorod of St. George call to mind a horse-riding show. Diversely rearing, prancing, or galloping, the horse is poised in harmonious interaction with the rider, whose crimson cape (*chlamys*) is exploited for most expressive effect, both in itself and in linear combination with the crystallized hillocks in the background.[4] Five of the Novgorod icons suggest an earlier model in the fourteenth century for the Menil *St. George*. By then, the specific qualities of this icon as pictorial image with characteristics such as its expressive power, its tonality, its color contrasts, its agreement of forms, the linear character of its design, as well as the character of execution, were fully developed.

The dragon's compositeness, exploited here to compositional advantage, denotes paradigmatically its monstrous nature. The lance is placed so as to be the most starkly rectilinear accent, a graphic link between the lower tellurian worlds of evil forces—the monster and its den, the latter a comparatively late accretion to the iconography—and the enclosure of the city above—above and not behind because the composition reads vertically: the den; the dragon, horizontally displayed in real counterpoint to the horse against a light barren ground with two diminutive prismatic hillocks, which expand the triangular motif of the den itself, amplified by the area between the horse's hind legs, a visual echo to the hillocks; the wall; and finally the city. This nonrecessive, spatial structure is yet compatible with spatially rendered details: Saint George, the royal group, houses, the left-hand side column are volumetrically conceived, receding or recessed. On the other hand, the dragon, the white steed with its missing foreleg—a unique feature—the city wall itself, are, as foils, devoid of terrestrial gravity. This dual rendering of sensible reality, characteristic of nonclassical, nonillusionistic styles, is essentially medieval and specifically iconic. Moreover, columns and draperies (*velaria*), far from picturesque, are emblematic. The draped column and the veiled dome signify, but do not describe, the interior of a palace and of a sanctuary, respectively. Thus both ecclesiastical and royal orders of society are efficiently, yet sufficiently, expressed. The unobtrusive distribution of facades, walls, and roofs, freehanded but carefully arranged, terse yet not cramped, will enchant the viewer with the feeling that a listener gains from the complex simplicity of a motet or madrigal of the same period.

Stylistically, there is hardly a motif in this icon that does not have a close counterpart in icons of the fifteenth and sixteenth centuries from Novgorod, whether it be the hillocks of the foreground interplaying with the *chlamys* and the horse's tail,[5] this particular "breed" of horse so typically Novgorodian,[6] the architectural background,[7] the groupings of figures and such details as wall patterns or crowns,[8] and the face types, although the dark facial complexions are common to both Russian and Byzantine icons (*sankir*). Highlights and serrated pleats also stylistically conform to the School of Novgorod; there is a palpability to them that suggests a generation closer to the middle of the sixteenth century than the fifteenth century.

Finally, one cannot stress enough that the making of an icon is based on premises that are radically different from Western art theory as a whole. Icons were not painted as mere aesthetic objects (at least until the middle of the seventeenth century) as paintings in the West were. An icon is a work of aesthetic theology, or, "A theology which expresses itself by means of aesthetic categories."[9] It follows that in the last analysis its merit does not lie solely, or even principally, with its artistic expression, but fundamentally as a revelation of either the Divine invisible (the Father, the Trinity, etc.) or the Divine incarnate (the Son, the Gospels, and the Saints). As with this icon of Saint George, excerpts from the visible are not intended as descriptions of the world *per se*, but rather to make the invisible or the immaterial—like angels, the Divine, or the concept of historicity with respect to the saints' lives—perceivable through the senses. In short, an icon is the experience of a divine manifestation. Unlike Western religious art, which is essentially descriptive, the icon is the actualization of the supernatural because it is believed to emanate from its prototype and share in its supernatural nature as the prototype, in turn, is believed to have its origin in God. Thus, a poorly painted icon may be regarded as superior to an artistically better one that departs from the established rules. Conformity to models (i.e., old Byzantine icons) is the only means available to the iconographer to reach the ultimate source—the hypothesized prototype—and conformity takes precedence over originality, an issue that was fiercely debated in Moscow in the seventeenth century. It is therefore crucial that a saint or a sacred scene be properly identified, hence the inscription identifying Saint George, to ensure correspondence to its real prototype and not with Saint Menas or Saint Demetrius, two warrior saints with similar iconography. The red inscription is in the Cyrillic alphabet, a Russian script evolved from the Greek uncial alphabet.

"By painting images of saints on icons," says the *Message to an Iconographer*, a fifteenth-century Russian treatise attributed to Saint Joseph of Volokolamsk, "we do not venerate a mere object but rather from that visible object our spirit and thoughts reach up to divine love and desire."[10]

NOTES

1. Kirchbaum, *Lexicon der christlichen Ikonographie*, vol. 6, cols. 365–90.

2. L. Ouspensky, *Théologie de l'icône*, Paris, 1982, pp. 262 ff.

3. New Grecian Gallery and C. J. Walter, *Warrior Saints*, exhibition catalogue, London, December 1972-February 1973.

4. 1. *St. George*, fourteenth century, Tretiakov Gallery, Moscow; V. N. Lazarev, *Novgorodian Icon Painting*, Moscow, 1969, pl. 41.
2. *St. George*, early fourteenth century, Russian Museum, Leningrad; Lazarev, *ibid.*, pl. 17.
3. *St. George*, fifteenth century, Tretiakov Gallery; Lazarev, *ibid.*, pl. 42.
4. *St. George*, late fourteenth century, Tretiakov Gallery; Falecitti-Lebanfeld, *Russische Ikonen*, fig. 254.

5. *St. George*, mid-fourteenth century, Russian Museum; *ibid.*, fig. 251.
6. *St. George*, fourteenth century, Tretiakov Gallery; *ibid.*, fig. 252.

5. *St. George*, mid-sixteenth century, Russian Museum; M. V. Alpatov, *Early Russian Painting*, Moscow, 1978, pl. 23.

6. See note 4.

7. *St. Theodore Strakelates*, late fifteenth century, Novgorod, Museum of History and Architecture; Lazarev, *op. cit.*, pl. 65.

8. *Idem* in *ibid.*, pl. 66.

9. Ouspensky, *op. cit.*, p. 242.

10. *Ibid.*, p. 245.

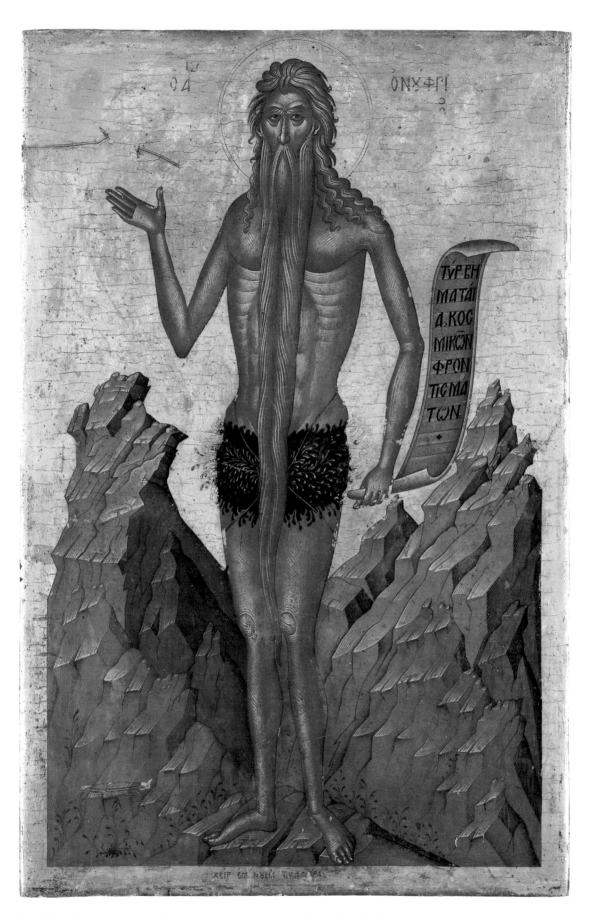

66. **EMMANUEL LAMBARDOS** (active, 1593–1647), *St. Onuphrius*, first half 17th century
Tempera and gold leaf on wood, 21⅞ × 14⅜ in.

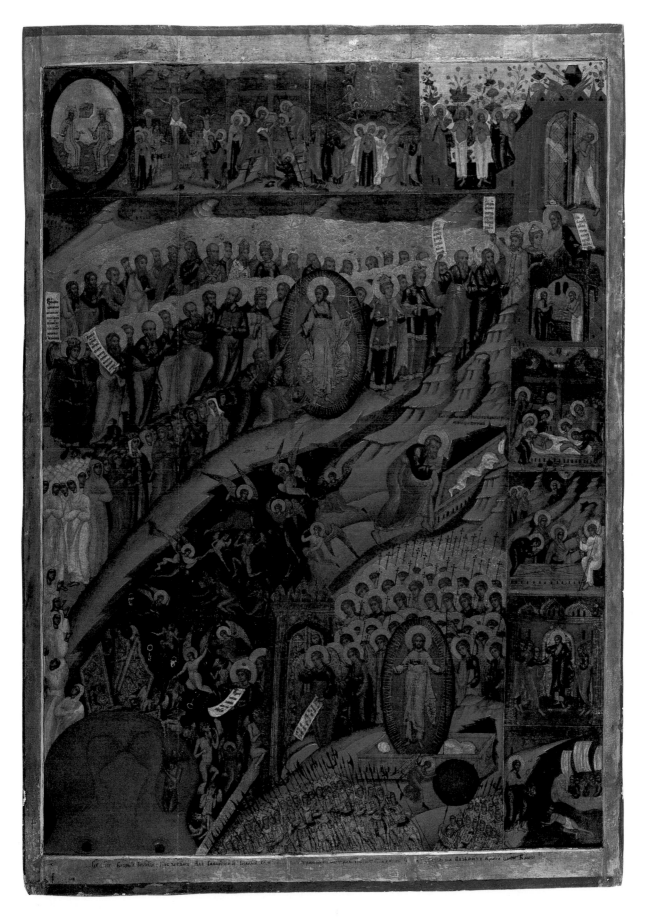

67. *The Resurrection*, Soviet Union, Ushakov School, 17th century
Tempera and gold leaf on wood, 59⅛ × 41⅜ in.

EUROPEAN PAINTING, SIXTEENTH–EIGHTEENTH CENTURY

What makes a private collection worthy of the name? In my eyes it simply consists of an assembly of works which have so impressed the collector that a desire has arisen to look at them frequently and to live with them. The unique link binding the works and the collector is the deeply rooted fascination for them in the collector's personality. As complex individuals, we can respond to more or less intense, obscure, and contradictory signals. Over the ages countless artists have discovered and expressed so many poetic aspects of form that no art historian has yet made, or ever will make, an inventory.

The process of collecting begins suddenly one day. Confronted by one of these objects, we sense in it the answer to a deeply imbedded need. If means permit, we seize the work. Finally, much later, we are surprised by the diversity of the works we have assembled. In the depths of our being we know that a secret bond exists between them much the same way we are aware that all the incredibly different faces in one's personal photographs spanning fifty years are really of one's self.

Dominique de Menil is such a collector. Her paintings are very varied. She has selected four works, spanning three centuries and several schools, for these brief studies.

Charles Sterling

Opposite:
68. FRANÇOIS CLOUET (1522–1572)
Equestrian Portrait of Dauphin Henry II, ca. 1543
Gouache on parchment mounted on wood
10¾ × 8¾ in.

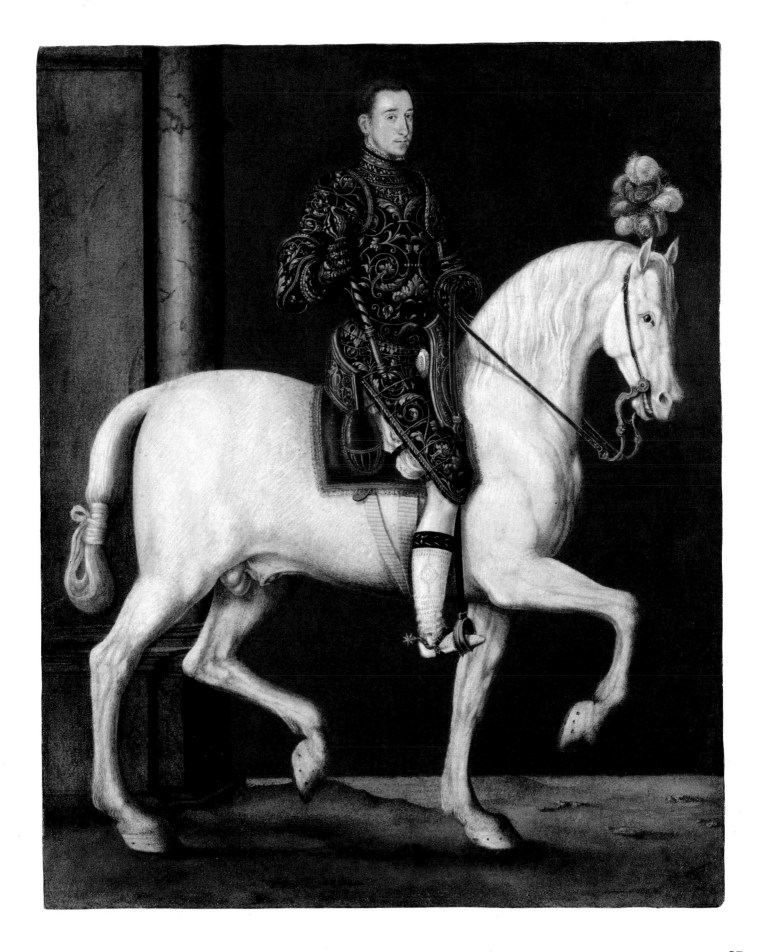

An Equestrian Portrait
by François Clouet

Charles Sterling

In this miniature, Henry II (1519–1559), the future king of France, is shown on horseback, aged around twenty-three or twenty-four—therefore this work can be dated ca. 1543. His black ceremonial armor, inlaid with gold, very likely came from the forge of Giovanni Paolo Negroli, the famous Milanese armorer, and it can be dated between 1540 and 1550. While this miniature is here reproduced near life-size, it is difficult to imagine it as such for it gives the impression of a painting in which both man and horse are life-size. Born in France, François Clouet assimilated the French miniaturist tradition, yet his compositions are conceived with a monumental amplitude recalling the art of his predecessor, Jean Fouquet, another artist in service to the monarchy. The son and assistant of Jean Clouet, a Flemish immigrant to France at the beginning of the sixteenth century,[1] François thus retained a preference for realistic detail and skillful illusionistic rendering, a heritage of the tradition of Jan van Eyck. For example, the prince's hand holding the mace stands out from the black armor and is so masterfully rendered that it surges toward us even though it too is gloved in the same black.

This is a perfect example of humanist portraiture. Its composition is based on the famous equestrian statue of Marcus Aurelius in Rome. The future French ruler is exalted through the spirit and political allusions appropriate to a courtly and Mannerist style. Like his father, Francis I, the future king of France saw himself as equal to the emperor. This ambition of future political prestige resulted in the creation of many equestrian portraits in large and small formats[2] of both Francis I and Henry II as king. Jean and François Clouet's workshop produced royal gifts, miniatures that were refined and portable. These masters still worked in a medieval tradition. For instance, they frequently entrusted original drawings to collaborators carefully trained in the application of color. For particularly important works, the masters themselves executed the significant features and the faces. Only sensitivity and experience allow critics to distinguish the different hands so admirably harmonized in these works. Their judgment, naturally, remains subjective. In the Menil miniature, the architecture, ground, and background may have been done by assistants. The remainder, down to the smallest detail in the figure and horse, so full of vitality, is undeniably the work of François Clouet.

The dauphin's face in particular is a masterpiece of execution in miniature. It is no larger than a fingernail yet drawn with sovereign precision and delicacy. At the same time the features appear veiled with the uncertainty of youth. The look is cautious, the mouth only apparently firm. Cavalli, an Italian, wrote in 1542 that the prince's mood is "just a little melancholic" and that "he shows courage and little intelligence." Courage proved fatal for Henry, who died during a tournament, his eye pierced by a lance. François Clouet subtly highlighted the face—a small, clear patch surrounded by the deep blue background which irresistibly attracts our attention despite the dazzling whiteness of the horse.

While rich in psychological analysis, and a hallmark of French portraiture, this is, in essence, a Mannerist court portrait. Its elegant allure and curvilinear refinements are inseparable from the definition of the model.

It is very likely that this portrait was executed as a pendant to the *Equestrian Portrait of Francis I* (Fig.1), a miniature now in the Louvre and correctly attributed to Jean Clouet; the apparent age of the king places it between 1540 and 1541.[3] Though reversed (the horse moves to the left), the composition is the same; the architecture and the ground are comparable; the dark blue background and the dimensions are identical. The only differences are the still Flemish massive weightiness of the whole and the insistence on detail characteristic of Jean Clouet in contrast to the willowy silhouette painted by François, who was not insensible to the sinuous seductions of the School of Fontainebleau.

Fig. 1 Jean Clouet
Equestrian Portrait of Francis I,
ca. 1540–41
Musée du Louvre, Paris

NOTES

1. Unfortunately I must repeat what A. Blunt and I said in the compilation of essays offered to him in 1967. Jean Clouet was already working for Louis XII (1498–1515). Peter Mellen's monograph, *Jean Clouet*, 1971, created great confusion over the birthdates of Jean and François Clouet. The conscientious author of this book ignores the fact that François Clouet, in order to receive a donation from the king in 1541, had to have reached the legal age of twenty-five. The expression "twenty-five years or more" was commonly used in legal documents since the fifteenth century and in no way signifies that the age of the person concerned was necessarily near twenty-five. An equally qualified person could have been from thirty to forty years old.

2. A good replica from François Clouet's workshop, now at the Metropolitan Museum of Art in New York, is proof that a large equestrian portrait of King Henry II existed. See Charles Sterling, *A Catalogue of French Paintings: XV–XVIII Centuries*, New York, The Metropolitan Museum of Art, 1955, pp. 54–57, reproduced on p. 55. Even though reversed, the entire composition follows the formula of the Menil miniature.

3. Reproduced in the catalogue *La peinture au Musée du Louvre: École française XIVe, XVe, XVIe siècles*, Paris, 1965, pl. 170.

A City in Ruins at Night by François de Nomé

Charles Sterling

The painting by François de Nomé included here is one of the forty works representing still or crumbling ruins revealed in shadows by ghostly rays of light.[1] Similar cataclysmic visions were commonplace in the theatrical shows of the time, where all kinds of structures exploded noisily to the sound of fireworks. De Nomé's constructions are liberally interpreted clusters of antique monuments and Gothic structures. Which Italian city, excluding Milan and its dome, could boast of so many authentic Gothic monuments as Naples? What other city resided in a climate of permanent anxiety at the foot of Mount Vesuvius? Several Neapolitan artists, including Didier Barra, painted a violent eruption of the volcano in 1631, and it is possible that this eruption inspired de Nomé as well, for he depicted collapsing buildings in several works, one of which is dated 1634.[2] Naples had a ready clientele patronizing the painters of catastrophe, and de Nomé was quickly imitated. His lack of interest in scenes of human activity is proof that de Nomé's true subject matter is ruins. For the most part the actions of the small figures in his scenes remain unclear, as is the case in this painting. When the action can be deciphered, the message is banal, drawn from the Old and New Testaments or from the Iliad (the fall of Troy). The figures in de Nomé's paintings were also occasionally added by other artists, a common practice at the time. However, in the Menil painting they appear to be de Nomé's work as the brushstroke is the same throughout and the folds of the garments have the same cast as those of his sculpted figurines.

Living in terror, our century responded immediately to de Nomé's art and all too readily called him a precursor of Surrealism—a facile analogy at best. De Nomé can be fundamentally distinguished from Surrealism by the absence of deliberate provocation. Instead, he is anchored in the art of the theater of his time. He simply pushed a social need for drama and the delight in the fantasies of Mannerism to an extreme point. Later, Alessandro Magnasco exploited the same vein.

To find François de Nomé's kindred spirits, one could turn to Victor Hugo, whose powerful wash-drawings are as good as those done by professionals. De Nomé, Magnasco, and Hugo present a chiaroscuro charged with an expressive thrust approaching brutality. It is difficult to find other examples of such recurrent chiaroscuro outside that of Chinese brushwork.

The effects of overemphasis carry an imminent danger. "That which is exaggerated is insignificant," said Talleyrand, embracing a profoundly French way of thinking. A gathering of more than ten works by each of these artists produces an irresistible impression of procedure and routine—the poetic emotion that inspired them being no longer credible.

NOTES

1. F. Sluys, *Didier Barra et François de Nomé, dits Monsù Desiderio*, Paris, Editions du Minotaure, 1961.

2. R. Causa, *La Paragone* 75, 1956, pp. 30–46.

69. FRANÇOIS DE NOMÉ
(ca. 1593–after 1644)
A City in Ruins at Night, 1625–1650
Oil on canvas
40¾ × 60¾ in.

Four Vases of Flowers in a Niche by Tomas Hiepes

Charles Sterling

Barely studied and only recently appreciated, this Spanish painter specialized in still-life painting including *bodegones* and flower-filled vases. His activity in Valencia is known from 1642 until his death in 1674. While the large Menil painting is not signed,[1] it can be convincingly compared to several paintings of vases of flowers signed by Tomas Hiepes, whose dates, when they accompany his signatures, are 1663 and 1664.

Two of these paintings, pendants from 1663,[2] are strikingly different in style. One has a markedly old-fashioned spirit, the flowers and leaves spread on the painted surface, almost as if separately adhered. Meticulously executed, they are arranged with decorative regularity linking them in a sort of naive ostentation to the "naives" of the twentieth century; one is particularly reminded of the sheafs by Séraphine.[3] Concern with the ornamental harmony of the entire painting extends to the exchange between the floral designs of the pottery and the tablecloth on which the vase is placed. The other painting, in contrast, contains larger flowers grouped together more closely and less systematically. These more sensually presented and highlighted blossoms seem to underscore the stern atmosphere of the bare table and neutral background. Unlike the other work of 1663 it is a painting of restrained Baroque naturalism. The artist, in carefully signing the more archaizing work, obviously wished to show himself capable of versatility.

Such a demonstration stands as a warning to the historian not to expect Hiepes's logical evolution, nor to arrange chronologically the numerous undated works. Furthermore, we must remember that there exists no dated evidence of this artist's work for twenty years after 1643.

With this caution in mind we may tentatively date the Menil painting a little before 1660. The vases depicted may well have been made in the workshop of Talavera de la Reina and they were distributed all over Spain. They are straightforward in design and resemble the vases represented in the pendants of 1663. The following year, Hiepes displays a preference for complex and extravagant vases, decorated with pale green ceramic, sometimes even bronze figurines[4] carved in high relief. These designs must have been purely imaginary, for we have no specific or concrete examples of such vases. They attest to Hiepes's recurrent archaism, his fidelity to the arbitrary fantasy of Mannerism. In this painting the four vases are of the simple type, their floral decoration enlivened by birds. However, the artist's sense of symmetry prompted him to place two smaller vases at the fringes of the composition in an intimate relationship to the recessed arch. Hiepes's desire to create balance is less pronounced in the floral arrangement. If order holds sway in the center of the composition with the carnations and the rushes, which bind with their stems at the same level, a play of contrasts is tolerated between the white tuberoses on the left and the red nasturtiums on the right. In a general manner, the symmetry is subtly varied and the abundant vegetal vitality is not smothered. The *horror vacui*, a constant in Hiepes's work, is present in this composition as well, yet it is controlled. The flowering rushes appear also in the flower still life signed and dated 1664 in Alfonso Fierro's collection.[5] The butterflies in the Menil painting have not landed

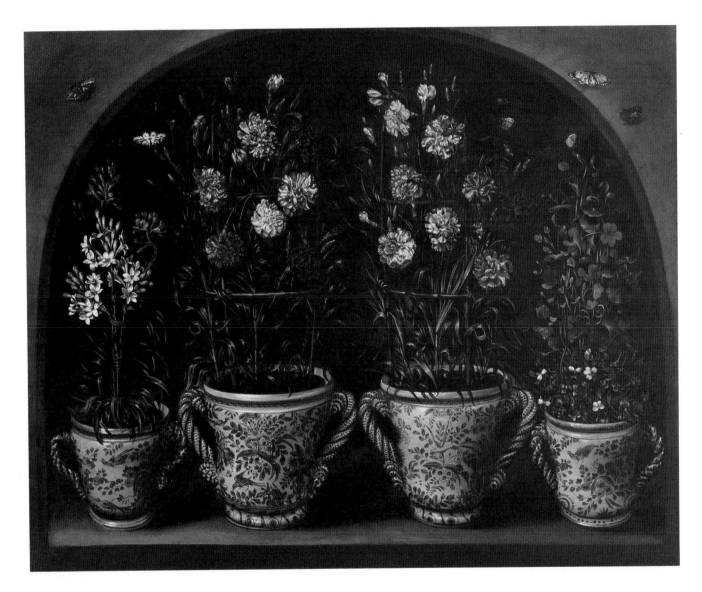

70. TOMAS HIEPES (1620–1674)
Four Vases of Flowers in a Niche,
ca. 1660
Oil on canvas
47 × 58 in.

solely on the wall but also on the flowers, and this motif can also be found in the paintings in the Asbjorn Lunde Collection.[6] These two motifs corroborate the attribution of the Menil painting to Tomas Hiepes.

Butterflies on the wall of the nook sheltering a vase of flowers is an old and traditional Dutch and Flemish motif. We have only to recall the works of Jacob de Gheyn or Roelant Savery. Since it has not yet been done, it seems important to consider the Flemish influence on Hiepes's still obscure pictorial culture. His interest in Flemish art can be seen in a painting representing a collection of rare and precious objects, above which hangs a work by Rubens, *The Head of Cyrus Brought to Queen Tomyris* (now in the Museum of Fine Arts, Boston). Rubens's composition is reversed, however, indicating Hiepes's use of an engraving[7] as his source.

In the Menil painting, the niche with butterflies is set in a garden and is derived from the tradition observed in the works of Sánchez Cotán and other Spanish painters in which niches serve as cool larders within Spanish homes (and not as shop fronts as has often been claimed). While in seventeenth-century Italy we often find still lifes set in the open, Hiepes's presentation is exceptional in Spanish paintings. Here again, as in other aspects of his art, the painter shows his independence. The true and simple secret of this inventive freedom—as Eric Young so intelligently suggested[8]—is the relative isolation of the artist working in a provincial center far from Spanish sources producing floral paintings. Thus, he was able to give "full rein to his fancy in a composition both archaic and personal at the same time."

Despite the naturalism—relative, of course, since stylization is never absent—the Menil painting's flowered niche maintains its very special poetic flavor. The repetitiveness and the staccato rhythm of the bright colors create an essentially Spanish magical atmosphere.

NOTES

1. This painting was published for the first time and fully discussed in Charles Sterling, *Still Life Painting from Antiquity to the Twentieth Century*, 2nd rev. ed., New York, Harper and Row, 1981, pl. 66 bis.

2. They are part of a private collection in Bordeaux (formerly Galerie Heim, Paris and London). It is beyond doubt that they are pendants, as the compositions and dimensions are identical.

3. See for example p. 107 in Sterling, *op. cit.*

4. For reproductions see the painting with a vase in the Ahmanson Collection, Los Angeles, fig. 27 in Eric Young, "New Perspectives in

Spanish Still Life Painting of the Golden Age," *Burlington Magazine* (April, 1976), p. 213. This painting is dated 1664. Two almost identical vases figure in the painting reproduced in the important catalogue *Stilleben in Europa*, Münster-Baden-Baden, 1979–80, p. 94, fig. 53. Still another, with figures in relief and certainly by Hiepes, is reproduced in the same catalogue, fig. 210 and p. 561. Neither work is dated.

5. Fig. 21 in Young's article cited in note 4.

6. Fig. 210 in the catalogue cited in note 4.

7. Fig. 53 in the catalogue cited in note 4.

8. Young's article cited in note 4.

Landscape with Giant Tree
by Marco Ricci

Charles Sterling

Born in Bellano in 1676, Marco Ricci first trained in Venice drawing landscapes in the tradition of Titian. According to early biographers he benefitted from the art of his uncle, Sebastiano Ricci. While his interests were varied, the initial influence of Salvator Rosa and Alessandro Magnasco proved decisive. A visit to Florence ca. 1705 gave him the opportunity to study the former master—the founder of the genre of romantic landscapes—and allowed him to work with the latter on a painting in which Marco's task was the rendering of "water and rocks." In 1706–7 he collaborated with his uncle, Sebastiano, on a fresco in the Palazzo Marucelli in Florence.

During these years Lord Edward Irvin purchased twenty seascapes, landscapes, and battle scenes from him for Temple Newsam House in Leeds; in general, English collectors had a strong taste for Marco's works. In 1708 Lord Manchester invited Marco to accompany him to England via Holland. Marco returned to London, perhaps in 1710 but certainly in 1712 with Sebastiano, once again travelling through the Low Countries. Memories of Marco's visits to Holland are evident in several drawings preserved at Windsor. These names and years are important in dating the Menil painting.

The essential element of the landscape is unquestionably the old giant tree in the center. With its enormous broken branches dramatically outstretched, it dominates and commands the entire composition. It is the hero of an exuberant vegetal feast. This in turn hardly reveals the passionately painted blue mountains lying under a sky invaded by gray and white clouds in the background at the left. In contrast to this extravagant blue and its cool tonalities, the foliage and the rocky ground appear yellowish.

Salvator Rosa also painted a landscape in which broken tree trunks stripped of their bark, and a mass of greenery topping the central group of trees, constitute the painting's true theme.[1] There can be no doubt that the fundamental idea of untamed nature dominating man came from the great romantic Neapolitan painter. Rosa gave such detail to his vegetation that it is almost possible to count the leaves, yet his composition was never deliberately confused. Rosa's art, however, does not entirely explain the vitality and broad jagged treatment found in the Menil painting. We must turn to Magnasco to find the key.

The Menil painting undoubtedly dates from Marco Ricci's youth for there is nothing like it in his known work. It is an enthusiastic experiment. Later—having multiplied his themes and technical resources—he painted solemn ruins, animated *capriccios*, and deliciously rustic views in oil and tempera, and he made etchings as well. In time his art became less lively, evolving toward a clearer sense of scale well in tune with that of eighteenth-century Venice.

The figures in the Menil painting are noticeable in the mass of greenery due to the lively red accents of their clothing. They so resemble figures by Sebastiano Ricci as to suggest collaboration. However, the landscape is directly inspired by works of Magnasco dated between 1710 and 1715, as a comparison with landscapes by the Genoese master in the Italico Brass Collection in Venice[2] and the Warsaw

Museum[3] makes clear. Not only are these works dominated by giant trees bending as if in a hurricane, but the human scene is analogous as well. In the Menil painting a peasant, who has climbed a tree, is cutting branches while to the right another moves away leading a horse burdened down with logs. Woodcutters are shown at work in one of these works by Magnasco, and in another a horse draws a cart loaded with a cask and logs. Above all, Marco Ricci borrowed Magnasco's vision of nature's dramatic vitality expressed through a sense of visionary movement and dramatic illumination—all this is directly visible here.

Sensitized by Magnasco, Marco Ricci may have been impressed in Holland by landscapes, which, without attempting a visionary ambiance, revealed in nature aspects of a savage splendor that approach the fantastic. The Northern painters of forests rarely failed to exalt the ancient trees venerated by their pagan ancestors. Gillis van Coninxloo, Roelant Savery, Alexander Keirinckx, and Jacob van Geel heralded the great Jacob van Ruisdael.[4] This master created several astonishing engravings, which would have been readily accessible to a painter travelling through Holland.[5] The power and the movement of the trunks and leaves of these enormous trees—the principal theme of the compositions—do not pale before Magnasco's passionate visions. Marco Ricci recognized in Ruisdael—the great contemporary of Salvator Rosa—his own view of nature's limitless vitality and a heady obsession with baroque lyricism.

The preceding observations thus suggest a date around 1715 for the great *Landscape with Giant Tree* in The Menil Collection.

NOTES

1. London, National Gallery. Reproduced in color in L. Salerno, *Salvator Rosa*, 1963, pl. XXIII.

2. Reproduced in *Marco Ricci*, exhibition catalogue by G. M. Pilo, Venice, 1963, no. 5.

3. Reproduced in J. Bialostocki and M. Walicki, *Malarswo Europejskie W Zbiorach Polskich, 1300–1800 (European Paintings in Polish Collections, 1300–1800)*, Cracow, 1955, pl. 372.

4. See reproductions in W. Stechow, *Dutch Landscape Painting of the Seventeenth Century*, 1966, figs. 122, 136, 127, 130.

5. See reproductions in *Les Grands Illustrateurs, trois siècles de vie sociale 1500–1800*, Munich, 1888–91, vol. V, no. 2472, *The Big Tree With Two Peasants and Their Dog* (Bartsch, I, p. 312, no. 2) and no. 2473, *The Tree Near the Cottage* (Bartsch, I, p. 313, no. 3).

71. MARCO RICCI (1676–1729)
Landscape with Giant Tree, ca. 1715
Oil on canvas
36⅛ × 51¼ in.

IMAGE OF THE BLACK IN WESTERN ART

In The Menil Collection representations of blacks are frequent. They range from a substantial number of Greek and Roman works to contemporary art. This engagement reflects a commitment going back to my first encounter with America. I landed in New York in June, 1941, and reached Houston, Texas, soon after. In those days segregation in the South was as firmly established as a law of nature. The experience was a shock. Travelling to Houston from New York by train, I found myself in a car packed with soldiers. I moved to a less crowded one, empty but for three or four blacks. A conductor soon told me I could not stay there. I had crossed the color bar.

Indignation grew with time: dignity of man was at stake—the dignity of the African so eminently revealed in the late fifteenth- and sixteenth-century paintings of the Adoration of the Magi. Of the three kings the black one, the youngest, is the most beautiful, the most regal. Then why rejection? How sad. A sadness W. E. B. Dubois expressed when he said that every black child in America, sooner or later, makes the painful discovery that he is born "behind the veil."

To address this fundamental injustice, the Menil Foundation established a research project focused upon the ways blacks have been portrayed in Western art. A vast archive of photographs, from holdings throughout the world, documents these portrayals as found, for example, in Egyptian reliefs, Greek vases, Byzantine and Arabic illuminations, Renaissance painting, as well as popular representations and racist ephemera. These images often retain insights and information that written documents do not communicate. In the iconography, visual traces of customs can be found that were so taken for granted that they were never addressed in writing. Historical texts are also researched and juxtaposed with images, often shedding light on works of art whose meaning, once immediately apparent, now eludes us.

The project, now twenty-five years old, has been directed from Paris by Ladislas Bugner; a Houston office is headed by Karen Dalton. To date, three volumes have been published under the title *The Image of the Black in Western Art*: Vol. I, *From the Pharaohs to the Fall of the Roman Empire*; Vol. II, in two separate parts, *From the Early Christian Era to the "Age of Discovery"*; a fourth volume devoted to the nineteenth century will appear in 1988.

Among the Collection's important acquisitions of works depicting blacks, other than the four included in this section, are Nos. 27, 53, and 232. For a black, to see the image of another black living, say, in the fifth century B.C. or the sixteenth century, is often a revelation. He had been made to believe that blacks had little part in Western history, had left no marks in the memory of whites. The acknowledgment of concrete traces of a past existence, however tragic or noble, is a long overdue restitution.

Dominique de Menil

72. *Ointment Jar (Balsamarium)*
Hellenistic, late 3rd–early 2nd
century B.C.
Bronze
2⅞ × 2 × 2⅜ in.

An Oinochoe Handle

Jean Leclant

In The Menil Collection there is a large vertical handle of greenish bronze with faint reddish oxidation traces and silver niellowork,[1] partially preserved. At the rim of the vase, the head of *Africa*, which constitutes the attachment of the handle, is flanked on either side by a long vegetal motif; the handle was fixed on the body of the vase (the oinochoe) by a mascaron constituted by a head of a young Negro.

The whole handle should be regarded as a kind of full-blown floral element[2] which opens out downward, with the very conventionalized corolla lying upside down on top of the Negro's head. On each side, the handle is bordered by a fillet formed by an alignment of very small, partially worn, ovolos.

On the upper part, the attachment of the handle spreads out on either side of a very expressive face of *Africa*. This female face, with plump cheeks, a strong chin, a thin nose, and a small mouth, has two very round eyes; the silver incrustations of the irises accentuate the penetrating gaze, which is even a bit disturbing; the fixity of the gaze reminds one of a Gorgon. The hair falls down from the top of the forehead on either side of the face in two smooth intertwining locks. The locks are prolongated by a vegetal motif, consisting of a poppy and what looks like a wheatear.

The elephant exuviae characterize this female head as being an allegory of *Africa*: the two wide round discs are the external part of the animal's ears, while the trunk, on which some remains of the silver plating can be seen, rises on top of *Africa*'s forehead. The two tusks, where remains of silver coating are also visible, point upward; they could also evoke the extremities of a moon crescent, which would have been appropriate for a representation of Isis-Selene.

On top of the trunk of the elephant, a complex vegetal motif develops, the upper elements of which reach the vertical part of the handle. At the base, immediately above the trunk's extremity, appear three lightly carved stems. In the central part, these stems change into a kind of pistil topped by a bee. The bee, with its wings spread out, is seen in profile and is as lightly carved as the pistil. The pistil has on either side two flowers with long hollow stems, originally inlaid with silver niello that partly subsists.

The top of the handle's vertical part ends with this floral motif and bee. Then comes a Heraclean knot, its bands constituting a kind of lyre with its extremities bent in volutes. Short oblique strokes of silver niello remain in the center of the "lyre" and on either side of it.

The lower free ends of the Heraclean knot enclose a slightly protuberant, rockwork-like element. This could symbolize a cavern, from which pops out what looks like a lizard, if not a saurian.[3] On either side, on the very edge of the handle, there seem to be traces of a vegetal element with remains of silver inlays.

This double vegetal motif frames the upper part of a huge scorpion, which faces the lizard and flashes its glance at it. Both eyes are very well marked by two small silver balls. The scorpion has four pairs of silver-inlaid legs; its two claws close in front, while its ringed tail is tucked in at the back.

Opposite:
73. *Oinochoe Handle*
Roman, 1st century A.D.
Bronze with silver inlay
8 × 4⅞ × 2½ in.

100

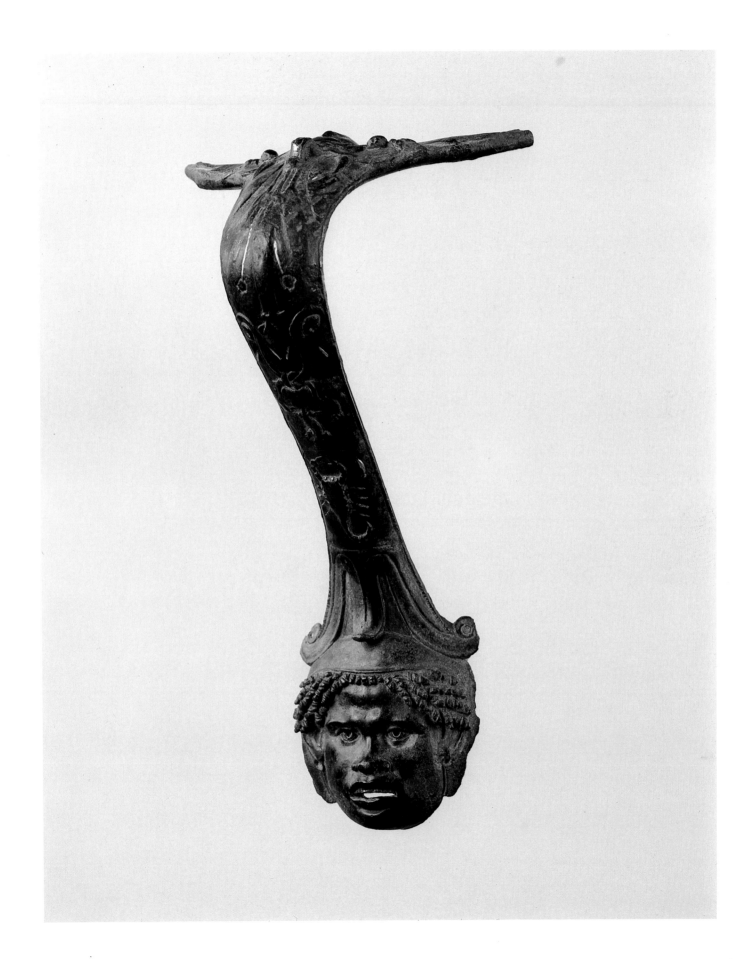

Under the scorpion, the corolla spreads out, emphasizing gracefully the whole movement of the vertical part of the handle. The very conventionalized corolla consists of two volutes framing a central part, which is bent in a distinct relief on top of the cap-covered Negro head.[4]

The relief of the Negro head appears very prominently. The face is broad, with well-marked cheekbones, a flat nose, and a thick-lipped mouth. The lips open up on a wide slot enhanced by a silver line suggesting the teeth of the upper jaw. Under the forehead, marked by a wrinkle, the browridges are very prominent. The iris of both eyes is underlined by silver inlays, which give the face an attractive expression of both strength and life.

Only the inferior parts of the wide ears appear, half covered by the curly hair. The lower parts of the lobes show small cavities that may have been previously inlaid with silver, indicating earrings or their attachments. The crisp hair is set in small twisted locks, leaving the forehead free. The locks pop out of a kind of flattened cap with a lightly rolled rim.

Undeniably, the Negro head is the major element of this handle's sumptuous decor. During the Hellenistic and Roman periods, the attachment of vertical handles on the body of vessels such as hydriai, amphorae, and particularly oinochoes, is often constituted by a bust or a large mask,[5] a kind of apotropaism as is shown by the frequent Gorgon heads whose hypnotic glance is sometimes emphasized by silver inlays.[6] The mask can also originate from the dionysiac repertory,[7] the classical pantheon,[8] or from the oriental divinities.[9]

The theme of the Negro is nevertheless seldom seen on this type of object. Still, let us mention a head in relief of a young Negro decorating the attachment of an isolated bronze handle, now preserved in Munich,[10] and another attachment of a bronze handle at the National Museum in Naples, which represents a bearded mask with corkscrew curls in the Nubian fashion and which could depict a black slave.[11]

The superb Negro head of the Menil handle is very decorative, yet its apotropaic character, already mentioned above and proved by other elements of the decor, must be noticed: the representation of Blacks in antiquity was supposed to bring luck, to banish evil or baleful influences, and to bring fertility and a good harvest.[12] This is the case, for instance, of scaraboids with Negro heads, which appear in Egypt during the twenty-fifth dynasty and which seem to have become a specialty of the workshops in Naucratis,[13] from where they were exported or even copied in several areas of the Mediterranean.[14] According to Pausanias (I, 33, 3), the statue of Nemesis at Rhamnus, Attica, held in its hands a phial decorated with Negro heads. On a gold vessel from the treasure of Panajurište (Bulgaria), considered to be a fourth century B.C. product from Attica,[15] three rows of Negro heads alternating with conventionalized lotus flowers and a row of acorns encompass the omphalos of the phial. A comparison should be made with a terra-cotta phial found in a votive deposit of a temple at Locri[16]: one row of bees, one row of acorns, and one row of Negro heads decorate the vessel around the central omphalos. It is supposed to be an Ionian product dating from the first half of the fifth century B.C. On this last object, the presence of a row of bees[17] was mentioned; this insect is precisely the one appearing on the Menil handle, where it is also associated with a vegetal element. In antiquity, the bee seems to have been sometimes connected with the evil eye.[18] While it was a symbol of royalty in ancient Egypt,[19] it was particularly a symbol of fecundity and of life in Classical antiquity.[20]

On the Menil handle, the bands figured near the bee are linked by a Heraclean knot. This decorative ornament was very much in use in Classical jewelry,[21] but it

also had a religious value, symbolizing divine unions,[22] fertility, and resurrection.[23]

Out of the rocky shelter under the Heraclean knot, facing the scorpion, appears a crawling animal. Its identification is uncertain: saurian or lizard. Horapollon[24] mentions the hostility prevailing between the crocodile and the scorpion; as for the lizard and the scorpion, their enmity is a topic for Classical writers, as well as later on for Arab authors.[25] In itself, the lizard[26] has an apotropaic value. It is found on intaglios,[27] in I. Sabazios's *The Hands*, and in similar documents.[28] It is also found on numerous amulets as it was known to have healing virtues for eye diseases; furthermore, it played a part in oracles and magic.[29] The presence of the lizard on funerary cippi as a symbol of resurrection[30] may be explained by the fact that this animal used to sleep through winter and to wake up in spring.[31] On vase handles, where it does not appear very frequently, the lizard is sometimes associated with Bacchic themes.[32]

Facing the lizard, the huge scorpion with its threatening eyes inlaid with silver is a dangerous venomous animal; it was nevertheless known for its efficacy against the evil eye, which explains its presence on several intaglios.[33] On a mosaic from Antioch, an eye is being attacked by a pygmy, a trident, a sword, a crow, a dog, a panther, a snake, a scolopendrid, and a scorpion.[34] The same theme is represented on two small gold medallions of the Late Imperial period, now preserved at the Benaki Museum in Athens; the evil eye is here attacked by a scorpion, several other animals, and a thunderbolt.[35] At Carthage, small bronze scorpions have been found in terra-cotta vases that were buried in the foundations of houses which they were supposed to protect from the invasion of these dangerous animals.[36]

Since the scorpion is a typical African creature,[37] it is often associated with *Africa*,[38] the allegoric representation of this Roman province.[39]

The elephant hide appears at the end of the fourth century B.C. on the reverse of coins of Ptolemy I, where it covers the effigy of Alexander the Great or of the first Ptolemaic sovereign. The oldest association known of exuviae with the representation of *Africa* is to be found on a gold stater of Agathocles of Syracuse (310–304 B.C.), son-in-law of Ptolemy I.[40] But the iconographical type of *Africa* was only constituted at the beginning of the first century B.C.[41] and its cult as *dea patria* developed in particular during the second century A.D. *Africa* represented the province that, as well as Egypt, supplied Rome and Italy with corn.[42] The wheatears that adorn the allegoric head of the Menil handle refer clearly to the agricultural wealth of Roman Africa.[43] It should be pointed out that on certain representations, *Africa* has clearly Negroid features or a dark complexion,[44] reminding one of the inhabitants of the African continent. This brings us back to the Negro head decorating the other extremity of the Menil handle. The theme of *Africa* is not frequent on bronze vessels, yet some appliqués and attachments should be kept in mind.[45] Also, the handle of a bronze patera found at Calmasino near Verona[46] is decorated with a head of *Africa*, and on a silver pan recovered at Bourgoin (Isère) the two elephant heads decorating the attachment of the handle may be an allusion to *Africa*.[47]

To complete these remarks, which emphasize the apotropaic character of the somewhat incongruous representations, let us take a look again at the vegetal motifs that surround the allegoric head of *Africa* (Fig. 1). The wheatears obviously refer to the agricultural wealth of Roman Africa. Associated with the poppy,[48] they are the usual attributes of Isis and Serapis[49]; thus a bas-relief fragment shows an Isiac sistrum, a poppy, and two wheatears side by side.[50] Like the Heraclean knot,[51] the wheatears and the poppy mean fertility and resurrection, and they can be seen in the hands of several deceased in Greco-Roman Egypt.[52]

The comparisons that we have mentioned above are not exhaustive, and so it is difficult to situate with accuracy the Menil handle among the products of the so-called "Alexandrine" toreutics, of which little is known.[53] The exceptional quality of the object must be emphasized. A few hints point toward the Roman period rather than the Ptolemaic: it looks as if it could belong to the floruit of the first century A.D.

Fig. 1 Head of *Africa*
Upper attachment of Oinochoe handle

NOTES

1. Silver inlays are not infrequent on bronze handles, where they are a sign of quality. See Th. Schreiber, *Die alexandrinische Toreutik: Untersuchungen über die griechische Gold-schmiedekunst im Ptolemaeerreiche*, I. Theil, *Abhandlungen der Philol.-hist. Klasse der Königlich Sächsischen Gesellschaft der Wissenschaften*, XIV, no. 5 (Leipzig, 1894); no. 70–71, p. 345; no. 74–75, 77, p. 346; no. 81, pp. 347–48, no. 88, p. 350; no. 110–112, pp. 358–59.

2. An identical vegetal motif appears on the female mask of a bronze handle from Pompeii, (National Museum of Naples Inv. no. 69487); cf. Schreiber, *op. cit.*, no. 83.

3. The two right feet of the animal have three distinct toes.

4. For this vegetal element forming a kind of "hat," see terra cottas from al Fayum or Alexandria. See L. Keimer in *Egypt Travel Magazine*, no. 25 (August, 1956), pp. 27–28, figs. 20–21.

5. See Schreiber, *op. cit.*, pp. 375–76 and 456 ff.; F. Drexel, "Alexandrinische Silbergefässe der Kaiserzeit" in *Bonner Jahrbücher*, (1909), 118, 178, pp. 208–16; J. Charbonneaux, "*Les bronzes grecs*" in *L'oeil du connaisseur* (Paris, 1958), p. 47.

6. Schreiber, *op. cit.*, no. 69–75, pp. 344–46.

7. For Bacchus, see *ibid.*, no. 78, p. 347, fig. 81; for Pan, *ibid.*, no. 111, p. 359, fig. 114 and no. 128, p. 366, figs. 104–5; for a Satyr, *ibid.*, no. 150, p. 372.

8. For instance, a mask of Triton, see *ibid.*, nos. 76–77, p. 346; a herm of Heracles, *ibid.*, no. 129, p. 366; a mask of Apollo, *ibid.*, no. 145, pp. 370–71; a mask of Artemis, *ibid.*, no. 148, p. 371.

9. For instance, a mask of Jupiter-Ammon, see *ibid.*, no. 130, pp. 366–67; nos. 146–47, p. 371; J. Leclant and G. Clerc in *Lexicon iconographicum mythologiae classicae*, I, 1 (1981), s.v. *Ammon*, nos. 91–92, 95, p. 678; a juvenile head with a Phrygian cap, cf. Schreiber, *op. cit.*, no. 118, pp. 362–63, figs. 99–100; a head of "Rhea-Cybele," *ibid.*, no. 123, pp. 364–65 and 448.

10. Klaus Vierneisel, "Berichte der Staatlichen Kunstsammlungen Neuerwerbungen," in *Münchner Jahrbuch der bildenden Kunst*, XVII, 1966, p. 226, fig. 3: the handle (Inv. no. 4328) is decorated on its whole height with plain pearls. See also Michael Maass, *Griechische und römische Bronzewerke der Antikensammlungen*, Munich, 1979, p. 55, no. 31.

11. Inv. no. 72633, National Museum, Naples. Two documents at the National Museum in Naples (no. 69471 and no. 72633) were quoted with nubian features by Schreiber, *op. cit.*, no. 123

and no. 149, but these are in fact not really characteristic. We are grateful to Dr. Fulvio De Salvia for interesting indications.

12. See for instance A. J. B. Wace in *BSA* X (1903–4), pp. 107 ff.

13. See W. M. Flinders Petrie, et al., *Naukratis* I (1884–85, ed. 1886), pl. XXXVII, no. 4, 9, 11, 26, 83, 133, 141, 142; pl. XXXVII, no. 8–10; E. A. Gardner, *Naukratis* II (ed. 1888), pl. XVIII, no. 55, 59–61; G. H. Beardsley, *The Negro in Greek and Roman Civilization*, 2nd ed. (New York, 1967), pp. 17–19; F. M. Snowden, Jr. in *The Image of the Black in Western Art*, Vol. I (Cambridge, 1976), p. 140, fig. 148.

14. Similar scaraboids have been found at Tyre (see Beardsley, *op. cit.*, no. 23, p. 18); at Amrit (see R. Giveon, *Egyptian Scarabs from Western Asia from the Collections of the British Museum*, [Freiburg, 1985], no. 58, p. 154, with figures); in Cyprus (Beardsley, *op. cit.*, no. 24–27, pp. 18–19, and two specimens, still unpublished, from Amathus, Inv. no. LM 750/60 and LM 756/76); at Carthage (J. Vercoutter, *Les objets égyptiens et égyptisants du mobilier funéraire carthaginois* [Paris, 1945], pp. 195–99, pl. XIII and no. 908, p. 279, pl. XXIV); at Ibiza (A Vives y Escudero, *Estudio de Arqueología Cartaginesa: La Necrópoli de Ibiza* [Madrid, 1917], no. 657, p. 107), at Aegina (Beardsley, *op. cit.*, no. 18, p. 17).

15. D. Končev and of P. Gorbanov, "Der Goldschatz von Panagjurište" in B. Svoboda and D. Končev, *Neue Denkmäler antiker Toreutik* (Prague, 1956), pp. 143–46, pls. X–XI.

16. G. Jacopi, *Locrika, Presenza*, I, 4–5; IV–VI (1947), 3 ff., figs. 1–2; Končev, *op. cit.*, p.144, pl. IX, bottom.

17. A gold libation phial (third century B.C.) (Metropolitan Museum Inv. no. 62. 11.1), shows around the omphalos a concentric decor of beechnuts, acorns, conventionalized lotus flowers, and bees (cf. D. von Bothmer, "A Gold Libation Bowl" in *Metropolitan Museum of Art Bulletin*, XXI, no. 4 [1962], pp. 155 ff., figs. 2–4); the weight of the object is given in an Attic measure, thus indicating its provenance. On a gold phial from Kul Oba, South Russia (late fifth, early fourth century B.C.), bees and Gorgon heads are represented with other decorative elements (von Bothmer, *op. cit.*, pp. 162–63, figs. 18–19).

18. See O. Jahn, "Über den Aberglauben des bösen Blicks bei den Alten" in *Berichte über die Verhandlungen der königlich-sächsischen Gesellschaft der Wissenschaft zu Leipzig*, (1855),

pp. 99–100. See also M. Leibovici, "L'abeille et le miel dans l'histoire des réligions" in *Traité de biologie de l'abeille*, (Paris, 1968), p. 36.

19. J. Leclant, "L'abeille et le miel dans l'Égypte pharaonique" in *Traité de biologie*...pp. 56–57.

20. R. Lullies, "BATPAXOI" in *THEORIA: Festschrift für W. H. Schuchhardt*, edited by F. Eckstein (Baden-Baden, 1960; *Deutsche Beiträge zur Altertumswissenschaft*, 12/13), p. 145.

21. Berta Segall, *Katalog der Goldschmiede-Arbeiten, Museum Benaki, Athen* (Athens, 1938), nos. 28–30, 46, 76, 180 and 193.

22. See Segall, *op. cit.*, no. 180, pp. 118–25; pl. 39.

23. See Segall, *op. cit.*, p. 125.

24. Horapollon, II, 35, with a comment by L. Keimer, "Interprétation de quelques passages d'Horapollon," CASAE 5 (1947), pp. 47–49 and figs. 41–42.

25. Keimer, *op. cit.*, p. 49, mentions *Géop.*, XIII, 9, p. 7; Plinius, *Natural History*, XXIX, p. 28; and P. Kraus, *Jabīr ibn Hayyān*, II, p. 66.

26. The lizard can sometimes be mistaken for a salamander.

27. Campbell Bonner, *Studies in Magical Amulets*, Ann Arbor, 1950, pp. 69–71; A . Delatte et Ph. Derchain, *Les intailles magiques gréco-égyptiennes*, Paris, Bibliothèque Nationale, 1964, pp. 259–60.

28. See M. J. Vermaseren, E. Westra and M. B. De Boer, *Corpus cultus Iovis Sabazii*, I. *The Hands*, coll. *EPRO* (Leiden, 1983), index p. 42 s.v. *Lizard*.

29. Jahn, *op. cit.*, p. 99.

30. See *CIL*, VI, no. 12059.

31. See J. M. C. Toynbee, *Animals in Roman Life and Art*, London, 1973, pp. 220–21.

32. See E. Babelon and J. A. Blanchet, *Catalogue des bronzes antiques de la Bibliothèque Nationale*, Paris, 1895, no. 1380, p. 567: H. B. Walters, *Catalogue of the Bronzes, Greek, Roman and Etruscan, in the British Museum*, London, 1899, no. 2495, p. 324.

33. Bonner, *op. cit.*, pp. 77–78; Delatte and Derchain, *op. cit.*, pp. 271–73.

34. G. Spano, "Paesaggio nilotico con pigmei defendentisi magicamente dai croccodilli" in *Atti della Accademia Nazionale dei Lincei: Memorie*, VI, serie VIII (1955), p. 348, fig. 5.

35. Segal, *op. cit.*, no. 213, pp. 137–38, pl. 42.

36. Babelon and Blanchet, *op. cit.*, no. 1231, p. 491, with figure.

37. In Lucanus (*Pharsala*, IX, 833), it appears on a list of venomous animals from Africa.

38. About Africa and her iconography, see L.

Rocchetti in *Enciclopedia dell'Arte Antica, Classica e Orientale*, I (Rome, 1958), pp. 107–9, J. M. C. Toynbee, *The Hadrianic School: a Chapter in the History of Greek Art*, Rome, 1967, pp. 33–38; M. Leglay, in *LIMC*, I, 1 (1981), s.v. Africa, pp. 250–55, pls. 184–90.

39. The scorpion is associated with Africa on Hadrianic coins (see P. Gardner, "Countries and Cities in Ancient Art" in *The Journal of Hellenic Studies*, IX [1888], p. 72; Toynbee, *op. cit.*, pp. 23–24, pl. I, and 1–4, pl. 11) and on coins of Septimius Severus (*op. cit.*, p. 16, pl. X).

40. Toynbee, *op. cit.*, p. 35.

41. See coins of Iarbas, king of the West Getulains (108–81 B.C.); Leglay, *op. cit.*, p. 255.

42. On the theme of abundance and fertility, see below, notes 48–52.

43. See Leglay, *op. cit.*, nos. 1, 3, pp. 31–35, 50, 52. The cornucopia, one of her most usual attributes, also symbolizes the fertility of *Africa*.

44. Leglay, *op. cit.*, nos. 49, 50, 51 and 54.

45. Babelon and Blanchet, *op. cit.*, no. 618, p. 262, and C. C. Edgar, *Greek Bronzes*, General Catalogue of the Cairo Museum (1904), no. 27843, pl. XVII; no. 27844 and no. 32372.

46. G. Fogolari, "Paterera di bronzo rinvenuta a Calmasino" in *Studi Storici Veronesi* (1950), p. 239.

47. See Schreiber, *op. cit.*, no. 34, pp. 327–28 and 448, fig. 131.

48. Fr. Muthmann, *Der Granatapfel, Symbol des Lebens in der alten Welt*, Bern, 1982; M. Dewachter, "Isis et Chelles sur Cher" in *Carobrias*, 3 (1980), p. 8, note 30 bis.

49. F. Dunand in *Bulletin de l'Institut Français d'Archéologie Orientale*, 67 (1969), pp. 34, 35, and 37.

50. M. Dewachter, *op. cit.*, pp. 4–5, fig. 1.

51. See note 25.

52. Dewachter, *op. cit.*, p. 5 and notes pp. 32–34, and in particular C. C. Edgar, "Graeco-Egyptian Coffins, Masks and Portraits," *CGC* (1905), no. 32.127, pl. VII; no. 33.216, pl. XXXI; *The Brooklyn Museum Annual*, X (1968–69), frontispiece (Inv. no. 69.35); C. Grimm, *Mumienmasken aus Ägypten* (1974), pls. 14,3 and 15,1.

53. Besides Classical works, often out of date like Schreiber's study, one should refer in particular to H. V. Nuber, *Kanne und Griffschale*, Berlin, 1973; Cl. Rolley, *Les Bronzes grecs*, 1983; Anne Pariente, "Une oenochoé plastique en bronze de provenance égyptienne" in *Bulletin de correspondance hellénique*, 108 (1984), pp. 301–16, 5 figs.; and to the series of acta published by the *Colloque international sur les bronzes antiques*, IV (Lyons, 1976), V (Lausanne, 1978).

Saint Philip Baptizing the Ethiopian Eunuch by Aelbert Cuyp

Seymour Slive

Cuyp's imposing painting shows the climax of the account told in Acts of the Apostles of the meeting of Philip the Deacon and the Ethiopian eunuch who served and had charge of all the treasures of Candace, queen of the Ethiopians. According to Acts (8:26–40), an angel told Philip to go south on the desert road which led from Jerusalem to Gaza. On it he encountered the Ethiopian eunuch in his chariot, who was returning from a pilgrimage to Jerusalem. The eunuch was reading the Book of Isaiah. Philip asked him: "Understandest thou what thou readest?" He responded: "How can I, except some man should guide me?" Then the eunuch invited Philip to sit with him and he posed questions regarding the text (Isaiah 53:7,8) he did not comprehend. Philip explained that it prophesied the Passion of Jesus and preached of Him to the eunuch. As they continued on their way they came to a body of water, and the eunuch said: "See here is water; what doth hinder me to be baptized?" Philip replied: "If thou believest with thine heart, thou mayest." The eunuch answered: "I believe that Jesus Christ is the Son of God." Then the eunuch commanded the chariot to stop, and both Philip and the eunuch went into the water, and Philip baptized him.

Since it is arguable that the Christian evangelization of the wider world began with the baptism of the Ethiopian eunuch—he was the first non-Jew to be baptized—it hardly is surprising that Church Fathers began to write exegeses on the story and its protagonists as early as the fourth century.[1] The subject, however, is exceedingly rare in Early Christian, medieval, and Renaissance art. The situation changes only after the middle of the sixteenth century, when representations of it begin to appear with some frequency in the north and south Netherlands. During the seventeenth century the subject became popular in Holland, where well-known examples were done by Rembrandt and his teacher, Pieter Lastman.[2] Dutch artists, who seldom painted religious subjects, also made pictures of the theme. Aelbert Cuyp, best known for his sun-drenched views of the Dutch countryside and rivers, and for his sparkling imaginary landscapes that evoke the idyllic mood of the Roman Campagna, belongs to this group.

Today it is common knowledge that it was not unusual for Dutch artists who were specialists of one category of painting occasionally to try their hand at other genres. Nineteenth-century attributions given to the Menil *Baptism* suggest that during the last century a narrower view was taken of the range of the subjects they painted. Although the Menil picture is clearly signed by Cuyp, it passed through two nineteenth-century London sales as a work by Dietrich, a reference to the versatile eighteenth-century Dresden painter, Christian Wilhelm Ernest Dietrich, whose name became a convenient catchall for paintings that stumped experts because he was able to work in many different styles. Possibly the authors of the early sale catalogues found it hard to believe that Aelbert Cuyp, the favorite Dutch landscape specialist of English collectors of their time, also painted biblical subjects. We shall see that an additional suggestion can be offered to account for their error.

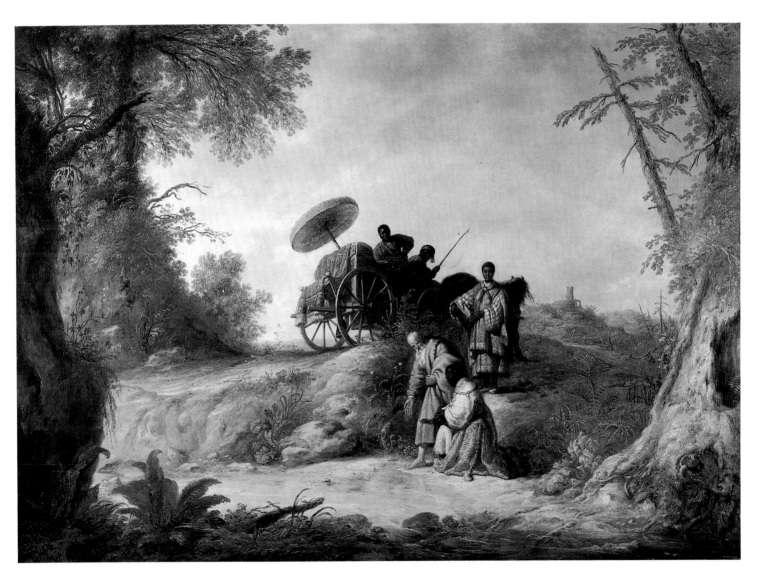

74. AELBERT CUYP (1620–1691)
Saint Philip Baptizing the Ethiopian
Eunuch, ca. 1639
Oil on canvas
42½ × 59½ in.

It is no accident that so many depictions of the baptism of the eunuch appear in the newly established Dutch republic where Protestantism was the major religion. The story of his conversion and subsequent baptism by Philip could serve as a paradigmatic illustration of Protestant baptismal doctrine. Sixteenth-century Protestant reformers challenged the Catholic doctrine that baptism was a precondition of future salvation. They taught that faith must precede baptism (in infant baptism the conscious faith is that of the parents). Only if a person has faith before baptism does the rite assure salvation and the gifts of Christ. Without first hearing and believing the Gospel, baptism is not efficacious.

The close connection between the Protestant beliefs regarding baptism and the eunuch's story is obvious: he first professed his faith, then he was baptized. Even Philip's preaching to him, on the passage in Isaiah that he initially found incomprehensible, could be related to the way baptism in the seventeenth-century Dutch Reformed churches was administered. In them the rite was preceded by Bible reading and spoken commentary. The connection between baptism and preaching services was also emphasized by the place where the rite was administered; it was performed in the chancel near the pulpit, not in the rear of the church or in a separate chapel. Additionally, baptism held a special significance for Protestants because this sacrament and communion were the only two of the Seven Sacraments that the Reformed Church recognized.[3]

The relationship between the eunuch's story and Protestant baptismal doctrine could hardly have been an esoteric subject to Cuyp. He himself was baptized in 1620 in the Reformed Church at Dordrecht, his native town. The few scraps we know about his life in Dordrecht, where he remained active until his death, indicate that his connection with the Reformed Church remained firm. He married a wealthy, strictly orthodox Calvinist widow there in 1568; he served as a deacon (1660–61) and as an elder (1672–74) in a Dordrecht church of his faith; and he was buried in one in 1691. Arnold Houbraken, Cuyp's first biographer, who also was born in Dordrecht and lived there long enough to have had firsthand contact with the artist, alludes to this aspect of his life. He tells us "Cuyp was a man of blameless character and an elder of the Reformed church."[4]

Virtually nothing is known about the conditions that prompted Cuyp to paint his pictures or of his transactions with his clients. The Menil *Baptism* is not an exception. It is not known whether the artist painted it on order, for his stock, or for his own pleasure. However, we can be certain that it was not commissioned or purchased by a Protestant congregation for use in the nave or a chapel of its church. Paintings of religious subjects were not hung in Reformed churches because Protestants considered them idolatrous. Since the prohibition against religious art did not extend to Protestant homes or other buildings, we can assume with some confidence that Cuyp's painting was mounted in a private or public room where it could remind its viewers of the early propagation of the Christian faith and a key Protestant doctrine. There also is evidence suggesting that seventeenth-century Dutchmen, inclined to employ pictures as a source for emblematic references, used his painting as a point of departure for composing variations on the age-old calumnious theme of the difference between the eunuch's black skin and his soul washed clean by baptism.[5]

There are some tantalizing analogies as well as some differences between Cuyp's *Baptism* and a lost painting of the subject by Rembrandt, which is known today from an etching made after it by Jan van Vliet, dated 1631 (Fig. 1), and some painted copies by unidentifiable artists.[6] Possibly Cuyp used Rembrandt's earlier version of the story as a crutch while he was working up his painting. Or did Cuyp

intend it as a variation on a theme set by his slightly older contemporary, whose reputation was already firmly established and whom he wanted to emulate and conceivably surpass?

In any event, the character and arrangement of Philip and the kneeling eunuch in Cuyp's painting and their isolation before a prominent hillock, upon which the members of the Ethiopian's retinue and his four-wheeled chariot are massively silhouetted against the sky, appear to be derived from Rembrandt. Motifs such as the large mound with its tangled growth in the left middle ground, and the position of the halted chariot also are related to Rembrandt's painting. Differences between the two works show that Cuyp cannot be accused of slavish imitation. He reduced the size of the eunuch's retinue and made its presence less overpowering. Significantly different too is the attention Cuyp, the landscape specialist, gave to the extension and breadth of his landscape. Rembrandt's picture is essentially a figure composition. Cuyp made a greater effort to show his figures in what he and probably his contemporaries were prepared to accept as a view of the desert land en route to Gaza. He achieved a more expansive effect by setting his protagonists further back in the landscape, and he considerably broadened and extended it by using schemes that were employed by Northern landscapists long before he picked up his brushes. For example, the conspicuous dark foreground growth along the lower edge of the picture and the large gnarled trees on either side of the painting, which firmly but rather obviously establish the foremost plane, and the spatial recession, which relies heavily on the distinct rises in the terrain that diminish in size as they recede toward the distant horizon, were old-fashioned landscape conventions.

Cuyp's reliance on antiquated pictorial devices, which do not play an equally prominent role in any of his other paintings, and other stylistic criteria—the rather ornamental foliage, the delicate sky with its thin gray clouds, the landscape done with a palette virtually restricted to pale greens and a range of yellowish browns, and the isolated local color accents—signal the Menil *Baptism* as a work done during the first phase of his activity as an artist. Cuyp's early period begins about 1639, the year inscribed on his earliest existing dated paintings, and extends to about the mid-forties when his color harmonies become more vivid and glowing, and an overall airiness, fine atmospheric effects, and golden sunlight begin to permeate his pictures spreading warmth and beauty over his calm landscapes and views of majestic rivers. The marked shift, which was the result of his contact with Dutch landscapists who had been to Rome and returned to Holland with an Italianate style, had a lasting impact on his subsequent paintings.

The Menil *Baptism* is Cuyp's only existing biblical picture datable to his first phase. The other paintings assignable to this period are rather a mixed lot and only with the benefit of hindsight hint at the characteristic style he evolved in his early maturity. Perhaps ignorance of the range of his first efforts as well as of his work as a painter of biblical themes led the nineteenth-century cataloguers mentioned earlier to misattribute the Menil *Baptism* to Dietrich. If the former was the case, their error is understandable. Most of what is known regarding the character of what Cuyp painted *avant la lettre* is the result of research done more than a century after they made their mistake.[7]

Cuyp's only other known painting of *Saint Philip Baptizing the Eunuch* is now at the National Trust, Anglesey Abbey, Cambridgeshire (Fig. 2). Like his very few other surviving biblical subjects,[8] it shows the story in a peaceful luxuriant landscape pervaded by the luminous moist atmosphere and glistening golden light that are essential parts of the enduring basis for Cuyp's high reputation as a leading artist of the heroic age of Dutch painting.

Fig. 1 Jan van Vliet
Etching after Rembrandt's *Baptism of the Eunuch*, 1631
Rijksmuseum, Amsterdam

NOTES

1. Jean Marie Courtés, "The Theme of 'Ethiopia' and 'Ethiopians' in Patristic Literature," in Jean Devisse, *The Image of the Black in Western Art*, Vol. II, Part I, Cambridge, Mass., 1979, pp. 21–29, offers a valuable survey and interpretation.

2. Andor Pigler, *Barockthemen*, 2nd ed., vol. I, Budapest, 1974, pp. 389–92, gives a comprehensive list of sixteenth-century and later artists who represented the theme (it includes some borderline and questionable attributions). An important painting to add to Pigler's list is Rembrandt's recently discovered *Baptism of the Eunuch*, monogrammed and dated 1626, now in Utrecht, Rijksmuseum het Catharijneconvent (inv. sch. 380). It was first published by H. L. M. Defoer, who recognized it in a private collection in 1974; see his article "Rembrandt van Rijn, De Doop van de Kamerling," *Oud Holland*, 91, nos. 1–2, pp. 2–26. A Pieter Lastman painting of the subject that escaped Pigler's fine net is in Paris, Collection Frits Lugt, Fondation Custodia (inv. no. 4886); see the exhibition catalogue *Reflets du siècle d'or, tableaux hollandais du dix-septième siècle*, Institut Néerlandais, Paris, 10 March–30 April 1983, pp. 74–76, no. 45.

3. A full discussion of the connection between the eunuch's story and the Dutch Reformed baptismal doctrine and practice is in Defoer, *op. cit.*, pp. 21–24. Also see the unsigned brochure prepared for the first exhibition of Rembrandt's recently discovered *Baptism of the Eunuch* of 1626 at Utrecht, Aartsbisschoppelijk Museum, 31 March–10 May 1976 (n.p.), and Réau, *op. cit.*, p. 1070.

4. Arnold Houbraken, *De Groote Schouburgh der Nederlantsche Konstschilders en Schilderessen*, vol. I, Amsterdam, 1718, p. 249. A brief, well-documented biography of Aelbert is included in the exhibition catalogue *Aelbert Cuyp en zijn familie, schilders te Dordrecht: Gerrit Gerritsz. Cuyp, Benjamin Gerritsz. Cuyp, Aelbert Cuyp*, Dordrecht Museum, 1977, pp. 18–19.

5. For changes rung on the theme by Early Christian exegetes see Courtés, *op. cit.* J. Bruyn *et al.*, in *A Corpus of Rembrandt Paintings, I, 1625–31*, The Hague-Boston-London, 1982, pp. 102–103, cites two seventeenth-century references to it: a Latin inscription on an engraving by Claes Jansz Visscher's free copy after Rembrandt's lost painting of the *Baptism of the Eunuch* (see note 6 below), which reads: "Here Philip washes the black Ethiopian, dispels color, Not of his skin but of his soul, after having explained the prophecies" (Visscher's print is reproduced, *ibid.*, p. 38, fig. 5); the Dutch sonnet "Camerling Candaces," by the Calvinist preacher and metaphysical poet Jacobus Revius, which begins with an allusion to the impossi-

bility of washing a black man white, and ends with the thought that the eunuch, after receiving baptism from Philip with "a faithful heart, His outer skin remained black, Yet in his soul he was whiter than snow." Revius's poem appears in his *Over-Yselsche Sangen en Dichten*, Deventer, 1630; the 2nd ed., Leiden, 1634, was included in the Utrecht exhibition of 1976 dedicated to Rembrandt's recently discovered *Baptism of the Eunuch*, 1626 (see note 3 above).

6. Stephen Reiss, *Aelbert Cuyp*, New York–Boston, 1975, p. 32, recognized the similarity of handling between the Cuyp and van Vliet's etched copy, but he overcautiously states that the etching is after a "supposed" lost original by Rembrandt. Among the painted copies, the one which appears to be the most faithful was formerly at Oldenburg, Grand Ducal Gallery (sale, Oldenburg, Amsterdam [F. Muller], 25 June 1924, no. 154; repr. Bruyn *et al.*, *op. cit.*, p. 37, fig. 4).

7. Contributions to our knowledge of Cuyp's early works are found in Wolfgang Stechow, "Significant Dates on Some Seventeenth-Century Landscape Paintings," *Oud Holland*, 75, 1960, pp. 86 ff.; J. G. van Gelder and Ingrid Jost, "Vroeg contact van Aelbert Cuyp met Utrecht," *Miscellanea J. Q. van Regteren Altena*, Amsterdam, 1969, pp. 100–103; D. G. Burnett, "Landscapes of Aelbert Cuyp," *Apollo*, 89, 1969, pp. 372 ff.; Reiss, *op. cit.*; Albert Blankert, *Nederlandse 17e Eeuwse Italianiserende Landschapschilders*, rev. enlarged edition, Soest, 1978, pp. 170 ff.; Dordrecht Museum exhibition catalogue *Aelbert Cuyp en zijn familie...*, 1977 cited in note 4 above.

8. A fair estimate of the existing number of Cuyp's biblical pictures cannot be offered until a fresh investigation has been made of his entire painted *oeuvre*. To judge from those known today, the number will not be large; an estimate of ten may be on the high side. A clue to the very small percentage of his total output devoted to biblical scenes is offered by the extraordinary collection of Cuyp's paintings assembled by the eighteenth-century Dordrecht collector Johan van der Linden van Slingeland. When it was sold in Dordrecht in 1785, it included thirty-eight paintings attributed to Cuyp; only one of them, *The Conversion of Saul*, depicted a biblical subject. Some of Slingeland's Cuyps were outstanding, but not all of the works attributed to the artist in his collection have stood the test of time. Moreover, the description of Slingeland's single biblical picture, which has not been firmly identified, understandably led Hofstede de Groot (*op. cit.*, p. 11, no. 10) to suggest that it may have been a work by Aelbert's uncle, Benjamin Cuyp.

Fig. 2 Aelbert Cuyp
Saint Philip Baptizing the Eunuch
The National Trust, Anglesey Abbey

Study of a Black Man
by Joshua Reynolds

Ellis K. Waterhouse

This painting was not a commissioned picture but a sketch made for study purposes, which remained in Reynolds's studio until his death. It appeared in his posthumous sale by Greenwood, April 14–16, 1796 (Lugt no. 5433), on the second day, April 15, lot no. 53 as "Do [i.e. Study of a] black man's head," when it was bought by Sir George Beaumont, Baronet, for eighteen guineas. Sir George Howland Beaumont (1753–1827), 7th Baronet, one of the most generous art patrons of his time, was an intimate friend of Sir Joshua Reynolds, who painted the portraits of both Sir George and Lady Beaumont, and he would long have been familiar with the picture and would probably have known who was the model. The picture was twice lent to the British Institution in Sir George's lifetime. In the first "Old Master" exhibition ever held in England, that of the works of Reynolds (B.I. 1813), it appears only in the first edition of the catalogue[1] (no. 140) as *Black servant of Sir Joshua*, and in B. I. 1823 (no. 41) as *Head of a Black: a Study*. The suggestion that the sitter may have been Frank Barber, Dr. Samuel Johnson's black servant, does not occur until after Sir George's death. The picture remained at the Beaumont house at Cole Orton in Leicestershire until 1902, the succeeding baronets (all of whom were called Sir George) becoming increasingly irresponsible. Its later exhibition record is Manchester, Modern Masters (no. 58), *A Negro. ? Frank Barber, Dr Johnson's Black Servant*; B. I. 1861 (no. 177), *Frank Barber, servant of Sir Joshua Reynolds* (sic); Royal Academy 1877 (no. 290), *A Negro. Said to be Francis Barber, a servant of Dr Johnson's*; Grosvenor Gallery, 1883–84 (no. 42), *A Negro. Said to be Frank Barber, Dr Johnson's black servant.*

Reynolds did himself have a black servant, whom he sometimes used as a model, as Northcote,[2] who lived for some years in Reynolds's house as a pupil, relates: "This black man had lived in his service as footman for several years, and has been pourtrayed in several pictures, particularly in one of the Marquis of Granby,[3] where he holds the horse of that General." This is the portrait that was exhibited at the Society of Artists in 1766 (no. 137), in which the black servant, who holds the horse, is taken from quite a different model than the one in the Menil picture. It is possible, however, that the Menil picture may have been painted in connection with another black servant, who appears holding the horse of a general in another portrait, which was almost a companion to that of the Marquis of Granby. This is the portrait of Frederick, Count of Schaumburg-Lippe,[4] which was probably completed in 1767 and which hangs in St. James's Palace, London. Here the black servant wears a turban, but the likeness and the pose of the head are more or less in agreement with the Menil picture. There is also some reason to believe that the model may have been Frank Barber, Dr. Johnson's black servant. For in the sitter book for 1767, "Count La Lippe" appears under August and "Frank"[5] under April.

Frank Barber (ca. 1745–1801), a Jamaican slave, was the son of a slave of Major Richard Bathurst of Orange River estate, Jamaica, who died in England; there he made his will, April 24, 1754 (shortly before his death), in which he liberated Frank, who was at school in Yorkshire. Bathurst's son, another Richard Bathurst, was one of Johnson's most devoted friends, and Johnson took over the

responsibility for the boy and continued his education. Frank was good-natured but rather improvident, and after one or two attempts at outside activities settled down in the very odd Johnson household and acted as Johnson's servant. Johnson treated him almost as a son, and Frank was his principal legatee, receiving an annuity of £70 a year. He married an English girl, and, after Johnson's death, they retired to Lichfield where Frank taught in a school. But he managed to get his hands on the lump sum invested to produce the annuity, squandered it, and died in extreme poverty in Stafford Infirmary in January 1801.[6]

There is no unquestionable likeness of Frank Barber known, but in 1868 a small engraving was made by Alexander Scott (published by Henry Graves and Co.) after the Menil picture, with some drapery added, which was lettered as Frank Barber. This has no doubt caused a particularly undistinguished copy—with the drapery "completed"—which is now in the Dr. Johnson's House Museum in Gough Square, London (where it is incorrectly ascribed to Northcote), to do duty in a number of recent books[7] as a portrait of Frank Barber. A model called "Frank" was certainly sitting to Reynolds in 1767, and, on stylistic grounds, a date of 1767 is acceptable for the Menil picture. One can perhaps say that there is a slight inherent probability that the sitter in the Menil picture is Frank Barber, but there is no conceivable reason for supposing that he was the man whose name[8] has been attached to it in the present century—the Tahitian Omai.

In 1902 the Menil picture was sold from Cole Orton by Sir George Beaumont, the 10th Baronet, to Colnaghi & Co. It was sold almost immediately to C. S. Carstairs of Knoedler's, but Colnaghi bought it back in 1904, and it entered the collection of Jacques Doucet in Paris, where it was called *Omiah, Indigène de O'Tahiti*. It has not been established who was responsible for this piece of nonsense.

Omai (or Omiah)[9] was not a black man at all. He was a Polynesian from Tahiti, brought back to England in 1774 by Captain Furneaux at the end of Cook's second voyage to the South Seas. He was an attractive savage and a great social success. He was presented at Court and presumably sat to Reynolds in 1775, but the sitter books are missing for the years Omai was in England. Reynolds painted a splendid full-length of him (now at Castle Howard) in the pose of the Apollo Belvedere, which was exhibited at the Royal Academy in 1776, and remained, like the Menil picture, in Reynolds's possession until his death. The likeness of Omai is authenticated by a mezzotint engraving by John Jacobé published in 1780, and Omai does not bear the slightest resemblance to the sitter in the Menil picture. A rather battered head in the Yale University Art Gallery may well be a Reynolds study of Omai made with the same study intention as the Menil picture.

The Menil picture appeared in the second part of the Jacques Doucet sale, at the Galerie George Petit, Paris, June 6, 1912, lot 174, when it was bought by Monsieur Pardinel for 120,000 francs. The Pardinel collection was later bought *en bloc* by Monsieur François Coty, and the picture next appeared at the F. Coty sale, Galerie Charpentier, Paris, November 30, 1936 (no. 28), when it was bought for the Paris collection of the Honble. Mrs. Reginald Fellowes. Mrs. Fellowes was Marguerite ("Daisy") Séverine Philippine (1890–1962), daughter of Elie, 3rd Duc Decazes and Isabelle Blanche Singer; she had first married, in 1910, Prince Jean Anatole de Broglie (1886–1918), by whom she had three daughters. In 1919 she married the Honble. Reginald Fellowes. At her death in 1962, the picture passed to the eldest daughter of her first marriage, Emeline de Broglie, who married Comte Alexandre de Castéja.

As a painter of portraits Reynolds was always interested in sitters of other races, whom he painted with considerable sympathy. After the picture of Omai,

Opposite:
75. SIR JOSHUA REYNOLDS (1723–1792)
Study of a Black Man (Frank Barber), 1767
Oil on canvas
31 × 25⅛ in.

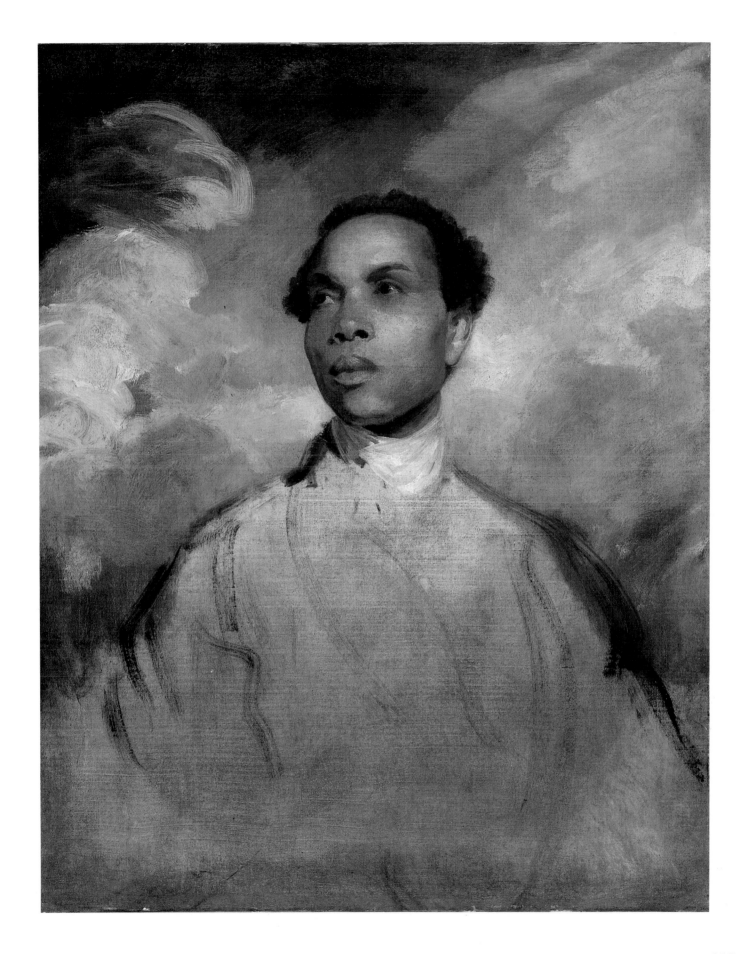

113

shown in 1776, he painted in the same year the Chinese boy, Wang-y-tong, for the Duke of Dorset, which is now at Knole, but his interest in black sitters had begun much earlier. About 1748, when working at Devonport, he had painted a portrait of Captain Paul Henry Ourry[10] (now in the possession of the National Trust at Saltram) with a black servant, who is painted with more sympathy (and a more lively technique) than the portrait of his master. And when he had settled in London, Reynolds seems to have taken the view that the grandest full-lengths of generals required a black servant, although this was not a practice in the British army. It was perhaps a notion he had derived from pictures he had seen in Venice. He used his own black footman for the portrait of the Marquis of Granby, and the same man was probably the sitter for a rather handsome sketchy bust, with the suggestion of a military uniform and a tremendous turban with a crescent on it, suggestive of a Moslem prince,[11] which was last recorded in Mrs. Derek Fitzgerald's sale, Sotheby's, London, July 3, 1963 (no. 10).

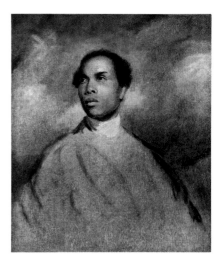

Fig. 1 After Sir Joshua Reynolds
A Negro, Said to be Sir Joshua's Black Servant
The Tate Gallery, London

Considerably later, in a portrait modeled on Van Dyck of "Charles, 3'rd Earl of Harrington," shown at the Royal Academy in 1783 (now in the British Art Center at Yale), Reynolds also introduced a young Negro servant, even though Lord Harrington was not yet a major-general, but he had been a colonel and a regimental commanding officer in the United States.

Reynolds did not allow students and pupils to copy his commissioned portraits, but he was generous with pictures that he had in the studio and had made with a view to producing "fancy pieces" or to helping with subsidiary figures in commissioned portraits. This explains why so many copies are known of the Menil picture, and its next owner, Sir George Beaumont, probably encouraged the painters who stayed with him (such as Jackson) to copy the picture. More than half a dozen such copies are known. Most of them have at some stage been called "Omai" and have been claimed as originals, but none known to me seems to be by Reynolds himself. Indeed it is very unlikely that Reynolds himself would have repeated a picture that was probably made from life at a single sitting. The sky and clouds were no doubt put in later in the studio, but the head has that quality of freshness that indicates it was painted by Reynolds himself directly from the model, free from the studio assistants' intervention present in most of Reynolds's commissioned portraits. No doubt this is what made so many students wish to copy it. Two of these copies have been bequeathed at different times, as originals by Reynolds, to the Tate Gallery in London (Figs. 1 and 2). The others are on the art market or in private collections in England and the United States.

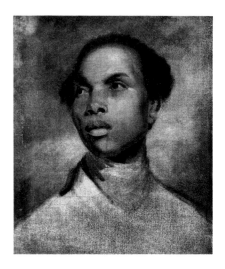

Fig. 2 After Sir Joshua Reynolds
A Negro's Head
The Tate Gallery, London

That the Menil picture is the only original seems to me clear, and I think it in the highest degree probable that it was painted at a single sitting from Dr. Johnson's servant, Frank Barber, on April 23, 1767, shortly before the establishment of the Royal Academy in 1768, of which Reynolds was to be first president, when his powers were at their peak.

NOTES

1. There were three editions of the catalogue. This picture only appeared in the first edition, which is reprinted in Algernon Graves, *A Century of Loan Exhibitions*, III (1914), pp. 1017–1025; in the second and third editions, which included additional paintings, it was withdrawn, presumably because it was unfinished. Sir George Beaumont was one of the principal promoters of the British Institution.

2. James Northcote, *Memoirs of Sir Joshua Reynolds, Knt....* vol. I, London, 1813, p. 117.

3. This picture was engraved in mezzotint by James Watson. What was presumably the prime original was burnt in the fire at Belvoir Castle on October 26, 1816 (Rev. Irvin Eller, *The History of Belvoir Castle*, London & Grantham, 1841, p. 127), but a posthumous repetition was made for the Maréchal de Broglie in 1773 (now in the Ringling Museum, Sarasota), and another is at St. James's Palace in London.

4. Frederick, Count of Schaumburg-Lippe (1724–77), who appears in Reynolds's sitter book as "Count Lippe" or "Count La Lippe," was generally known in the eighteenth century as Count of Lippe-Bückeburg. He was in command of the joint British and Portuguese forces which resisted the Spanish attack on Portugal in 1762. His mother was Margaret Gertrude (1701–26), illegitimate daughter of King George I of England by the Duchess of Kendal. She had married Count Albrecht Wolfgang zu Schaumburg-Lippe (1692–1748) in 1721.

5. There is a single sitting only, at 12 o'clock on April 23, for "Frank" (or conceivably "Franks") without the normal prefix of Mr. or Mrs. Tom Taylor first suggested, very reasonably, that this stood for Frank Barber.

6. Frank Barber is abundantly mentioned in J. Boswell's *Life of Johnson* (6 vols., Oxford, 1934–50) and in all other literature on Johnson. The fullest account of what is known about him is to be found in Alleyn Lyell Reade, *Johnsonian Gleanings* (11 vols., privately printed, 1909–52), Part II, 1912 (reprinted edition, New York, 1968), pp. 103–109.

7. Such as Christopher Hibbert, *The Personal History of Samuel Johnson*, London, 1971; John Wain, *Samuel Johnson*, London, 1974.

8. In the Witt Library in London, for instance, all the versions of this design, even when they are lettered as "Frank Barber," are filed under Omiah.

9. The best account of Omai is to be found in Chauncey Brewster Tinker, *Nature's Simple Plan*, Princeton, 1922.

10. Illustrated as pl. 12 in *Reynolds* by Ellis K. Waterhouse, 1941.

11. The fullest account of this picture occurs in the 1963 sale catalogue, but there is a misleading notice about it in the 1935 *Commemorative Catalogue of the Exhibition of British Art, Royal Academy 1934* (no. 140), where it is called "Omai." It is the only portrait of a black man, other than the Menil picture, whose ownership can be traced back to Reynolds's lifetime, since it first belonged to Mary Hamilton, who married John Dickenson in 1785, from whom it passed to her son-in-law, Sir William Anson, 1st Bart. (1772–1847), in whose possession it was known as "Reynolds's negro servant" (Graves and Cronin, i. 27).

BIBLIOGRAPHY

Reynolds's manuscript Sitter Book for 1767 (in the Library of the Royal Academy of Arts, London).

C. R. Leslie and Tom Taylor, *Life and Times of Sir Joshua Reynolds*, 2 vols., London, 1865.

A. Graves and W. V. Cronin, *A History of the Works of Sir Joshua Reynolds*, 4 vols., London, 1899–1901 (125 copies only).

Ellis K. Waterhouse, *Reynolds*, London, 1941, and *Reynolds*, Phaidon, 1973.

COLONIAL ART IN THE NEW WORLD

The conquest of the pre-Columbian civilizations of the New World at the beginning of the sixteenth century represented a collision of two complex, urban, and utterly alien imperial societies. Unlike the assimilation and enculturation that followed conquests and occupations in the Mediterranean world over a thousand years earlier, what was found in the Americas was crushed and brutally obliterated.

With mass conversions of the Indian population came the re-education of native craftsmen to create new artifacts propagandizing the faith. The sophisticated visual cultures of pre-Columbian societies were forcibly suppressed by the terrifying zeal of the Holy Inquisition. One can only speculate upon the ways in which the Indian consciousness apprehended Christianity. Working under duress in fundamentally foreign modes, converted Indian artisans interpreted Christianity's images in a way uniquely their own. The stylizations and direct emotional appeal of their work recall the art of the early Christian era more than the imported grand style of the European Baroque.

Consider the three works included in this section. The *Virgin of Belem*, painted two centuries after the conquest, was copied from a more elaborate treatment of the subject hanging in the Cuzco Cathedral in Peru. This painting by Basilio de Santa Cruz was itself based on a statue of the Virgin in the Church of La Belem in Cuzco. As images were freely borrowed from one artist to the next, each focused on those visual elements that interested him the most. Here, the artist has lavished attention on the richly patterned vestments of the Holy Mother and Infant; the naturalistic rendering of the faces of these doll-like figures seems to bring to life the mysteries of the incarnation.

The same poignant faith literalized in the *Virgin of Belem* animates the Deposition scene from Bolivia or Paraguay. The unencumbered embellishment and angular rhythms in this liturgical cloth recall its makers' aesthetic ancestry—those relief carvings and linear patterns that embellished the architecture and decorative objects of pre-Columbian empires. Space and relative scale disregard post-Renaissance pictorial conventions: the actors in this religious pageant assume the size of their dramatic importance. Attributes of the Passion, some familiar, others arcane, share the background with repeating floral motifs. Pictographic and decorative elements crowd the picture plane, each element imbued with its own magical weight and mystical significance.

The Penitente cults of northern Mexico and New Mexico, which have survived into this century, practiced an extreme expression of Catholic piety. Their ritual mortifications and fervent spirituality intermingle Christian and pagan impulses. This is embodied here in the tiny figure of a frail and bloodied Jesus seated on his cross, contemplating his lonely martyrdom. The tortured spirituality of this work and its devastating humility make it compelling to the modern eye.

Walter Hopps

76. *The Virgin of Belem*
Peru, Cuzco
First half 18th century
Oil on canvas
56⅛ × 32¼ in.

77. *Lenten Curtain—The Deposition*
Bolivia or Paraguay, Jesuit mission,
Mojos people
Early 19th century
Waterbased paint on cloth
147⅝ × 89½ in.

Opposite:
78. *Christ Seated on the Cross*
New Mexico, Penitente sect
20th century
Wood with gesso, paint, and straw
4⅝ × 8¾ × 5⅛ in.

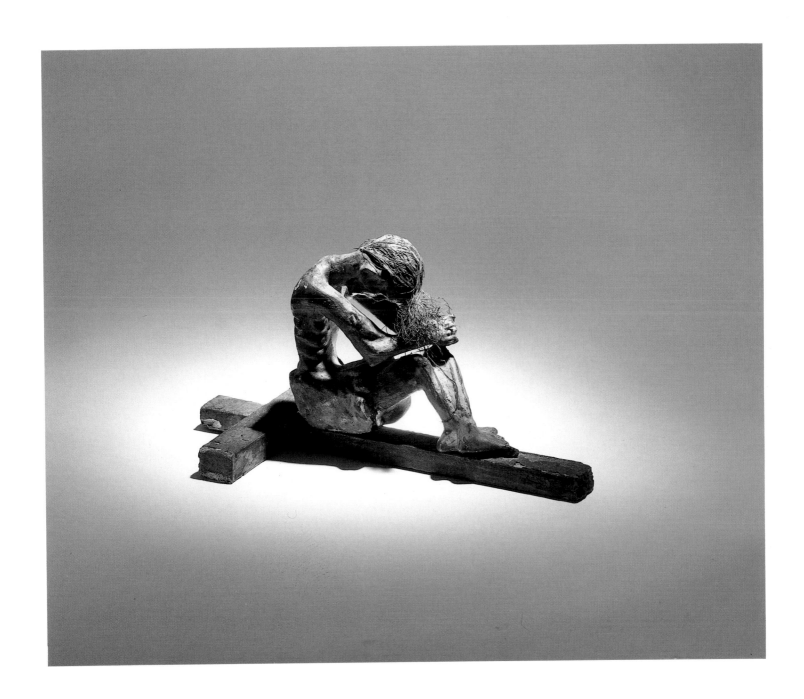

ART OF THE TRIBAL CULTURES

Once, looking at a group of Minimal works of art, intermixed with Oceanic and African "sculptures" mostly made in this century, John Cage greatly admired the first, but said of the tribal artifacts, "They are so old!" If our nonliterate contemporaries can trouble the more ecumenical minds of our time, then Primitivism, both in representation and as a new dimension of *taste*, must constitute a radical change in Western aesthetic habits, beyond what the examples of tribal "derivations" and "affinities," so diligently displayed in art museums, suggest. Following the reappropriations of the past we have the appropriations of the different; in Modernity, the "Primitive" replaces the Classics, the Remote replaces the Ancient. The Different, though, is *alive* (if not well) and resists obsolescence.

Style, in the immemorial perspective of the Primitive, is an "art of memory" as much as one of "imitation." For vast areas of Primitive art, imitation primarily concerns a grounding of our existence in the con-memoration of the dead. Also, by the rituals that evoke their appearance, initiation is imprinted on the living: depiction, impersonation, and staging provide a metaphysical hold on life's transitions and on the flow of natural cycles. In these "performances," images of the Wondrous and Horrid, *in their beauty*, present the frightening face of completions and achievements that are constantly repeated and renewed. In them, the human sees "nature," the extra-human, as the embodiment of the super-human, as an other-yet-not-other with which it entertains a contiguous and continuous relation: the things made to *re-present* it are like notations in the ritual rhythms. But style also implies a belonging: traditional *re-semblance* (not our "realistic resemblance") authenticates the objects and marks their makers' collective identity. Their beauty, then, is indeed un-Modern, as Cage well saw, and "very old."

Difference and distance do not preclude rapport. The disjunctions and displacements Picasso introduced as problems into Western representation, he had encountered as *stylistic* "solutions" in ethnographic galleries. In their expressive semblance and in their plastic efficacy, those "specimens" were the product of a "magic" force: the concentrated and *bodily* evocation of complex and even contradictory realities. Surrealism generated a new sense of what Picasso had perceived as the "magic" of tribal art. Its "primitivism" was more than a stepping out of the canons of Western art, and its "relativism," by showing the arbitrary nature of all representation, conjoined a sense of simultaneity with one of distance. In seeking remoteness, Surrealism gave new substance to the longing that from the Enlightenment to Gauguin had fathomed exotic paradises as metaphors of (and for) *new styles*; in the clash of synchronous occurrences, such as those that brought the Modern in direct contact with the Primitive, it linked deep strata of the European and of the archaic psyche. As Alienation won the West, Disjunction and Displacement became part of the very gesture that appropriates the alien.

One of Modern Art's greatest gifts to us has been the *invention* of "Primitive Art."

Francesco Pellizzi

Opposite:
79. *Woman and Child*
Mali, inland delta of the Niger River,
Jenne culture
11th–17th century
Terra cotta with traces of red slip
18¾ × 7⅜ × 11¼ in.

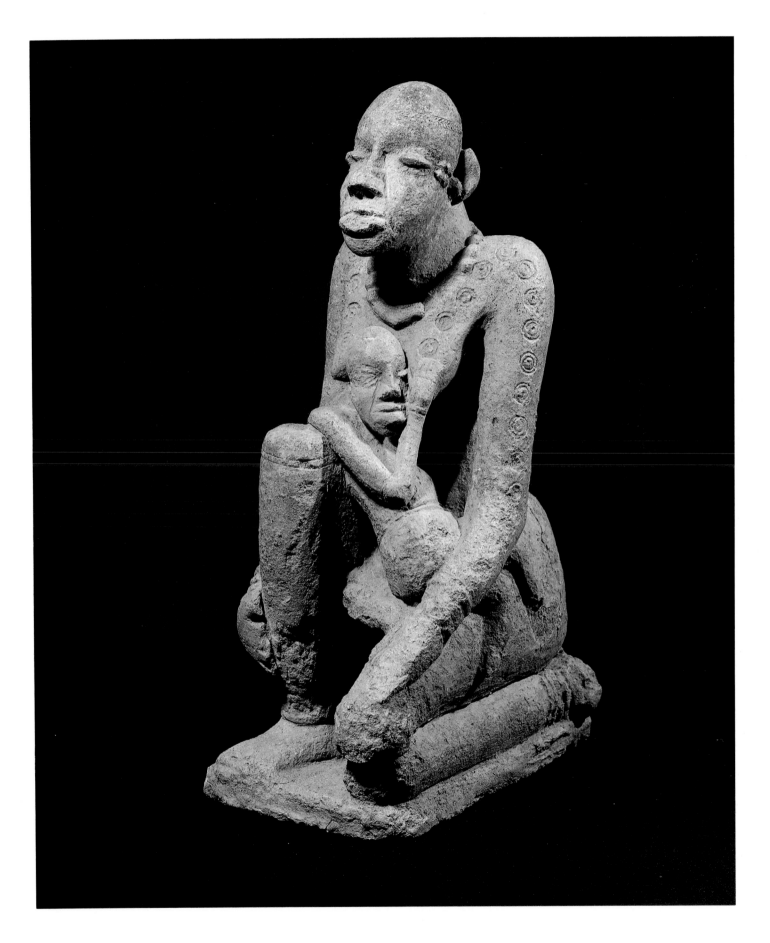

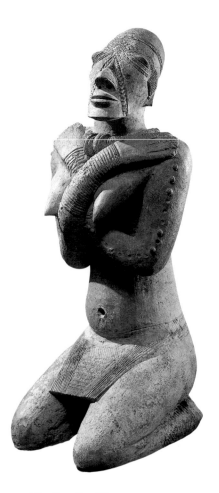

81. *Kneeling Woman*
Mali, inland delta of the Niger River,
Jenne culture
11th–17th century
Terra cotta with traces of red slip
20 × 8⅜ × 10¾ in.

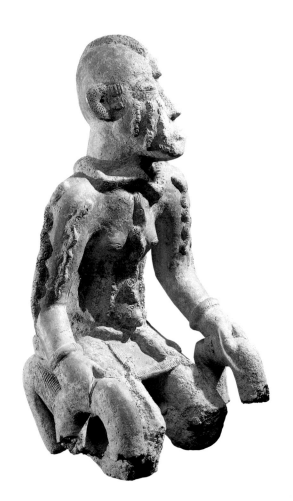

80. *Kneeling Man Covered with
Serpents*
Mali, inland delta of the Niger River,
Jenne culture
11th–17th century
Terra cotta with traces of red slip
18⅞ × 9¾ × 10¾ in.

Opposite:
82. *Seated Figure Covered with
Serpents*
Mali, inland delta of the Niger River,
Jenne culture
11th–17th century
Terra cotta with traces of red slip
12½ × 7½ × 9⅞ in.

African Aesthetics and the Art of the Ancient Mali

Susan Vogel

The art of the region properly called the Inland Delta of the Niger River in Mali is as old as the "classical" art of Ife in Nigeria. Unlike the Ife terra-cottas and bronzes, however, those from Mali come from an immense region suggestive of local art traditions rather than from a single centralized court such as at Ife. Whether there was contact between the two contemporary art-producing areas is unknown, but there is no evidence so far to substantiate this hypothesis. Similar preoccupations apparent in the sculpture of the two cultures, as well as affinities with the art of the earlier Nigerian culture known as Nok, can arguably be attributed to characteristics that the two share with African art from other traditions even more distant in time and place than these two; this may be construed as a broad underlying African aesthetic sensibility. Based on ancient Malian works in The Menil Collection, I will consider the nature of this African aesthetic and explore the degree to which it is a valid concept in the wider area.

Unlike most traditional African art, the figures from Mali (Nos. 79–82) show people in active poses and making gestures that undercut the timeless, motionless quality normally associated with African art. The figure shown in No. 80, head turned and half rising from a crouch, has a kind of specificity rarely found in other African art. This large terra-cotta seems to portray a particular person whose body shows the marks of sanctity or disease, with the serpents that rise across his chest, back, and arms, encircle his waist and neck, and descend his cheeks and scalp. Serpents used in this remarkable and disturbing way had not been seen in African art before the discovery of these archeological terra-cottas, although serpents appear in many other guises. What is unusual in the ancient Malian works is the variety of forms taken by the portrayal of states of sanctity or disease. Elsewhere in African art, the portrayal is standardized to become almost emblematic. This unique figure has an individual character. It may be that we know proportionately so little of the art of the Inland Delta that a stereotypical image seems highly particular to us only because the other examples of the genre are not available; more likely, the art of this ancient culture consistently differs from the mainstream of African art in its temporal relationship.

By showing, as No. 80 does, an individual at a particular stage of a disease (his ears inflamed, his swollen, puffy nipples resembling the lozenge-shaped sore on his back), the sculptor evokes human mortality; and with the great curved bars (perhaps metal currency) half lifted in his hands, the artist has suggested the completion of the gesture and the passage of time. Consider for comparison the figure in No. 108, which can be taken to represent the mainstream of African sensibility. It is symmetrical, still, standing beyond gesture and event, removed from the effects of time, being neither young nor old. It does not suggest a man to us; it suggests man as a universal, mankind in a sense that transcends the mortal individual. Its stillness and its remoteness from the everyday world of movement and change place it in a higher realm of immortality and perfection—massive, sober, enduring.

Where most African art depicts states of peace and composure, many archeo-

logical sculptures from Mali suggest suffering and anguish. Covered with serpents, worms, or skin eruptions, head slumped on his arms, the figure in No. 82 is an extreme example of this aspect of Malian art. Every line speaks of unrest and agony, from the fierce ribbing around the waist (which may show emaciation) to the jagged lines of the limbs and the nervous writhing textures that cover most of the surface. The small areas of smooth skin on the crown of the head and the hands lend the figure a poignant human quality; without them it would be deformed and unrecognizable, beyond human pity.

Most African art is idealizing and evokes perfect beings in their essence. Bongo grave figures (No. 110), for example, depict deceased heroes who will watch over their descendants and grant them health and prosperity, abundant hunts, and success in war. The figure is accordingly shown as youthful and strong, with the muscular calves, thighs, and buttocks of a runner or a wrestler. The arms are held close to the body in a pose common to African art, a gesture suggesting respect, submission to rules, and modesty. The prominent fingers, however, invoke competence and skill; the bald head alludes to the wisdom and knowledge of elders; the compressed features and squinting eyes reassure the living of the deep vigilance of the dead.

A kneeling figure from Mali (No. 81), arms crossed on her breast, is firmly in the mainstream of African art. Serene and idealized, she has many of the features found in figures of wood, metal, or ivory from all parts of Africa. She is depicted as youthful and healthy; the soft, fleshy thighs and round belly bespeak fertility; her high pointed breasts show that she is young and has not yet borne children; her smooth skin is a sign of health, cleanliness, and beauty; she is adorned with scarifications at her temples and along her arms, bracelets at her wrists, many strands of anklets at her feet, and large carved beads at her throat and coquettishly on her hip. She is not bald, but wears a tightly fitting cap with a patterned band. Her posture suggests respect or supplication with dignity. She is shown as a physical and moral ideal, combining the personal physical qualities with signs of social standing, wealth, and prestige. Throughout Africa scarification and elaborate coiffure are signs of social integration, of respect for self and for others. Scarification marks one as a full-fledged member of one's group, one who has submitted to the pain (and often accompanying instruction) of the scarification process. Although this figure does not have a coiffure, elaborate ones such as that of No. 92 represent social standing because coiffures were done generally by friends or family members (one could not do it oneself), who could only be persuaded by affection to put in the many hours required for an elaborate coiffure. Such work was generally upaid.

Figures that combine the best features of age with those of youth are commonly seen in African art, this being one of the basic ideas underlying African aesthetics. African aesthetic systems are not alone in considering that what is good is beautiful, and what is beautiful, good. Thus moral perfection is as essential to the aesthetically successful work as the depiction of physical perfection. Indeed, the two are to a degree inseparable. The perfect body of a woman carved or modeled is pleasing for the connotations of productivity, the promise of children, and the ability to work hard. A healthy, perfect body implies moral rectitude in a world where disease and many kinds of misfortunes are seen as indications of a moral flaw or a lack of harmony with the spirits. An idealization that includes the moral dimension is inclined to combine the best qualities of age with those of youth to suggest a being more complete than any in life. Thus the prestige, knowledge, and wisdom of the elders can be contained in a body having the strength, fertility, and vigor of

youth. So basic a preoccupation is this that sculptures not seeking to suggest the qualities of age and youth still deal with the issue in a fairly focused way.

The figure of a mother and child from the Inland Delta of Mali (No. 79) is an image freighted with meaning far more complex than it might at first appear. Closer inspection reveals that the "child" has the body proportions of an adult: the somewhat stooped posture of the neck, the slack-muscled belly, and the lined face reveal that the artist did not intend to depict a young person. What is one to make of the diminutive size and suckling posture of this full-grown "baby"? Among the nearby Senufo, all initiates (which is to say virtually all adult men) are considered the children of the deity, Ancient Mother, the supreme Creator. Perhaps here we have a metaphorical expression of the idea that mankind is the child of a supreme ancient mother, who will nurture, instruct, and protect them, just as the Catholic Church is called Holy Mother, invoking its role to instruct, guide, and shield.

Whatever its meaning, this early figure, dated from the twelfth to thirteenth century, already possesses one of the fundamental qualities of late African art: it is an art of ideas. African artists were rarely interested in duplicating the visible world. Their male figures are not depictions of ordinary men; their mother and child figures are almost never literally a woman with a baby. Not only are these not ordinary people, they are not people at all. Neither are they usually depictions of gods or spirits.

African sculptures are almost always expressions of highly abstract and intellectual concepts such as the dependence of man on god, as we have just seen, or of a generalized idea of increase and fertility. But even fertility in African thinking is nothing so literal-minded as having babies; it is a vision of abundance in which crops in the fields, domestic animals, game in the forest, and the human group with all its wealth and possessions, would multiply prodigiously. This concept in turn implies peace and harmony among men and in their relations with the spirit world, without whose assistance such prosperity would be impossible. Other sculptures deal with ideas of order and disorder, mortality and immortality, power and control, protection and vulnerability, and the interrelationship and interdependence of men and animals, of village and wilderness. Most sculptures have multiple meanings that are modified by their context and by the depth of understanding of the person who contemplates them. Many are only superficially comprehensible to young people and are progressively revealed in all their complexity as a person ages and passes through different grades of initiation. Their full meaning in all its richness and nuance is virtually unknowable to the outsider.

The formal qualities of a male figure from northern Nigeria (No. 91) show a typically African segmentation of the body that is found over many thousands of miles all across the continent. The treatment of the breast and arm as a single unit, and the buttocks, thigh, and leg as another, can be seen in different styles from Mali—ancient (No. 79) and historical—to eastern Zaire (No. 108). In each case the torso is treated as a distinct unit either bracketed by the first two, or crossing them and rising to include the neck. This conception of the body as a series of discrete geometric forms is one of the most obvious features of an African artistic sensibility and one that permits us to identify a work as African even if we cannot begin to guess where on the continent it might have been made.

A combination of organic and inorganic elements, and a fusing of animal and human characteristics, are two other important aspects of the African vision expressed in sculpture. The majestic male figure from northern Nigeria (No. 91) is a magnificent example. While the torso and thighs are billowing rounded forms,

flowing and turning like human flesh, the lower legs are cylinders, the arms are squared-off posts. The gently modeled nipples contrast with the navel in the shape of a plug and with the brusque ridges forming the fingers. To a certain degree this figure suggests animal features in the heavily muscled thighs tapering down the still lower leg, which recalls the shape of an antelope's or horse's leg. Conversely, animal figures often have human characteristics, such as the conspicuously human nose worn by the small bronze figure from Nigeria (No. 95). The birdlike head perched on a rather human foot from Zaire (No. 107) is another more fanciful melding of the indistinctly human and nonhuman. The antelope headpiece from Mali (No. 84) has a human nose and appears to have been circumcised, a practice rarely observed in animals.

As the West gradually became aware of the terra-cottas emerging from the earth in the region around Jenne in Mali, it began to realize that these discoveries, this wealth of new sculpture, challenged some old assumptions about African art and confirmed others. The works that came to light represent one of the oldest art styles so far known from sub-Saharan Africa. They have been dated by thermoluminescence to the ninth through seventeenth centuries; most fall in the period between these dates. They include the largest terra-cotta figures known from Africa and display a wide range of unusual subjects executed in a variety of different styles. Since there has been little scientific information published on the cultures from which they came, the significance and use of these works of ancient Malian art remain obscure. We can only begin to speculate on the meanings behind their complex system of gestures and symbols, and on their place in the art history of West Africa.

BIBLIOGRAPHY

Bascom, William, *African Art in a Cultural Perspective*, New York, 1973.

Eyo, Ekpo and Willet, Frank, *Treasures of Ancient Nigeria*, Detroit, 1980.

Fagg, Bernard, *Nok Terracottas*, Lagos, 1977.

McIntosh, Susan and Roderick, "Finding West Africa's Oldest City," in *National Geographic*, Vol. 162, No. 3 (September 1982), pp. 396–418.

Segy, Ladislas, *African Sculpture Speaks*, New York, 1969 (3rd ed.).

Thompson, Robert Farris, *African Art in Motion*, Los Angeles, 1974.

Vogel, Susan Mullin, *African Aesthetics*, New York, 1985.

83. *Male Figure*
Mali, Bandiagara Escarpment, attrib-
uted to the Dogon people, Jenne style
ca. 15th century
Wood covered with sacrificial patina
32¾ × 6¼ × 7¼ in.

85. *Abstract Antelope Headdress*
(Chi Wara Initiation Society)
Guinea and Mali, Wassulu and
Bamana peoples
Early 20th century
Wood
25¾ × 10¾ × 2 in.

84. *Male Antelope Headdress*
(Chi Wara Initiation Society)
Mali, region of Koutiala, Minianka and
Bamana peoples
Late 19th–early 20th century
Wood
37¼ × 18 × 2⅝ in.

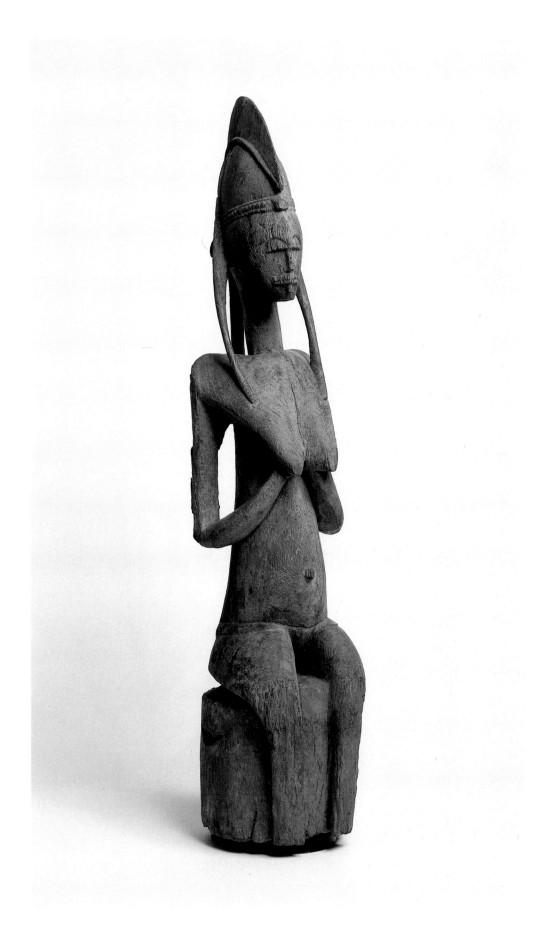

86. *Seated Woman (Gwan Cult)*
Mali, region of Dioïla, Bamana people
Late 19th–early 20th century
Wood
33½ × 6½ × 8½ in.

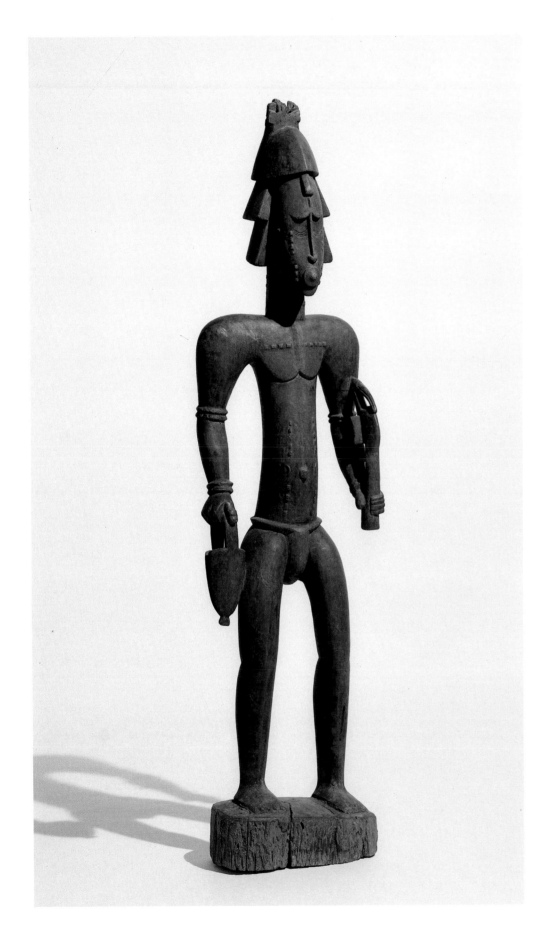

87. *Young Man Carrying Initiation Insignia*
Ivory Coast, Eastern Senufo people
Late 19th–early 20th century
Wood
50¾ × 12¾ × 7 in.

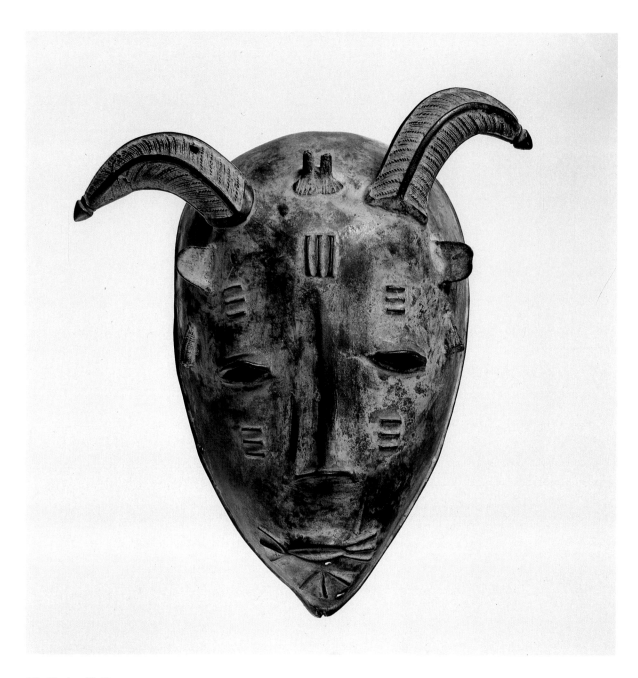

88. *Mask with Horns*
Ivory Coast, made by the Dyula people
for the Senufo
Early 20th century
Copper alloy
10 × 9 × 3½ in.

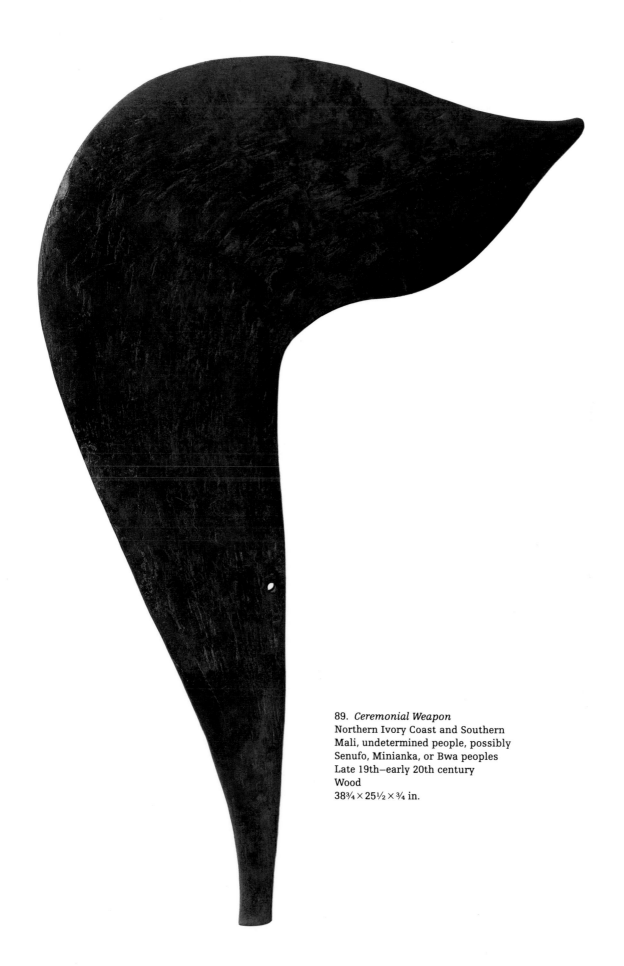

89. *Ceremonial Weapon*
Northern Ivory Coast and Southern
Mali, undetermined people, possibly
Senufo, Minianka, or Bwa peoples
Late 19th–early 20th century
Wood
38¾ × 25½ × ¾ in.

90. *Male Figure*
Nigeria, upper Benue River,
Mumuye people
20th century
Wood
40 × 4¾ × 7¾ in.

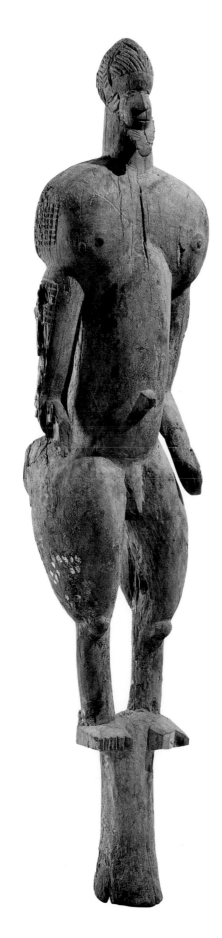

91. *Male Figure*
Nigeria, region between Shani and
Gombe, Mboye people
ca. 1470
Wood with traces of pigment
69½ × 14 × 14 in.

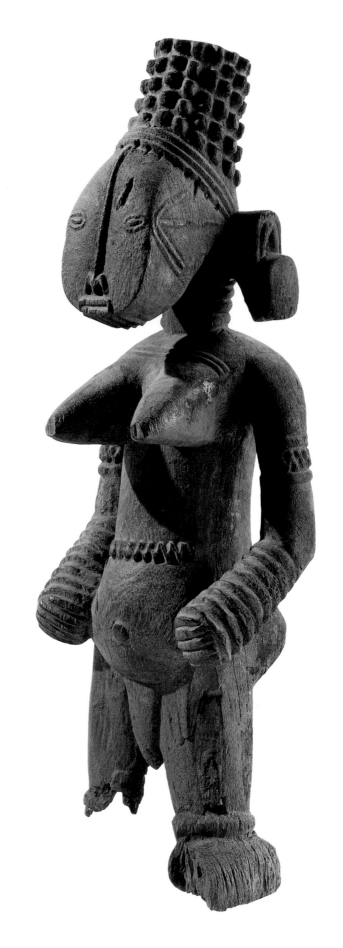

92. *Female Figure*
Nigeria, region of Wurbon Daudu,
Jukun people
Late 19th–early 20th century
Wood
23½ × 7⅞ × 8¾ in.

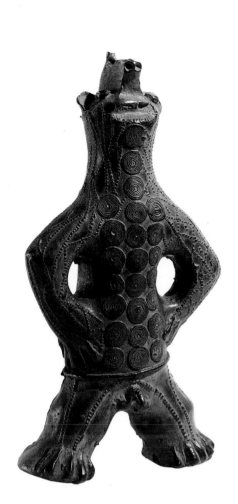

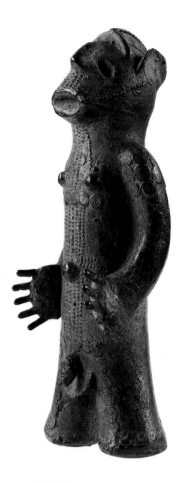

93. *Male Figure*
Nigeria, middle Benue River, possibly
Abakwariga people
Before 1850
Copper alloy
10 × 5¼ × 2½ in.

94. *Male Figure*
Nigeria, middle Benue River, possibly
Abakwariga people
Before 1850
Copper alloy
9¼ × 3½ × 2¾ in.

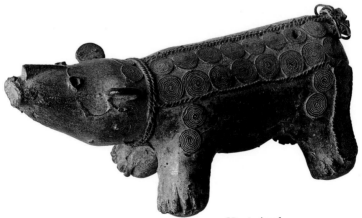

95. *Animal*
Nigeria, middle Benue River, possibly
Abakwariga people
Before 1850
Copper alloy
3½ × 8¼ × 3½ in.

96. *Mask*, Southern Guinea, probably Kono or Guerze peoples, early 20th century
Wood with metal, cloth, and string, 14½ × 18 × 3½ in.

97. *Royal Ancestor Seated on a Leopard Stool*, Ivory Coast, Baule people
Late 19th–early 20th century, wood with raffia, 26 × 9¾ × 8¾ in.

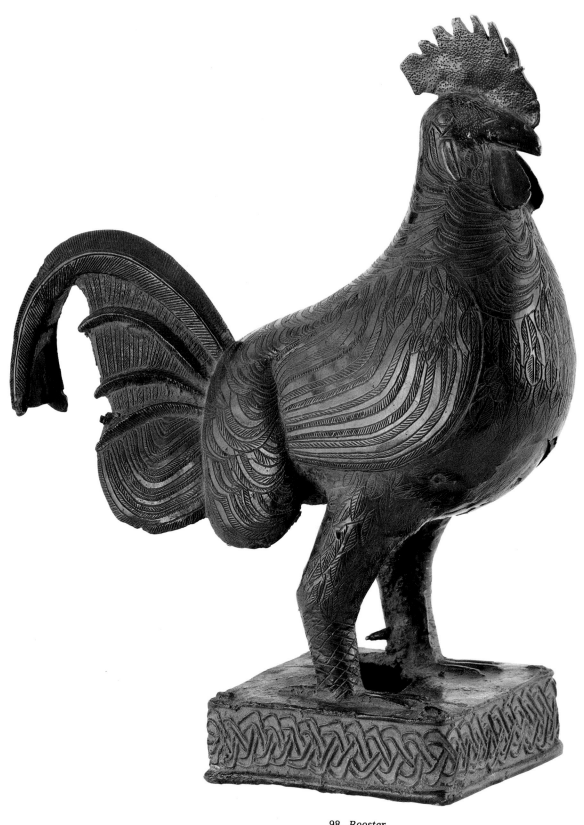

98. *Rooster*
Nigeria, Benin
ca. 17th century
Cast brass
20⅜ × 17¹¹⁄₁₆ × 8⅜ in.

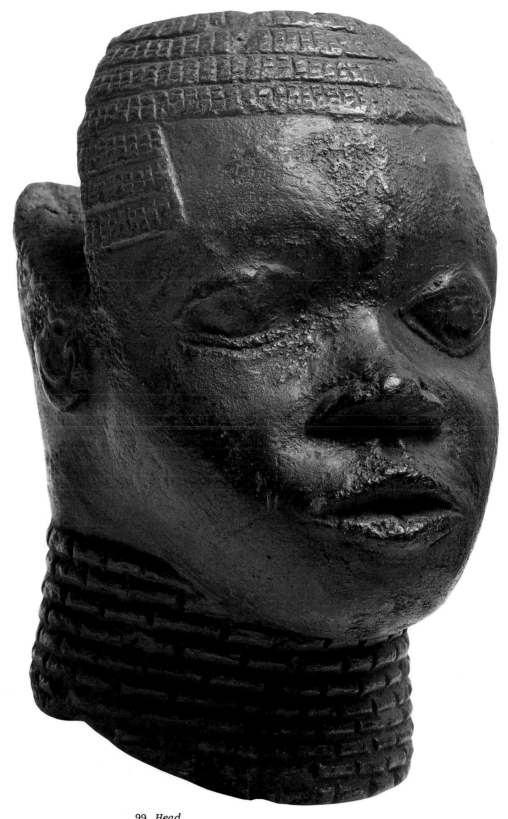

99. *Head*
Nigeria, Benin
16th century (?)
Terra cotta
9½ × 6 × 2⅞ in.

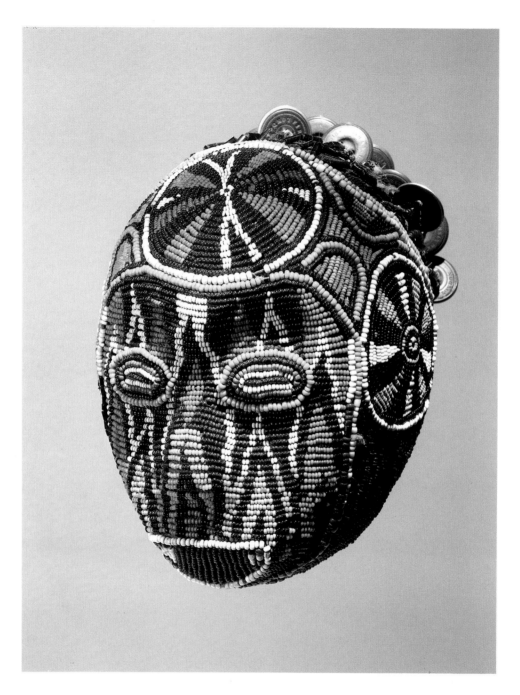

100. *Trophy Head*
Cameroon, region of Dschang,
Bamileke people
Late 19th–early 20th century
Wood covered with fiber, European
glass beads, and brass buttons
5½ × 5 × 7½ in.

Opposite:
101. *Funerary Mask*
Gabon and the Congo, region between
Ngounié and Niari Rivers, Shira-Punu
peoples
Late 19th–early 20th century
Painted wood
12¾ × 9¼ × 7⅞ in.

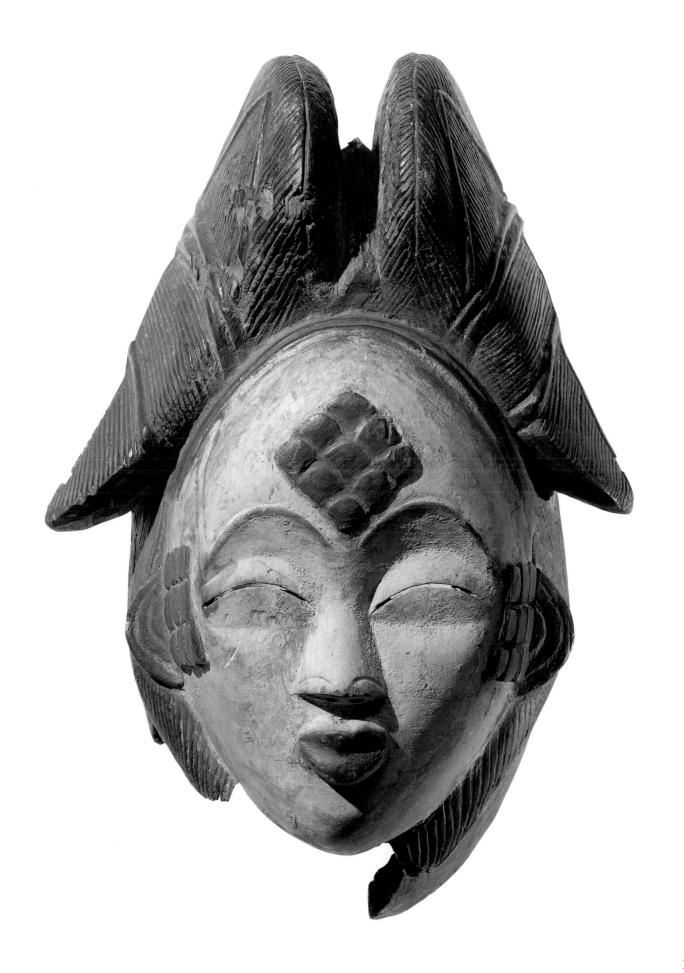

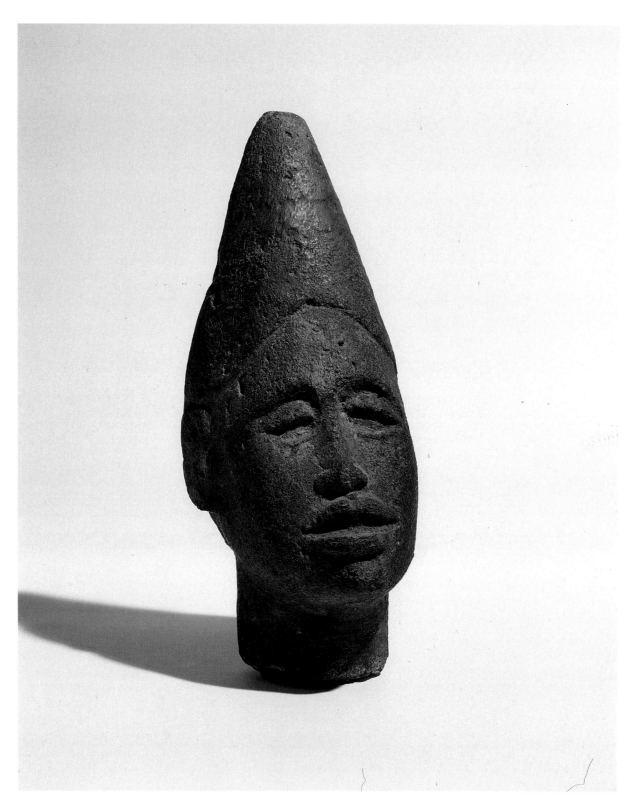

102. *Head*
Congo and Zaire, Western Kongo
people (Vili and Yombe)
Stone
11⅛ × 4½ × 4⅞ in.

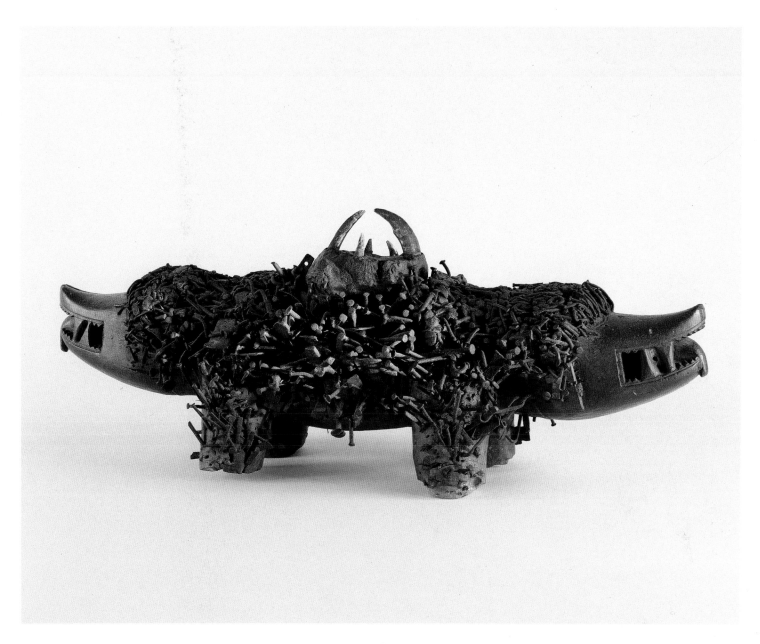

103. *Janus Dog (Nkisi Nkondi Malanda)*
Congo, Angola, and Zaire, Western Kongo people (Vili, Yombe, or Woyo)
Late 19th–early 20th century
Wood with iron nails, cloth, resin, animal teeth, and shell
10½ × 28½ × 8 in.

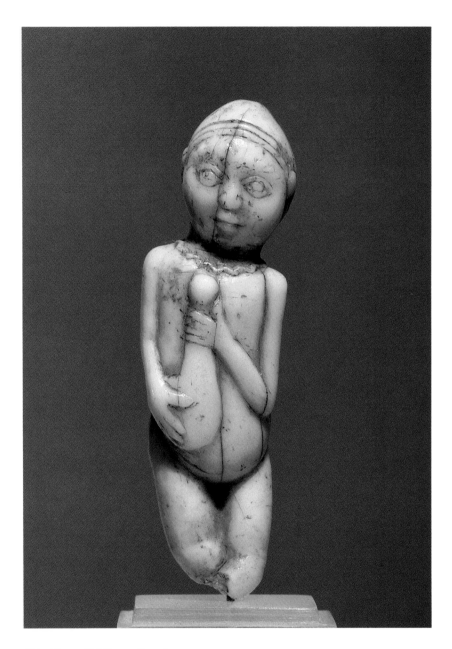

104. *Figure Holding a Gourd*
Congo, Angola, and Zaire, Western
Kongo people (Yombe or Woyo)
19th century
Ivory
$2\frac{5}{8} \times \frac{3}{4} \times \frac{7}{8}$ in.

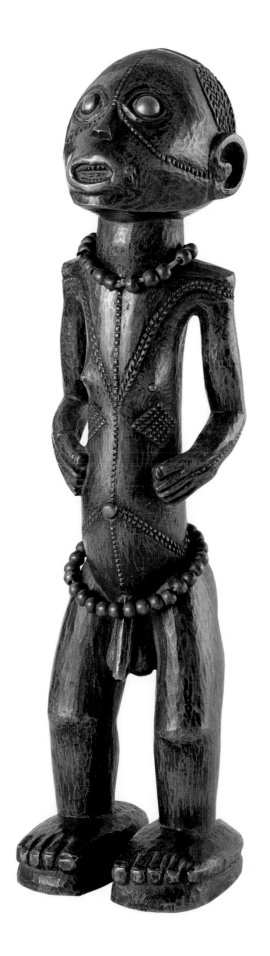

105. *Ancestor Figure*
Zaire, Tabwa people
Late 19th–early 20th century
Wood with beads and brass studs
14⅝ × 3¾ × 3¾ in.

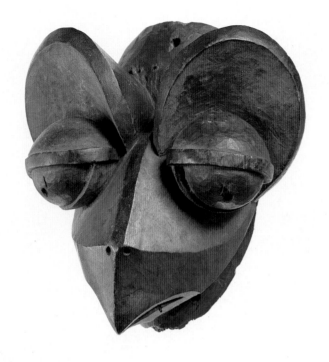

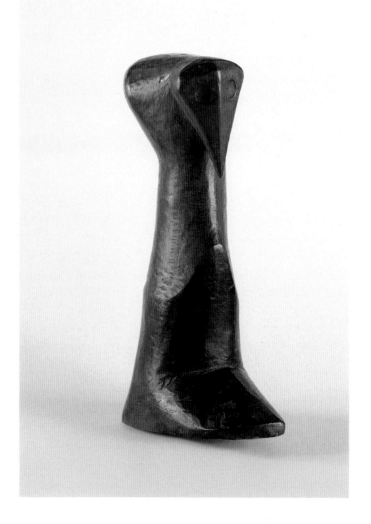

106. *Mask in the form of a Bird's Head*
Zaire, region of the Kwango River,
Yaka people
Early 20th century
Wood with paint
9 × 8⅛ × 4¾ in.

107. *Zoomorphic Head on a Foot*
Northeast Zaire, undetermined people
Wood
8 × 2¾ × 4¾ in.

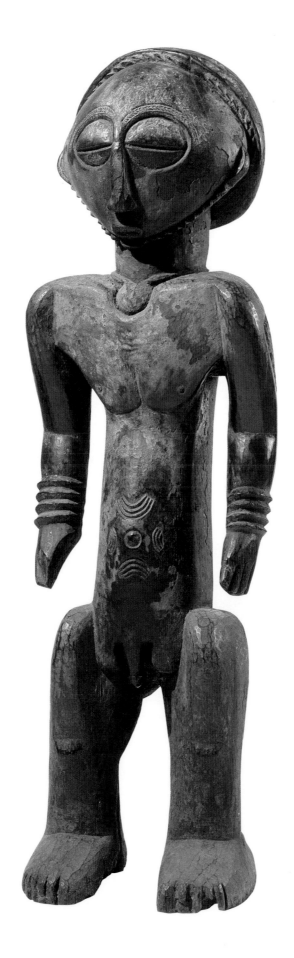

108. *Royal Ancestor Figure*
Zaire, upper Luama River, Boyo people
19th century or earlier
Wood and undetermined substance
inserted in crown of head
38⅜ × 11⅞ × 10½ in.

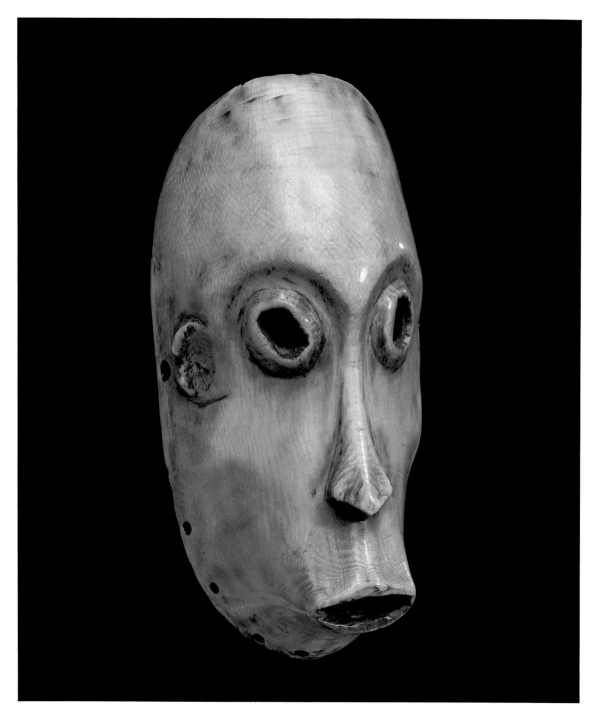

109. *Mask*
Zaire, Luama River, Zimba, Bango
Bango, or Hemba people
Late 19th–early 20th century
Ivory
8⅞ × 4⅛ × 2⅞ in.

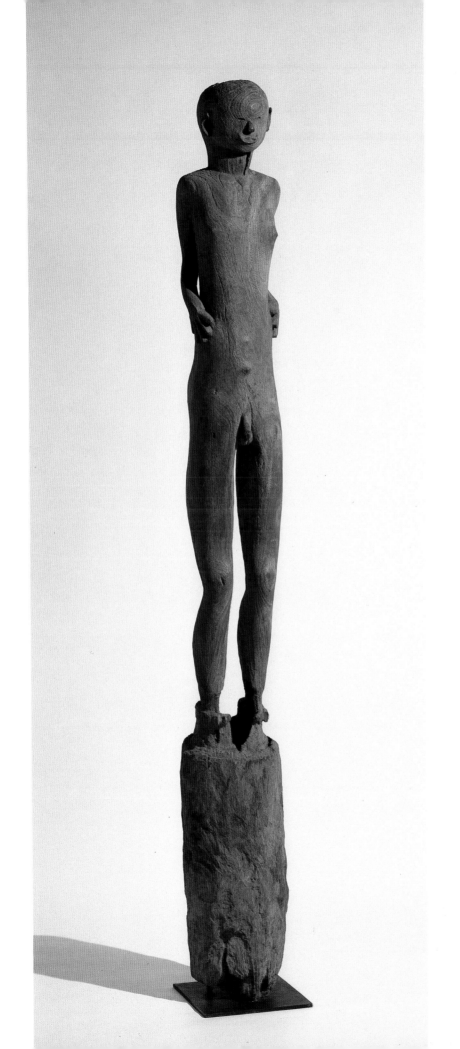

110. *Male Grave Effigy*
Sudan, western Bahr-al-Ghazal
province, Bongo or Belanda people
Late 19th–early 20th century
Wood
94½ × 11⅛ × 12½ in.

Southern Cross
A REFLECTION ON OCEANIC ART
Remo Guidieri

Aspiritual, matrixlike passageway molding history into shape, beyond recall: Oceania. It is the history of peoples, a history that is the galactic sedimentation of myths, which have been elaborated into oral, ritual, and plastic forms—forever incomplete. These are as intense as the hallucinations men project onto their own past in order to master it.

Asia is this gateway, opening onto the Pacific Ocean; through it for millennia have poured migrating peoples, a Babel of nomads settling on hundreds of tropical archipelagos consisting of flat white coral reefs; on jungle-covered excrescences of lava and alluvium; on paradisiacal coves where the fresh water of the estuaries is as treacherous as the foam-covered reefs; on littorals over abysses—pale blue mastabas in the distance toward which navigators have steered to cast anchor.

Since the sixteenth century we occidentals have become the vagabonds of this world where men stray on the sea lusting for the unknown. Like Ulysses in Dante's *Inferno*, we ventured to "the other side," to the southern hemisphere, watching out for the crests of uncharted islands now swallowed up by the sea, now emerging on a fogless day and traversed in haste through crowds of hostile islanders. With the trade winds filling the sails, this ocean is like a mirror that reverses our polarities—east becomes west, before becomes after. Traveling toward China, time flows backward. As in the metaphysical fantasies of Melville's *Mardi*, we sense the existence of a center, the Eye, the Mountain, or the silent universe of Cytherea, where opposites cancel each other. At the slightest move, east becomes west, and tomorrow is already today. With time I have become convinced that any consideration of the forms and cultures of the Pacific must somehow be grounded on this disorientation, and that such a symbolical spatial inversion, associated with a backward migration in time, cannot but be fraught with consequences.

A corollary to all this is the fact that Oceania cannot be sighted when leaving the American shores (*our* westernmost horizon), and that the Pacific is not tinged with American influence. Indeed, going *that* way, there are no traces of any cultural interplay; this seems to be confirmed by anthropological as well as archeological evidence (except perhaps for Easter Island). Therefore we must look to Asian roots for the Oceanic world, although proof of a common *Urbild* is not easily found and direct evidence will always be lacking.

Coming from Asia, one can trace the routes followed for millennia across Oceania by migrating peoples. One realizes that the Indian subcontinent (as Mead and Bateson have noted) has profoundly influenced the cultural heritage, social structure, and gestural as well as plastic expression of Indonesia—that outpost of Oceania and the last post among Indian islands. Skipping over Melanesia, that obscure bastion opening the way to Polynesia, one becomes aware of the similarities early noticed by A. M. Hocart between the forms of Vedic authority, the Indian hierarchical structure of the *Varna*, and the varieties of kingship systems allied to a system of rank found in Polynesia (particularly in Hawaii, Tahiti, and Tonga). Turning back to Melanesia, and following the intuition of the eminent specialist of Indonesia, H. C. Rassers, one can correlate the ogival shape of the screen of the Balinese

shadow theater with the facades of men's houses in New Guinea. The symbolic division that places male spectators on the same side of the screen as the puppeteers and women on the other side also structures many rites and is strictly observed in Melanesian social life.

While post-Vedic influence is clear and obvious in Indonesia, and more diffuse in Polynesia where it cannot be traced through historical analysis of cultural borrowings, there is yet another influence, more remote, more subterranean, and elusive—the influence of China. The link between ancient China and the cultures of the Pacific, particularly those of Melanesia, is undoubtedly the ancient primacy of ancestor worship—never denied by Confucianism or Shintoism; it is the postmortem projection of the human to an indestructible mnemonic site with impressive graves and stelae inscribed with invocations—to man's thanatological future as his most certain end.

Liturgical calendars, cyclical mourning observances, simultaneous funerary commemorations, and seasonal festivals—all suggest a deeply rooted affinity between Chinese sources and the Oceanic derivatives. If this is indeed the case, then the primacy granted by these cultures to the question of death and the hereafter must entail corresponding representations, especially plastic representations in which life, absorbed by commemoration, is clad in funereal attire, and everyday "furniture" becomes a commemorative device. These are disguises conveying the presence of the dead, or "tools" bringing about a coincidence between the metamorphosis of the dead into ancestors and the piety of the descendants. Loyalty to the dead becomes ritualized obsession, and the affinity between the two cultures is embodied, in the strict sense of the term, in the plastic motif of a hybrid human presence.

This hybridization despecifies; it negates what makes man a particular species among others in nature. It shows man's ontological duality but, above all, it entails metamorphosis. Hybridization as a concept and as a plastic expression confers duration to forms, to all forms, including change itself in the representation. To that end, form must be perpetually in process and primarily bear evidence that man as such is in transit toward a new nature.

In the China of the Yin and Tcheou dynasties, hybridization is found in the motifs of the *t'ao t'ie* mask, of the monster (*p'an k'ouei*), of the dragon with a bird's beak (*k'ouei wen*), and of the dragon itself (*long*). O. Sirén commented on the migration of these motifs to the south, toward India and Indonesia, with the mask called *kirtimukha* used in temples dedicated to Shiva in India and Java. One can also trace this to the heart of Oceania: the claw with three parted fingers holding the abdomen, as seen in The Menil Collection's remarkable Maori *poutokomanawa* (No. 113). This motif found on ancient Chinese pottery is the Maori *signatura*. It is applied to effigies, roof beams, and canoe prowheads; it is also found in other regions of Polynesia, on *tiki* of various sizes, on pirogue ornaments in Rarotonga (Cook Islands), and on the numerous objects, miniature or monumental, made of volcanic rock, wood, or bone of the Marquesas Islands.

On the Maori *poutokomanawa*, "a central ancestor figure" (Barrow: 26), the sculpted top of the doorjamb of the Chief's house (East Coast area, Rongowhakoata groups, North Island), the motif of the three-fingered hand is clearly related to the motif of the bird man as well as to that of the lizard man; this particular hybridization of the human extends from New Zealand to Hawaii via the Marquesas Islands (petroglyph figures) and via Easter Island (the *moai moko*, as well known as the *moai kavakava*).

P. Barrow, in *Two Studies of Art in the Pacific Area* (Vienna, 1966) wrote: "The important symbol of Maori carving termed *manaia* [this Maori expression is also found in Hawaiian] I believe is basically avian in origin, assuming human characteristics in many of its forms, and producing 'bird-men' of distinctive type." In Maori, *manaia* has such meanings as "chief," "beautiful decoration," "a certain lizard," and "seahorse." It refers to hybrid beings and/or exceptional beings endowed with authority. *Manaia* in Williams's dictionary of Maori is "a grotesque beaked figure often introduced in carving; so sometimes ornamental carved work," the word implying that which is excessive, therefore powerful. It is not surprising that throughout Oceania authority and its figures are expressions of ontological ambiguity—chiefs being half-human and half-divine, alive and dead at the same time. A *manaia* figure is a synthetic representation of ambiguity itself. It is the same with the Sepik effigies, some of which are found in The Menil Collection—the stoppers for flutes used in initiation rites (in the Bwat and Mundugumor areas); others of the hook-style type, found east of the Karawari and Sepik rivers, are single-legged and vary in size from 30 to 40 centimeters to 2 meters. Of note are the motifs of the bent legs and the nose joined to the body's bone structure. These traits are also found in pieces from the Mindimbit area (Yatmul group) or from Tambunum more to the east, which are close to the flute-stopper effigies.

The eternal return—myth or (self) initiation—enacts the mimesis of that which occurred in the beginning: the god's self-sacrifice in the Vedic tradition; or the redemption offered by the crucified Christ; or the killing of the king, naked as in the woods of Nemi or in full attire as in African kingships; or the apparition on a natural screen of the primary Being, such as the black silhouettes of the Australian *mimi*—petroglyph shadows outlined by a thick black halo, which men charged with their remembrance draw again and again on the walls of caves where commemorative rituals are performed.

In a society that constantly refers itself to the beginning (and this is the true meaning of tradition), the beginning not only has authority over memory but depends on the representations periodically summoned by memory. The re-enactment must appear as if brought about by men, but must also be endowed with a life of its own. It is hardly possible to distinguish narrative mimesis (myth or ritual) and mimesis inherent in objects (ornament or effigy). Cult objects, whether called idols or fetishes, are the instruments of invocation used in commemorative rituals. The Oceanic world understands both. It is through commemoration that the link with the Asian matrix is confirmed.

Commemoration relates a genesis of cosmic order and seals man's position as a generic entity. It stands for rupture and beginning, the narrative of what happened. To commemorate is to reconstitute the initial event. Or, in another way of commemoration, one forces evocation to coincide with vertical memory, which links the beginning to men of the present according to a particular causality, articulated with names themselves linked with figures. In this case, evocation must combine the narrative and the reconstitution of presences.

Verbal commemoration is spun with an infinite wealth of details, according to the twists and turns of narrative argumentation. In the other type of commemoration, which can complement, disavow, or ignore the verbal form, it is the closed and compact image that embodies the event. Idols show the specificity of their approach.

From what little remains of Polynesian cosmological tales, the dawn of the world is suggested as an immensity still untouched by divine will, a universe whose

primary elements in their disjunctions and combinations are reminiscent of Asiatic dualism. For instance, in the Hawaiian *kumulopo* verse, in the beginning the divine is a yet sterile force resting on its own echo. The order engendered by genesis actualizes the primordial complementarity of the elements: *'ao*, light, and *poo*, darkness.

The other type of commemoration is found mostly in Melanesia. There too we find order, but precarious order, throbbing with the human rhythmical pulsations: birth, death. And although the principles are inevitably primordial, they appear less abstract than those of Polynesia because they are representations, anthropomorphized. That is why perhaps Melanesia, due to this tendency of relating everything to the human and this necessity of identifying the beginning and time to human destiny, conveys more than Polynesia a plastic conception of miracle—miracle essentially Baroque as E. D'Ors saw it. So powerful is the need for hypostatic movement that reason is subsumed. The hybrid presence is arrested while in motion, expressing the necessity to make the metamorphosis visible for commemorative purposes. More hauntingly than in Polynesia, in a plastic frenzy admired by the West, the forms that remind one of the origins of ritual evocations are bloated and deformed like anamorphic images: bodies coil like snakes and factually illustrate man's totemic destiny; appendages such as nose and penis meet; verticality becomes limp and bent; volumes are flattened. Commemorating seems to require evocations conceived as ontological collages, which obviously supersede the effects— marvelous though they be—of the narrations. At each event, upheaval, birth, and rebirth (initiation), war, and death, posts are erected to which men's wills can cling. In the many spirits summoned by the Melanesians the need for evocation through teratomorphic miracles remains constant. It is as if evocations could achieve perfection only by multiplying presences, and that the mystery of the universe's rhythmic motion could be perceived only by hyperboles. These stooping silhouettes endowed with phosphorescent eyes seem to be summoned to create a sharp contrast with everyday banality. The clear eye sockets, enlarged and outlined with fresh lava, of the polychrome figures from Ambryn, the fixed, pearly saurian eyes of the miniature idols from the Mundugumor area, or the flat, convoluted skeletal figures from the Karwari region—all these forms distract the mind away from language toward the discovery of the other world, a world as dense as the earth is thick with innumerable strands when it is upturned by men's sticks.

From this whispering swamp, this warm, posthumous mangrove in which species are reconciled, sap flows like lava, and figures stand still on the dance ground or are hidden in corners of men's houses, turning memory into a procession of epiphanies.

111. *Effigy (Tiki)*
Polynesia, Marquesas Island
18th or early 19th century
Volcanic stone
16¹⁵⁄₁₆ × 6⁷⁄₈ × 5½ in.

112. *Lizard Man (Moko miro)*
Polynesia, Easter Island
Wood (*toromiro*)
2¼ × 17 × 3½ in.

113. *Post Figure (Poutokomanawa)*
New Zealand, Maori
Wood
14½ × 4½ × 4½ in.

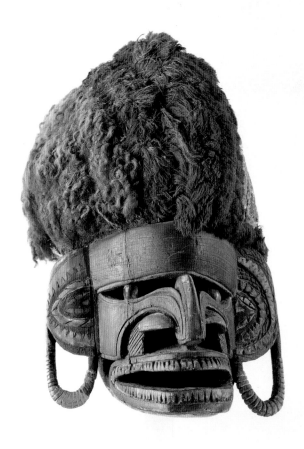

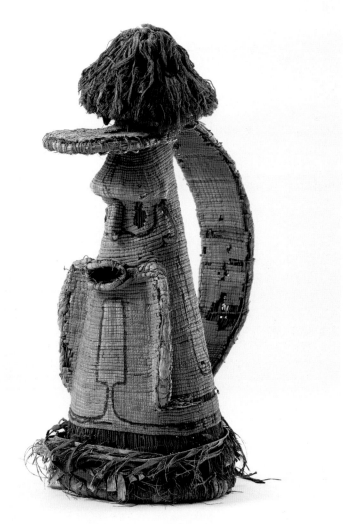

114. *Malanggan Mask (Tauatua)*
Melanesia, New Ireland
Wood with pigment, fiber bark, lime,
and shell
12¾ × 6 × 14⅜ in.

115. *Mask*
Melanesia, New Britain, Gazelle
Peninsula, Suka tribe
Palm wood with pith and pigments
24½ × 10⅜ × 16½ in.

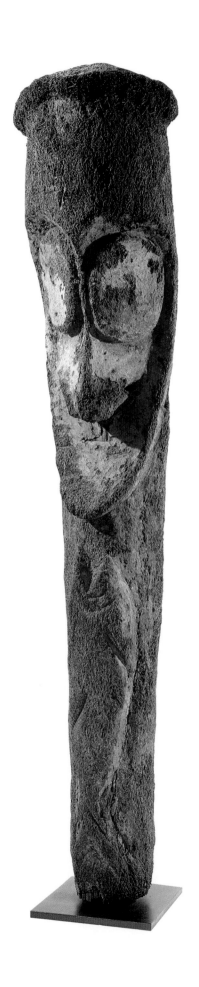

116. *Grade Society Figure (Mage)*
Melanesia, New Hebrides, northwest
of Ambrym Island
Fernwood and pigment
88 × 18 × 20 in.

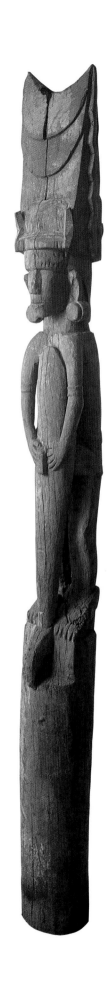

117. *Ancestor House Post*
Melanesia, Solomon Islands, Santa
Anna Islet, village of Lupana
Mid-19th century
Wood
102 × 11 × 13 in.

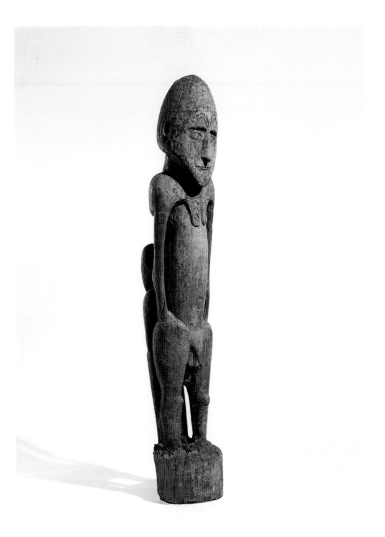

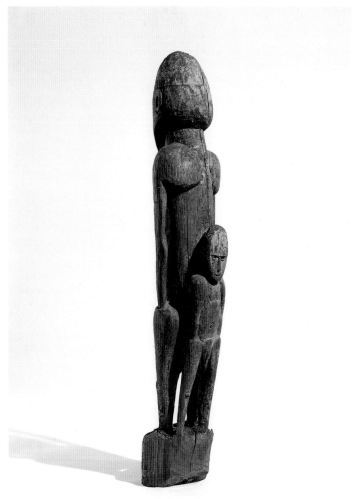

118. *Ancestral Couple* (front and rear view)
New Guinea, Irian Jaya, northwest coast of Lake Sentani
Wood
40⅝ × 7⅛ × 8⅛ in.

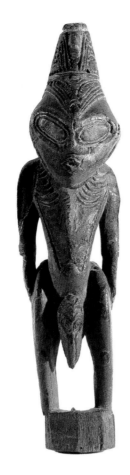

119. *Male Effigy (Malita kandimbwag)*
Papua New Guinea, lower Sepik River
Wood
10⅜ × 2⅝ × 1¾ in.

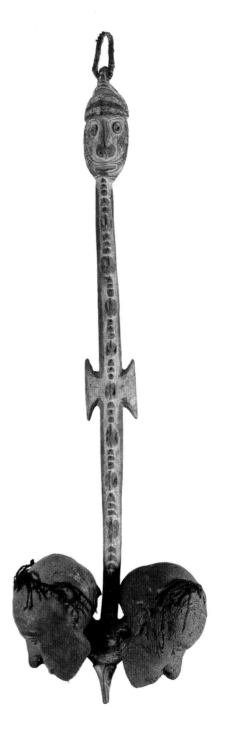

120. *Suspension Hook*
Papua New Guinea, Sepik River
Wood with pigments and human
skulls covered in clay with shell inlay
49½ × 14¾ × 6⅞ in.

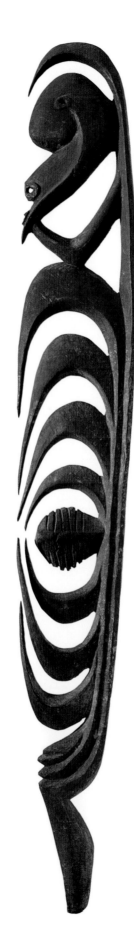

121. *War and Hunting God (Yipwon)*
Papua New Guinea, Wagameri River,
Mangubura village, Tangulamas people
Wood
8½ × 11½ × 4 in.

Deeply Carved
ART OF THE NORTHWEST COAST
Edmund Carpenter

Intellect and energy explain the preeminence of the Northwest Coast tribes in North America. Not that other tribes lacked intelligence or industry. But these coastal people focused their vast energies on technical problems which they solved artistically. Their solutions were uniformly elegant, beginning with graceful seagoing canoes, each shaped from a single log, some up to sixty feet in length.

When you go to sea, you need technology to a degree never demanded on land. Northwest Coast canoes were not just dugouts. There came a moment during construction, after the log had been hollowed and steamed, when it was "snapped" into its final spread-side form. If, in that single moment, it failed to assume a perfect balanced form, the whole effort was wasted. So a ridge was retained on the inside, which created just the stress and control needed to guide this huge shape into a beautiful form that could navigate stormy seas.

Surely the prototype for the little sheep-horn bowl (No. 125) was the cedar canoe, both in production and form. The horn was first carved out, steamed and spread, then locked in a mold where it cooled, retaining its new form. Similar molds were used in the Caroline Islands to shape bowls of tortoiseshell. My guess is that both imitated Asian molds used for metal-casting. The metallurgist's technology of softening by heat, then shaping by mold, was simply applied to horn in Alaska and to shell in Micronesia.

Northwest Coast artisan-carvers delighted in such problems. We still do not know how they made their fluted steel daggers, some of which they inlaid with copper; but however it was done, the result was worthy of a Persian armorer.

Challenge drew them on. They were richer, more powerful than anyone else they knew, and that is always a heady role. They acted like fifteenth-century Florentines. Fortune and fame, treachery and death, were daily concerns. Every house was a stronghold; every town a citadel. Raiders returned with booty and slaves. Rival families and towns, with a special gift for fighting one another, amassed and displayed wealth, commissioned works by leading carvers, imported treasures, and treated even the smallest village as a work of art. Some wealth was publicly displayed; other works could be seen by invitation only; and some objects were kept out of sight until the proper feast or ritual. Then they were unwrapped, handed about, examined carefully. All were judged by communities of informed critics.

Two basic styles characterize this art: Northern and Southern, with an earlier sculptural tradition underlying both. In the Northern style, surface treatment dominates, while in the Southern style, the sculptural freedom of the earlier tradition is retained, though sometimes overlaid by a surface decoration imported from the North.

The earlier, underlying tradition was generic to sculpture all along the coast: posts and figures, bowls, masks, rattles. Human and animal motifs, though emphasizing important features and suppressing nonessential details, remained rather naturalistic. Paint, when employed at all, merely emphasized sculptural forms or added naturalistic details. Surfaces were not the primary concern: large areas might be left unfinished.

Few examples of this earlier art survived in that damp fungus-rich environment. But fortunately a handful of carvings were collected in the earliest years of European contact. The mask (No. 128) was acquired by Captain James Cook, presumably at Nootka Bay in 1778.[1] Originally it had tufts of human hair attached with pegs and eyebrows attached by pitch. Its open mouth and puckered lips remind me of *Tsonoqua* masks, still used by the Kwakiutl today.

When Cook's ships entered Nootka Bay, they were greeted by a chief wearing a mask and shaking a rattle in the form of a bird. While he danced, his companions in other canoes accompanied him by singing and beating the sides of their canoes with paddles.[2] Later, the "Natives woud sometimes bring strange carv'd beads, & place them in a conspicuous part of the ship, & for these they would receive no return.... At the time when the Captain prevailed on some strangers to venture down into his Cabbin, they carried four wooden busts which they Placed in the Cabbin in a particular order...."[3] At least two of these gifts survive.[4] Both are unpainted and lack abalone eyes. Otherwise they generally resemble the carving in No. 127. No documentation accompanies this painted example, but it is Nootka, early, and presumably represents a decapitated human head. I assume it postdates First Contact, but not by many years.

The same comment applies to the Nootka rattle (No. 126). Again it is early and classic but with crisper lines than most of the bird rattles collected by Cook.[5] It gives an initial impression of serene simplicity, yet every element in this elegant design has its counterforce: curved vs. fluted surfaces; delicate lines vs. massive body; convincing naturalism vs. divided neck; tiny blue eyes vs. soft brown surfaces.

Before Contact, the southern tribes seem to have worked almost wholly in free sculpture. After Contact, they retained this freedom but grafted onto it painting and surface decoration borrowed from the North. What they did not borrow were the strict rules of color and composition governing the northern graphic tradition. The result was a freer use of color and form. At its best, this added to the wild extravagance of southern theater; at its worst, it turned controlled art into Halloween abandon.

By contrast, northern artists stuck to the rules. They wandered from flat-design to sculpture, then back, but flat-design always remained the model. Where southern artists carved naturalistic animals, hollowed them out into bowls, then perhaps added decoration, northern artists produced bowls whose surfaces accepted animal designs without violation. They used only full-face and profile views. Ribs, vertebrae, and joints were made visible. Symmetry remained a domineering principle, often achieved by "splitting" the subject into two symmetrical profiles for all or part of its length.

Basically, this was a painters' and engravers' tradition. Its subjects were animal and human motifs serving as crests for moieties and clans, families and individuals. Artists distorted nature by reducing each crest to its essential parts, exaggerating and distorting some of these, then dislocating and rearranging them within the design. By accentuating particular features of crest animals, they created an iconography of recognized symbols. To this they added highly conventionalized design elements such as ovoids, u-forms, and s-forms. The total effect was formal, intellectual, austere.[6]

I know of no better example of this than the Tlingit carving illustrated in No. 122. Here a sea-mammal headdress imitates a war helmet, complete with "visor" around its base, thus reminding the audience that this crest was earned in battle.

Primary form-lines cover its surface, filling the space completely. No vital feature is missing or misplaced. No extraneous addition violates its superb simplicity. The primacy of flat-design is obvious, yet the translation to three dimensions is flawless.

This is the sort of art sometimes described, by the people themselves, as "deeply carved," though many of the objects so honored are not carved deeply and, in this case, the carving is scarcely deeper than engraving. That metaphor covers other virtues: timeless tradition, fine workmanship, above all balanced composition—not balanced as equilibrium of repose but contesting forces frozen in unresolved rivalry.

Bill Reid writes: "If every line must flow in a course, and no matter how it swells and contracts, must eventually turn again upon itself, and each part of that line, wide or narrow, straight or curved, has equal strength, the tension is enormous. If every structure, be it box or totem pole, spoon or handle or rattle, must have for every thrust a counter thrust, then each object becomes a frozen universe, filled with latent energy."[7]

This style developed in the North probably well before Contact. I see its ultimate roots as Asian, some as deep and distant as the Amur region, but more immediately around the Bering Strait. Here ancient engravers applied immensely sophisticated flat-designs to ivory surfaces, complete with form-lines, ovoids, and spurred-circles. They "wrapped" tools in complex animal designs, using metal, small quantities of which reached them as early as A.D. 300.

Iron and steel remained rare in the Bering Strait until the coming of Europeans. But it was enough: artists learned the latest fashions and executed them with proper precision. Distant trade routes connected these arctic seafarers with tribes well to the south, on each continent. They became, literally, "middlemen," wealthy traders and raiders who wore armor, traveled in large boats, and prided themselves in wearing the latest fashion.

Furs, ivory, and possibly copper moved west; metals and fashions moved east. Fashions became a major by-product of this northern trade, leaving a legacy far out of proportion to the amount of goods actually received. I doubt if more than bits of iron and steel ever reached the Northwest Coast, but metal-inspired fashions certainly got through, and local artists were ready for steel when it finally arrived in quantity.

Did these northern tribes also acquire, from this same arctic source, their playfulness in art, their love of visual puns and comic combinations? Originality, in both places, was not a matter of theme but of treatment; austere adherence to rules combined with playfulness. Consider the Tlingit pipe in No. 123. Here the carver, without once violating classic forms, created a bird that is no bird. With massive head tilted back and chest thrown forward, it looks monumental but is less than five inches high. Its mischievous expression, the worried little man on its chest, and a third figure, which shares the bird's claws and tail feathers, all declare that something special is going on here, known to the bemused owner and probably to some of his friends.

Humor was not limited to secular subjects. The Nootka curtain (No. 129) depicts the epic struggle between Thunderbird, guardian of the Upper World, and Whale, guardian of the Underworld. Here that cosmic conflict is treated with joyous exuberance: Thunderbird spreads its great wings; Whale holds a creature in its jaws; Lightning Serpents (on the wings) and Wolves (in the Whale) bare their sharp teeth; while a little man stands inside Thunderbird, openmouthed.

Northwest Coast art was wholly representational, yet none of its figures belonged to this world. Even crest animals, used solely for social events, possessed mythic attributes and engaged in extraordinary activities. Among these unworldly figures were Primordial Ancestors who swallowed both the living and the dead, then disgorged them reborn. No documentation accompanies the wooden comb (No. 124), but the Tlingit who made it told of an Ancestral Bear whose body offered new life to novices and dead alike.

We can never translate such a myth perfectly because we lack an identical mind to grasp it, but remnants of mythology from our own past offer clues. In Western cosmology, God made man from His excrement; Jonah, spiritually reborn in the belly of the whale, came out crying, "Salvation is of the Lord;" and Christ, in the Harrowing of Hell, pried open a monster's jaws to release Adam and Eve and other biblical figures who died before Him. We still speak of the "jaws of death," for Death, that hungry monster, consumes all life, and we call the great recycler of life "Mother Nature."

NOTES

1. This mask was sketched by Sarah Stone (see *Force and Force*, 1968, pp. 143, 186) and Thomas Davies (*Album*, f. 37, British Museum) in the Leverian Museum. See Kaeppler, 1978, fig. 564 and pp. 258–59; and King, 1981, p. 77.

2. Beaglehole, 1967, pp. 1089–90.

3. Lt. James King, as quoted in Beaglehole, 1967, p. 1414.

4. See Kaeppler, 1978, fig. 565 and p. 258; and King, 1981, fig. 88 and pp. 79–80.

5. See Kaeppler, 1978, figs. 569–73, especially fig. 572, and pp. 260–61; and King, 1981, figs. 73–75 and pp. 71–73.

6. Paraphrased from Duff, 1967, p. 40.

7. Reid, 1967, p. 45.

BIBLIOGRAPHY

Beaglehole, J. C. (ed.), "The Voyage of the *Resolution* and *Discovery*," *The Journals of Captain James Cook on His Voyage of Discovery*, vol. 3, pts. 1, 2. London, Cambridge University Press for the Hakluyt Society, 1967.

Duff, Wilson, "Contexts of Northwest Coast Art," *Arts of the Raven*. Vancouver, Vancouver Art Gallery, 1967, pp. 738–40.

Force, Roland W. and Maryanne Force, *Art and Artifacts of the 18th Century, Objects in the Leverian Museum as Painted by Sarah Stone*. Honolulu, Bishop Museum Press, 1968.

Kaeppler, Adrienne L., *'Artificial Curiosities' being An exposition of native manufactures collected on the three Pacific voyages of Captain James Cook, R. N. at the Bernice Pauahi Bishop Museum January 18, 1978—August 31, 1978 on the occasion of the Bicentennial of the European Discovery of the Hawaiian Islands by Cptn. Cook. January 18, 1778*. Honolulu, Bishop Museum Special Publication 65, Bishop Museum Press, 1978.

King, J. C. H., *Artificial Curiosities from the Northwest Coast of America: Native American Artefacts in the British Museum collected on the Third Voyage of Captain James Cook and Acquired through Sir Joseph Banks*. London, British Museum Publications, 1981.

Reid, Bill, "The Art—An Appreciation," *Arts of the Raven*. Vancouver, Vancouver Art Gallery, 1967, pp. 45–46.

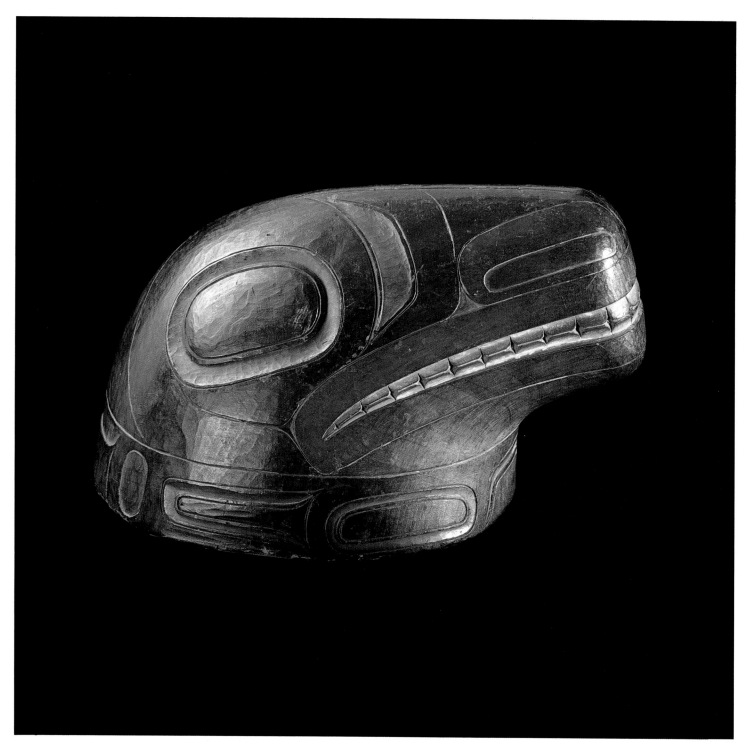

122. *Sea Mammal Headdress*
Alaska, Tlingit people
Wood with paint
7 × 12¼ × 7⅞ in.

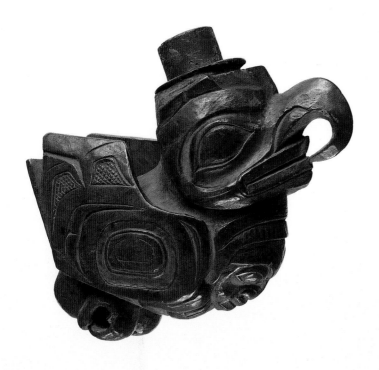

123. *Pipe*
Alaska, Tlingit people
Wood
3⅝ × 4⅞ × 2⅛ in.

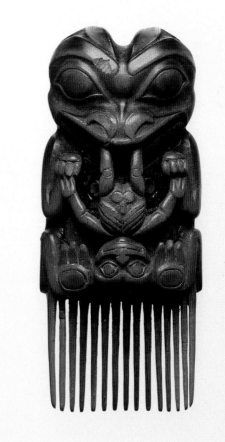

124. *Comb*
Alaska, Tlingit people
Wood with olachen oil
5¾ × 2⅝ × 1¼ in.

125. *Dish*
Alaska, Tlingit people
Sheep-horn
$3\frac{1}{2} \times 7\frac{5}{8} \times 5\frac{3}{4}$ in.

126. *Rattle*
Canada, Vancouver Island,
Nootka people
Wood with beads
$6\frac{1}{4} \times 16\frac{1}{4} \times 5$ in.

127. *Head*
British Columbia, Nootka people
Wood with paint, abalone shell, and
human hair
6¼ × 5⅜ × 4¾ in.

128. *Mask*
Canada, West Vancouver Island,
Nootka people
ca. 1750–1775
Wood with pigment, pitch, and
human hair
10 × 7¼ × 5¾ in.

129. *Curtain with Thunderbird
and Whale*
Canada, West Vancouver Island,
Nootka, Nitinat people
ca. 1860–1870
Painted muslin
81½ × 247 in.

TWENTIETH CENTURY ART

This selection of twentieth-century paintings, sculpture, and drawings is presented in an essentially chronological sequence. Art from the late nineteenth century to contemporary developments has been grouped according to affinities among individual artists or to a particular historical nexus. The Collection's involvement with art from the first half of our century has been almost exclusively with European modernism, mostly centered within the School of Paris. German Expressionist work, for example, is absent. From mid-century to the present, the majority of the works are American, although important bodies of material contrast related French and American activities.

A duality in which the abstract/structural is counterposed with the imagistic/iconological is found throughout the entire range of twentieth-century works. This occurs with the first group of works selected. Paintings and drawings by Ensor and Redon on the one hand, and by Cézanne and Seurat on the other, embody polar impulses: a haunting Symbolist imagism as opposed to phenomenologically structured form.

Two early paintings by Rouault and Matisse exemplify the graphic and chromatic intensity of Fauvist painting. They are set against important examples of Analytic and Synthetic Cubism, seen here in works by Picasso, Braque, Gris, and Léger. Two artists have been included here who were not part of French Cubism: Kurt Schwitters and Stuart Davis. Although the major figure within German Dadaism, Schwitters reveals a brilliant command of Cubist structure. Stuart Davis stands as the first artist to have translated Cubism into an American idiom. A rare painting by Léger (No. 144), one of only four completely abstract compositions by him, relates not only to Cubism but to important examples of nonobjective art: a Suprematist composition by Malevich and two Neo-Plastic compositions by Mondrian.

Klee and Miró stand as unique figures apart from the Expressionist and Cubist developments of their respective Swiss-German and Catalan-Parisian backgrounds. Each shares affinities with the Surrealist movement. Their free use of line and poetic imagery, informed with refined wit, resonates between Cubist form and Surrealist narrative.

Surrealism comprises the most celebrated body of work within the Collection. The tendency of the de Menils was to pursue Surrealism in terms of the power of the evocative image rather than in its engagement with automatism. Artists both of and related to the Surrealist movement are sequenced chronologically here, according to the historical emergence of their work. This selection begins with two works by de Chirico, the most important precursor of the Surrealists. Max Ernst's art has been collected in the greatest concentration of any artist in the Collection, and the selection here surveys the breadth of his career. René Magritte has been collected in a depth second only to Ernst, and included are several of the most renowned works from his career. The work of Victor Brauner has also been collected extensively, particularly his late work which introduces elements of Rumanian folk art into his Surrealist vocabulary.

Among the S realist works, significant examples by other artists have been included in reveal special facets of the movement, its complexities and impact. e from the late twenties and the other from the late thirties, b list period. Also included are works by two Americans, Ma an Ray is represented by one of his finest paintings, a the eighteenth-century libertine and man of letters. Joseph Cornell's two intimate object-poems date from his pre-1950 affinity with Surrealism. nary sculpture from 1970 dates beyond the period with Surrealism; however, its playful eroticism keys to st canon.

 note is the body of work from the period between 1942–52, years. Within it, three sets of activity have been distinguished: or figures of the School of Paris seen here in their full mastery; sec- younger generation of artists whose careers developed in Paris; and m the generation of vanguard American artists contemporary with the er Parisian artists. The first set is comprised of important examples of mid- tury work by Matisse, Braque, Picasso, and Léger; the second, of works by Jean Fautrier, Jean Dubuffet, Wols, Luis Fernandez, and Alberto Giacometti. The third set reflects the development of American Abstract Expressionism, from an early work by Jackson Pollock to paintings from the forties by Arshile Gorky, Mark Rothko, Willem de Kooning, and Clyfford Still.

Among the artists of the New York School, a particular commitment has been made to the art of Barnett Newman and Mark Rothko. Their innovations and achievements, along with those of Pollock and Still, most radically broke with and extended the structural imperatives of modernism from the early part of the century. Contemporaneous sculptures by Alexander Calder and Tony Smith have been juxtaposed. Calder's biomorphically-derived abstraction, which developed during the first part of the century in the framework of European modernism, is contrasted here with the geometric abstraction of Tony Smith, a participant in the postwar developments of the New York School.

Rauschenberg, Twombly, and Johns are from the second generation to emerge within the context of the New York School. Unique examples of their earliest work have been assembled in The Menil Collection. Included here is a work by Joseph Cornell, of the same period, which evinces certain visual and poetic parallels with the work of these younger artists.

Frank Stella and Yves Klein, in America and France respectively, pioneered the most authoritative directions in abstract art of the last twenty-five years. The literal physicality of Stella's deductive structure contrasts with the implicit metaphysical nature of Klein's work. The tenets vigorously set forth by Stella inform what has been identified as a Minimalist aesthetic, associated with work such as that by Dan Flavin and Walter De Maria. Perhaps the greatest influence to date of Yves Klein's work, following his untimely death in 1962, has been in the realm of conceptual art and performance.

Parallel in time with the abstraction of Stella and Klein is the development of American Pop Art and European *Nouveau Réalisme*. Characteristic of these developments is the abrupt introduction of common, cultural imagery and found material into formats previously established by modernist abstraction. Among the works chosen, contrasting sensibilities are most acutely revealed in the iconic isolation or

serial repetition of image in the case of Warhol versus the complex, absurdist assemblages of Jean Tinguely.

George Segal and Wayne Thiebaud were initially viewed in the context of Pop Art. However, the essentially representational nature of their art relates to a sustaining tradition of American realism as exemplified in the paintings of Edward Hopper.

An important imagist work by Larry Rivers, *Four Hanged Men*, was part of an exhibition commissioned by John de Menil for the Rice Museum in Houston in 1971. The exhibition, "Some American History," included Rivers and six Afro-American artists, making works that addressed brutal facts of the role of blacks in American history. Beyond the shocking subject matter of four hanged men, Rivers's rope-hung paintings introduce a deliberate irony: the real-world versus the art-world practice of "hanging."

The most active collecting of twentieth-century and contemporary art by the de Menils took place prior to the mid-1970s; acquisitions within the last ten years have been far more selective. Reflecting the more current concerns of the Collection would be the paintings of Brice Marden and David Novros, and the sculpture of Walter De Maria, Michael Heizer, and Mark di Suvero. Both Marden's and Novros's reductive paintings are consonant with the metaphysical position of Rothko's work and with aesthetic and philosophical concerns of the Collection. Likewise, di Suvero's monumental constructed forms, Heizer's negative carving in the earth, and De Maria's precise fabrications, each address issues of physicality and metaphysical transcendence through minimal forms.

This selection concludes with what appear to be markedly dissimilar works from the present by Michael Tracy and James Lee Byars. Byars's ideative abstraction seems enigmatic as to meaning, while Tracy addresses topicality through a historically referenced form. This form, a Catholic cross encrusted with votive *milagros* and piercing blades, responds to the anguished conditions in Latin America today. Byars's work, on the other hand, while formally related to currents of contemporary abstraction, suggests timelessness and unstated narrative. Together they recapitulate the dialogue between pure form and iconographic image that pervades The Menil Collection.

Walter Hopps

130. JAMES ENSOR (1860–1949)
Untitled (Masked Ball), ca. 1890
Oil on canvas
31¾ × 39½ in.

Opposite:
133. PAUL CÉZANNE (1839–1906)
Trees at Le Tholonet, ca. 1904
Oil on canvas
31¾ × 25½ in.

131. GEORGES SEURAT (1859–1891)
Corner of a Factory, ca. 1883
Conté crayon on paper
9¾ × 12⅝ in.

132. ODILON REDON (1840–1916)
Untitled, ca. 1885
Charcoal and ink on paper
16 × 12 in.

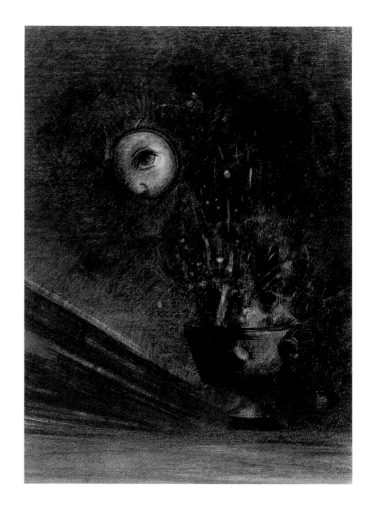

178

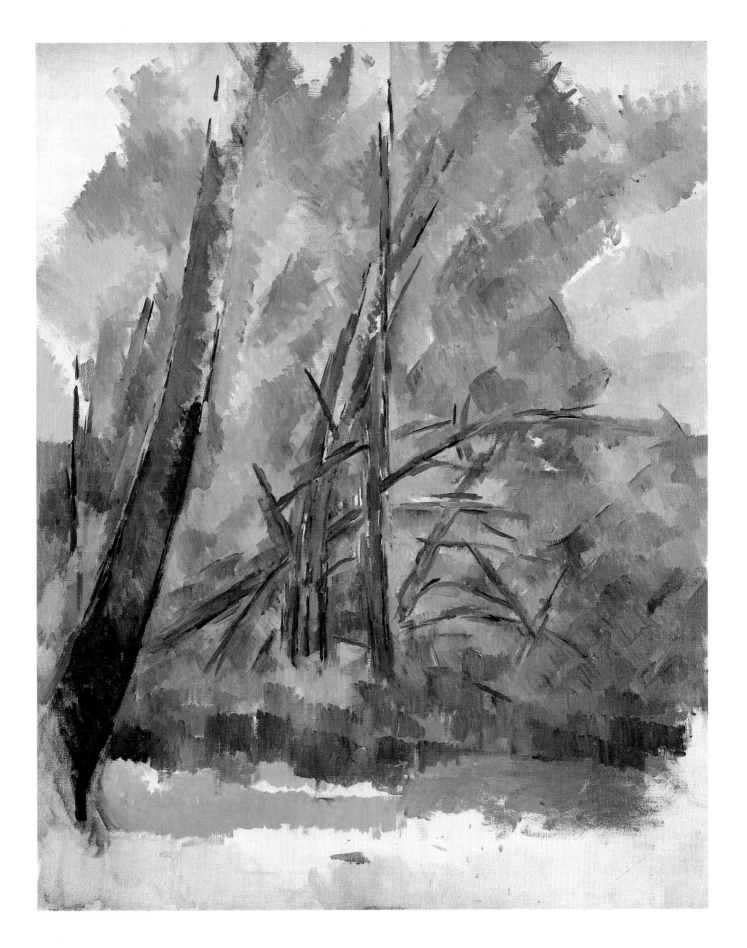

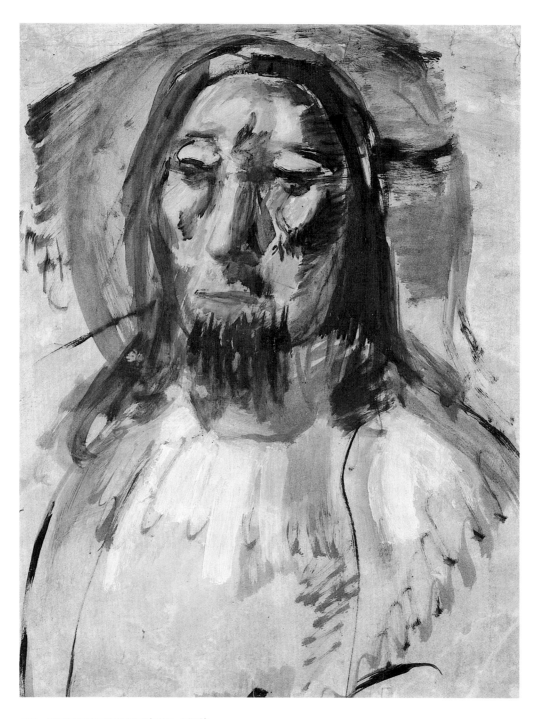

134. GEORGES ROUAULT (1871–1958)
Head of an Apostle, ca. 1905–1910
Oil on paper mounted on canvas
23¼ × 18¼ in.

Opposite:
135. HENRI MATISSE (1869–1954)
Brook with Aloes, 1907
Oil on canvas
28¾ × 23⅝ in.

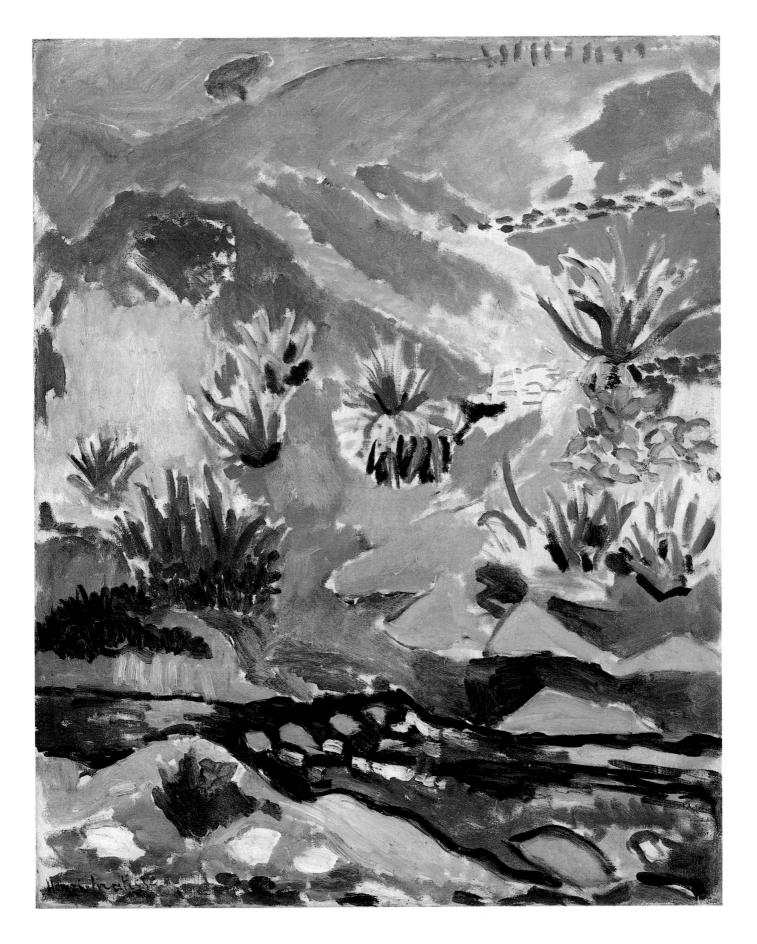

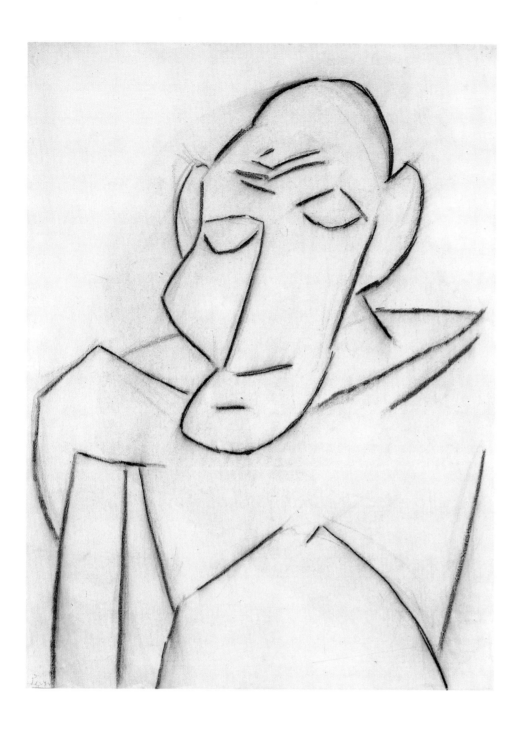

136. PABLO PICASSO (1881–1973)
Bust of a Man, 1907
Charcoal on paper
24¾ × 18¾ in.

Opposite:
137. PABLO PICASSO (1881–1973)
Female Nude, 1909–1910
Oil on canvas
28¾ × 21¼ in.

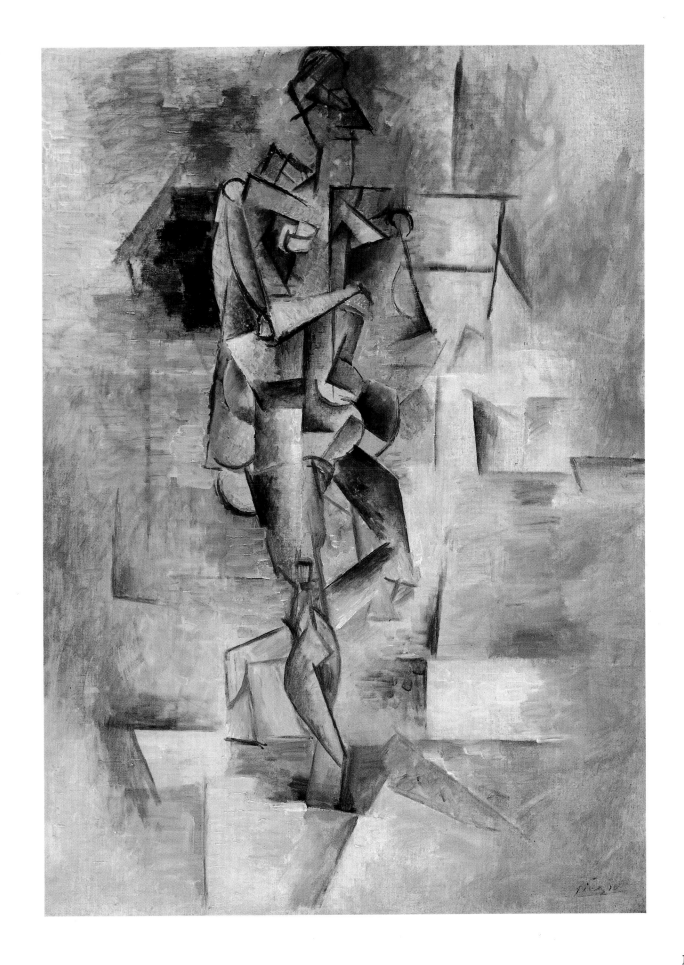

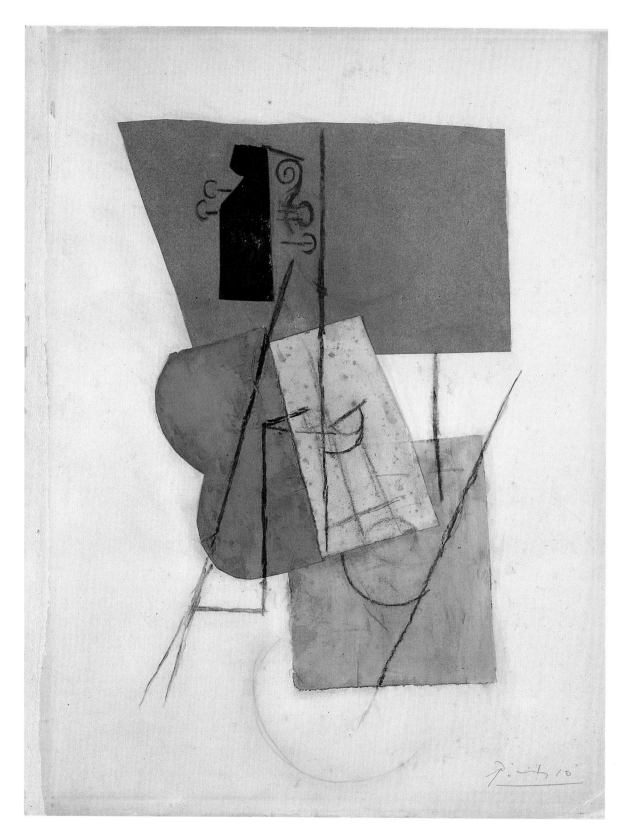

138. PABLO PICASSO (1881–1973)
Violin on a Table, 1912–1913
Collage: watercolor, charcoal, and cut
paper on paperboard
24½ × 18¼ in.

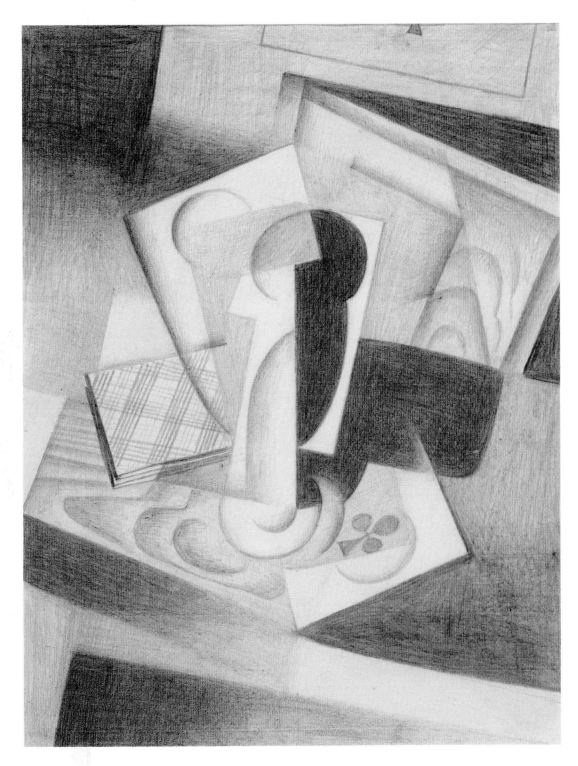

139. JUAN GRIS (1887–1927)
Still Life with Ace of Clubs, ca. 1915
Pencil on paper
14⅛ × 10¹⁵⁄₁₆ in.

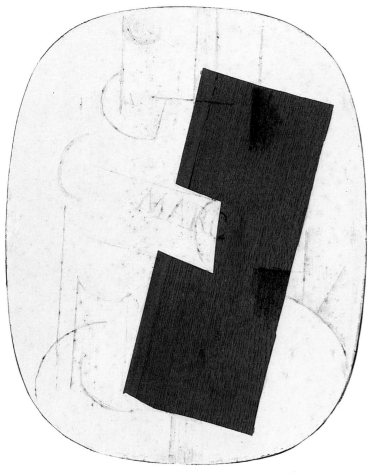

140. GEORGES BRAQUE (1882–1963)
The Bottle of Marc Brandy,
ca. 1912–1913
Collage: charcoal and paint on lacquered paper and gessoed paperboard mounted on fabric and wood
14⅜ × 11½ in.

Opposite:
142. STUART DAVIS (1894–1969)
Cigarette Papers, 1921
Oil, bronze paint, and pencil on canvas
19 × 14 in.

141. KURT SCHWITTERS (1887–1948)
Mz 371.bacco, 1922
Collage: cut and torn printed, handwritten, and tissue paper on paper
6¼ × 4⅞ in., image

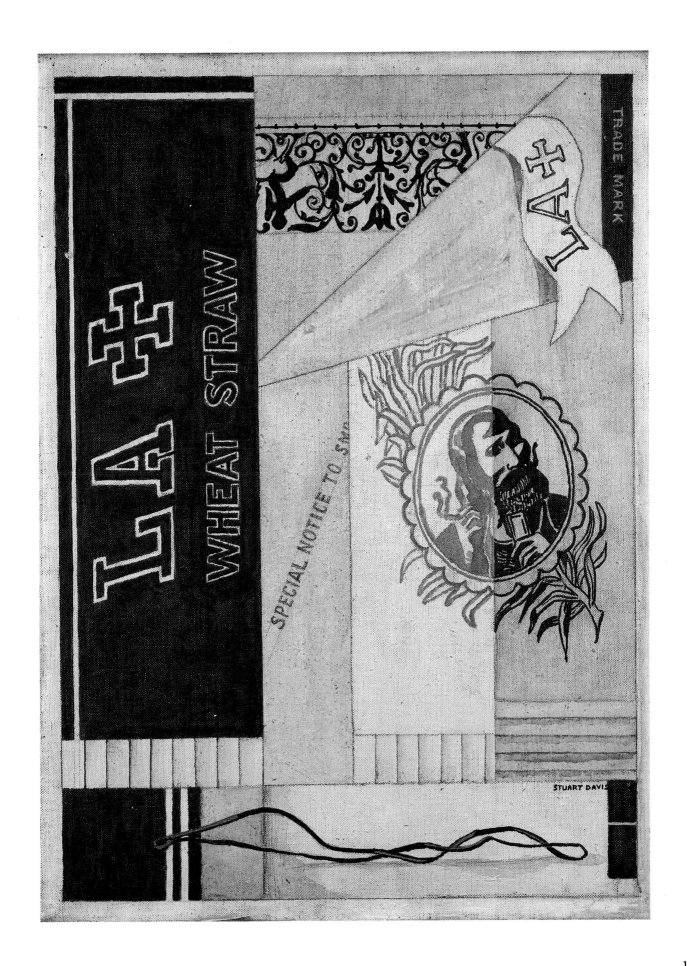

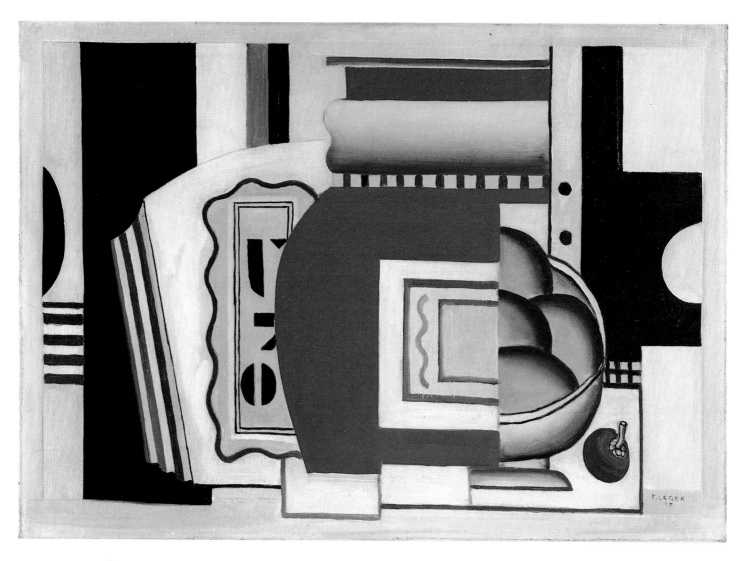

143. FERNAND LÉGER (1881–1955)
Nature morte, premier état, 1925
[Still Life, first state]
Oil on canvas
18¼ × 25½ in.

144. FERNAND LÉGER (1881–1955)
Peinture murale, 1926
[Mural Painting]
Oil on canvas
70⅞ × 31½ in.

A Suprematist Composition by Kasimir Malevich

Pontus Hulten

In the story of twentieth-century art the role of Kasimir Malevich is particularly unusual, romantic, and tragic.

He flirted with Symbolism at the turn of the century, as did several other Russian artists of his generation. Later he painted landscapes in a Post-Impressionistic manner. When we look at these little landscapes today, with the knowledge of what Malevich, the great artist and innovator, was to become, we can see that they have a power and freedom that is rather unusual. Their colors have a freshness, poetic lightness, and transparency that make them different from other Russian Post-Impressionist paintings. Later in the extraordinary saga of his life, Malevich introduced confusion into the apparently simple story of the evolution of his work as a young artist. We will return to this.

The arrival in Moscow of many of the greatest works by the most revolutionary French artists, brought by Shchukin and Morozov, had an immense impact on all the Russian artists of Malevich's age. These were works by Bonnard, Derain, Vlaminck, and Matisse; then works by Picasso, Braque, and Léger. From this contact a very significant movement was born. The first phase Malevich called Cubo-Futurism.

Looking at his work one can deduce that Malevich was at first very impressed by Léger and that little by little he enlarged his view. Both Picasso and Braque also became very important to him, as did some of the "minor" Cubists such as Le Fauconnier. This impression is confirmed by Malevich's writings. In great detail, and in several different versions, he relates his encounter with the Cubist painters and his impression of their ideas.

Curiously no work of the Italian Futurists, such as Balla or Boccioni, was then shown in Russia, but they were certainly known through reproductions. F.T. Marinetti, the Futurists' spokesman, visited Russia in 1915. Malevich did one work, *The Knife-Grinder*, 1912[1] (now in the Yale University Art Gallery), with a very clear reference to the manner in which the Futurists showed movement in their pictures: a succession of phases depicted one after another in a cinematic fashion.

Malevich, at this time, became a major figure in Moscow's new avant-garde. He worked (and quarrelled) with other leading artists and writers in the extraordinarily lively intellectual climate that dominated Moscow in the years immediately prior to the 1917 Revolution. He competed with Tatlin and collaborated with Khlebnikov, Kruchenikh, Matyushin, and Mayakovsky.

Prior to 1914 Malevich had produced a series of complex compositions of many interrelated planes and elements, compositions based on ideas borrowed from the Cubists, especially Picasso. In 1914 he abandoned that complexity and began to use simpler and more geometric elements, reducing his pictorial language to a play of rather simple forms on a white, or very light-colored, surface. Cubism had liberated art from its obligation to represent, to reproduce reality. It had given itself poetic license to be its own content, a free expression of the artist's mind. Malevich soon realized the consequences of the Cubist message and probably decided as early as 1913 to paint nonfigurative compositions, which he was to call

Opposite:
145. KASIMIR MALEVICH
(1878–1935)
Suprematist Composition, 1916
Oil on canvas
18 × 13¾ in.

190

Suprematist. During five or six years he produced a series of Suprematist pictures, some rather complex, some very simple. These pictures represent by their purity and their extraordinary force one of the pinnacles of art of this century, if not of all times.

The painting in The Menil Collection is from 1916, a year when Malevich produced some of the most serene of these images. There are others in two of the most important Soviet museums: the Russian Museum in Leningrad and the Tretyakov Gallery in Moscow; still another is in The Tate Gallery in London.

Malevich very quickly, perhaps already in 1915, posed the central question of painting: What does it take to make an image? He painted three different canvases with basic shapes: a square, a circle, a cross. One can imagine that this act of great courage was a kind of liberation. He felt free, inspired, and capable of almost anything. In any case, the Suprematist paintings from this time have a poetic freshness and lightness that is unsurpassed in his work. The space in the picture—the notion of space and the idea of space—is the main preoccupation. The forms on the surface move together in a world of harmony and spiritual interrelation that no other type of painting has obtained. There is an element of naiveté, simplicity, and directness that gives these paintings their extraordinary fascination. The shape in the upper left part of the Menil picture—the three red parallel lines—is probably a reference to an airplane. This poetic hint of a relationship between one pictorial world and another, between representation and abstraction, is a message about freedom that is being transmitted to us with the greatest delight.

In the late 1910s, when Malevich was still occupied with the idea of "aerial Suprematism," he started to work with architectural models. This continued for several years and was a logical consequence of the evolution of his art and his desire to make art central in his life. During these years he became engaged in the cultural restructuring that took place in the Soviet Union after the 1917 October Revolution. What had started as an optimistic and aggressive cultural activism of the best utopian quality was little by little to become a great deception.

In the middle of the 1920s, Malevich started to place his hopes in an artistic future outside the Soviet Union. His eyes were set on Paris, where he expected to have an exhibition. He managed to obtain a visa to go to Berlin, travelling via Warsaw, where he had an exhibition in the Hotel Polonia. His visit to Berlin started with an absurd mistake: he got off the train at the wrong station and landed by chance in a White Russian hotel. This attracted the eyes of the Soviet secret police, and Malevich had to return quickly to Leningrad before his Berlin exhibition was over, leaving behind everything he had brought with him. This material was rescued by his friend Hugo Häring, who managed to keep most of it together through the difficult time of the Nazi regime and the war years; finally Häring, in 1958, sold what he had been able to save to the Stedelijk Museum in Amsterdam. Malevich was never able to prove to the Russian secret police that his staying at a White Russian hotel was an accident, and he was never allowed to leave the Soviet Union again.

Until his death in 1935, Malevich seems to have ignored the fate of the bulk of his *oeuvre*. It seems that he considered it lost. Only in recent years has it become clearer what his reaction was to this terrible loss. There are good reasons to believe that he decided to paint again the pictures in all the different phases of his *oeuvre*— a most extraordinary decision. This hypothesis can explain the strange appearance of almost twin versions of the same work, both clearly by Malevich's hand but painted at vastly separate times. He seems to have virtually remade a whole series

of important paintings in all the styles that he had used in his artistic evolution. For the attentive observer, there is a discernible difference between the old paintings and the paintings done after his return from Berlin in 1927. The Suprematist works painted after 1927 are much stronger in color and contrast, and the brushwork is quite different. In the Russian Museum in Leningrad, which owns a great number of these late works, bought from the Malevich family, one can compare similar versions. The mystery of the dates becomes less mysterious, but the tragedy behind the existence of the two series becomes terribly evident.

The painting in The Menil Collection is undoubtedly from 1916. It combines the simplicity of the geometric paintings with the lyrical whimsy and playfulness of "aerial Suprematism." In the Stedelijk Museum in Amsterdam there is a drawing (Prentenkabinet A 7687) that shows the "airplane element"—the curved, crossed-over line and the straight bar—but the composition is quite different. Both works are typical results from the most sparkling year of a certain type of Malevich's production.

NOTE

1. This was the title given by Katherine Dreier. Literally, the translation of Malevich's title is *The Glittering Edge* (see version of the Société Anonyme catalogue, Yale, 1984).

146. PIET MONDRIAN (1872–1944)
Composition, 1927
Oil on canvas
15 × 14 in.

147. PIET MONDRIAN (1872–1944)
Composition, 1922
Oil on canvas
21¾ × 21⅛ in.

148. PAUL KLEE (1879–1940)
Baum-Physiognomie, 1932
[Tree-Physiognomy]
Colored ink and crayon on gessoed
gauze mounted on paperboard
20⅜ × 13½ in., image

149. JOAN MIRÓ (1893–1983)
Untitled, 1930
Oil on canvas
59⅛ × 88⅝ in.

150. GIORGIO DE CHIRICO
(1888–1978)
Perspective with Toys, ca. 1915
Oil on canvas
21⅝ × 18⅛ in.

151. GIORGIO DE CHIRICO
(1888–1978)
Metaphysical Interior with Biscuits,
1916
Oil on canvas
32 × 25⅝ in.

Max Ernst
A SUCCESSION OF NEW BEGINNINGS
Werner Spies

Max Ernst holds an immensely significant place in the history of twentieth-century art; the brilliant mixture of rebellion and vision that characterizes his life's work is without comparison. Lacking everything that might contribute to decorative harmony and visual familiarity, his art provokes more often than it flatters. The universe he created is both fascinating and disturbing, a dual effect for which he consciously strove, which indeed reflected his innermost nature. As he himself once said, "Painting happens on two different yet complementary levels. It delivers aggressiveness and uplift." Or again, "If a painter knows what he doesn't want, fine. But if he wants to know what he *does* want, it's all over. A painter is lost when he finds himself." The fact that Max Ernst has succeeded in not finding himself is what he considers his sole honor.

These paradoxes go far toward explaining the variety and change that most commentators on Max Ernst see as key features of his *oeuvre*. What initially appears to have resulted from a love of continually new distractions turns out, on closer scrutiny, to express a deeper and more compelling drive. For, in spite of its great diversity and sudden leaps from one technique or subject to the next, Max Ernst's work was guided by fundamental decisions which, once made, were never revised. One of these decisions was to waive spontaneous, direct painting and drawing. Put simply, every painting, drawing, or sculpture that he made was based on some find, some existing element or image that provoked or inspired him. The reasons for this were deep-seated: no other artist's biography reveals such an aversion to things aesthetic as Ernst felt from his boyhood on. The story of his "calling" as an artist reads like a tortuous subplot. He was continually dependent on some expedient that alleviated his fear of the empty canvas, white sheet of paper, or amorphous lump of clay. As he himself once put it with disarming irony, these unsullied things filled him with a virginity complex, which required little aids and devices to help him overcome his inhibitions.

Although Max Ernst's surviving work from the pre-1918 or 1919 period remains very much rooted in the styles of that time, it also records a precocious struggle to break the bonds of convention by not allowing any one influence to dominate him for too long. There is something self-destructive about these paintings. They tempt one to conclude that he was out to put insurmountable obstacles in his own chosen path as an artist. His lucid instinctive knowledge that the world of his ancestors was not for him had, it seems, first to be subjected to the test of experience. And it was this test that led him, as if automatically, to Dada, that comprehensive work of art destruction that eventually proved to be so miraculously constructive.

When Max Ernst returned to civilian life in 1918, he established himself as a painter "beyond painting." The first works produced in this new liberated state already show a complete independence of styles, previous or current. Although, objectively speaking, Dada provided him with a firm footing in his period, subjectively it gave him the tools he needed to cut himself free of every tie, be it family or nation, politics or culture. The ironic qualities and energies of the Dada movement were exactly what he had been waiting for: they permitted him to live out his con-

Opposite:
152. MAX ERNST (1891–1976)
La santé par le sport, ca. 1920
[*Health Through Sports*]
Photographic enlargement from montage of printed papers
$39\frac{7}{8} \times 23\frac{1}{2}$ in.

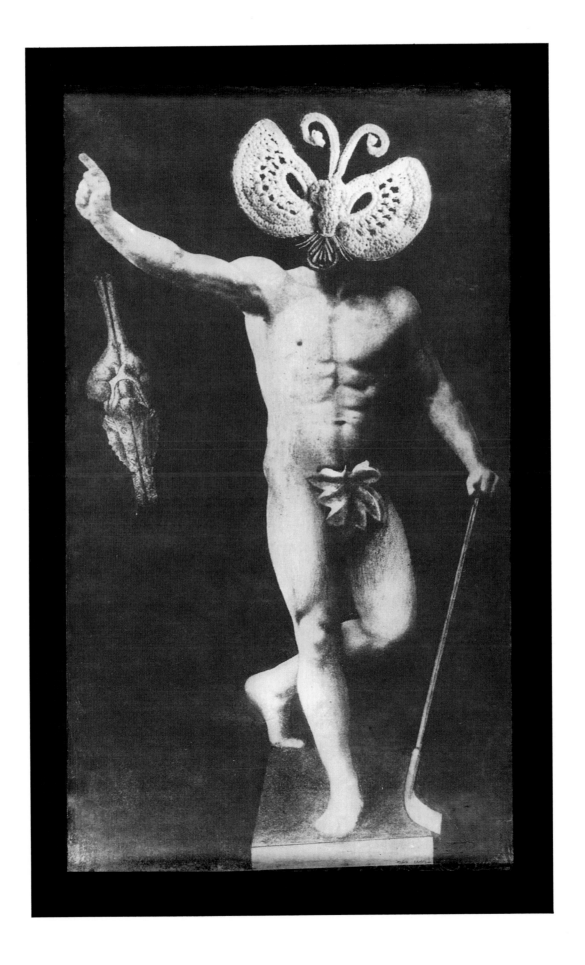

tradictoriness, his inveterate need to say and do the opposite of what was expected of him; his irony and self-irony eventually canceled each other out, making way for the conscious creation of a formally consistent *oeuvre*.

In 1919 Max Ernst discovered how to bypass direct artistic activity, how to get the better of that yawning canvas or frighteningly white sheet of paper. Collage was the way. Yet as a glance at his earliest work in this medium of combination shows, he by no means employed it arbitrarily. Faced with a seemingly infinite mass of printed imagery, most of it from popular publications of the nineteenth century, he sifted it with a critical eye, set limits on it by selection and reworking. His censorship—in the sense the word is used by Freud in his *Interpretation of Dreams*—functioned within a clearly defined formal and iconographic frame of reference. From an abundance of highly heterogeneous material Max Ernst chose single elements that seemed promising for recombination within a new and carefully delimited context. And the resulting imagery thus confronts us with a fascinating circumstance. Here, for the first time in the history of art, are pictures totally dependent not on ideals or influences but on already existing imagery: art in the making in which combination plays an equal part with invention. Yet the really decisive feature of his early Dada works was the *manner* in which he employed his seminal material, leading to an inimitable conception of style. Working in series played a key role in this development from the start. Max Ernst elaborated certain themes in terms of certain formal constants, which were to reappear over and over again in his later work. Aside from the stylistic changes that mark his *oeuvre* and of which he himself was definitely and sometimes tormentingly aware, it evinces technical constants, modes of choice, that aimed just as much at stylistic uniqueness and personal touch as any other, more conventional approach to imagemaking. No one recognized this earlier or more clearly than Piet Mondrian, who once said that he felt more affinity to Max Ernst than to all of modern painting. Underlying the proliferation of the visionary landscapes (*Day and Night*, 1941–42, No. 155), the Baroque agitation of *The Hordes*, and the apparently helter-skelter coherence of Max Ernst's collages, Mondrian detected the constant of inherent, planned structure and saw that his *écriture automatique* was, so to speak, inscribed in geometry. Ernst's spontaneity seemed tempered by careful, almost Constructivist, calculation.

Already in Ernst's early Dada work there was a fascination that ran counter to the anarcho-critical bent of the other Dadaists, a fascination that he owed to the work of de Chirico. In that artist's metaphysical, melancholy imagery, in his attempt to break out of the flux of time and explode the banality of everyday existence, Ernst discovered a way to express an old enthusiasm of his own—for the art of German Romanticism, Caspar David Friedrich's paintings, Idealist philosophy, and the poems of Hölderlin, Novalis, and Heine. Friedrich once said of his art that it was a world seen "with closed eyes," and these words apply equally well to Ernst's pictorial universe. The physical eye, both artists knew, simply revealed too little. It is not surprising that the French Surrealists and André Breton in particular should have celebrated Ernst as an incredibly free, independent spirit, whose richness of inward vision transcended mere reality, Breton's *peu de réalité*. Ernst's exploration of these realms of the imagination is reflected in a title such as *A l'intérieur de la vue: l'oeuf* (1929), a painting in The Menil Collection that gave the name to an entire cycle of works.

In an early text of 1921, the year of Max Ernst's first Paris exhibition, Breton made his friend's unique position clear. Preparing the ground for a transition to Surrealism, Breton diverged from all the other Dada manifestos of the period by

153. MAX ERNST (1891–1976)
Très jolie forêt allongée, 1925
[Very Pretty Elongated Forest]
Oil on canvas
39⅜ × 16¾ in.

making no further mention in his text of a destruction of art, saying instead that the new art must distinguish itself from both Cubism and Symbolism. Relying on Ernst's example, Breton attempted to shape a poetic out of Dada's shiftings and displacements of imagery. And, as if recalling the excitement he felt the first time he saw Ernst's collages, he declared that human consciousness was incapable of adding a single new element to reality. The mind must be content with varying the disposition of existing things, an assertion that Breton was later to bolster, in the Surrealist Manifesto, by references to Edgar Allan Poe, Raymondus Lullus, and the mathematics of combination and permutation. The incunabula of the ecstatic visual world of Surrealism, we might conclude, were already present in Ernst's work of the time—familiar things rendered unfamiliar, cut adrift, held in suspension by some enigmatic force. A title of the period is indicative: *Hier ist noch alles in der Schwebe* (Here Everything is Still Up in the Air, 1929).

One of the principal canvases of these years, *La Belle Jardinière* (1923), was soon to draw the Nazis' wrath. It was probably destroyed and Ernst never reconciled himself to its loss. In a later, and as he called it a transfigured, version, he returned again in nostalgia to the motif (*Retour de la Belle Jardinière*, 1967, No. 161). The ineffable mystery of these images, which lies so to speak on the tip of the eye's tongue, is simply not susceptible to logical explanation. Even at that early date, the effect that Ernst's works had on those who saw them might be described as a suspicion of something real, some happening long past or about to transpire, deepening to a certainty only to evade final definition.

Yet as a review of the early collages and paintings executed in Cologne shows, the material constituents of Ernst's imagery were quite solid and real. *La santé par le sport*, ca. 1920 (No. 152) is a case in point. Thanks to what he himself once called his "miraculous ability" to take two disparate realities and "strike a spark" from their conjunction, he was able to create *superimages*, pictures beyond any picture ever seen, which modified, even effaced, the reality of the elements of which they were constructed.

Active and passive vision, a skeptical dissection of reality, a euphoric projection of visionary worlds that oscillate between the larger-than-life and the smaller-than-life—all these diverse qualities are found in Max Ernst's *oeuvre*. Much of his imagery was inspired by a poetic fascination with natural phenomena. To the end of his life he remained susceptible to the vertigo of the man who resists the pull of banality, who can still marvel at the infinite universe in a grain of sand, who sees an imaginative challenge in the uncertainty factor present in even the most precise observations of modern physics. The questions that interested him, in any case, are couched more easily in philosophic than in aesthetic terms. Here lay his true commitment. The searching restlessness of his work and the contradictions in his nature point to a deep-seated disquiet, an insatiable need to know. Against the agnosticism of the modern age he set not a new faith but a profound uncertainty, which would focus the powers of the mind on existence, on human beings' helpless abandonment in an alien universe, from its most naive to its most sophisticated forms. It is no accident that Werner Heisenberg was a close friend, the physicist who challenged positivistic science by showing that there could be no such thing as absolutely definitive knowledge of the world.

Everything Max Ernst touched took on new depths of meaning. He never altered realities, motifs, or themes from the visible and visualized world simply by subjecting them to stylistic idiosyncrasy or to the accepted modern means of deformation or expressive heightening. Each work was like a crossroads at which a sub-

154. MAX ERNST (1891–1976)
Loplop présente Loplop, 1930
Oil, waterbased paint, and gesso on
wood, with attached oil and water-
based painting on fiberboard,
mounted on plywood
39⅞ × 72⅞ in.

ject met a technical procedure in such a way as to recapitulate, in terms of a discrepancy between some traditional, conservative technique and an innovative one, the discrepancy we feel between reality and its depiction in visual art. It was here that Ernst made a truly revolutionary contribution—by conceiving means to convey visionary or ironic content which *in themselves* expressed the newness or strangeness of his imaginative world. As with no artist before him, pure technique, astonishing and baffling interplays of structures and textures, became exciting statements in their own right.

No essay on Max Ernst can pass over the half-automatic techniques he introduced: collage, frottage, and the various procedures derived from them. Collage entered his repertoire in 1919, putting him on the track of a number of methods that permitted him, despite his skepticism as regards things aesthetic, to develop an *oeuvre* out of the conjunction of the divergent, to bring seemingly incompatible configurations into unities of a kind never seen before. This approach culminated in the late 1920s and early 1930s in his famous collage-novels: *La femme 100 têtes*, *Rêve d'une petite fille qui voulut entrer au Carmel*, and *Une semaine de bonté*. Though the separate elements that contribute to the effect of this composite universe can be isolated and defined, their sum resists calculation—to disassemble the work is not to explain it. Nor do attempts to shed light on these uncanny images by applying the methods of psychoanalysis get us much further. Ernst indeed replied to Freud, but his reply remained ambivalent.

Apparently Ernst's concern with Freud passed through two phases, with *Jokes and Their Relation to the Unconscious* affecting him more during the Dada period and *The Interpretation of Dreams* more after his transition to Surrealism. Freud's analysis of the technique of jokes can be taken as a rough guideline to the Dada collages and word-image conjunctions. Ernst was fascinated by composite words and *double entendres* of the type Freud described—they provided him with an inventory of the comical. If *The Interpretation of Dreams* seems more closely linked with the Surrealist phase of Ernst's *oeuvre*, this is because in "dream work" the conceptual disappears behind a veil of sensual and visual impressions. Yet when Freud began to analyze the distorting language of dreams, Ernst ceased to follow. He accepted this distortion as a poetic and pictorial value in its own right. And by the same token, analysis or interpretation of his suggestive, dreamlike imagery only destroys its effect. Its ambivalence is truly disturbing, provoking; and it is no wonder that we should wish to rid ourselves of this unpleasant feeling by focusing on details, hoping by analysis to reconstruct the meaning of the whole. However, it is no use. Max Ernst's images are holistic, more than the sum of their parts, force fields of irritation, and demonstrations of the insoluble that baffle logical explanation.

The other revolutionary technical innovation made its spectacular entry in 1925, in the frottages of *Histoire naturelle*. Here, Ernst summed up the meaning of his activity in concise, cyclical form—to present images to the eye and mind that no empirical method, no matter how sophisticated, was capable of revealing. They might be called expanded images, in analogy to Kant's "expanded judgments." And how were they produced? Max Ernst took a sheet of paper and, instead of beginning to draw in the conventional way, placed it over some rough or uneven surface, then ran a soft pencil over it to bring out the texture. The objects placed under the paper might range from pieces of raffia to cherry pits, dry bread to wickerwork, and, combined in various ways, the textures and images of these unassuming things took on tremendous evocative force. As in the collages, these seminal elements were

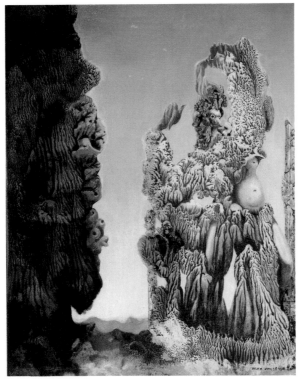

155. MAX ERNST (1891–1976)
Day and Night, 1941–1942
Oil on canvas
44¼ × 57½ in.

156. MAX ERNST (1891–1976)
Figure, Mythological Woman, ca. 1939
Oil on paperboard
15⁷⁄₁₆ × 12⅝ in.

in themselves quite banal, unworthy of serious regard; yet simply by transferring their images to paper by rubbing, Ernst created unprecedented effects. An infinite variety of textures and finely articulated forms emerged under his hand. The title he chose for the sequence, *Histoire naturelle*, says much about his intentions. While the words "natural history" call to mind a scientific classification and explanation of the real universe, what he gave us remained demonstratively unreal. As in his preceding work, his concern here was to combine formal discoveries with invented meanings.

From his pasted collages Max Ernst had derived painted collages—that is, he had executed a series of oils in which disparate, mutually alien, situations and figurations were juxtaposed. A comparable and equally significant expansion occurred in the case of frottage. The textural richness of his first frottages of 1925 tempted him to adapt the method for work in oils. This involved placing a wet canvas over the objects to be transferred and scraping lightly across the paint with a palette knife, removing it from the high spots; repeated several times, this procedure would give rise to complex interweaves of the shapes and textures under the canvas (*Très jolie forêt allongée*, 1925, No. 153). The resulting images, which Max Ernst called grattages, are rich in tiny forms over which the eye continually roves, a perceptual stimulus deriving from their relief effect that is difficult to resist. This type of effect was crucial to him, and he evoked it with a great variety of means, including the boards covered with an irregular layer of plaster that he interpreted in such images as *Loplop présente Loplop*, 1930 (No. 154).

The stimulating effect of these works, their ability to touch off that "poetic spark," goes far beyond anything else in Surrealist visual art. Every Max Ernst image balances on the razor's edge between the real and the possible. Landscapes of infinity, voracious forests full of a premonition of doom, were followed in the late 1930s by works employing the transfer technique known as decalcomania; then, under the impression of war and forced emigration, by such nightmarish visions of biomorphic distortion as *Le surréalisme et la peinture*, 1942 (No. 157). During the 1940s in the United States, crystalline imagery based on his own sculpture came to the fore (*Euclid*, 1945, No. 158; *Design in Nature*, 1947). Images followed in which paint and paint textures took on almost autonomous value (*Le Grand Albert, Albertus Magnus*, 1957, No. 159). The succession of styles, experiments, rejected attempts, and new beginnings is dazzling and impressive.

Postwar painting of the *informel* or action variety owes much to the partially automatic techniques that Max Ernst pioneered. He himself never attached an abstract significance to the finely articulated structures of his paintings, always linking them with some objective content (*Le cri de la mouette*, 1953; *Le ciel épouse la terre*, 1964, No. 160). This objective link arose from a fundamental conviction, one which the artist has frequently explained in his writings. He has described the experience that led him to begin projecting forms and figures into amorphous things, citing Leonardo da Vinci, who reported how formless blots and patterns, once you began looking at them intently, would congeal into shapes, landscapes, figures. Then Ernst adds, "Every picture reveals certain aspects of the painter's inner life. Your orthodox *tachiste* (action painter) would not think of letting himself be inspired by Leonardo's famous wall. Total refusal to live like an action painter."

Then there is his famous description of the shock he experienced when confronted by a new and baffling world which begged to be reinterpreted:

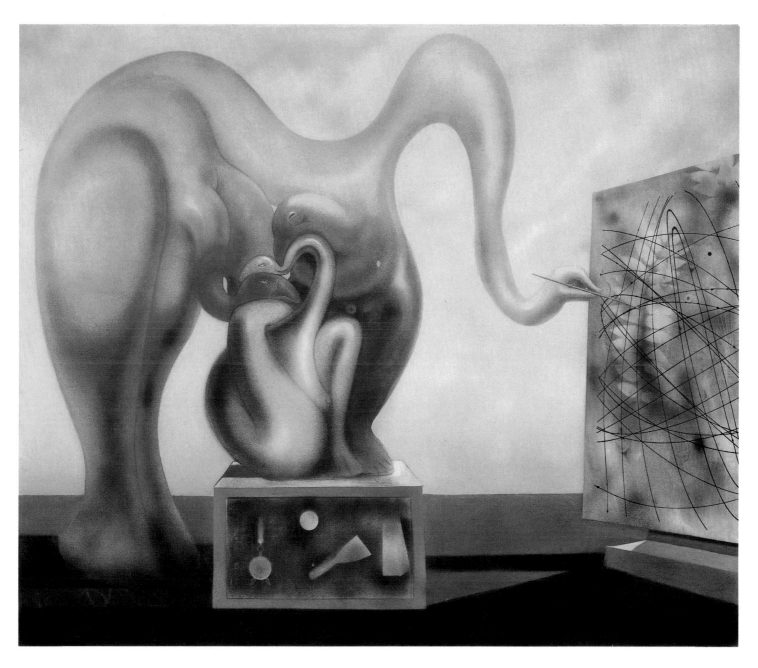

157. MAX ERNST (1891–1976)
Le surréalisme et la peinture, 1942
[Surrealism and Painting]
Oil on canvas
77 × 92 in.

One rainy day in Cologne on the Rhine my attention was riveted by a cata-
logue of teaching aids. I saw advertisements for models of all kinds—math-
ematical, geometrical, anthropological, physical, zoological, botanical,
anatomical, minerological, paleontological, and more. Elements of such a
diverse nature that the absurdity of their conglomeration had a sense- and
sight-confusing effect, evoked hallucinations, gave continually new and
changing meanings to the objects illustrated. I suddenly felt my "ability to
see" so heightened that I saw these objects transformed, materialized anew
against a new background.

This statement, corroborated by Leonardo's experience, perfectly describes the de-
cisive impulse behind Max Ernst's astonishing *oeuvre* and explains why it oscil-
lates between sheer fun and great wisdom. The revelatory experience, an epiphany,
an abandonment to the fascination of a moment, a feeling of being cut free of history
and the curbs of society, and of spontaneously entering a state of personal liberty,
seems to have been the necessary condition for an artistic activity the first premise
of which was a break with cultural and stylistic continuity. Against form clearly
perceived Max Ernst set an "open-endedness" of vision, a seeing-into-and-beyond
that which is seen.

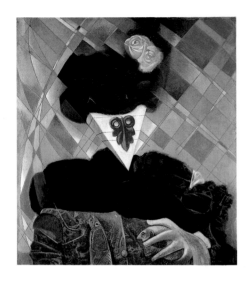

158. MAX ERNST (1891–1976)
Euclid, 1945
Oil on canvas
25⅝ × 23¼ in.

Right:
159. MAX ERNST (1891–1976)
Le Grand Albert (Albertus Magnus),
1957
Oil on canvas
60 × 42⅛ in.

160. MAX ERNST (1891–1976)
Le ciel épouse la terre, 1964
[The Sky Marries the Earth]
Oil on canvas
60⅞ × 78¾ in.

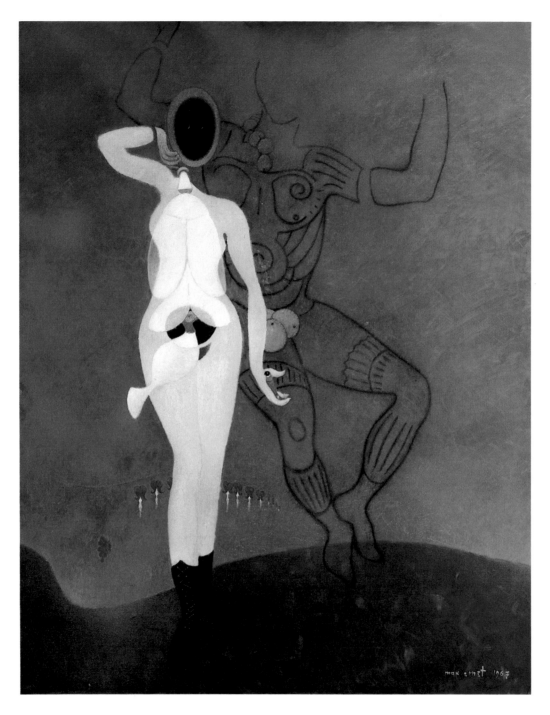

161. MAX ERNST (1891–1976)
Retour de La Belle Jardinière, 1967
[Return of The Beautiful Gardener]
Oil on canvas
63¾ × 51 in.

Opposite:
162. MAX ERNST (1891–1976)
Capricorn, 1948/1964
Bronze
94½ × 80⅝ × 51¼ in.

212

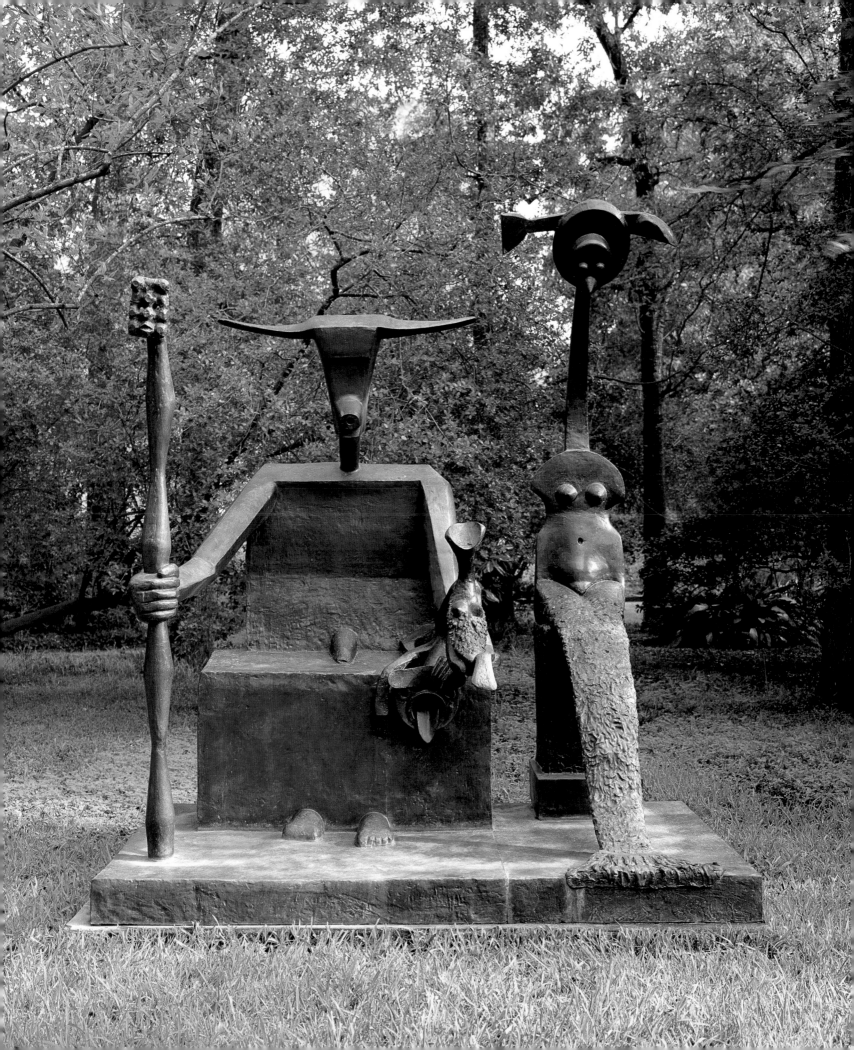

163. RENÉ MAGRITTE (1898–1967)
La loi de la pesanteur, 1929
[The Law of Gravity]
Oil on canvas
21⅝ × 15⅛ in.

164. RENÉ MAGRITTE (1898–1967)
Ceci est un morceau de fromage,
1936 or 1937
[This Is a Piece of Cheese]
Oil on canvas mounted on paperboard
in freestanding painted wood frame,
set in covered glass cheese dish
4¹⁵⁄₁₆ × 7¼ in., framed painting
12 × 31½ in., diameter, cheese dish

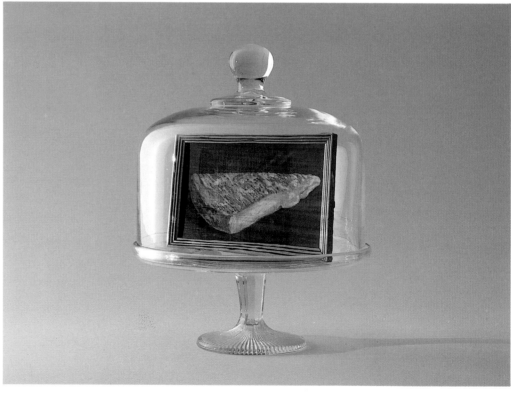

165. RENÉ MAGRITTE (1898–1967)
L'évidence éternelle, 1930
[The Eternal Evidence]
Oil on five separately stretched and
framed canvases
Dimensions top to bottom:
10¼ × 6⁵⁄₁₆ × 1¹⁄₁₆ in.
9 × 11 × 1¹⁄₁₆ in.
12³⁄₁₆ × 9 × 1¹⁄₁₆ in.
10¼ × 7⅞ × 1¹⁄₁₆ in.
10³⁄₁₆ × 6⁵⁄₁₆ × 1¹⁄₁₆ in.

Golconde
by René Magritte
David Sylvester

It is possible that they are coming down like rain or that they are ascending or that they are going up and down in invisible lifts. I tend to see them as if they were on a parade ground in the air. On other parade grounds, the ranks of men shoulder to shoulder have a reassuring solidarity. Here, where their spacing isolates them, making each one vulnerable, they are as apart as they are alike. Because the distances between them are both uniform and unnaturally wide, it seems unlikely that they would have moved into those positions, seems that they must have been moved (Magritte was addicted to chess). They are stuck there like repetitions of an ornamental device. In fact, they are parts of a pattern like a wallpaper pattern, infinitely repeatable and extendable. They are a sample of an infinity of identically helpless beings.

In this description, originally published in 1969,[1] my first two sentences were prompted by the affirmations that turn up in almost all the numerous commentaries on the picture—that the men are either falling, levitating, or static. They are said, for instance, to be "falling in a dark, vertical rain,"[2] to be "like drops of water stopped in their tracks, in a universal, grandiose levitation,"[3] to be "fixed, upright, their backs to the facade, at every possible height, suspended without support, motionless."[4] The majority of writers see it as rain.

Magritte saw it otherwise, or said he did, in the one statement he seems to have made about the matter. The reference he includes to the picture's title needs some expansion: Golconda[5] is a ruined city in southeast India, which from the mid-fourteenth century till the end of the seventeenth was the capital of two successive kingdoms; the fame it acquired through being the center of the region's legendary diamond industry was such that its name remains, according to the *Oxford English Dictionary*, "a synonym for 'mine of wealth.' " Magritte's statement reads: "Golconda was a ruined city in the ancient world. This picture represents a ruined city. The people are all ascending because they are ruined and are building castles in Spain."[6] There is a problem. That statement comes from an interview for a students' magazine in which quite a number of things were obviously said with tongue in cheek. The bit about castles in Spain is a clear case. So the remark that the men were ascending may have been as straightforward as it looks, but we cannot be sure.

The capriciousness of Magritte's responses to a juvenile interviewer reflects the irritation he felt about the widespread desire to find interpretations for his images. And I fear that my old description of *Golconde* may be too interpretative at moments, by tending to treat the picture as an imaginary event which is a distortion of a real event. We get closer to Magritte's way of thinking if we treat his image as the pure embodiment of an idea. For instance:

> When I was a child and shopping in the city with my parents, the streets were so crowded and claustrophobic that I wondered what would happen if everything were reorganised so that each person had exactly the right amount of living space—a fair share for everyone. There seemed so much room in the air, or across water (all that space taken up by sea, and not lived

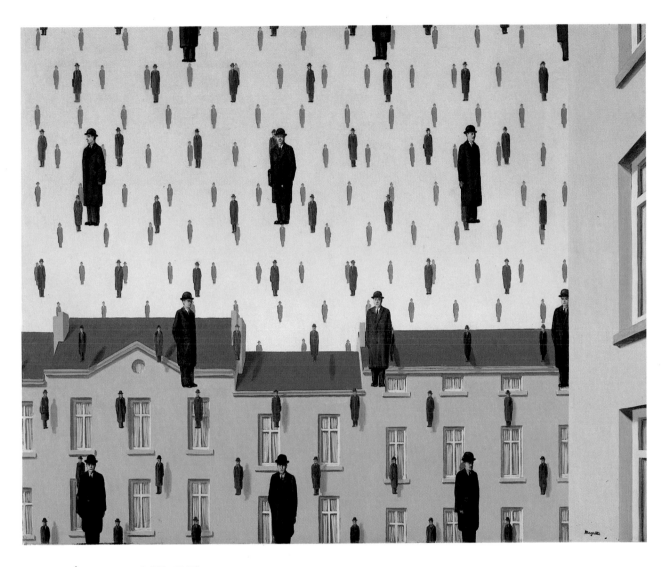

166. RENÉ MAGRITTE (1898–1967)
Golconde, 1953
Oil on canvas
31½ × 39½ in.

on!) that it was ludicrous for us all to be cramped into such a relatively tiny area. If you imagine what it would be like to have a world where everyone was neatly arranged with equal space, it would look pretty much like Golconde.

That commentary was contributed, suddenly, while I was working on this piece, by a colleague, Alison Ginsberg, who is not an art historian. It corresponds nicely with a remark Magritte made about the picture (this time in all seriousness) a few months after painting it. In a letter dated November 13, 1953, he was explaining to Gaston Puel, the French author, the two different ways in which he found his images: one was through their coming to him unbidden, which happened rarely; the other was as the result of purposeful research into some question posed by an aspect of reality. He went on to cite examples, saying, "*Golconde* too is the picture of an instantaneous vision."[7] But he qualified this, "It could have been the result of research starting off from the 'space question.' "[8]

Magritte's notion of arriving at an image by deliberately searching out the solution to a chosen problem was born in 1933, eight years after he started making Surrealist pictures. Explaining the idea to André Breton in the summer of 1934 (in two unpublished letters), he says his research is intended to reach an elementary understanding of things by discovering the hidden property that belongs indissolubly to a given object, yet that seems strange and monstrous when the connection between the two of them is revealed; the problem posed in each case has a unique solution lying in wait in the depths of his mind and, though its discovery is an arduous process, the solution seems totally self-evident once found.

Here and elsewhere, in letters and writings, Magritte mentioned a number of the particular problems and their solutions. The problem of the door was solved by a closed door with a man-sized hole through it; the problem of the sea was solved by a beached mermaid whose top half was fish and bottom half woman; the problem of woman was solved by a woman's face made of her body, with the breasts as eyes, the navel as nose, the pubic mound as mouth; the problem of water was solved by a sailboat made of the same substance as the sea. Magritte also wrote about the problem of the tree, the window, the house, the motorcar, the horse, the rose, the sun, rain, light; but the problem of space, to my knowledge, is one he never alluded to save in the remark that *Golconde* could have come out of it. We can only conjecture whether Magritte thereby meant that the problem related to the apportioning of space, or at least the occupation of space by man. What is certain is that *Golconde* deals with the suspension of solid forms in space; that this theme is one which is very recurrent in Magritte's work; and that in no other image of his is it developed so elaborately and systematically. It is developed elaborately inasmuch as there are a lot of figures in the picture, and the painter seems to have gone to a good deal of trouble to make them alike yet with subtle differences. But the idea is anything but elaborate. Composed of just three elements—men, buildings, and sky—this image is a classic example of that devastating simplicity which, more than anything, perhaps, is Magritte's hallmark. He is Surrealism's minimal artist. (One of the surest ways to spot a fake Magritte is that it usually contains one element too many.)

In only his first four or five years as a Surrealist, Magritte suspended in the air such things as a shell, a sponge, a fruit, a tree, a jug, a knot, harness bells, slaughtered birds, a torso, a tuba, a kitchen chair, and a word written in copperplate. Nothing mythical or fantastic; just standardized everyday things: Magritte's art is about revealing the mystery of the ordinary through rearranging the everyday

arrangement of everyday things. Magritte's iconography is a mine of standardized objects as rich as Léger's. In addition to some of those objects listed above one finds: banisters, floorboards, bowler hats, pipes, candles, clocks, suitcases, eggs, roses, loaves of bread, and the houses that most resemble other houses. And like Léger he often makes standardized objects out of human beings, impersonal, impassive. In the 1920s Magritte tended to do so by giving them the blank faces and stiff bodies of tailors' dummies. By the 1950s he was tending to do so by peopling his world with anonymous men correctly dressed in bowler hats and sober overcoats, some carrying umbrellas or attaché cases.

When these bowler-hatted men appear singly or in pairs, as they usually do, we need our cultural background to tell us that these are standardized figures, but the men in *Golconde*, being multitudinous, are visibly, explicitly, standardized. And that is the heart of the matter, that standardization—the standardization of people and also, as my colleague suggested, the standardization of space.

This crucial anonymity is denied by the sort of attempts made to identify the men as civil servants or small-town lawyers or whatever—worst of all, as clones of Magritte himself. The common supposition that any bowler-hatted man painted by Magritte is something of a portrait of the artist gets things the wrong way round. Magritte painted numerous bowler-hatted men—most of them in his last twenty years—without giving one of them features unmistakably his own—this in spite of the fact that several paintings of his demonstrate that he had no inhibitions about clearly portraying his own face when he wanted to. But as Magritte's figure of the bowler-hatted man increased in fame, a tendency arose for photographers to persuade the artist to pose as a bowler-hatted man—privately his hat was usually a trilby—and it is, of course, the case that nowadays our image of an artist is usually based on what magazine photographs have made of him. So the equation of Magritte with the bowler-hatted man derives not from his own paintings but from other people's photographs.

But if he is not present in *Golconde*, someone very close to him is. This is Louis Scutenaire, the poet, a great Surrealist writer still inadequately recognized outside Belgium, who was a friend of Magritte's for forty years and his most intimate friend for the last twenty or more. It was he, by the way, who found *Golconde* its title: Magritte always had a way of finding titles through picking the brains of his writer friends. Now, of the three men in the foreground at the level of the roofs, the one in the center has a singular resemblance to Scutenaire. When I asked Scutenaire what he thought about that, showing him a detail photograph, he agreed that this man was indeed very like him and might well have been a secret portrait of him. It does say something about Magritte, as a man and as an artist, that when he put his friend into his picture he kept quiet about it.

NOTES

1. David Sylvester, *Magritte*, New York and Washington, 1969, p. 13. A couple of minor alterations in the phrasing have been made here.

2. Gita Brys-Schatan, "Il s'appelait Magritte," *Synthèses*, no. 258–59, December 1967–January 1968, p. 138: "tombant en une pluie sombre et droite..."

3. Patrick Waldberg, "René Magritte: L'inspiration et le mystère," *XXe siècle*, nouvelle série, XXVe année, no. 22, 1963, p. 10: "comme des gouttes d'eau arrêtées en chemin, en une générale et grandiose lévitation..."

4. Henri Michaux, "En rêvant a partir de peintures énigmatiques," *Mercure de France*, vol. CCCLII, 1964, p. 585: "fixes, debout, dos à la façade, à toute hauteur, en suspension sans appui, immobiles..."

5. Golconda in French is Golconde; Magritte titled and signed the painting in French.

6. Magritte, cited in an interview-article by C[onrad] Altenloh, "Magritte," *Copères*, Dinant, 1955, pp. 17–19: "La Golconde fut dans l'antiquité une ville ruinée. Ce tableau représente une ville ruinée. Tous les gens montent parce qu'ils sont ruinés et qu'ils bâtissent des châteaux en Espagne" (p. 18).

7. Published in Harry Torczyner, *René Magritte: signes et images*, Paris, 1977, p. 200: " 'Golconde' est aussi le tableau d'une vision instantanée."

8. *Ibid.*, "Il aurait pu être le résultat d'une recherche partant de la 'question espace'."

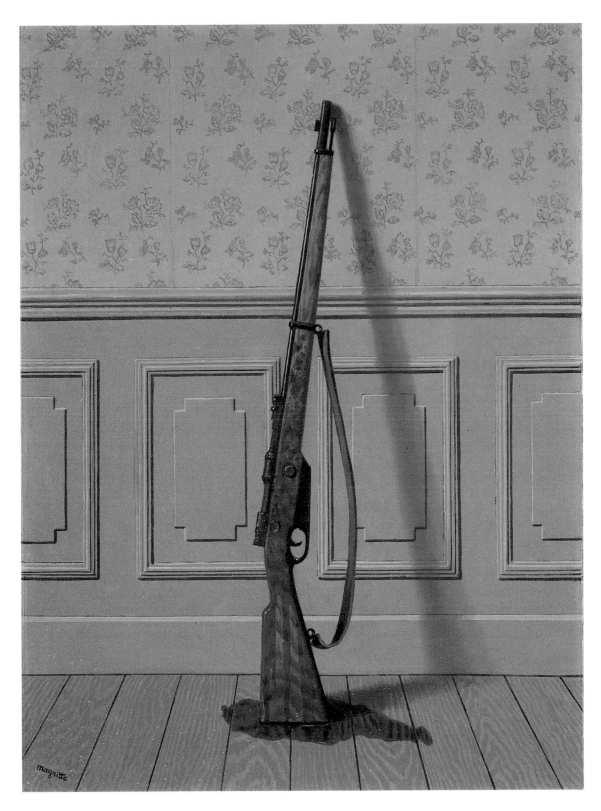

167. RENÉ MAGRITTE (1898–1967)
Le survivant, 1950
[The Survivor]
Oil on canvas
31½ × 23¾ in.

168. RENÉ MAGRITTE (1898–1967)
La clef de verre, 1959
[The Glass Key]
Oil on canvas
51⅛ × 63¾ in.

169. RENÉ MAGRITTE (1898–1967)
La lunette d'approche, 1963
[The Telescope]
Oil on canvas
69⁵⁄₁₆ × 45¼ in.

170. RENÉ MAGRITTE (1898–1967)
L'aimable vérité, 1966
[The Pleasant Truth]
Oil on canvas
35⅛ × 51⅜ in.

Opposite:
171. RENÉ MAGRITTE (1898–1967)
Madame Recamier, 1967
Bronze
sofa and coffin, 44⅞ × 74 × 26⅜ in.
lamp, 65⅜ × 12³⁄₁₆ × 14³⁄₁₆ in.
footstool, 4 × 19⁵⁄₁₆ × 9⅞ in.

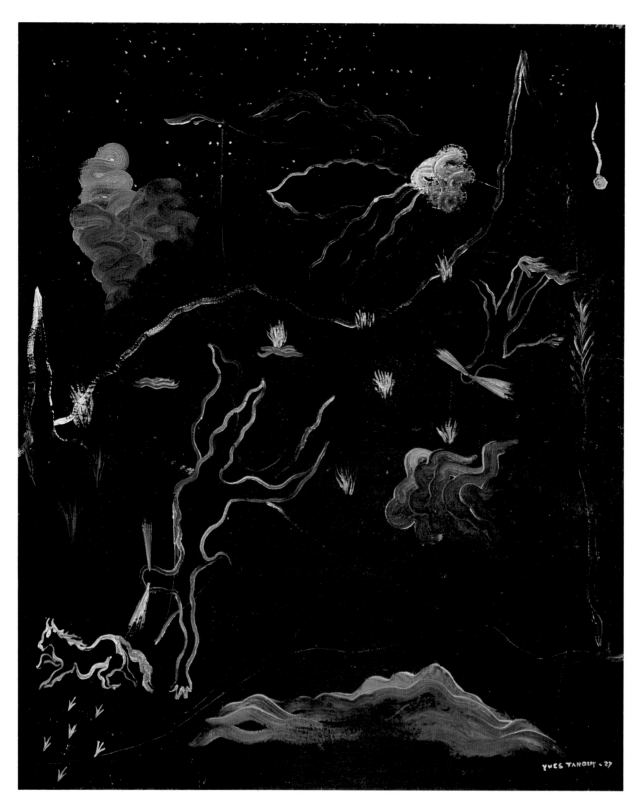

172. YVES TANGUY (1900–1955)
Et voilà!, 1927
Oil on canvas
25¾ × 21⅜ in.

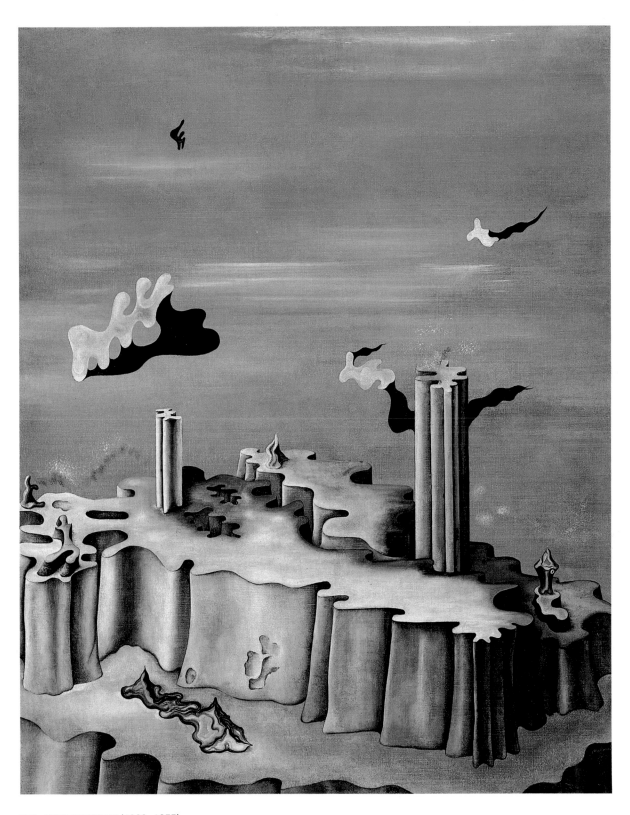

173. YVES TANGUY (1900–1955)
Légendes ni figures, 1930
[Neither Legends nor Figures]
Oil on canvas
32⅛ × 25⅝ in.

174. PABLO PICASSO (1881–1973)
Woman in a Red Armchair, 1929
Oil on canvas
25⅝ × 21¼ in.

175. PABLO PICASSO (1881–1973)
Seated Woman with a Hat, 1938
Oil and sand on wood
21⅝ × 18⅛ in.

afin que.... les traces de ma tombe disparaissent de dessus de la surface de la terre,
comme je me flatte que ma mémoire s'effacera de l'esprit des hommes... D.A.F. SADE

176. MAN RAY (1890–1976)
Portrait imaginaire de D. A. F. de
Sade, 1938
Oil on canvas with painted wood panel
24¼ × 18⅜ in.

Printemps by Francis Picabia

William A. Camfield

One of the most beguiling stories about Picabia is relevant to his painting of *Printemps* (Spring). That story—as related by Picabia's friend and neighbor, Henri Goetz—was set on a superb spring morning in Golfe-Juan during 1943. Goetz was awakened by the shouts of Picabia's distraught wife, Olga, pleading with him to rush immediately to the studio. Francis was ruining all of his paintings; he was painting flowers on everything in the studio and he refused to stop. Goetz hurried over, but Picabia would not stop for him either, insisting that it was a beautiful spring day, that he felt elated, and that he was having a merry time painting daisies on everything. To Olga's initial dismay, Goetz decided Picabia was right and promptly selected a canvas he especially liked for his own collection (Fig. 1).[1]

It is not certain that *Printemps* was one of those victims of Picabia's spring-time exuberance, but it seems likely inasmuch as it shares all the features common to other paintings associated with that incident, including the documented example in the Goetz collection. The Goetz painting began as a picture of a rather imperious, sultry woman (Marlene Dietrich?) standing in a landscape. A date of ca. 1935–37 is indicated by the stylistic features of that original image, namely somewhat simplified realistic forms which are heavily outlined, modeled, and rendered in pervasive blue-green colors. The flowers and dots were added in 1943, not only over the original painting of ca. 1935–37 but over several curious, abstracted forms superimposed on the figure of the woman sometime between 1935–37 and 1943.

A combination of visual inspection and recent laboratory examination reveals a similar, though more complex, process in the creation of *Printemps*.[2] It, too, began as one of the bluish paintings of ca. 1935–37 although no trace of that composition remains save for patches of the original blue-green surface left exposed within the bodies of the dancing figures and the pentimenti of a small churchlike structure sitting atop the landscape in the lower left corner. Other pentimenti and X-radiographs reveal a second painting composed of large and rather simple abstract shapes, which seem wholly unrelated either to the original painting or to the third stage, namely the dancing figures we now see which have long been attributed to 1938. The flowers, clearly brushed over cracks in that third stage, were added at a later date.

The actual evolution of *Printemps* may have been more complicated than the four-stage process just described, but the evidence at hand amply documents a process of creation, destruction, and re-creation that simultaneously reveals a great deal about Picabia and raises knotty questions regarding both his aims and attitudes and the viewer's response to the painting.[3]

The appropriation and repainting of older canvases was hardly new either in the history of art or in Picabia's own art. From the early 1920s until the end of his career, he frequently repainted his older pictures. No single motivation seems to have guided him in that practice. In some instances he deliberately retained passages of the original painting, integrating the older images within the overlay of new forms. In other instances he completely concealed the older painting, leaving no trace whatsoever save perhaps for pentimenti discernible in a raking light.

Opposite:
177. FRANCIS PICABIA (1879–1953)
Printemps, ca. 1937–1938, 1943
[Spring]
Oil on plywood
58⅜ × 37⅜ in.

Sometimes the older painting was sacrificed because he disliked it or had simply lost interest in it. At other times he covered paintings of such significance that it is difficult to imagine he no longer cared about them. The "difficulty," however, is ours and not Picabia's, who may have been ready to paint over any of his pictures—not to reject his past work but to liberate himself from it. In an interview from 1926, Picabia made this persistent Dadaist attitude abundantly clear:

Is it indiscreet to ask if you renounce your earlier painting?

I don't remember it.

But can you name for me the best painting you have made?

All of them, even those I have destroyed, for each gave me for a second the impression that it was the best.

Why are you amused to destroy the artistic movements that you have created?

For love of my next one.[4]

Fig. 1 Francis Picabia
Figure and Flowers,
ca. 1935–37 and 1943
Musée National D'Art Moderne, Centre Georges Pompidou, Paris, H. Goetz Collection

Similar statements abound in his memorable one-liners: "There is only one way to save your life: sacrifice your reputation," and "Taste is fatiguing like good company."

For decades the irreverence of such remarks struck most critics as being fully in accord with Picabia's madcap life and the erratic, self-indulgent quality of his painting. More recently some of Picabia's audience has been better able to register his profoundly serious insistence on freedom and to perceive refreshing results of that freedom in such paintings as *Printemps*.

It is a very odd painting, but an unforgettable one, simultaneously simple and complex, naive and sophisticated, controlled and catch-as-catch-can. On one level, Picabia's big, brash, brightly colored composition presents an uninhibited celebration of life and love in the form of a couple, interlocked as a single form and dancing against a brilliant blue sky sprinkled with marguerites. From another viewpoint, the style of the painting appears so naive and the subject so trite that spectators might question whether they are confronted with the product of an impetuous, uncritical artist or a master of parody.

No option should be eliminated. Insofar as parody is concerned, it was a major ingredient in his work from the epoch of Dada onward. Several substantial periods in his career may even have originated in a few paintings initially intended to mock the style of a contemporary artist or movement.[5] Distinguishing between parody and genuine celebration is, however, an elusive exercise. We have no divining rod to detect the presence of parody nor meter stick to measure it. Assessments are inescapably shaped by expectations of the viewer and undermined in this instance by an artist for whom parody and personal expression seem to have existed in a perpetual, ambivalent flux.

I believe, nevertheless, that *Printemps* exhibits most effectively that shifting plane between personal expression and parody in Picabia's work. In many ways *Printemps* is a heavy-handed painting. The dancing couple is an awkward form, harsh in contour, clumsily joined/divided along the juncture of the burnt orange and black figures, and as jerky in movement as cardboard marionettes. Furthermore, the orange figure is missing one arm, the gender of the black figure is ambigu-

ous, and the internal divisions of the landscape have no rhyme or reason. From another viewpoint, all of these "negative" comments may be perceived as "pluses." There is no place for the "missing" arm of the orange dancer. Three arms are "correct," and the busy landscape below is necessary to balance the bold pattern of those arms. The awkward joining of the figures is overcome by the simple color reversal of the flowers—orange on black and vice versa, and the choice of white daisies for the blue sky is an equally simple but inspired decision that unites the entire painting and activates that field of the sky as an equal partner with the figures.

Perhaps Picabia did not "ruin" his painting that spring morning in Golfe-Juan but saved it. He seems to have struck a provocative balance between a work that is genuinely awkward yet disarmingly effective—a work difficult to imagine in any other form, and, finally, a work realized by a process of creation, destruction, and joyous re-creation commensurate with the subject of springtime itself.

NOTES

1. Interview with Henri Goetz and his wife, Christine Boumeester, Paris, August 20, 1962.

2. Laboratory examination, including a complete X-radiographic mosaic and the use of ultraviolet light, was conducted during April 1985 by Carol Mancusi-Ungaro, Conservator of The Menil Collection. I am indebted to her for wholehearted support of this project.

3. The limitations of the X-radiographs preclude both an exact count of the various repaintings of *Printemps* and the sequence of those repaintings. The present estimate of four stages between ca. 1935–38 and 1943 rests finally on stylistic analysis. The oldest form identifiable in the X-radiograph is the church-like structure, which is almost identical to a church in one of the blue-green landscapes of ca. 1937 in the Romain Collection, Paris (see Camfield, *Francis Picabia*, Princeton, 1979, fig. 376). Abstract forms similar to those in the second stage of *Printemps* occur in two periods of Picabia's work, ca. 1937–38 and 1946–48 (see Camfield, *ibid.*, figs. 375, 383, 402, 403, and 406). In addition to factors previously cited, weight is lent to the 1937–38 period by the exhibition of *Printemps* in its present form as early as January 1946 (Kunsthalle Basel, *Francis Picabia*, January 12–February 3, 1946, no. 276), and by the absence of any comparable paintings around 1946–48.

Above the title *Printemps* in the upper left is a partially obscured older title which Carol Mancusi-Ungaro has also deciphered as "Printemps." Alligator cracks in the third stage of *Printemps* were inpainted by Bernard Rabin in January 1966. Those deep cracks suggest that the dancing figures and blue sky were brushed over an older composition not yet dry—further indication of several stages to *Printemps* around 1937–38.

4. Francis Picabia, "Interview," *Volonté*, Paris, March 4, 1926, p. 3. Interview conducted by Christian (Georges Herbiet).

5. For commentary on this topic and related issues see Camfield, *Francis Picabia*, p. 258 and Robert Rosenblum's essay, "Francis Picabia: the Later Work," for the Mary Boone and Michael Werner Gallery, *Francis Picabia*, New York, September 10–October 22, 1983.

BIBLIOGRAPHY

Guth, Paul, "Francis Picabia," *La Gazette des Lettres*, no. 39 (Paris, June 28, 1947), pp. 1–2.

P. T., "Reviews and Previews," *ARTnews*, vol. 55, no. 7 (November 1956), p. 8 (illus.).

"In the Galleries," *Arts* (November 1956), p. 60 (illus.).

Devree, Howard, "About Art and Artists," *The New York Times*, October 26, 1956.

Altmann, Robert, "Francis Picabia," *Islas*, III, no. 1 (Santa Clara, Cuba, September–December 1960), p. 206.

Sanouillet, Michel, *Picabia*. Paris, L'Oeil du temps, 1964, p. 134.

Art poster and postcard, Villamandeur, Nouvelles Images, 1975, color (D. and J. de Menil Collection).

Bois, Yves-Alain, *Picabia*. Paris, Librairie Flammarion, 1975.

Camfield, William A., *Francis Picabia: His Art, Life, and Times*. Princeton, Princeton University Press, 1979.

Szeemann, Harold, "A Note Concerning Francis Picabia," *Artforum* (November 1983), pp. 41–43.

178. VICTOR BRAUNER (1903–1966)
Petite morphologie, 1934
Oil on canvas
25⅜ × 17⅞ in.

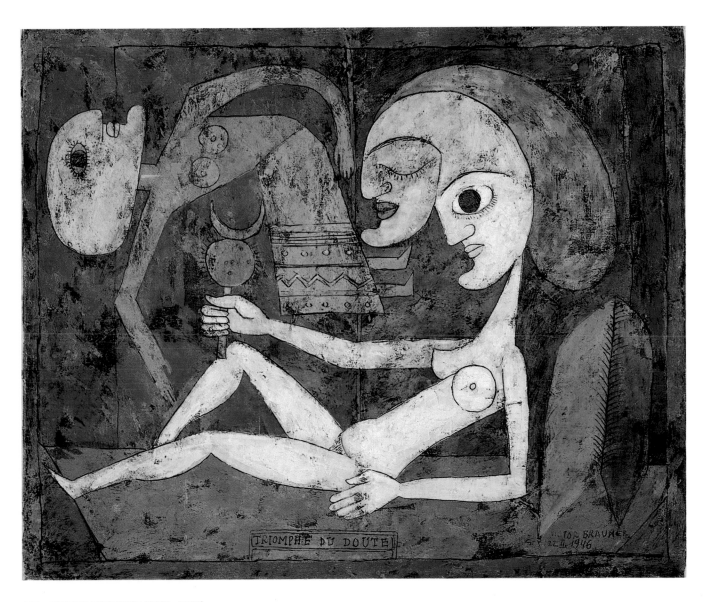

179. VICTOR BRAUNER (1903–1966)
Triomphe du doute, 1946
Oil, ink, and wax on canvas
32¼ × 39¹³⁄₁₆ in.

180. VICTOR BRAUNER (1903–1966)
Tête, 1952
[Head]
Oil on canvas
31¾ × 25½ in.

181. VICTOR BRAUNER (1903–1966)
Mémoire des réflexes, 1954
Oil and wax on masonite
49⅛ × 54⅜ in.

182. JOSEPH CORNELL (1903–1972)
for the Sylphide, Lucille Grahn (Homage to the Romantic Ballet), 1945
Wood box with lid, paint, glass, velvet, and photostat with costume beads, glitter, potpourri, tulle, and butterfly wings
1⅜ × 4½ × 4⅝ in., closed

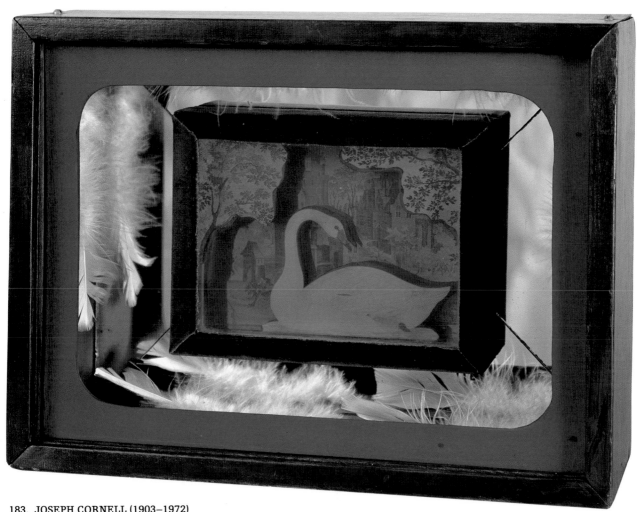

183. JOSEPH CORNELL (1903–1972)
A Swan Lake for Tamara Toumanova
(Homage to the Romantic Ballet), 1946
Box construction: painted wood, glass
pane, photostats on wood, blue glass,
mirrors, painted paperboard, feathers,
velvet, and rhinestones
9½ × 13 × 4 in.

184. SALVADOR DALI (b. 1904)
*Gangsterism and Goofy Visions
of New York*, 1935
Pencil on paper
21½ × 15¾ in.

Opposite:
185. WILFREDO LAM (1902–1982)
La Visitante, 1948
[The Visitor]
Gouache and charcoal on canvas
83½ × 77³⁄₁₆ in.

Opposite:
186. MATTA (b. 1911)
Je m'honte, 1948–1949
Oil on canvas
76¾ × 55⅞ in.

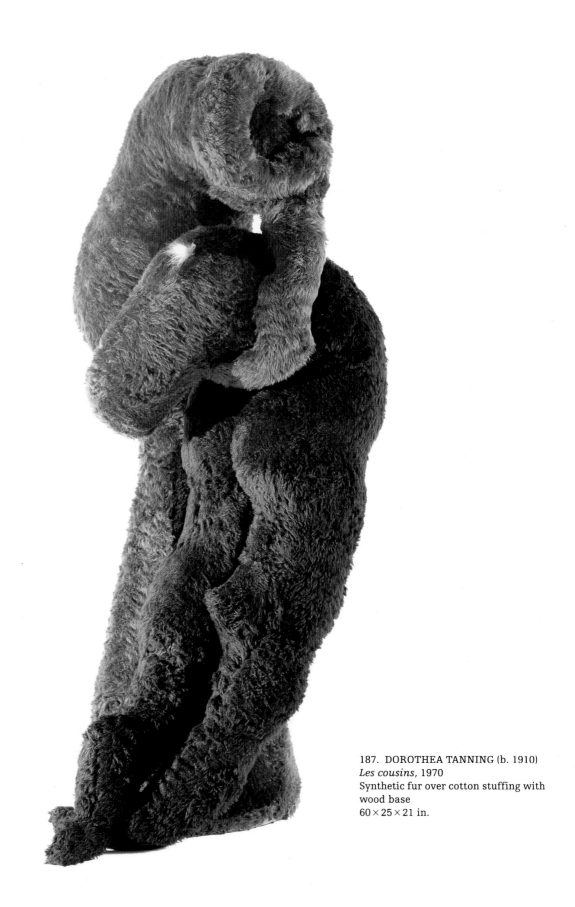

187. DOROTHEA TANNING (b. 1910)
Les cousins, 1970
Synthetic fur over cotton stuffing with
wood base
60 × 25 × 21 in.

188. HENRI MATISSE (1869–1954)
Composition, Green Background, 1947
Collage: gouache, cut papers, and
pencil on paper
41 × 15⁷⁄₁₆ in.

189. GEORGES BRAQUE (1882–1963)
Interior with Palette, 1942
Oil on canvas
55⅝ × 77 in.

190. PABLO PICASSO (1881–1973)
Skull and Pitcher, 1945
Oil on canvas
28⅝ × 36⅛ in.

Opposite:
191. FERNAND LÉGER (1881–1955)
La mère et l'enfant, 1951
Oil on canvas
36½ × 25¹¹⁄₁₆ in.

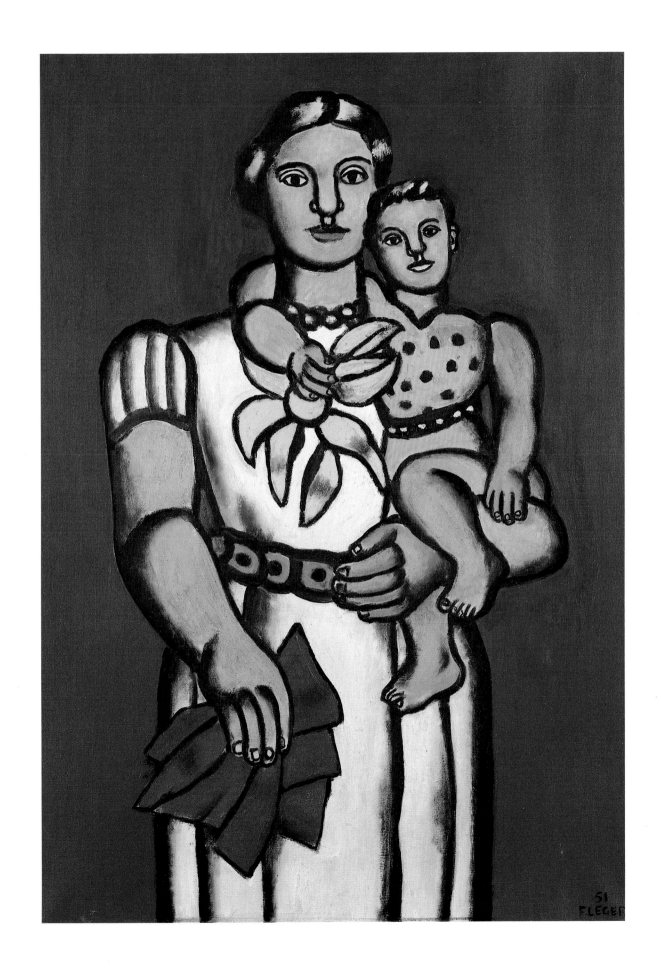

Oradour-sur-Glane
by Jean Fautrier
Dominique de Menil

On Saturday, June 10, 1944, the French village of Oradour-sur-Glane was burned and its inhabitants were massacred under order of General Lammerding, Dickmann Company, 2nd Battalion in the Regiment "der Führer" of "Das Reich" section, 2nd SS Panzer Division.

Oradour-sur-Glane was a rural community about 230 miles south of Paris. The village had no hidden arms and was not in contact with partisans, but nearby partisans had fired upon a retreating German detachment.

On that Saturday afternoon, at two-fifteen, army vehicles and two hundred German soldiers appeared in the village. An order was given the Mayor to assemble the population in the marketplace for verification of identity papers. This was announced by drum rolls at every street corner. Clear of conscience, people assembled, frightened yet unaware of the real danger. The children, who had by circumstance been gathered for a health checkup, innocently joined the others.

At three o'clock a house-to-house search was over and everyone was assembled. Six machine guns were aimed at the crowd. At three-thirty men were divided into groups and herded into six barns. One man who managed to escape related that after waiting five minutes inside all were machine-gunned. Those still living were shot with pistols. Yet some remained alive. There was a terrible silence. Soldiers came back. They covered bodies with straw and set the barn on fire. Five men escaped from that barn, none from the others.

Meanwhile, the children and women, some carrying their babies, some pushing carriages, were forced into the church. Around four o'clock soldiers carried inside a crate with explosives and ignited it. Survivors were machine-gunned. Two women managed to escape through a window, one with her baby. She and the child were shot. The other woman was the sole survivor.

Before they left, the SS set fire to the village. The statistics of the destruction, established shortly afterward, state: 123 houses, 98 barns, 54 sheds and garages, 48 shops and warehouses, 4 schools, 1 railroad station, 1 church. The entire village.

How many were killed at Oradour? The *Documents pour servir à l'Histoire de la Guerre* of the *Archives du Service de Recherche des Crimes de Guerre Ennemis* indicate the figure of 634. Jean-Pierre Azema in *De Munich à la Libération, 1938–1944* gives the figure of 642, of which 240 were women and children. It seems that only 8 managed to remain hidden and that 16 were able to escape.

Under the shock of the news of the Oradour massacre, Jean Fautrier painted the work of this title. It is the first in his series known as *Hostages.*

During the German occupation Fautrier remained hidden in his park surrounded house, La Vallée-aux-Loups, outside of Paris. Beyond its fenced enclosure executions were carried out by the Gestapo. Fautrier lived in horror of these executions. He was moved to produce the *Hostages* paintings—about thirty—all dated 1945.[1] Actually, they were painted in 1943 and 1944. Fautrier, constantly under the threat of house search, distributed the paintings among his friends, leaving them unsigned and undated for safety reasons. They were all dated after the Liberation and exhibited at the Galerie René Drouin. André Malraux wrote the preface to the catalogue. He heralded the *Hostages* as "the first attempt to dissect contemporary pain, down to its tragic ideograms, and force it into the world of eternity."[2]

NOTES

1. and 2. Michael Ragon, "Fautrier," *Le Musée de Poche,* George Fall, editor, Paris, 1957.

192. JEAN FAUTRIER (1898–1964)
Oradour-sur-Glane, 1945
Oil, waterbased paint, and dry pigment on paper mounted on canvas
57⅛ × 44⅜ in.

193. JEAN DUBUFFET (1901–1985)
Paysage aux ivrognes, 1949
[Landscape with Drunkards]
Oil, sand, and granular filler on canvas
35 × 45¾ in.

Opposite:
194. WOLS (1913–1951)
Manhattan, 1948/49
Oil on canvas
57½ × 38⅜ in.

195. LUIS FERNANDEZ (1900–1973)
Crâne, 1955
[Skull]
Egg tempera on canvas mounted on
board
18⅛ × 15 in.

196. ALBERTO GIACOMETTI
(1901–1966)
Standing Woman, 1953
Plaster and paint
8½ × 3½ × 4¾ in.

The Magic Mirror
by Jackson Pollock

Walter Hopps

In November 1943, Peggy Guggenheim's Art of This Century gallery in New York staged Jackson Pollock's first exhibition. Fifteen paintings and an unrecorded number of works on paper were presented, all executed between 1941 and 1943. Viewed today, this exhibition arguably signals the emergence of a major historical change within art and introduces a set of masterworks by Pollock that came to place him at the forefront of a new art. The major historical change was the development of Abstract Expressionism. The masterworks by Pollock would surely include *Male and Female*, *The She Wolf*, and *The Guardians of the Secret*. It is *The Magic Mirror*, dated 1941, one of the two earliest works in this exhibition, that stands at the edge of Pollock's breakthrough into a new realm. As no one at the time would have suspected, the heroic period of what Alfred H. Barr, Jr., came to refer to in 1957 as the "New American Painting" would largely unfold in the years between Pollock's first exhibition and his early death in 1956.

In its time, Peggy Guggenheim's Art of This Century became the essential gallery to commingle European moderns with a crucial set of emerging American artists. Prior, only two galleries involved with modernist art in America—Alfred Stieglitz's "291," from 1908 to the twenties, and Julien Levy's gallery, from the early thirties—attempted to bring together the high ground of advanced European art with new American work. Art of This Century, operating between 1942 and 1947, was a unique enterprise that maintained permanent installations of Miss Guggenheim's collection of abstract and Cubist works in one gallery, Surrealist works in another, as well as a space for changing exhibitions. In extraordinary rooms, designed by the architect and sculptor Frederick Kiesler, one found works by Picasso, Kandinsky, Ernst, and Tanguy, among others, hung alongside exhibitions of both the European and American avant-gardes. Exhibitions including work by Arp, de Chirico, Duchamp, and Giacometti alternated with those by American artists such as William Baziotes, Joseph Cornell, David Hare, Robert Motherwell, Jackson Pollock, Mark Rothko, and Clyfford Still.

It is worth noting that virtually none of the aforementioned American artists were either being shown or collected by American museums or galleries at this time. Peggy Guggenheim's gallery came at a moment of major transition, when a new generation of American artists assumed a vanguard position, lost to Europe during World War II. Pollock's exhibition in 1943, during the heart of the war years, was the first by an American artist to be presented at Art of This Century. Thereafter, Pollock and his work became a focal point of the gallery's activities.

Pollock, who in 1930 had arrived in New York from the West at the age of eighteen, worked in relative obscurity until the time of his exhibition. For a first exhibition, Pollock received an unusual amount of attention. Within two years two paintings were acquired by American museums: *The She Wolf* by the Museum of Modern Art, New York, and *The Guardians of the Secret* by the San Francisco Museum of Modern Art. Further, in 1945, the key paintings from Pollock's first exhibition were reassembled at the Arts Club of Chicago and the San Francisco Museum of Modern Art. All of this was extraordinary for the time.

Pollock's work commanded notice, even if it was not fully appreciated or understood. James Johnson Sweeney, an active American critic and organizer of vanguard exhibitions, wrote a preface for the Art of This Century brochure. Sweeney in part stated: "Pollock's talent is volcanic. It has fire. It is unpredictable. It is undisciplined. It spills itself out in a mineral prodigality not yet crystallized. It is lavish, explosive, untidy."

In the contemporary press, Pollock's exhibition was in general widely heralded, but such praise as he did receive was neither universal nor unequivocal. As conservative a critic as Edward Alden Jewell at the *New York Times* found Pollock's work "extravagantly, not to say savagely romantic. Here is obscurantism indeed. . . ." Jewell might echo Sweeney's initial perception about the work but not his good opinion, finding the meaning to be impenetrable. In *The New Yorker*, the genial art critic Robert Coates observed that Pollock's work boded "what seems to be an authentic discovery . . . and I had the satisfied feeling that in such pieces as *The Magic Mirror* and *The Wounded Animal* he had succeeded pretty well and pretty clearly in achieving just what he was aiming at." Nonetheless, Coates makes no attempt to specify what he believed were Pollock's goals.

In *The Nation*, the vanguard art critic Clement Greenberg placed Pollock within a particular tradition of the American arts and letters:

> *There are both surprise and fulfillment in Jackson Pollock's not so abstract abstractions. He is the first painter I know of to have got something positive from the muddiness of color that so profoundly characterizes a great deal of American painting.*

Robert Motherwell, a younger contemporary and fellow artist, writing in the *Partisan Review*, identified with Pollock's breakthrough, finding in his example, "one of the younger generation's chances," but noting that Pollock's "principal problem is to discover what his true subject is."

From Sweeney to Motherwell, all sensed the tremendous energy and ambition of Pollock's work, yet each observer remained wary of something unruly, if not uncontrolled, in his work. Their comments are generally laudatory but always cautionary. The way in which each one shied away from both the power and purpose of Pollock's imagery suggests the origins of the eclipse in the years after his death until the early 1970s of this period of his work.

Pollock's career conventionally is divided into five periods of more or less distinct kinds of activity. They may be characterized as follows: (1) the regionalist and incipiently imagist work of the 1930s; (2) the classic imagist works made between 1941 and 1946; (3) the poured abstractions of 1947–50; (4) the black and white poured imagist compositions of 1951–52; and (5) the painterly synthesis of abstract and imagist impulses that occupied Pollock from 1953 until his death in 1956.

Pollock's work in the 1930s reflects a succession of essentially overlapping influences in the following order: Thomas Hart Benton, the most prominent champion of American regionalist painting during the 1930s, with whom Pollock studied at the Art Students League between 1930 and 1932; the darkly romantic and painterly works of the nineteenth-century American artist Albert Pinkham Ryder; the expressionism and social consciousness of modern Mexican muralists, specifically José Clemente Orozco and David Alfaro Siqueiros, whose works and workshops Pollock encountered throughout the 1930s; and finally Picasso, particularly in his

work from the late twenties and thirties, whose influence had overtaken the others by the end of the decade.

In the imagist paintings made between 1941 and 1946, Pollock moved beyond the influence of Picasso and the vocabulary of Synthetic Cubism to achieve his first fully independent body of work. The emphasis on mass and modeled forms, impacted into a shallow relief space, which prevails in Pollock's work throughout the 1930s, gives way during the early forties to a new consciousness of the picture plane and to increasingly improvisational painterly gestures. The major works of this period, invariably invoking mythic and atavistic themes, in addition to *The Magic Mirror* (1941), include *Male and Female* (ca. 1942), *The She Wolf* (1943), *The Guardians of the Secret* (1943), *Pasiphaë* (1943), *Gothic* (1944), and *Totem Lesson 2* (1945).

The three phases of the last ten years of Pollock's life may be summarized as follows: from 1947 to 1951, Pollock painted his classic poured works involving minimal direct intervention of the brush. It is the major works of this period, such as *Autumn Rhythm* and *Lavender Mist* (both 1950), and the truly radical innovations of their technique and structure that have carried Pollock's fame to the present. Powerful figurative references re-emerge in the black and white imagist compositions of 1951–52, such as *Echo* (1951). In his final phase of works, which would include the famous *Blue Poles* (1952), Pollock re-introduces easel painting techniques, often co-existing with poured techniques. Generally, in his last years Pollock synthesizes disparate images, themes, and methods from his earlier work. A major example would be *Portrait and a Dream* (1953).

At the time Jackson Pollock painted *The Magic Mirror*, American artists encountered two opposing positions within contemporary art. On one side, they faced the dominance of European modernism, imported and canonized by such institutions as New York's Museum of Modern Art; on the other, the ideological imperatives of a specifically American regionalist painting, whose principal exemplar was Thomas Hart Benton. In an interview appearing in *Arts and Architecture*, February 1944, subsequent to his first exhibition, Pollock addressed his situation vis-a-vis European modernism and American regionalism:

> *...I accept the fact that the important painting of the last hundred years was done in France. American painters have generally missed the point of modern painting from beginning to end. (The only American master who interests me is Ryder.) Thus the fact that good European moderns are now here is very important for they bring with them an understanding of the problems of modern painting. I am particularly impressed with their concept of the source of art being the unconscious. The idea interests me more than these specific painters do, for two artists I admire most, Picasso and Miró, are still abroad.... The idea of an isolated American painting, so popular in this country during the thirties, seems absurd to me.... An American is an American and his painting would naturally be qualified by that fact, whether he wills it or not. But the basic problems of contemporary painting are independent of any one country.*

Pollock's stance, like that of his contemporaries, became central to the agenda of the new American art. From the early forties, American artists found themselves at the watershed of a historic moment. Not only the possibility for working out a new

Opposite:
197. JACKSON POLLOCK (1912–1956)
The Magic Mirror, 1941
Oil, granular filler, and glass fragment on canvas
46 × 32 in.

kind of abstract art that would go beyond European models presented itself, but an urgency to achieve this became increasingly manifest for Pollock and a handful of his contemporaries. They faced the dominance of Picasso, then in full power, and the authority of Cubist-like structure, which pervaded the spatial organization of modern art. Concurrently, Surrealism at its zenith had arrived in America, bringing forth the technique of automatism and the wellspring of the unconscious.

American Abstract Expressionism derived a synthesis that attempted to deconstruct the Cubist grid, while absorbing a belief in the unconscious intrinsic to Surrealism. Automatist gesture and pictographic imagism became the means to supersede the refinements of Cubist structure on the one hand and the elaborations of Surrealist pictorialism on the other. While the term may suggest affinities with or origins in German painting at the beginning of the century, Abstract Expressionism responded essentially to the stimuli and challenges posed by the school of Paris at mid-century.

Among the ranks of the Abstract Expressionists in New York, as many as thirty artists might be named who were working at a high level alongside better-known figures such as Pollock, Hofmann, Gorky, Still, Rothko, Newman, de Kooning, Kline, Motherwell, and David Smith. Concurrently with these artists, who came to be identified with the New York School, an active and related group of artists was emerging in the San Francisco Bay area during the forties and fifties. The large number of artists associated with Abstract Expressionism in the United States represents a new order of magnitude compared to the smaller elite groups in prior vanguard movements in Europe. It should be noted that a public for this new American art had scarcely emerged until after Pollock's death in 1956.

From the time of his first exhibition at Art of This Century in 1943, Pollock was recognized by his peers as being at the forefront in pursuing his insights at whatever risk. In the paintings from this exhibition and subsequently, Pollock brought abstraction and imagism to the frontiers of a new complexity and ambiguity of allusion. In these paintings, composition was not pre-planned so much as visibly worked out on the canvas. Pollock's gestures were attuned to exploratory streams of imagery that developed during the act of painting or were come upon as revelations. The intensity of Pollock's psychic identification with his work introduced a new degree of subjectivism into the painting process; with him, gesture in painting came to signify a language of expressive graphology unique to the artist. Working within gestural abstraction, Pollock nevertheless created a body of imagery, which, while eschewing the topical or anecdotal, explored the atavistic and the archetypal.

Unlike Surrealist artists such as de Chirico and Magritte, Pollock did not first imagine and then depict his images. Automatism, as a means of painting or drawing in which any pre-determination or control yields to unconsciously impelled movements of the hand, was taken to extreme positions by Pollock. For artists such as Ernst, Miró, and Masson, automatism never became the entire means to achieve a completed painting. Rather, the automatist elements of a work inevitably co-exist with those that are rendered with calculation. Even the brilliant morphological permutations in Picasso's painting from the late twenties and thirties reveal his unrelinquished command of structured depiction.

Automatism and related techniques, used to induce a margin of painterly improvisation, were crucial to Pollock as a means of confirming the importance of the unconscious as a source of images and subjects. Pollock's conviction in this regard led him to exert less painterly control in defining his imagery. Pollock pro-

ceeded from an act of faith, however problematic, that powerful and important images would surface from his unconscious when he was totally immersed in the process and moment of painting. Painting was for him an existential exploration, in which images discovered and unleashed form a progressively complex set of layers within a single work. This may begin to explain why even his peers, from Greenberg to Motherwell, were at a loss to grasp "the subject" in Pollock's imagist work. By relinquishing certain a priori controls in defining his imagery, Pollock had forced a redefinition of such controls in subsequent art.

Finally, a powerful current of American transcendentalism brings itself to bear as a critical factor in Pollock's temperament. In 1942, when Lee Krasner introduced him to Hans Hofmann, the elder painter, after looking at his work, observed that Pollock "worked from the heart" and advised him to enroll in his school and work from nature. Pollock replied, "I am nature." For Pollock, nature was neither a touchstone of poetic invention as it was for a painter such as Gorky, nor a body of perceived phenomena, as it was for Hofmann. Rather, his identification with nature was complete. He saw nature as encompassing the unconscious, an uncharted realm to be explored through painting in pursuit of selfhood.

Measuring 46 × 32 inches (117 × 81.3 cm), *The Magic Mirror* is a medium-size easel painting, typical for Pollock up to this time. Examination reveals that the canvas with the design surface of *The Magic Mirror* had been cut from a prior painting, and remounted on another stretched and painted canvas of slightly larger dimensions. A photograph showing the painting unsigned, in the possession of the work's original owner, the artist and collector Jeanne Reynal, suggests that the work was probably signed and dated just before it was exhibited in 1943.

The Magic Mirror is covered with a skin of variously thick and crusty paint mixed with a granular filler, possibly fine gravel. Its surface recalls the rugged topographies of other works by Pollock from this time, particularly *Bird* (ca. 1938–41), in which sand has been mixed with oil paint, as well as *The She Wolf* (1943), painted with oil, gouache, and plaster, and *Wounded Animal* (1943), painted with oil and plaster. In its relative fusion of figure and ground, *Wounded Animal* bears a close affinity to *The Magic Mirror*, which, however, is much more complex. It discloses clear evidence of three distinct strata of painting activity that approach, but intentionally do not resolve, a conventionally legible composition. An initial level of composition has been occluded beneath a layer of uniformly colored, but variously keyed, paint, further embedded in places with impasto and a thickening agent, composed of a finely ground mineral substance. This second layer selectively masks out much of the original composition. In a third stage of paint application, Pollock has emphasized certain aspects of the composition's residual structure and introduced new disjunctions of form with brushstrokes of black, red, and yellow. The final composition is extraordinary as much for what it conceals as for what it reveals.

The titles Pollock has given his works have a serious function beyond identification; allusion to specific themes is clearly Pollock's intent in this regard. The imagery of *The Magic Mirror* is so obscured and complex that if Pollock had not titled the painting there would be little basis upon which to propose a directed reading of the images. Its title immediately suggests the presence of a figure before a mirror. Accordingly, one might "read" what is depicted in Pollock's composition as follows: beginning at the top of the composition, a dominant form suggests a radically abstracted head with a feathered headdress, outlined in very pronounced

strokes of black, yellow, purple, and red. The headdress element is echoed in the imagery of a later painting, *The Moon-Woman Cuts the Circle* (ca. 1943). The cephalization of the form at the top of the composition recalls the split silhouettes, tilting planes, and gaping mouths in those paintings by Picasso from the 1930s associated with Surrealism. This form also has counterparts in the network of interlocking masks in Pollock's own earlier works, particularly *Masqued Image* and *Birth*, both dated ca. 1938–41, as well as in his drawings of this time, which are redolent of correspondences with American Northwest Coast and Southwest Indian art.

From the putative head form at the top of *The Magic Mirror* the outlines of a seated figure appear to continue in fragmentary fashion to the bottom edge of the canvas. Although the anthropomorphic patterns not quite submerged by the layers of painting tend to indicate a single large figure, other human presences are intimated in various scales throughout the composition. The figure identified in the reading at hand appears to be situated in an architectural setting, an interior whose physical character is denoted by broken lines set at right angles, demarcating particular spaces within the composition. At the upper right corner of the composition, there is an enclosed rectangular form, the nature of whose framing suggests that it may be the image of a mirror, revealing a complicated, ambiguous reflection.

From the allegorical figures of Venus at her toilette in Baroque paintings such as by Rubens and Velázquez to the more secular representations of figure and mirror from the eighteenth century through modern art, Western tradition clearly favors women as the subject interacting with mirrors. Exceptions include masterpieces by Van Eyck and Velázquez, in which the male artist, or patron, is brought into the composition by way of a mirror reflection. Picasso's *Girl Before a Mirror*, painted in 1932, bears most directly upon Pollock's painting insofar as *The Magic Mirror* may be said to allude to the depiction of a figure in an interior with a mirror.

Picasso's painting, acquired by the Museum of Modern Art in 1938, was conspicuous in two exhibitions at the Museum the following year: *Picasso: Forty Years of His Art* and *Art in Our Time*, the Museum's tenth anniversary exhibition. Pollock would have been familiar with the painting as early as 1937 from a reproduction in John Graham's article, "Primitive Art and Picasso." Picasso's *Girl Before a Mirror* was one of the most accessible and celebrated works of recent European modernism to be seen in New York at the end of the 1930s. A decade later, when *Life* magazine gathered a panel of art experts for a "round-table" on modern art, Picasso's *Girl Before a Mirror* was one of the first works put forward. The painting was addressed by the art historian Meyer Schapiro:

> *In painting the girl before a mirror, Picasso proceeds from his intense feelings for the girl, whom he endows with a corresponding vitality. He paints the body contemplated, loved and self-contemplating. The vision of another's body becomes an intensely rousing and mysterious process. Picasso and other moderns have discovered for art the internality of the body . . . Thus the body is represented from outside and within, and in the mirror is still another image of the body. I think that is a wonderful, magical, poetic idea, to show the human body which is ordinarily represented in one way— in its familiar surface form—as belonging to three different modes of experience within one picture. I don't know of another picture in all history that does that. . . .*

The essential differences between Picasso's assured Cubist structuring and Pollock's deliberate abstract and imagist ambiguity could not be more apparent than

Fig. 1 Pablo Picasso
Girl Before a Mirror, 1932
The Museum of Modern Art, New York,
Gift of Mrs. Simon Guggenheim

in comparing *Girl Before a Mirror* and *The Magic Mirror.* The profound difference is especially telling in that evidence points to the Picasso painting being a stimulus, if not a model, for Pollock's work. There is an additional significant difference between the two paintings: the figurative elements in Pollock's painting reveal no specific sexual identity. In many of Pollock's paintings with figures, there is no clear separation between male and female identities, rather, implications of both exist, either locked in a struggle of forces or in an embrace in which male and female merge.

Another interaction between figure and mirror in Western art involves the practice of self-portrait painting. Here the mirror is literally used by the artist for self-scrutiny, but invariably the mirror is not depicted. Given Pollock's absorption with the significance of the unconscious, the relationship between the artist and canvas may be likened to that between artist and mirror. In this sense, the canvas may figuratively become a mirror reflecting back what the artist has put of himself into a painting. Pollock's characterization of the mirror as "magic" suggests his preoccupation with atavistic or nonrational sources of meaning. Further, magic invokes transformation. What Pollock has put of himself into his painting comes back magically transmuted; the act becomes revelation rather than mere artifact. If the entire canvas of *The Magic Mirror* may be likened to the surface of a mirror, by analogy its composition might be seen as a self-portrait of the artist, where the likeness is reflected as a subjective, psychic transformation.

The prevailing body of opinion about Pollock's work, set forth during his lifetime and enduring through the sixties, addressed itself to only one phase of a much more complex and vital career. According to this conventional view, the poured paintings from the late forties through the early fifties are his works of first importance and the basis of his contribution to modern art. An essentially formalist reading of Pollock's work has hailed the nonhierarchical "all-over" fields of the poured paintings as the ultimate break with Cubist space. Earlier and later periods of his work have been acknowledged to contain splendid works seen in isolation, but their cumulative achievement and relationship to the entirety of Pollock's work have usually been slighted or dismissed.

The Magic Mirror stands as a crucial early example of Pollock's radical fusion of abstraction and imagism. This fusion informs most of his early and late work. The initial misapprehensions with which his contemporaries greeted this work were communicated to the generation that followed. During the seventies, however, a critical revisionism intervened, which proposed psychoanalytic readings, essentially Jungian, of Pollock's mythological-imagist compositions from the forties. While the revisionism of the seventies tended to literalize his subjects, nevertheless it played an important role in reinstating the importance of the unconscious and atavistic themes into Pollock's concerns. At present, the unique synthesis of imagism and painterly abstraction in Pollock's early and late work has found a particularly responsive audience among a new generation of painters emerging since the late seventies and associated with the issues of a post-modern position in art. A new understanding of his imagist work is beginning to place the entirety of Pollock's achievement in a broader perspective in which the poured paintings constitute one phase of the greater arc of a remarkably complex and consistently powerful body of work.

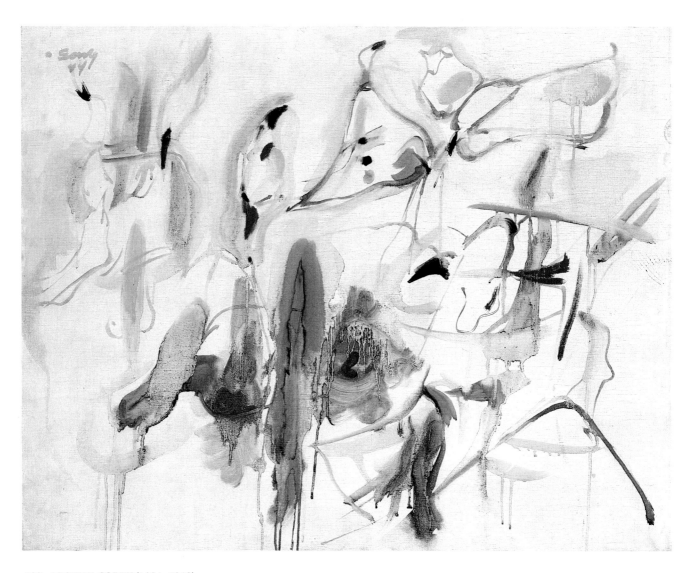

198. ARSHILE GORKY (1904–1948)
L'Amour du Fusil Neuf, 1944
[Love of the New Gun]
Oil on canvas
29¾ × 37¾ in.

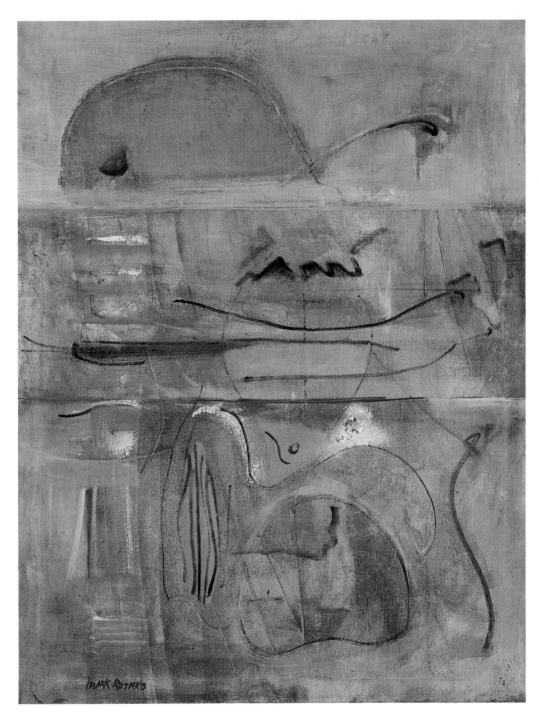

199. MARK ROTHKO (1903–1970)
Astral Image, ca. 1946
Oil on canvas
44 × 33⅞ in.

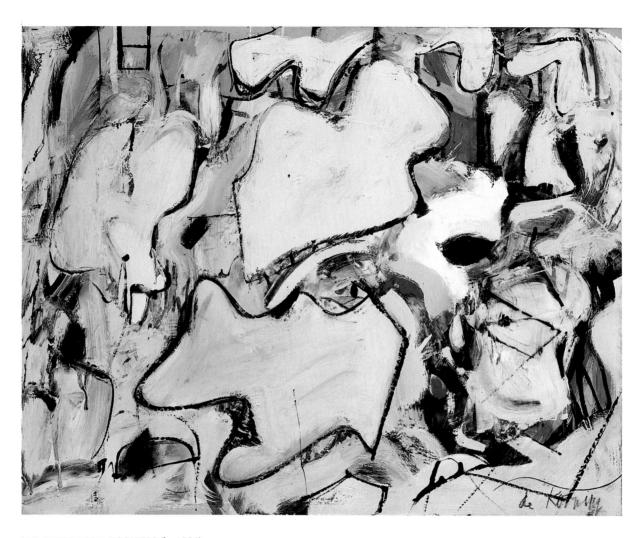

200. WILLEM DE KOONING (b. 1904)
Attic Study, 1949
Oil, enamel, and pencil on paperboard
mounted on masonite
18⅞ × 23⅞ in.

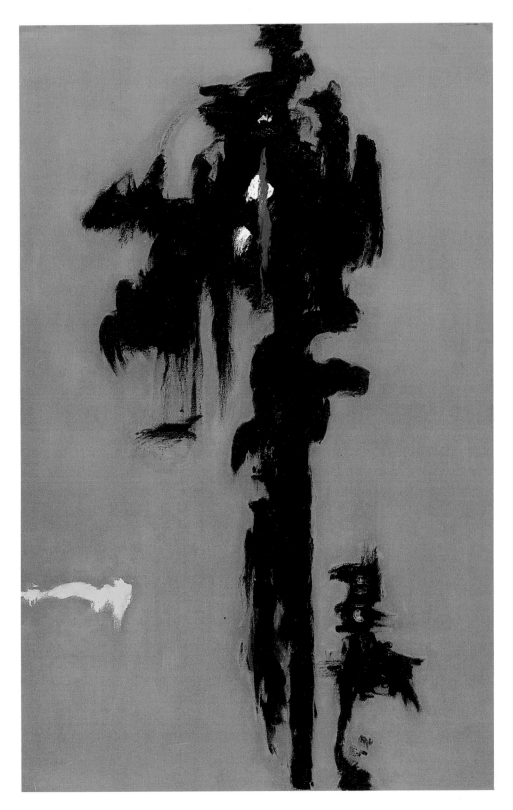

201. CLYFFORD STILL (1904–1980)
Untitled, 1946
Oil on canvas
51 × 32⅞ in.

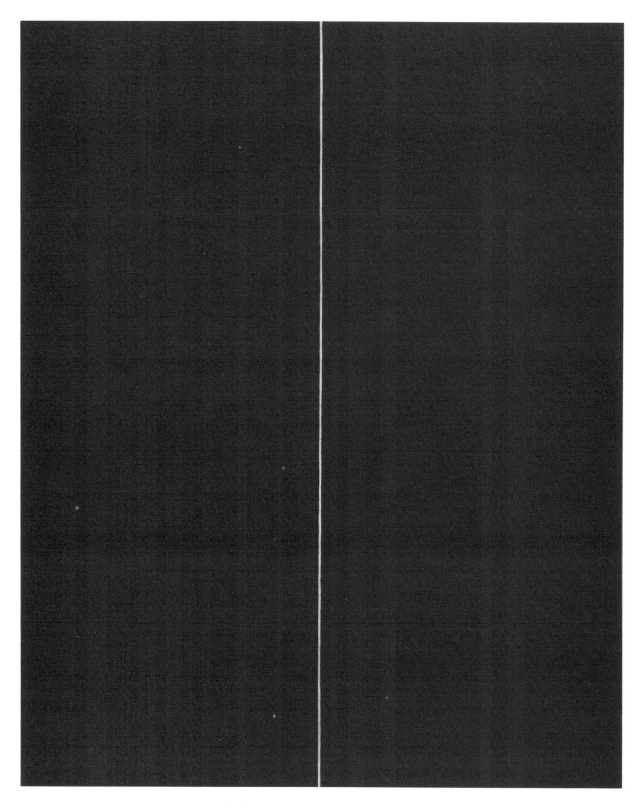

202. BARNETT NEWMAN
(1905–1970)
Be I, 1949
Oil on canvas
94 × 76 in.

203. BARNETT NEWMAN
(1905–1970)
Ulysses, 1952
Oil on canvas
132 × 50 in.

204. MARK ROTHKO (1903–1970), Untitled, 1956
Oil on canvas, 67¾ × 58½ in.

205. MARK ROTHKO (1903–1970), Untitled (No. 10), 1957
Oil on canvas, 69¼ × 62 in.

206. ALEXANDER CALDER
(1898–1976)
The Y, 1960
Oil on sheet steel and steel wire
98¹³/₁₆ × 174½ × 66⅜ in.

Opposite:
207. TONY SMITH (1912–1980)
Marriage, 1961
Painted milled steel
10 × 10 × 12 ft.

208. ROBERT RAUSCHENBERG
(b. 1925)
Crucifixion and Reflection,
ca. 1950–1951
Oil, enamel, waterbased paint, and
newspaper on paperboard
51⅛ × 47¾ in.

209. ROBERT RAUSCHENBERG
(b. 1925)
Untitled (Night Blooming Painting),
ca. 1951
Oil, latex paint, and granular filler
on canvas
62¼ × 31½ in.

What Is the Poetic Object

David Shapiro

Cy Twombly had made an object of wood, whitewash, mirrors of glass, various cloths, rope twine, wire, and graphite—a work as personal and humble as van Gogh's paintings of shoes. But the catalogue of materials and the size ($80 \times 13\frac{7}{8} \times 11$") will satisfy only the nominalists, though we will find in his materialism and his sense of proportion part of his sculptural largesse. We know Twombly as a painter and as a draftsman, and we will be seeking in this object, and will find, what are the privileges of the sculptural object in comparison to the two-dimensional. Most of all, since we are "condemned to meaning," we will address the object as a sign seeking to address us.

The palpability of the object is unquestionable, from its forthright base to its two-armed swing with "sacrificial" bag. Its symmetry is established with the radiant grid of nine circular mirrors toward the middle of this wooden icon. Front and back may be distinguished by the lack of mirrors in the dorsal view, a lack we may compare to absence of "eyes" as we sense the human in this object. The mirrors are separated vertically by wooden ribs, again absent from the more vacant back. A horizontal slat above the mirrors contributes to another sense of palpable sectioning, and mounted above this is a passage of sudden scrawl—Twombly's "signature" of *graphesis* or impure writing. The most riddling aspect of the sculpture, perhaps, vying with the facade of mirrors as enigma, is the bandaged and bound other "object," hung up as it were by two bonelike spoons and tied to a horizontal dowel. This is, indeed, a sculpture within the sculpture and one that addresses us with all the doubt of the riddling and bound objects of Man Ray, Magritte, and the Surrealist tradition as it reaches public form in Christo's bound buildings.

Why is it that Twombly's beautiful work as a sculptor has been overlooked? He has not been falsely productive (in the sense of a gallery-induced end to experimentation with the making of too coherent styles). One sculpture from 1977 is a playful chariot that takes its place among the critiques of Greek epic elsewhere in Twombly's work. The heart-shaped fan entitled *Cycnus* (1978) is decorative and inventive. Always there is a refutation of the merely minimal and yet a saving of the geometric, as in his radiantly symmetrical, untitled "palms" of 1955. We might compare the eroticism of his encrusted sculptures of 1979 to Giacometti's insistence on the mottled human; certainly there is something of that master in the thin poles of an untitled work from 1980. Twombly never relaxes his wit for all his nominalist zeal. In one last work, which could be a wry revision of Rilke's famous epitaph for himself ("Oh rose, pure contradiction..."), a rose on a dowel is pinned down like a victim upon a bed of wood. It is in Twombly's work that we find a kind of tomb for the natural, reminding us of Sartre's horrifying joke that dying would be his one natural act. In his sculpture Twombly has found the way to larger and larger uses of language and memory, of the Classical tradition, and, with skeptical asides, of the very idea of tradition.

Twombly's sculpture reminds us of the constricting myth of the antinomy of the arts of painting and sculpture. Picasso has forced upon us the sense of assemblage and collage as uniting his great *oeuvre* in esemplasticity. Matisse is perhaps only today being rediscovered as one of the great sculptors of the epoch. Because of

Opposite:
210. CY TWOMBLY (b. 1929)
Untitled, ca. 1953–1954
Construction: paint and crayon on wood with glass, mirrors, two wooden spoons, fabric, twine, and wire
$80 \times 13\frac{7}{8} \times 11$ in.

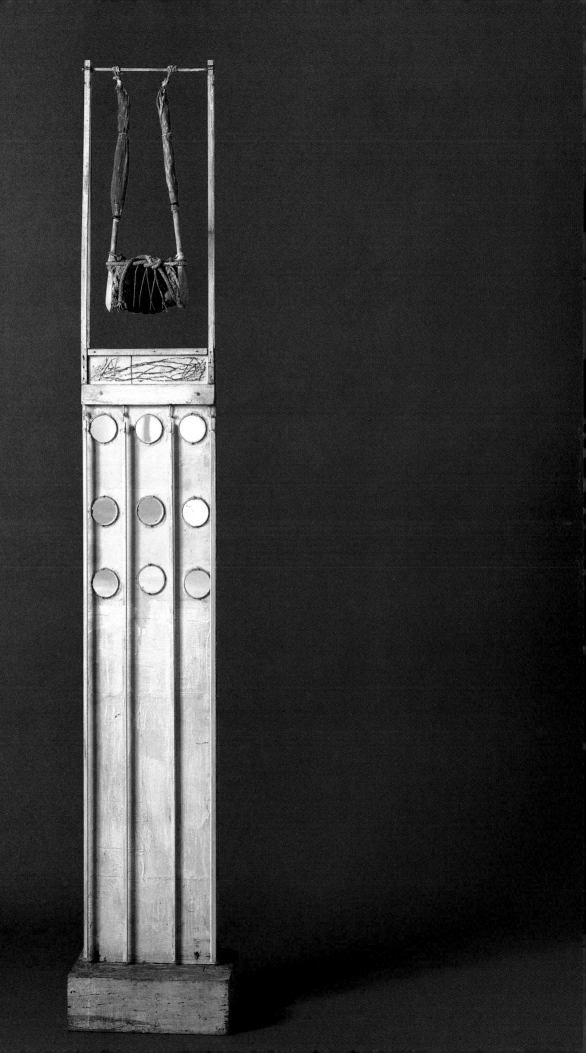

the tragic destruction of the architectonic *Merzbau* in Hanover, Kurt Schwitters is too often seen as a Symbolist and intimist rather than as a creator of volumetric adventures. Robert Rauschenberg and Jasper Johns, so close to the Schwitters ideal of the rescue of everyday detritus, have contributed more to sculpture than most practitioners. Twombly must be thought of as another transgressor of the boundaries of genre. He is a master of rupture, discontinuity, and collage, and it is here that his sculpture takes it place. His bound poles of 1955 have the melancholy Egyptian pose and poise of Johns's light bulbs, but without the insistent reference to the real.

Jasper Johns has, in his early target with faces, an important sculptural-painterly analogy with Twombly's untitled object. In both, a rational abstraction is surmounted by something biomorphic, mutilated, cut off. Johns rejects the idea that his recent using of body parts on wooden slats in an untitled tetraptych is like a sacrificial crucifixion, but few of his critics have accepted his nominalist interpretation of these cut-off body parts. We may see in Twombly's little bound sacrificial bundle something of the lurking melancholy in Johns's opposition of the human and inhuman. Twombly's bound object is not unlike Rauschenberg's *Erased de Kooning Drawing*; in both, a whole language is being effaced through strategies of concealment that leave only the traces as a dominant theme.

If the topic in many of Twombly's paintings has sometimes been thought to be the winding and whimsy of free associations, here we sense the fatefulness of associative thinking, the sense that one never attains the "free." In Jackson Pollock, the continuity of the stream of writing was its own affirmation. In Twombly's greatest works, such as his remarkable *Six Latin Poets*, we find the artist actively working toward the obliteration of sense, as Jasper Johns attacked the numerals and flags with loving defiance. A word has its shadow; the artist repeats it like an autistic poet and there is unremitting play on the idea of art as a playful screening. Perhaps this play of veils in Twombly's work must force us to conclude that his sculpture is as much a screen placed between inner and outer chaos as it is an index of expression, or a mimetic icon seeing and seen. In other sculptures of 1955 and 1978 we find fanlike shapes of "oriental splendor" (Baudelaire's phrase), which are as much antisublime blockages as they are anything, and they are questions concerning the status of a "thing."

We see a plural dynamism in Twombly as his sculpture underlines all the axes of the aesthetic. The expressionist shall find in this personal object the fore-grounding of Twombly's hand, seen in the painterly disjunction of the midsection with its dark abstraction of linear loops. The impersonalist or formalist will pay attention to the calm of this monument to sculpture, of its almost mocking use of the base and the de Stijl parody of calm in its **gridded** and rational mirrors. The richness of this object lies in its multiplicity, in **the way** that it functions as a polysemic object. From Giorgione's *Tempesta* to Marcel Duchamp's puzzling objects, there is a dark tradition in which allegory has delighted in opacity itself. For some, there is a tactlessness in ascribing meaning to the paradoxes of the maze of the modernist object. The sense of the object as affording a free play of limitless readings is perhaps true only of certain subjects. Twombly's object invites polysemy by the way it uses the tactics of concealment. One is not asked to unbind the enigma; one is asked to look at this ritual of concealment and to enjoy the pleasures of the negative. Twombly's sculpture is a transgression of the "still life" as it holds it up to doubt.

Thomas McEvilley has been extremely skeptical of the misreading of "primitive" objects as "aesthetic" in the Western sense, but he has elsewhere more widely

analogized certain performance and process pieces as shamanistic, with some emphasis on "self-injury and self-mutilation." Perhaps something of the riddling control and paradoxical abandon of Twombly's object may be sought in the philosophical-anthropological problem of the "primitive." For there is no doubt that, like many of Rauschenberg's wonderfully humble so-called Neo-Dadaist objects in which a bathtub may be a logical base or a goat an expressive *persona*, the sense of Twombly's icon is one of ritualism without sacrificial context. The context is missing, but the viewer is lured to guess at a proper context for this particular piece. Rauschenberg collaborated with dancers; Twombly was perhaps *always* a choreographer of the hand, and one can be dazzled by the performative nature of his process drawings and collages.

If the use of the "shamanistic" as a tone, a theme, and a *mythos* in recent Western art is part of a search for states of wholeness, then we look at the Twombly object as a totem of our skepticism. We find in this work a kind of decoy of the Neo-primitive, an effigy to rituals that can no longer be comprehended. The nine "eyes" of the totem speak of its own magisterial power to reflect our lack of certainty.

Cy Twombly's "object" reminds us of the grand comedy in the Surrealist tradition, for example Joan Miró's *Poetic Object* (1936)—an assemblage that culminates in a stuffed parrot. Miró's column, no matter how intimist, is one of desire, interrupted by a model of a lady's leg with a fetishistic shoe and a map of the world curling around a hat that is its base. It is important not to delete humor from Twombly's late Surrealist object. Fairfield Porter was one of the first critics to note the appealing humor of Twombly's graphological marks, but it is in his sculptures that his wit is most energized; it is the humor of inclusivity that furnishes the chief topic of many of his objects: fans, palms, and chariots. Like Miró, Twombly affords us a view of intrepid affirmation, though Porter is correct in saying that he never becomes a satirist. These parodies do not hurl themselves against ignorance, like Classical parodies. Thus the Greek and Neoprimitive themes in Twombly's *oeuvre* are ways of speaking in a gently self-lacerating tone about one's lack of "originality." Twombly is filled with a humor of quotation. The Surrealist may have investigated a kind of revelatory route to the unconscious truth, but Twombly, like Johns, celebrates a darker truthlessness: a sculpture presenting a lack; a poetic object speaking of absence. Twombly's object concludes with a trussed secret; humor resides in humiliated expectations. Like Schwitters and Joseph Cornell, Twombly yields us a glimpse of the occluded subject and derides our demands for a more explicit statement.

With René Girard we would insist that the nameless object of Twombly, for example, corresponds to the hallucinatory double of the sacrificial victim. We know that the modern object is not sacred, but in it we find an echo of the liturgical. Twombly's object is thus explicable in its ambiguity of the maleficent and benevolent in much the ways Girard finds legible the contradictory qualities of all tragic doubles. It is and is not an altar.

In this Twombly, we find our own culture's answer to the chaos that threatens it by an establishing of order out of seemingly low or polluted materials. The humble *bricolage* of the Dadaist and Neo-Dadaist is a search for the proper surrogate object that necessarily, after a social spell of stigmatization or neglect, becomes the celebrated hero among objects: the full object, the maximal thing, untitled because maximal. It is exactly because of art's ability to generate celebrated rejected objects that our epoch enjoys its rare moments of orders born of the paradoxical self-lacerations of the artist.

As Meyer Schapiro has instructed, we must not use a too large theory to forget the sensual particularity of the "personal object." Objects should not be bound by theories, like victims. After all, we return to Twombly's untitled thing as a kind of anthology of quotations concerning sculpture. The base privileges its totem; the mirrors yield a masklike possibility, but in their slight irregularities provoke a sense of doubt, as if they were a triple pun or triple loss of meaning, as in James Joyce. The sense of loss is given again as Twombly quotes himself in the souvenir of his personal handwriting. The artist Joseph Beuys became notorious for his use of "unpleasant" natural media, and one might say that the central bandaged baggage of this sculpture is indeed an "unpleasant" object. And yet it hangs with a doleful simplicity. We might say that the secret here is the "laying bare" of the artistic device itself. Sculpture within sculpture, object within object, this multiplicity baffles us. The artistic object becomes so real that we ourselves are shifted from our usual equilibrium and complaisance to find ourselves curiously unreal.

211. JOSEPH CORNELL (1903–1972)
Untitled (Window Facade), ca. 1950
Box construction: painted wood, glass,
cracked glass, and mirror
18⅝ × 12⅜ × 3½ in.

212. JASPER JOHNS (b. 1930)
Star, 1954
Oil, beeswax, and housepaint on
newspaper, canvas, and wood with
tinted glass, nails, and fabric tape
22½ × 19½ × 1⅞ in.

Opposite:
213. JASPER JOHNS (b. 1930)
Grey Alphabets, 1956
Beeswax and oil on newspaper and
paper on canvas
66⅛ × 48¾ in.

281

214. FRANK STELLA (b. 1936)
Lake City, 1962
Copper paint on canvas
22⅝ × 30 in.

Opposite:
215. FRANK STELLA (b. 1936)
Avicenna, 1960
Aluminum paint on canvas
74½ × 72 in.

216. YVES KLEIN (1928–1962), *Requiem*,
blue (RE 20), 1960. Sponges, pebbles,
dry pigment in synthetic resin on board
78⅜ × 64⅞ × 5⅞ in.

217. YVES KLEIN (1928–1962)
Untitled monogold (MG 7), ca. 1960
Gold leaf on primed board
78½ × 60¼ × ¾ in.

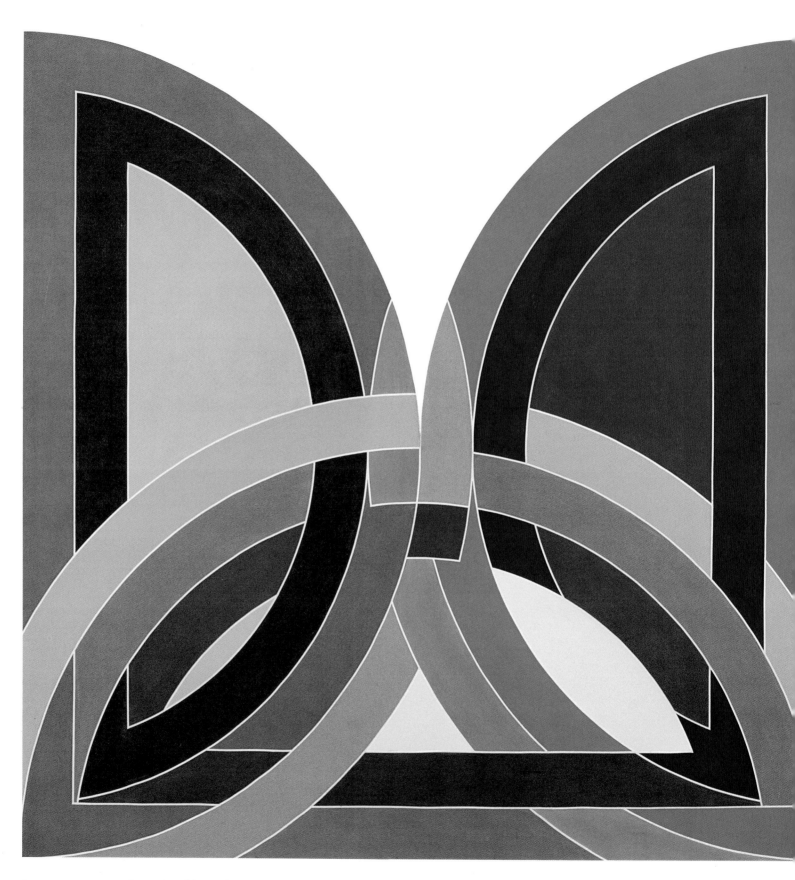

218. FRANK STELLA (b. 1936), *Takht-i-Sulayman I*, 1967
Synthetic polymer on canvas, 120⅞ × 240 × 3 in.

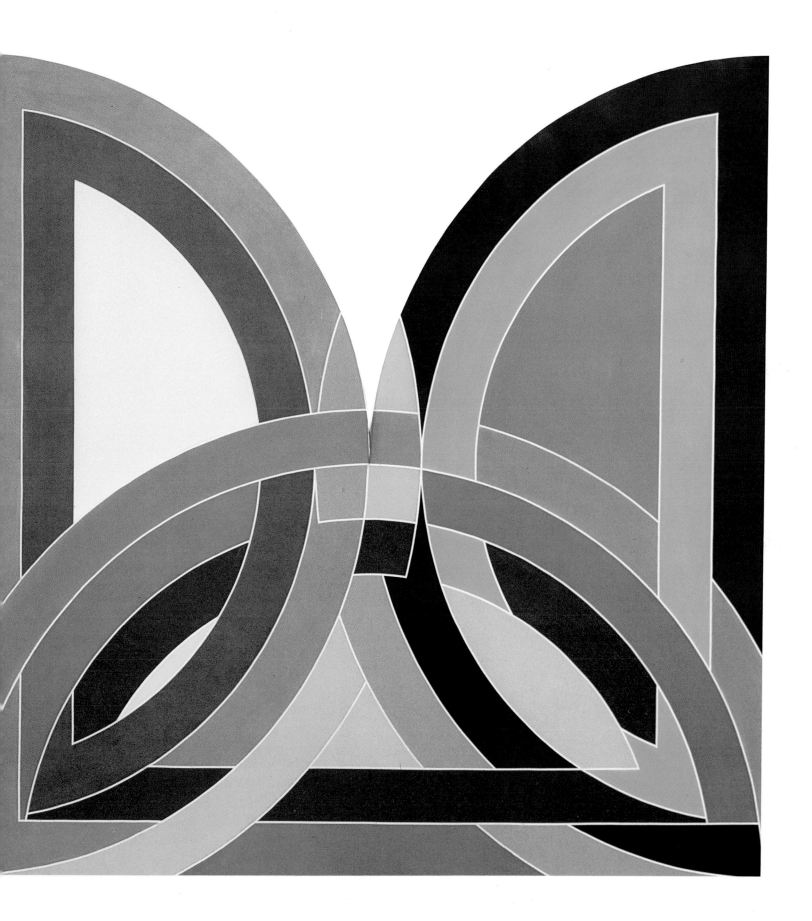

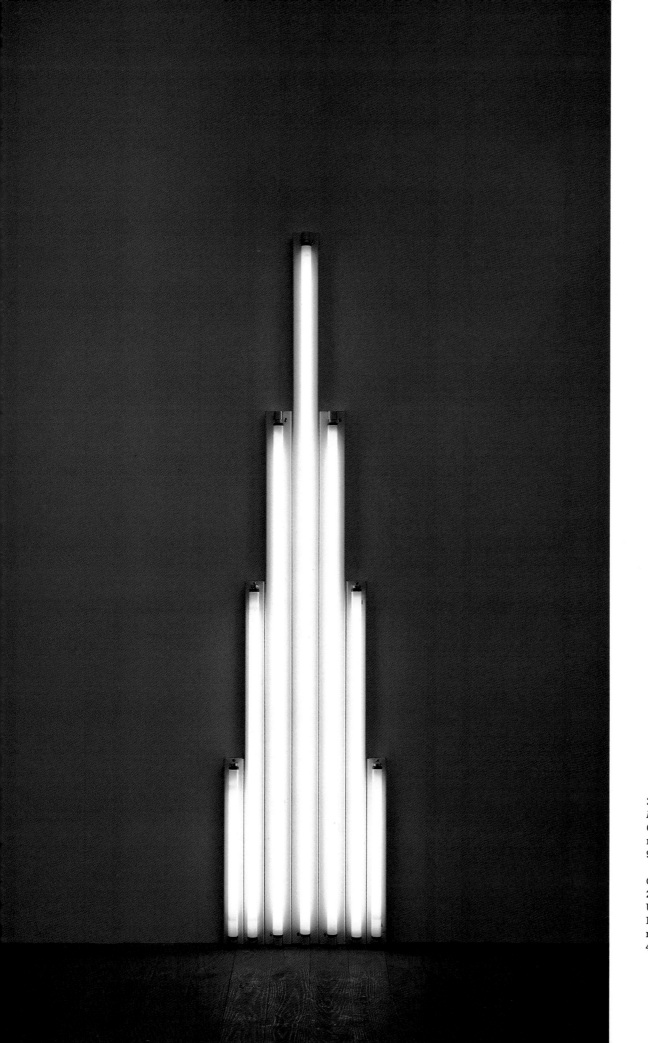

219. DAN FLAVIN (b. 1933)
Monument 1 for V. Tatlin, 1964
Cool white fluorescent tubes and
metal fixtures
96 × 23 × 4 in.

Opposite:
220. DAN FLAVIN (b. 1933)
Untitled (to Barbara Wood), 1970
Red and pink fluorescent tubes and
metal fixtures
48 × 48 × 8 in.

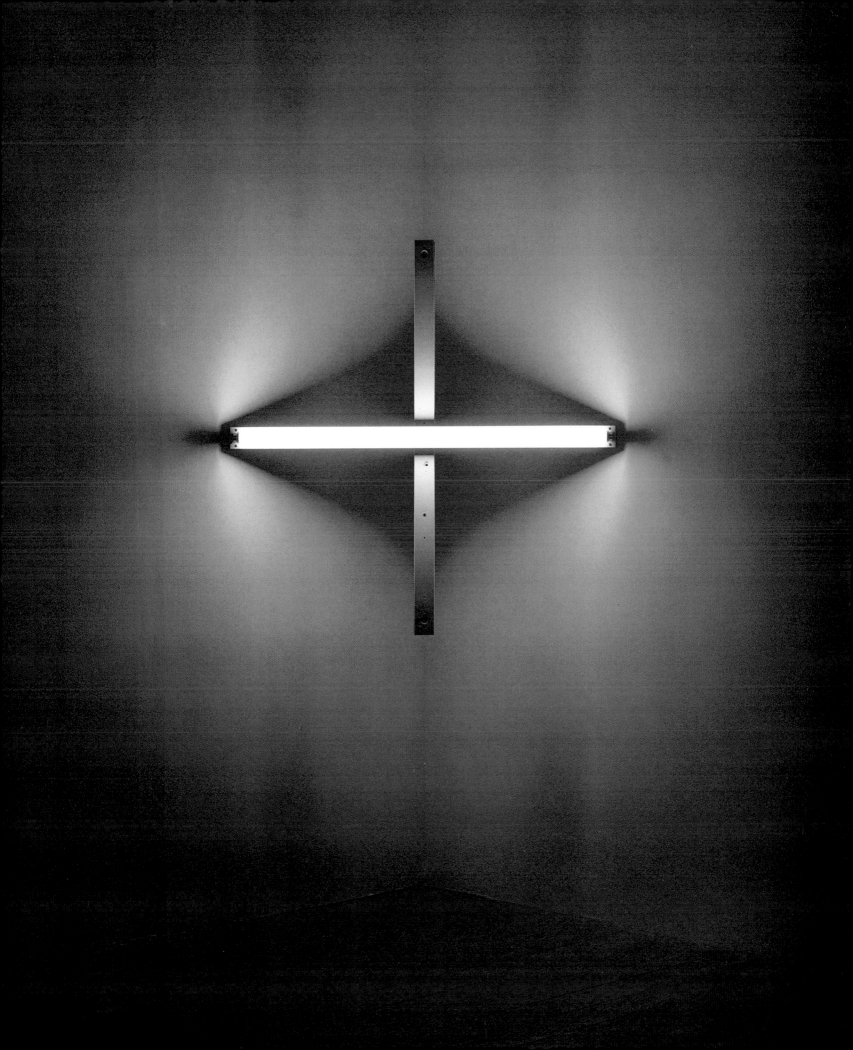

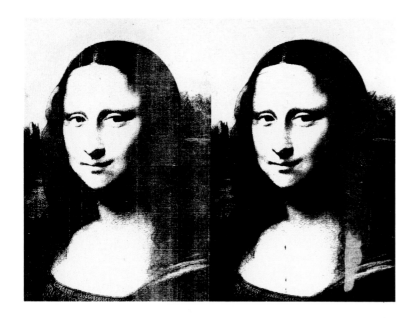

221. ANDY WARHOL (b. 1930)
Double Mona Lisa, 1963
Acrylic and enamel silkscreened
on canvas
28⅛ × 37⅛ in.

Opposite:
223. ANDY WARHOL (b. 1930)
Lavender Disaster, 1963
Acrylic and enamel silkscreened
on canvas
106 × 82 in.

222. ANDY WARHOL (b. 1930)
Big Campbell's Soup Can, 19¢, 1962
Acrylic on canvas
72 × 54½ in.

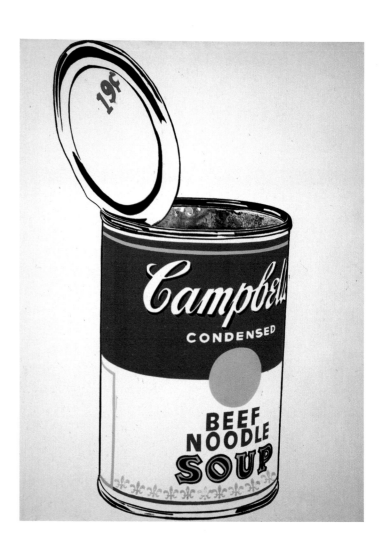

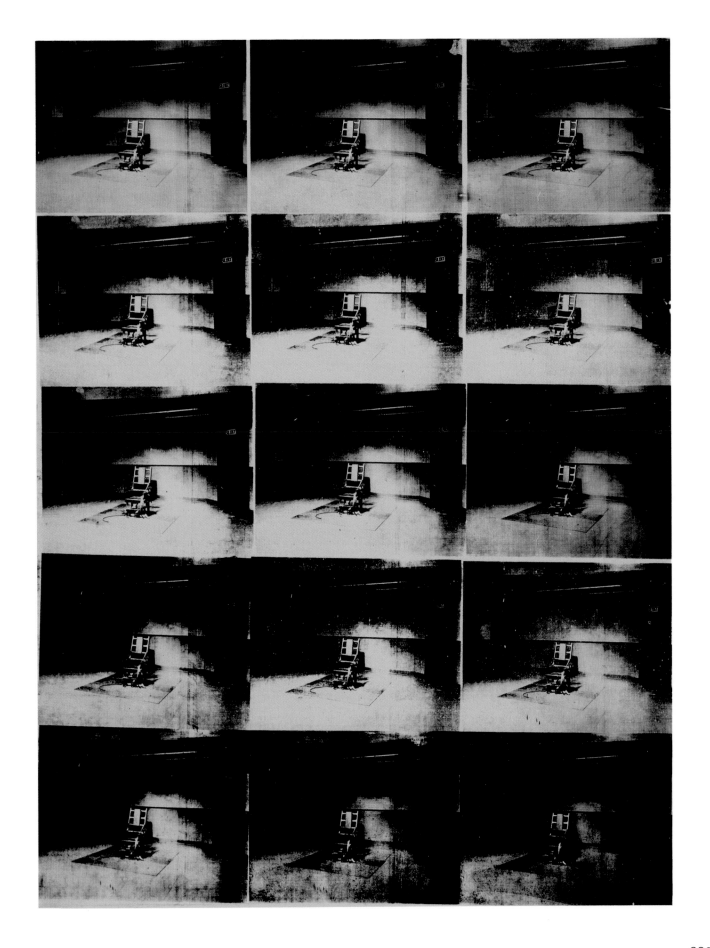

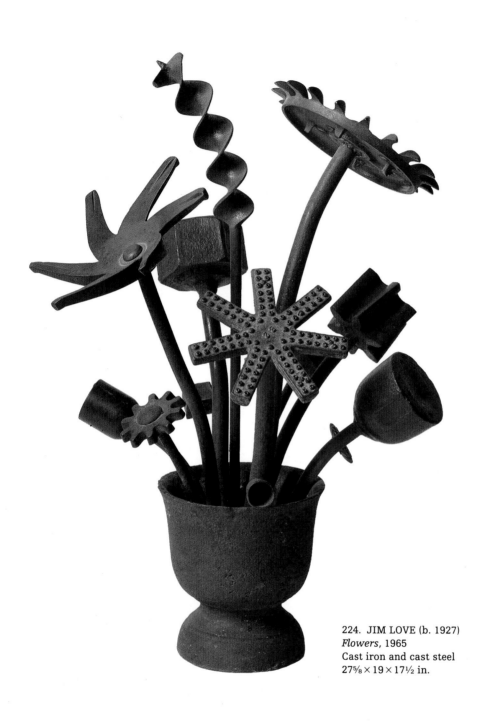

224. JIM LOVE (b. 1927)
Flowers, 1965
Cast iron and cast steel
27⅝ × 19 × 17½ in.

Opposite:
225. JAMES ROSENQUIST (b. 1933)
Promenade for Merce Cunningham,
1963
Oil on canvas
60 × 70 in.

226. ARMAN (b. 1928)
Suffragette héroïque, 1963
Synthetic resin on cut metal castings
mounted on painted wood
28¼ × 36¼ × 2⅜ in.

Opposite:
227. MARTIAL RAYSSE (b. 1936)
Printemps, 1963–1964
[Spring]
Oil on oilcloth with neon tube and
transformer
51⅛ × 38⅛ × 3⅛ in.

228. NIKI DE SAINT PHALLE (b. 1930)
Reims, 1962
Spray paint, plaster, and wire on
plywood with fabric, plastic toys,
masks, and horns
74½ × 48 × 11⅞ in.

Opposite:
229. JEAN TINGUELY (b. 1925)
Dissecting Machine, 1965
Motorized assemblage: painted cast
iron and welded steel machine parts
with mannequin parts
72⅞ × 74 × 83⅞ in.

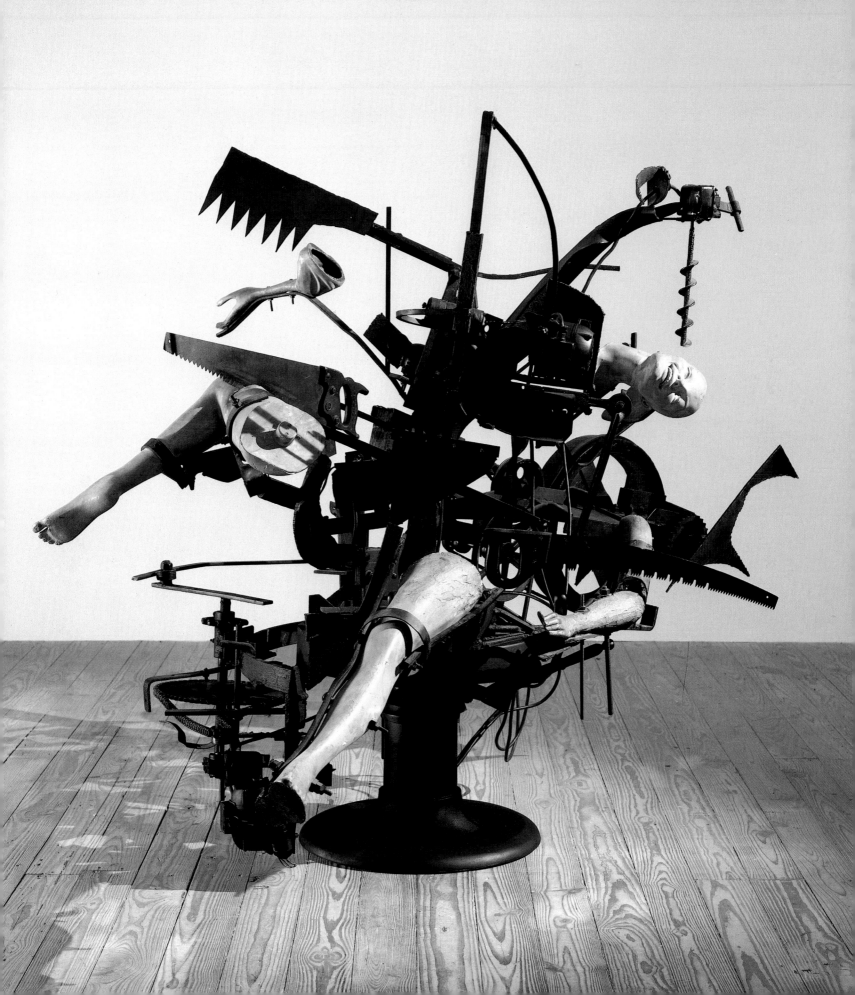

230. WAYNE THIEBAUD (b. 1920)
Delicatessen Counter, 1962
Oil on canvas
30¼ × 36¼ in.

231. GEORGE SEGAL (b. 1924)
Seated Woman, 1967
Plaster figure on wooden chair with
vinyl seat pad
51³⁄₁₆ × 24 × 26½ in.

Overleaf
232. LARRY RIVERS (b. 1923)
Four Hanged Men, 1970
Painted wood constructions with rope
Dimensions, left to right:
Hanged Man: Florida, 72 × 17 × 5 in.
Hanged Man: Mississippi, 68 × 18¼ × 5 in.
Hanged Man with Torn Shirt: Indiana,
79 × 18 × 4 in.
Hanged Man: Indiana, 79 × 22½ × 5 in.

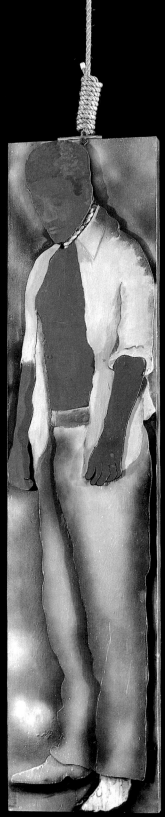

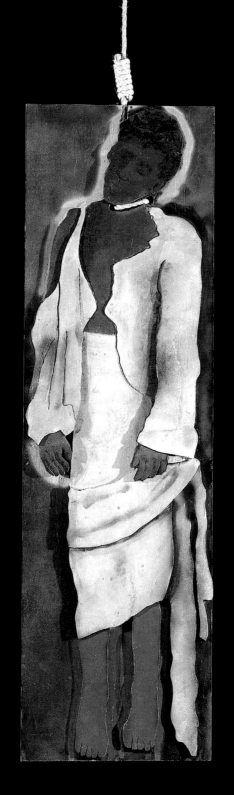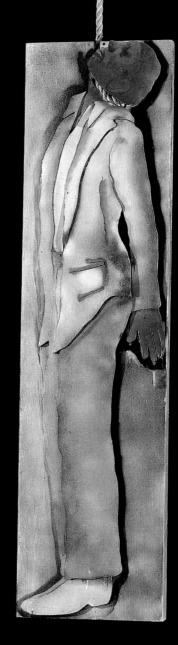

233. CY TWOMBLY (b. 1929)
Untitled, 1968
Acrylic on canvas
79½ × 103½ in.

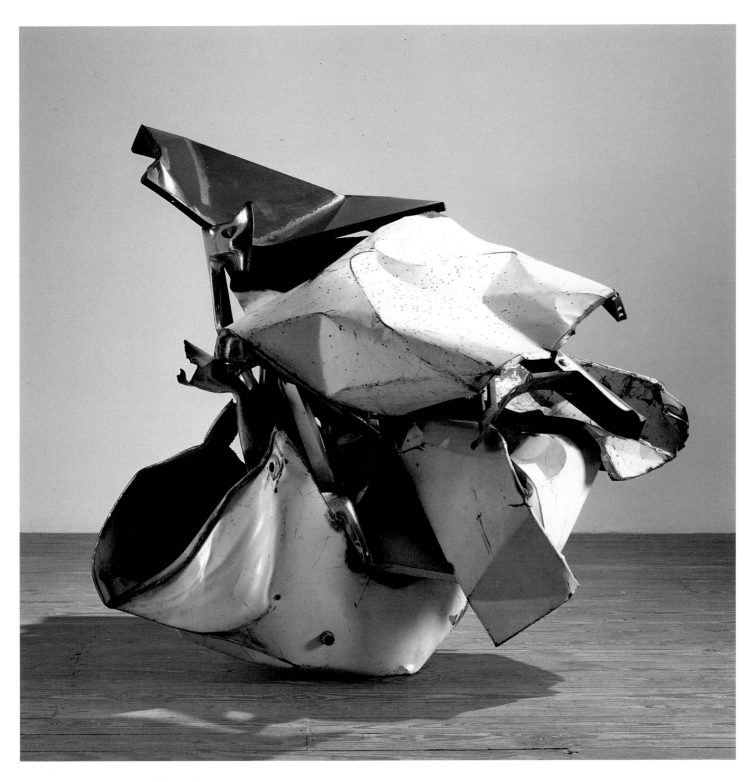

234. JOHN CHAMBERLAIN (b. 1927)
Nanoweap, 1969
Painted and chromium-planted steel
54 × 63 × 47 in.

235. BRICE MARDEN (b. 1938)
Seasons—Small Version, 1974–1975
Oil and wax on paper mounted on four
separate canvases
29¾ × 22¼ in., each

236. DAVID NOVROS (b. 1941)
Untitled (No. 9), 1972
Oil on canvas
84¾ × 243 in.

237. WALTER DE MARIA (b. 1935)
Square, 1972
Brushed stainless steel
3¾ × 39⅜ × 39⅜ in.

238. KENNETH NOLAND (b. 1924)
Pomona, 1977
Acrylic on canvas
68 × 88⅛ in.

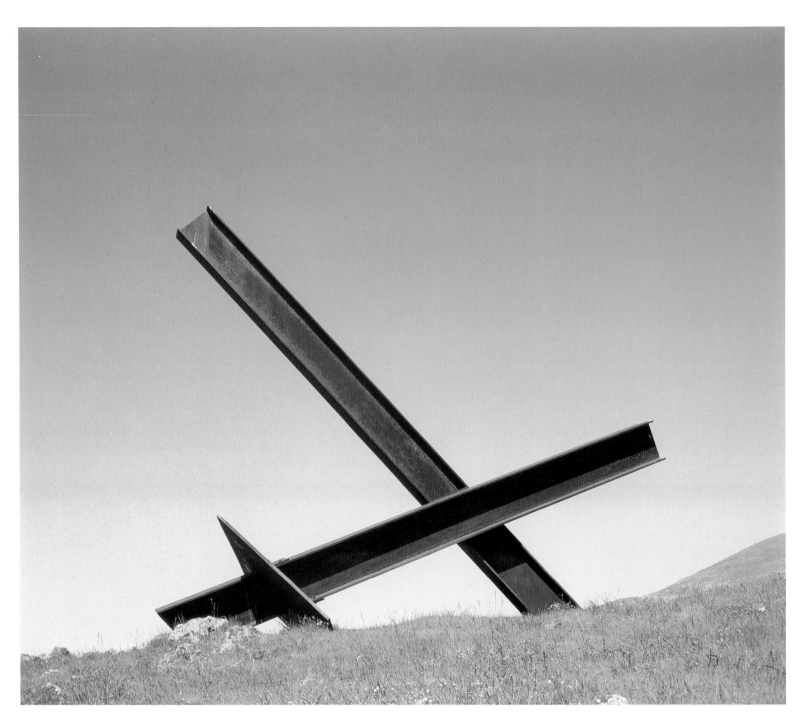

239. MARK DI SUVERO (b. 1933)
Bygones, 1976
Cor-ten beams and milled steel plate
25′11″ × 31′6″ × 14′2″

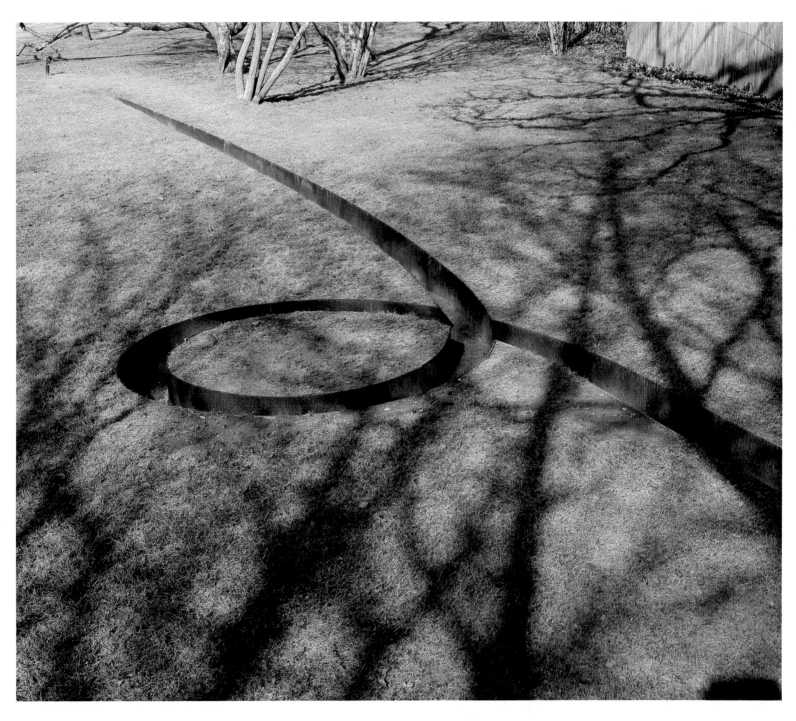

240. MICHAEL HEIZER (b. 1944)
Isolated Mass/Circumflex (#2),
1968–1978
Mayari-R steel
$1' \times 8'8'' \times 80'$

241. KEN PRICE (b. 1935)
Dobus, 1983
Glazed and painted ceramic
$3 \times 4^{15}\!/_{16} \times 3^{1}\!/_{2}$ in.

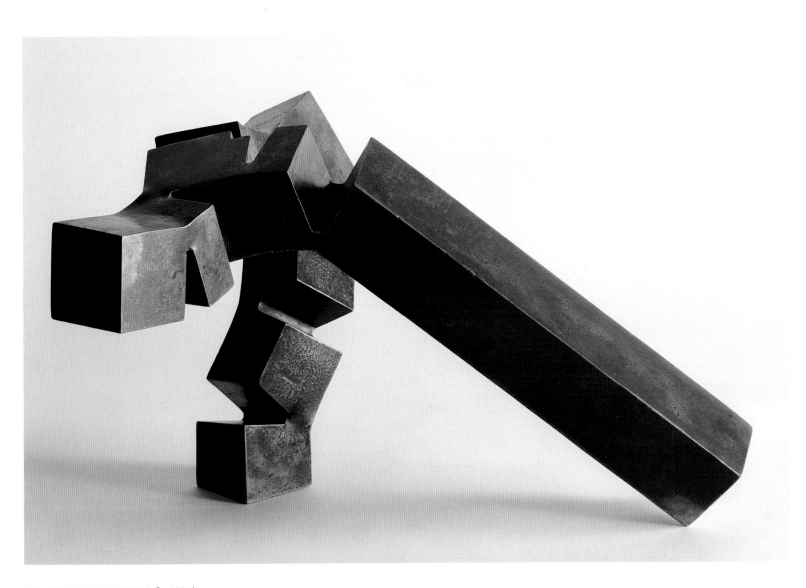

242. EDUARDO CHILLIDA (b. 1924)
Project for a Monument in Düsseldorf,
1970
Steel
11¾ × 16½ × 20¼ in.

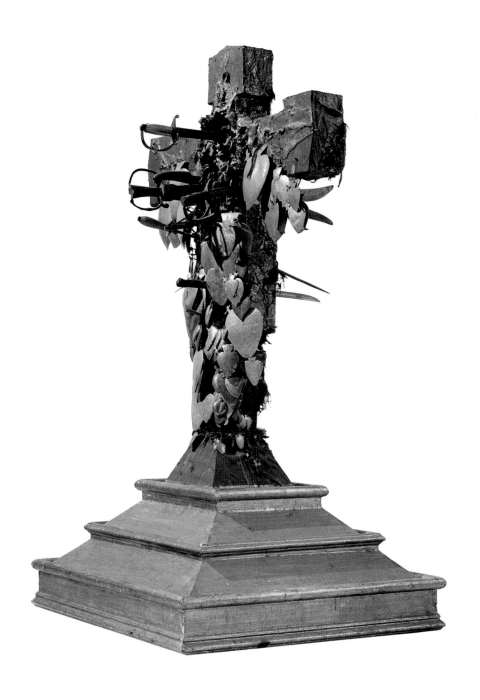

243. MICHAEL TRACY (b. 1943)
Cruz De La Paz Sagrada, 1980
Acrylic on rayon wrapped over wood
with tin and brass *milagros*, rosary
beads, metal swords, spikes, and nails,
string, wire, ribbon, human hair, and
crown of cactus needles; gold leaf on
wood base
69 × 43 × 31 in.

Opposite:
244. JAMES LEE BYARS (b. 1932)
The Halo, 1985
Gilded brass
86½ in., diameter

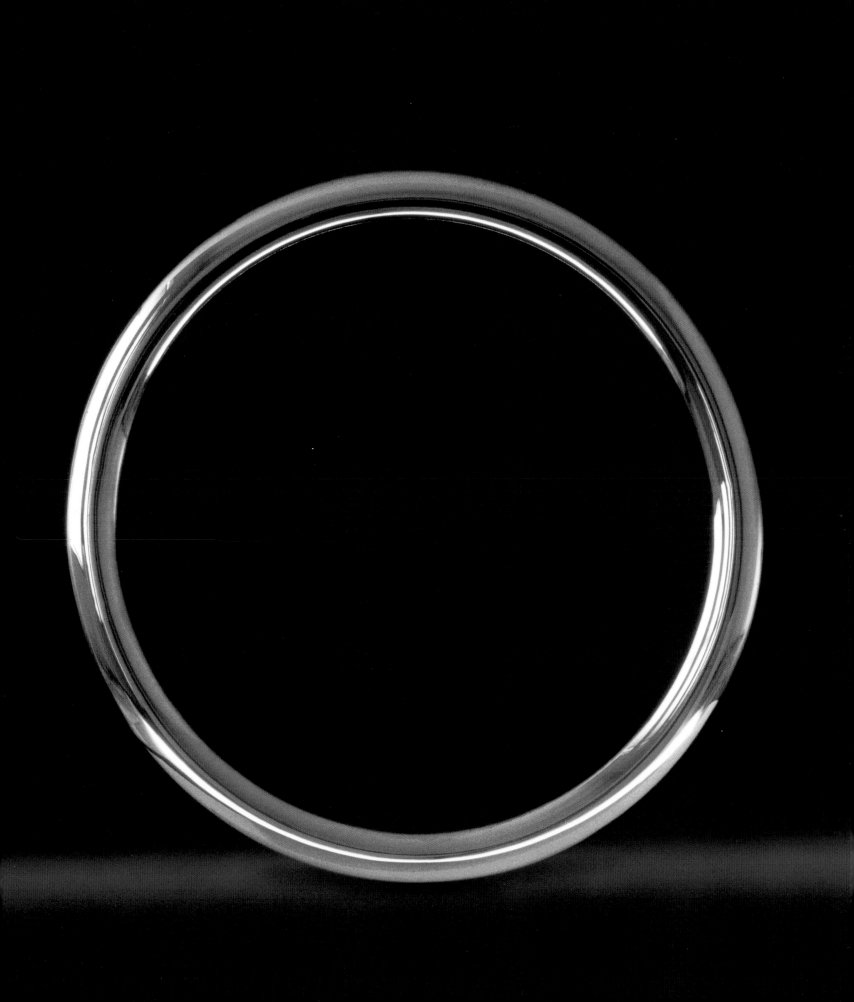

THE ROTHKO CHAPEL

On February 27, 1971, the Rothko Chapel in Houston, Texas, was opened to the public. From conception to its consecration, seven years of intense activity were involved in its realization. The Chapel complex is physically comprised of three essential elements: an octagonal chapel structure of brick; a set of vast paintings by Mark Rothko within the structure; and Barnett Newman's sculpture *Broken Obelisk* set in a reflecting pool facing the Chapel.

The Rothko Chapel functions as a spiritual sanctuary, open to all religious faiths and nonbelievers alike. Occasional public presentations include classical and contemporary music, as well as scholarly colloquia devoted to issues of social and spiritual concern. In 1981 and 1986, the Rothko Chapel Awards for Commitment to Truth and Freedom were presented to human rights activists.

Although the Chapel architecture was essentially determined by Philip Johnson with Rothko and the de Menils, he withdrew from the project in 1969 and it was completed by architects Howard Barnstone and Eugene Aubrey. The final design is simple, even austere. A skylight admits natural daylight, subject to change according to weather, time of day, and season.

The paintings achieved by Rothko constitute an ensemble of eight essential parts, utilizing fourteen canvas panels. On the north wall, corresponding to an apse, is a triptych of three abutted canvases. Facing it on the south wall is a single vertical canvas. On the east and west walls are a pair of similar triptychs. Four large individual canvases are placed on the diagonal axes of the plan.

The somber expanses of color and ineffable forms in the paintings defy verbal description and are virtually beyond photographic depiction. Addressing the issue of what is seen, Harris Rosenstein has written:

> ... that first experience of the Chapel paintings was—in the light of what I had known before—staggering....Before monochromatic painting can function outside itself, as it does in the greater scheme of the Chapel, it must hold its shape—i.e., work in itself—by stimulating and conducting eye movement up, down, and across the surface, so that the painting is not merely seen but continuously and vividly experienced....The extraordinary variegated and breathing surfaces of Rothko's monochromes...accomplished this and more.

Emerging from Abstract Expressionist art, the Rothko Chapel paintings stand at the zenith of the reductive sublime.

Broken Obelisk, Barnett Newman's largest and most ambitious sculpture, was conceived in 1963 and fabricated in 1967. Three identical examples were made under Newman's supervision. In 1969 the sculpture was acquired by the de Menils, and Newman joined them in siting it across from the Chapel's entrance. As John de Menil determined with Newman's concurrence, it was dedicated to the late Dr. Martin Luther King, Jr. In a 1971 essay about *Broken Obelisk* and Newman's other sculpture, Harold Rosenberg wrote: "Measurement, proportion, shape awakened ideas in Newman that were not only plastic ideas but ideas and feelings about God, man, and destiny."

Walter Hopps

245. MARK ROTHKO (1903–1970)
Untitled (South wall painting,
the Rothko Chapel), 1964–1967)
Dry pigments, polymer, and rabbit
skin glue on canvas
180 × 103 in.

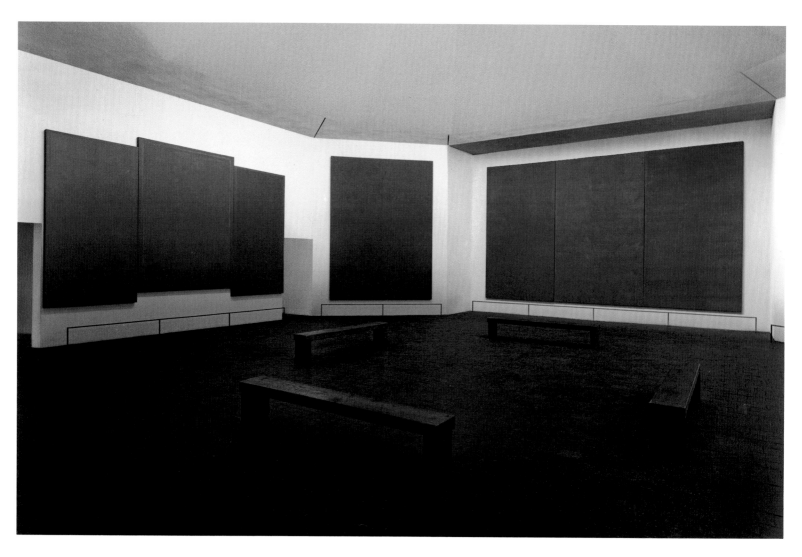

246. Interior, the Rothko Chapel
North view, including the apse
triptych at far right

Opposite:
247. BARNETT NEWMAN
(1905–1970)
Broken Obelisk, 1963–1967
Cor-ten steel
26′ × 10′5″ × 10′5″
Background: exterior, the Rothko
Chapel

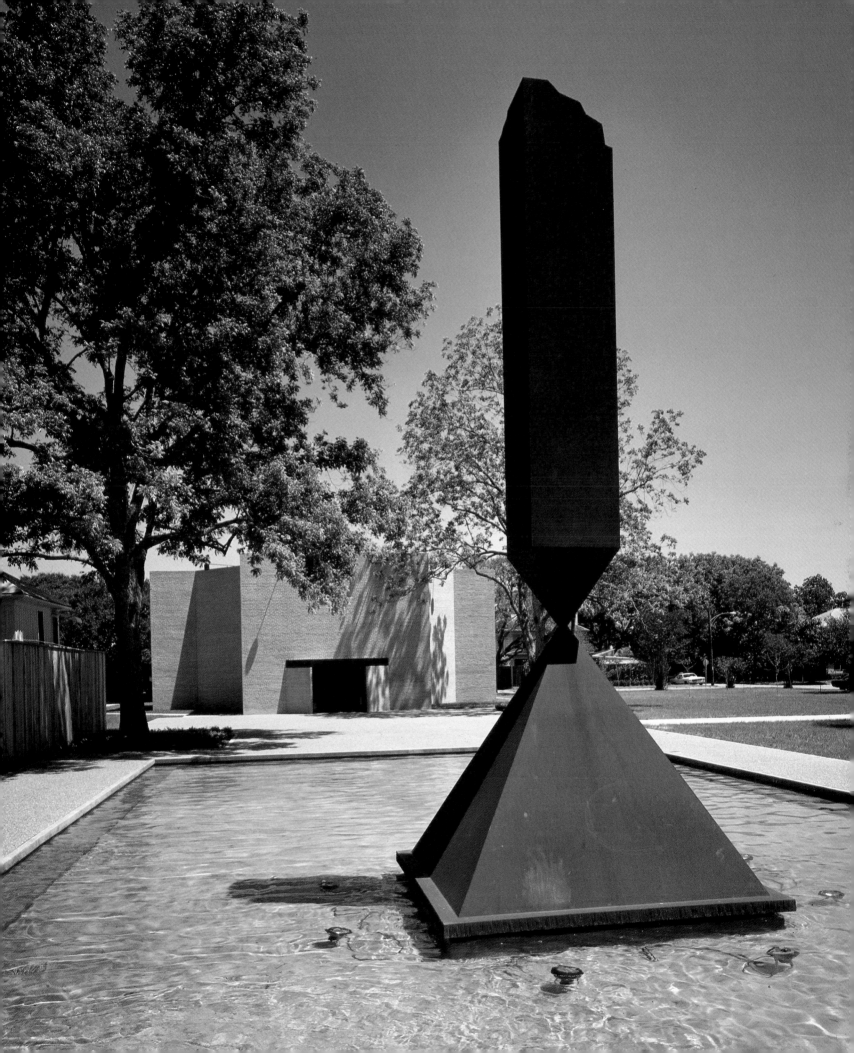

INDEX OF ARTISTS

182, 183

189

318

CONTRIBUTORS

Pierre Amiet	Chief Curator, Department of Oriental Antiquities, Musée du Louvre, Paris
William A. Camfield	Professor of Art History, Rice University, Houston
Edmund Carpenter	Anthropologist. Author of *Eskimo Realities*, 1970, and *Social Symbolism in Ancient and Tribal Arts*, 1986
Bertrand Davezac	Medievalist and Curator, The Menil Collection, Houston
Dominique de Menil	President, The Menil Collection, the Menil Foundation, and The Rothko Chapel, Houston
Remo Guidieri	Professor of Anthropology, University of Paris X
Walter Hopps	Director, The Menil Collection, Houston
Pontus Hulten	Director, Palazzo Grassi, Venice
Jean Leclant	Professor, Collège de France. Secrétaire Perpétuel de l'Académie des Inscriptions et Belles Lettres, Paris
Francesco Pellizzi	Associate of Middle American Ethnology and editor of *RES*, Journal of Anthropology and Aesthetics, Peabody Museum of Archaeology and Ethnology, Harvard University
Harris Rosenstein	Editorial Council, The Menil Collection, Houston
Anne Ross	Former Research Fellow, School of Scottish Studies, University of Edinburgh. Author of *Druids, Gods and Heros of the Pagan Celtics*, London, 1985, and *The Pagan Celtics*, London, 1986
David Shapiro	Poet and Visiting Professor, Cooper Union, School of Architecture, New York
Seymour Slive	Gleason Professor of Fine Arts, Harvard University, Cambridge. Author of *Rembrandt and His Critics*, The Hague, 1953, and *Frans Hals*, London, 1970
Werner Spies	Professor of Art History, Düsseldorf. Author of the Max Ernst catalogue raisonné (with Günter Metken), the Menil Foundation, 1975–79, and other monographs on Ernst and Picasso
Charles Sterling	Honorary Curator, Musée du Louvre, Paris. Professor Emeritus, Institute of Fine Arts, New York University
David Sylvester	Author of the René Magritte catalogue raisonné to be published by the Menil Foundation
Susan Vogel	Executive Director, Center for African Art, New York
Ellis K. Waterhouse	Deceased. Art historian. Director, Paul Mellon Center for British Art (1970–73). Director and Founder, Barber Institute, University of Birmingham (1953–71). Director, National Gallery of Scotland (1949–52)

PHOTO CREDITS AND TRANSLATORS

Translators

Ladislas Bugner for Jean Leclant
John Gabriel for Werner Spies
Jennifer Kilian for Pierre Amiet and Charles Sterling
Martine Karnoouh-Vertalier for Remo Guidieri

Photography

All photographs Hickey & Robertson, Houston, except the following:
Frontispiece, No. 202, Allan Finkelman, New York
No. 56, 59, 89, 117, 225, D. James Dee, New York
No. 65, 66, 67, A. C. Cooper, London
No. 70, 76, 96, 101, 139, 142, 169, 178, 183, 191, 192, 198, 199, 200, 201, 213, 215, 216, 222, 227, Courtesy of The Menil Foundation, Houston
No. 71, 208, Rick Gardner, Houston
No. 74, Janet Woodard, Houston
No. 195, Adam Rzepka, Paris
No. 203, David Allison, New York
No. 236, Paul Hester, Houston
No. 239, M. Lee Fatherree, San Francisco
No. 240, Courtesy of Sotheby Parke-Bernet, New York
No. 244, Courtesy of Michael Werner Gallery, Cologne

Ancillary Photography

De Menil, Fig. 1, Courtesy of the National Gallery of Art, Washington, D.C.
Amiet, Fig. 1, Hickey & Robertson, Houston
Davezac, Fayum, Fig. 1, André Berlin, Dijon
Davezac, Reliquary, Figs. 1, 2, William Hartman, Houston; Fig. 3, Courtesy of the Hermitage Museum, Leningrad
Sterling, Clouet, Fig. 1, Courtesy of the Musée du Louvre, Paris
Leclant, Fig. 1, Hickey & Robertson
Slive, Fig. 1, Courtesy of the Rijksmuseum, Amsterdam; Fig. 2, John Bethell, London
Waterhouse, Figs. 1, 2, Courtesy of The Tate Gallery, London
Camfield, Fig. 1, Courtesy of H. Goetz, Paris
Hopps, Fig. 1, Courtesy of The Museum of Modern Art, New York